Museums in the
Digital Age

Museums in the Digital Age

Changing Meanings of Place, Community, and Culture

SUSANA SMITH BAUTISTA

ALTAMIRA
PRESS

A Division of
ROWMAN & LITTLEFIELD
Lanham • Boulder • New York • Toronto • Plymouth, UK

Published by AltaMira Press
A division of Rowman & Littlefield
4501 Forbes Boulevard, Suite 200, Lanham, Maryland 20706
www.rowman.com

10 Thornbury Road, Plymouth PL6 7PP, United Kingdom

British Library Cataloguing in Publication Information Available

Library of Congress Cataloging-in-Publication Data

Bautista, Susana Smith, 1966–

 Museums in the digital age : changing meanings of place, community, and culture / Susana
Smith Bautista.
 pages cm
 Includes bibliographical references and index.
 ISBN 978-0-7591-2412-7 (cloth : alk. paper)—ISBN 978-0-7591-2413-4 (pbk. : alk.
paper)—ISBN 978-0-7591-2414-1 (electronic) 1. Museums—History—21st century. 2.
Museums and community. 3. Museums—Data processing. 4. Museums—United States—
History—21st century. 5. Museums and community—United States. 6. Museums—United
States—Data processing. 7. Museums—United States—Case studies. I. Title.
 AM5.B335 2014
 069.09'05—dc23

 2013032735

∞™ The paper used in this publication meets the minimum requirements of
American National Standard for Information Sciences—Permanence of Paper for
Printed Library Materials, ANSI/NISO Z39.48-1992.

Printed in the United States of America

I dedicate this book to all museums everywhere for having the courage, creativity, and commitment to survive in a changing world, so that my son and all children will continue to enjoy and learn from you.

Contents

Illustrations

Foreword

I first met Susana Bautista when she was beginning her studies in the Museum Studies Program, which I directed for over twenty-five years at the University of Southern California. Susana was young and eager, while also worldly and sophisticated. I saw her as an ideal candidate to undertake our three-year-long master's program, which was almost a PhD in its scope and intellectual rigor. As I suspected, Susana devoted herself to fulfilling all of our requirements, in the fields of both art history and museum studies. From the start, Susana sought to marry theory and practice, steeping herself in the literature, curating exhibitions in Los Angeles and in Mexico, seeing opportunities for future relationships of museums and their constituencies, and exploring fresh ideas within the wider context of museums in the world. Susana finished her master's degree, and we remain in close contact to this day.

When we discussed Susana's desire to earn a doctorate, somehow she seemed destined to attend the program of the USC Annenberg School for Communication and Journalism. Together we determined that she needed to undertake a course of study that would provide her with a much broader cultural knowledge of museums and the arts and how they functioned (and could potentially function) in our rapidly changing society than an art history PhD could offer. She received a coveted Provost's Fellowship to that program, and we communicated constantly throughout about digital technology and its potential for the universe of art museums. I reminded Susana not to abandon the core values and traditional roles of art museums as she was encountering the seduction of the

new, even when all those around her were rushing to apply technology without possessing an understanding of the art that the emerging technologies were supposed to serve. It became evident that the element in the museum world that Susana consistently cared about was the possibility of creating and nurturing new communities of art lovers. Thus, there was never an issue of Susana putting the "cart" of the digital technologies ahead of the "horse" of the arts. And so she joined the ranks of the few in her field who bring that depth and understanding to the task of activating museums responsibly and creatively in the digital age.

Frankly, it is Susana who has helped me advance my own thinking about the digital transformations that museums are undergoing. She tracked the struggles to move forward in responsible ways that work well, she is alert to the failures, and she always enables us to see the big(ger) picture. She possesses the insight that the future of museums lies in the multidisciplinary field of communications because she understands and values the communicative power of museums and the arts. It was in serving as a committee member for Susana's qualifying doctoral exams and her dissertation that I witnessed the development of ideas that became the basis of this book. Susana is already a leader in her field, and she is the kind of professional we want writing about digital technology. Why? Because Dr. Bautista is a humanist at heart, and the technology she advocates for will always serve our highest goals for the museum profession. She is the epitome of the intellectual and practical leader we need now.

I have been in the museum field now for almost forty years. I began my curatorial career acquiring art for the Norton Simon Museum; I have been the director of the USC Fisher Museum of Art for decades; I have developed a museum studies program that can boast of its alumni curating and managing programs from the Getty to the Metropolitan Museum of Art, the National Gallery of Art to the San Diego Museum of Art. And I know that the future of art museums lies in the balance of preserving the best of the creative arts humanity has produced while introducing the most creative of the technologies born in the digital age. In this balance lies our capacity to understand our own creativity and that of others different from ourselves in a greater global community than we could ever have imagined and accessed before. Dr. Susana Bautista's book will aid us in seeing the power of that technology as more than a marketing tool or a glitzy program, beyond one that will garner media attention and funders. She will help us understand it as fundamentally related to the organizational mission, goals, and community of museums. This book will become one of our navigational tools, reminding us to think of museums primarily as social institutions. *Museums in*

the Digital Age: Changing Meanings of Place, Community, and Culture will help us to harness the social networks of visitors and define the social capital museums can provide to the public.

I am proud to remain at Susana Bautista's side, and I hope to learn from her now, in our ever-shifting roles of teacher and student, colleague and treasured friend.

Selma Holo, PhD
Director, USC Fisher Museum of Art and USC Dornsife
International Museum Institute (IMI)
Professor, Art History

Preface

The philosopher Martin Heidegger (1977) writes about technology as "a way of revealing" through ordering, and he references Aristotle and the ancient Greek word τέχνη (*techne*), which connotes truth and a bringing forth. My study of museums' use of technology will reveal significant insight into how museums are responding and adapting to a changing society in the digital age. This book began with three general questions based on my specific interest in studying art museums in the digital age.

1. How are art museums addressing digital technology today, what is their motivation to use it, and what do they hope to achieve with it?
2. How are art museums addressing the notion of community online, how is that online community related to their physical community, and what is the role of *place* in the networked museum of the digital age?
3. How can technology help all museums to better understand and engage their communities in the digital age?

The reason why I chose to write about museums in the digital age is actually part of a bigger question; that is, why an art historian chose to get a PhD in the field of communications. I started out as a very traditional art historian who focused on the object, the artwork; as a scholar who studied it, a critic who wrote about it, and a curator who displayed it for public benefit. And then I had the opportunity to become the executive director of the Mexican Cultural Institute

of Los Angeles, a nonprofit organization that began as part of the Mexican government and later became independent. The institute had an art gallery, but it also had a library, a bookstore, a community room for lectures, a technology center, and a collection of regional dresses. Housed at Olvera Street, the "birthplace of Los Angeles" and a popular tourist destination, the Institute organized Mexican cultural celebrations, film festivals, and concerts, often accompanied by great food. I came to understand the nature of *culture* as encompassing all of these elements, and to accept the subservience of art to culture. I knew that I had to immerse myself in an academic program that would help me understand that very culture which envelops, inspires, and articulates art.

The magic of the communications field is that because almost everything in life boils down to communication (visual communication, organizational communication, mass communication, computer-mediated communication, intrapersonal communication, etc.), the field is wonderfully adaptive, drawing upon many other fields such as sociology, anthropology, psychology, media studies, business, and information science. I perceived art as a means of communication for the artist on a range of levels, and then museums as representing a more public means of communication and interpretation.

Not being a digital native myself, I went through a natural period of rapture when first encountering many of these digital technologies; exciting new museum projects, online spaces, open source offerings to the world, games and competitions. But then the analytical scholar in me regained control and I began to examine technology in relation to culture, both the museum culture and the larger culture from which it was born. I thought about the various methodologies with which to answer my three questions, from surveying museum directors and visitors to a content analysis of museum websites, finally deciding on case studies of the most technologically advanced art museums in the United States; this would allow me to delve deeply into each institution and its culture (internal and external). This became the basis upon which I developed a new methodology for evaluating museums in the digital age; a *digital ethnography* (fully explained in appendix A) that takes an aggregated approach to museums with equal consideration of their physical and online spaces, their fixed and mobile programs, and their local and global communities. The five case studies are in chapters 3 through 7 and can be read in any order. It is important, however, to read chapter 1 ("The New Museology") first. This chapter provides a historical context for the current shift in museology, and chapter 2 ("Framing a Changing Museology in the Digital Age") introduces the four pillars of the book, which frame this shift

(place, community, culture, and technology). While the case studies are a comprehensive investigation, chapter 8 ("Greater Than Five") supplements the five cases, briefly describing other innovative examples of situated technology praxis in museums around the world, including virtual museums.

Art historians and museologists are accustomed to studying relatively stable objects, but communications scholars study a world that is changing on a daily basis as innovations in digital communications technologies influence nearly every aspect of society and are consequently adapted by users. This was perhaps the hardest part of the research and still remains a challenge to keep current. This book was written between early 2010 and April 2012, and up until the very end I have incorporated relevant news and projects as they unfolded on the communications channels that I continued to monitor from the museums and other related sources (e.g., blogs, social media, RSS feeds, websites). Although the final manuscript was submitted to the publisher in May 2013, I made a conscious decision not to update the content, despite being aware of many changes in the five museums as well as in other museums. For example, the Indianapolis Museum of Art updated its website for ArtBabble in November 2012 and its general website in February 2013 (it is now without the Interact section, Collection Tags, and Tag Tours); in 2013 the Brooklyn Museum began experimenting with 3D printed models of sculpture in its monthly gallery Sensory Tours for visitors with impaired vision; and the San Francisco Museum of Modern Art announced its extensive off-site programming while the museum closes for construction from June 2013 to early 2016, with its director Neal Benezra stating on the website, "SFMOMA is more than just a building. We're a set of intersecting cultural communities." Staffing has changed, new departments have been created, the numbers cited for Facebook fans, Twitter followers, and website visitors have all increased, and collections have expanded. And even if I included all of the updates between April 2012 and May 2013, there would still be others that I would miss before the book came out in print. That is the nature of technology, the impetus of museums, and the immediacy of digital information today. Therefore, I decided that the case studies represent a snapshot in time of these important institutions and examples of how they are utilizing technology to build community, mark place, and reflect culture, with a solid theoretical explanation that will help readers to understand the importance of these changes as they continue to appear in institutions around the world.

I would like to recognize the debt that I owe to the Annenberg School for Communication and Journalism at the University of Southern California. My

department welcomed me as an outsider to the field, coming from art history and museum studies, and supported and encouraged me wholeheartedly as I strove to learn about communication, but more significantly as I applied this newfound knowledge to museums and the arts. While I owe my deepest gratitude to my advisor, Larry Gross, for his guidance and continuing support, I must also acknowledge all of my professors for their wisdom and inspiration, and my brilliant colleagues, especially when helping me wade through quantitative methods. This book would not have been possible without the tremendous time, dedication, and insight from my committee: Larry Gross (chair), Anne Balsamo, and Selma Holo. I was fortunate to work with Anne on various projects at USC for four years, and she has consistently been a most generous and caring professional of the highest integrity and intellect. My friendship and respect for Selma has only grown since I first met her in 1998 at USC's Museum Studies Program, which I attended. As I explored how museums are changing in the digital age, Selma and I had great conversations about what remained the same and why that was important. I would also be remiss not to recognize the cooperation of all the individuals that provided me with interviews, information, and invaluable assistance while researching the museums and their communities described in this book. Peter Samis was also extremely helpful in his detailed review of the manuscript. I am indebted to AltaMira Press and my editor, Charles Harmon, for believing in the important place this book serves within the greater field of museum studies, and in the need for a bit of academic theory to help us understand museums in the digital age. And last but certainly not least, I must thank my family for their never-ending encouragement, patience, confidence, and love.

Introduction

The space of museums in the digital age has been defined by the distinctive ways in which visitors use and transform it. As society changes, so do museums (slowly, but surely). Michel de Certeau (1984) makes an important distinction between space and place, defining space as a "practiced place" in the sense that as people walk they transform a street (place) into a space. The "representational space" of Henri Lefebvre (1991) is also a lived space, a social space that is a distinct product of every society. The modern museum has undergone a transformation from an early *place*-based cultural institution to a more dispersed (post)modern *space*. Digital technology has affected practically every aspect of modern society, from the economic to the social to the personal. It has transformed the ways in which we acquire information, how we shop and pay bills, how we listen to music and watch television, how we communicate with our friends and family, and how we make, save, and share our creative expressions such as photography or video. For these reasons, we call the present time *the digital age*.[1] This is not to propose a strict technologically determinist view, but to consider how new digital technologies are influencing the ways in which individuals and institutions continue to function within society, and in particular, museums. The post-postmodern age of museums today represents not so much a step forward, but a step *backward*, embracing more traditional elements still within the context of a digital age, such as the importance of place, locality, culture, and community, that assimilate well with populist tendencies from the late twentieth century.

All of these changes reveal the extreme fluidity that defines the institutional boundaries of museums today. This fluidity is a good thing, because when we define museums too rigidly we risk losing sight of their widespread potential. Ironically, their ability to endure as a sociocultural institution that embodies authority, trust, and expertise lies in their ability to adapt to a changing society. Most writings about museums and technology today focus on how technology offers unprecedented opportunities for museums, completely transforming the ways in which they operate. While this book acknowledges those changes and possibilities, it focuses more on what remains the same in the midst of a rapidly changing sociocultural environment. And furthermore, this book focuses on why such dependable and continuous features of the museum as an institution are needed in a changing digital age.

The theoretical framework of this book addresses the place, community, and culture of museums in the digital age; not only the physical or virtual space as defined by those who use it most, but its nodal place within the shifting framework of what is meant to be a social institution in the larger, global sociocultural network. To understand a museum in the digital age is to understand how its online (global) community is related to its physical (local) community and to all the points and flows of interaction within its distributed network. Whether the space of museums is determined top-down by the cultural elites, bottom-up by the communities that are actively engaged, or through a negotiated process that somehow reflects both interests, museums must navigate a larger, more diverse, and demanding public in the digital age.

The incorporation of technology, through its various historical manifestations, has been integrally related to changes in both culture and its contextual conditions. Culture will be addressed throughout this book as both a local culture and as the broader culture of museums (which is now global in scope). The anthropologist Clifford Geertz wrote, "The study of culture . . . is thus the study of the machinery individuals and groups of individuals employ to orient themselves in a world otherwise opaque" (1973, p. 363). Jennifer Daryl Slack and John Macgregor Wise propose the cultural studies approach to understanding technology, which they refer to as "a site for significant cultural struggle and change." Rather than technological determinism, Slack and Wise believe that *cultural determinism* is a more effective term, asserting, "as culture changes, it needs and develops new technologies to accomplish its goals" (2005, p. 46). They explain how our modern view of technology is closely related to the ideas of science and rationality (values of the Enlightenment), and therefore also to prog-

ress, which is not always helpful in understanding situated technology praxis today. Raymond Williams (1983b) describes culture as a process rather than an absolute. James Clifford similarly describes culture as, "a process of ordering, not of disruption. It changes and develops like a living organism" (1988, p. 235). Rosalind Williams, a cultural historian of technology, encourages us to view technology less as tools or objects and more as environments. As she writes, "In the late 20th century, our technologies less and less resemble tools—discrete objects that can be considered separately from their surroundings—and more and more resemble systems that are intertwined with natural systems, sometimes on a global scale" (1990, p. 1). Technology continues to permeate the museum institution and in the process it continues to change the institution, changing technologies as they are adapted to new uses and changing culture as both a product and consumer of the creative adaptations of technology in museums, particularly in art museums.

This book analyzes five case studies of museums in the United States that are most remarkable for their innovative uses of technology (onsite and online). The focus on art museums is due to their particular ability to sustain a discussion around issues pertinent in the digital age such as authenticity, contemplation, discourse, expertise, creativity, and authority. These five museums include the Indianapolis Museum of Art, the Walker Art Center, the San Francisco Museum of Modern Art, the Museum of Modern Art in New York City, and the Brooklyn Museum. All five museums were studied in relation to their physical locality, the extent to which their blogs and social media engage communities online, their website strategies, their onsite uses of technology, and through interviews with staff to ascertain their views about technology, success, and goals. The objective was not to compare the five museums to each other; this was an unavoidable outcome which ultimately revealed how the differences were a result of internal museum administrative strategies and goals, as well as highly distinctive geographic and demographic communities. While the five museums are large museums with international reputations and substantial budgets, each of their particular approaches to technology and community uncover great insight that can be applied to museums of all sizes and types. These cases clearly demonstrate how their particular localities and cultures should be the determining factors for how they use technology.

The Indianapolis Museum of Art (IMA) is located in the Midwest, but Indiana is known as the Crossroads of America for the number of interstate highways that connect its capital to the rest of the country. Indianapolis is

also known more as a destination for sports than for arts and culture, but the museum remains the most important art museum in the city and state, with a world-renowned encyclopedic collection, a new art and nature park, and a growing international presence, having represented the United States at the 2011 Venice Biennale. Digital technology is used carefully inside the museum, serving a community that has the highest poverty rate of all five museums studied and that is the least educated. Its audience is not as technologically comfortable as in other parts of the country and is more used to a traditional museum experience —despite a large percentage of youth—so its online and behind-the-scenes uses of technology is where it has made its mark, such as ArtBabble, Dashboard, and the IMA Lab that develops open source software and social tagging. These technological innovations, along with a strong Web presence, provide the museum with an audience larger than that of its immediate community and one which, according to museum officials, in turn generates local interest in the museum. The museum and its director, Maxwell Anderson, are open to experimenting and taking risks, shielded by a substantial endowment of $308.3 million and the longtime, local support of Lilly Endowment.

The Walker Art Center is also situated in the Midwest, yet Minneapolis is a very different city. Minneapolis consistently scored highest of all five museums regarding measures of service, social connectedness, giving, political action, and belonging to a group. The Twin Cities region is home to a large number of Fortune 500 companies, including Target and Best Buy, and adjacent to the Mall of America, the nation's largest shopping center and the region's number-one attraction. Minneapolis is also a city with a long theater tradition; the historic Guthrie Theater recently rebuilt by the Pritzker Prize–winning architect Jean Nouvel. The Walker Art Center's recent expansion was by Herzog & de Meuron, another Pritzker Prize–winning architectural firm. The Walker focuses on contemporary art as well as on its local artistic community. Its technological innovations can be found inside the galleries—a result of early artist commissions and its rich holdings in new media art—and online to facilitate specific programs with teens (WACTAC), Minnesota artists (mnartists.org), and educators (ArtsConnectEd). The museum receives generous support from local foundations, individuals, and corporations. Since 2003, the Walker has espoused the notion of the museum as a town square, a metaphor that still describes its approach to onsite and online programming.

The San Francisco Museum of Modern Art (SFMOMA) also serves a geographic region that is highly committed to culture and community, with a strong

literary tradition and a dedication to local historical preservation. San Francisco is urban, cosmopolitan, a major tourist destination for its natural beauty and historical landmarks, and adjacent to Silicon Valley, which houses the world's largest share of technology-related start-up companies, venture capitalists, and eight Fortune 500 companies including Hewlett-Packard, Google, and Yahoo. Previous director David Ross was instrumental in strengthening the museum's focus on digital and Internet-based art, as well as its use of technology for visitor interpretation and education. The museum's visitors are largely from the Bay Area, and it dedicates substantial resources in reaching out to its local creative community, with its Artists Gallery at the marina and through its community producer who manages online and onsite programs. Despite this strong local focus, the museum's website is globally ranked far above the other four museums (except for the Museum of Modern Art), and it reports a desire to begin inviting national and international contributors to its blog.

The Museum of Modern Art in New York (MoMA) is first and foremost an international museum that strives to maintain a commitment to its local community. While these last two museums—MoMA and Brooklyn—are both based in New York City, it is only by studying their immediate communities (boroughs) that we understand their profound differences. Founded in the late 1920s, MoMA embodied Manhattan's rise to fame as the new art center of the world and the recognition of a uniquely American, modernist art. Manhattan is an area with the highest education and income of the five museums studied, and it is the commercial and tourist center of New York City, adjacent to Times Square, Central Park, the Empire State Building, and major cultural destinations. MoMA has 2.8 million physical visitors a year (60 percent of ticket buyers are foreigners), its website receives 18 million visits, it has an international membership category, and it has a design store in Tokyo. MoMA uses the Internet to better serve its international audience; its website is partly translated into seven languages, it offers Courses Online, and it reaches many millions of people through social media. Its partnership with PS1 in Queens was instrumental in connecting with the local artistic community, both physically and online through Studio Visit, and the museum serves twenty-nine local organizations in its Community Partnership Program.

The Brooklyn Museum opened in 1897, just one year before Brooklyn formally became a part of New York City. Brooklyn has long defined itself as a region through its relationship to neighboring Manhattan just across the river. With its world-class encyclopedic art collection, the museum has likewise been in the shadows of its Manhattan neighbors, including the Metropolitan

Museum and many tourist attractions. Yet today Brooklyn has become the cultural capital of New York City with rapidly growing artistic communities, cultural organizations, and ethnic neighborhoods. Brooklyn is the largest community of all five museums studied with 2.5 million people, the most diverse, and while there is high crime and poverty, Indianapolis fares much worse. The Brooklyn Museum's use of technology can be characterized by a focus on its visitors and a willingness to take risks. Its endowment is the smallest of all five museums, but perhaps its position away from Manhattan and nearby great museums takes the pressure off and gives it more freedom to experiment, both programmatically (the *Sensation* exhibition and First Saturdays) and technologically (*Click! A Crowd-Curated Exhibition*, 1stfans on Meetup.com, BkynMuse, and Posse). Like the IMA, there is surprisingly little digital technology in the galleries; rather the Brooklyn Museum's mark is in how it uses technology strategically, integrated throughout the entire museum's practices.

Recent developments in mobile telecommunications, wireless, geospatial, and location-based technologies support a more mobile society that is no longer dependent on physical, static places. Nevertheless, *place* remains a critical component of the digital age in the same way that the physical object remains critical to art museums despite the ubiquity of their digital images. All museums—from the Enlightenment to modern-day—begin with a place-based idea, whether they are small community museums, ethnic museums, national museums, or great encyclopedic museums that represent the aspirations (and financial support) of local elite. French sociologist Bruno Latour writes about what he calls the *rematerialization* of digital techniques: "the expansion of digitality has enormously increased the *material* dimension of networks: The more digital, the less *virtual* and the more *material* a given activity becomes" (2011, p. 802). Museums have historically had an imposing physical presence since their beginnings in eighteenth-century Europe, the combination of great architecture and a series of interior spaces that offer a glimpse into rare, beautiful, and provocative objects. These physical, place- and material-based experiences remain essential to museums in the digital age, defining their authenticity, authority, and most importantly, their idiosyncratic representations of place, culture, and community.

NOTE

1. Other popular terms include the Information Age, the Internet Age, the Global Age, the Creative Age, the Age of Access (Jeremy Rifkin), the Age of Relevance (*Mahendra Palsule*), and the Network Society (Manuel Castells), yet all are still based upon the social implications of new digital technologies.

1

The New Museology

The significance of this book lies in recognizing the role of museums as important sociocultural institutions. Museums are relatively modern institutions—much like public libraries—that have their roots in the Age of Enlightenment that spread across Western Europe in the seventeenth and eighteenth centuries. Great private and princely collections were opened up to the public, a relative term at that time. Through the establishment of public universities, libraries, museums, even coffeehouses and debating societies, men could participate in the public sphere and educate themselves in the hopes of becoming a valuable member of society. While the ruling elite certainly understood the meaning of a public collection of valuable objects from around the world to reflect the nation's wealth and cohesion (as well as its colonial supremacy), they likewise understood that the uneducated, working-class masses of the Industrial Age needed to be properly *socialized* into this new urban society. Early museums were socially reformist in providing not so much an education about the denotative history of their objects, but more the values and morals of proper society.[1] At the same time, however, social classes and differences were reified by such altruistic aspirations while hegemonic values of the ruling and educated classes were imposed upon the masses. Museums became more than repositories of precious objects; they were bastions of authority and tradition that represented social norms, cultural capital to be acquired by all citizens, memories to be preserved for future generations, and public displays demonstrating what society valued most.

The new museology that began in the late twentieth century marked a significant shift in museums' attitudes toward society in the United States. Museum administrator and scholar Stephen Weil (2002) claims that economics turned the focus of museums from collections care to public programming. Objects became too expensive to purchase, and museums were increasingly concerned about the repatriation of historic objects from other countries, export controls, and rising insurance costs. In *The Birth of the Museum*, sociologist and cultural historian Tony Bennett also notes economic bases for the populist nature of the modern museum: "In order to attract sufficient visitors to justify continuing public funding, [museums] thus now often seek to imitate rather than distinguish themselves from places of popular assembly" (1995, p. 104). At the same time, an explosion of new museums in the mid-twentieth century created fierce competition for funding, both public and private, which drove museums to appeal more to popular interests while also appealing to the increasing interest in education and outreach on the part of philanthropic foundations. Museums of all types became more socially relevant in their curatorial and public programming, responding to social issues in a myriad of new ways. Being accessible to all types of visitors became a main concern, with museums expanding their programs in surprising ways that appeared more like popular entertainment and community centers: yoga classes, Alzheimer's programs, jazz concerts, gourmet restaurants, and more.

The notion of a participatory culture in the digital age is based upon the *constructivist theory of learning* first proposed by French developmental psychologist Jean Piaget in the 1960s (himself influenced by John Dewey and Lev Vygotsky) and later applied to museums in the early 1990s by George Hein. The constructivist approach suggests that museum visitors actively *construct* their own meanings rather than passively accept those imposed on them by museum curators and educators. Vygotsky contributed to the social constructivist theory in his 1962 book *Thought and Language*, where he suggests that language and the articulation of ideas are central to learning and development in children. Dewey's most influential publications were on the topics of education and philosophy, including *Moral Principles in Education* (1909), *Art as Experience* (1934), and *Experience and Education* (1938). Dewey founded what later became known as the progressive education movement that claims children learn best through an active experience. Piaget asserts that children build cognitive structures to adapt to the world of physical experiences, an idea which he developed in *Origins of Intelligence in the Child* (1936), *Play, Dreams and Imitation in*

Childhood (1945), and *The Child and Reality* (1973), among other writings. His dual concepts of assimilation and accommodation describe how people adapt to the world around themselves; the former by absorbing the environment into their own cognitive structure or schema, and the latter by altering their preexisting schema as a result of new experiences and information.

In *The Constructivist Museum* (1995), George Hein proposes that museum knowledge and meaning is constructed by visitors based on their prior knowledge, assumptions, interests, and experiences, as well as through the active process of learning, rather than the more traditional transmission approach. Although he does not give examples of a constructivist museum, Hein describes a constructivist exhibition, the 1993 *Nehru Gallery National Textile Project* at the Victoria and Albert Museum in London, England. For this exhibition, South Asian immigrant women were invited into the museum to design and create their own embroidered tent hangings, which Hein credits as achieving "the aim of making the museum more accessible to the community." In her book on *Interpretive Communities*, Eilean Hooper-Greenhill refers to Hein and the constructivist ideas of learning. She describes these communities:

> "Interpretation" is the process in which visitors engage in order to make sense of the experience of the museum and its collections. Although at one level this is an individual matter, the interpretations we make are mediated through the communities of interpretation to which we belong. In acknowledging the concept of "interpretive communities," a museum accepts the active processes of meaning-making that visitors deploy, and accepts that communication is a partnership between the museum staff as producers of exhibitions and (other "products"), and visitors, who construct their own experience of the exhibition according to their interpretive strategies and repertoires. (1999, p. 1)

Hooper-Greenhill based her own notion of interpretive communities on Stanley Fish (1980), who first used the term to talk about shared interpretive strategies for writing text, but she then applies it to museums as a way of "going beyond personal meaning-making" into the communal level. John Falk and Lynn Dierking's (2000) *Contextual Model of Learning* is similarly based on constructivist theories, emphasizing that all learning is contextual on three levels: personal, sociocultural, and physical (meaning the physical environment and its properties). The model suggests that museums provide connections and opportunities for interaction that directly relate to visitors' different interests and motivations in these three levels for free-choice learning.

Starting in the late 1980s, a proliferation of museum visitor studies created visitor typologies in order to better serve specific groups and to understand the growing diversity of visitors in ethnicity, age, socioeconomic levels, and education, largely a result of increased outreach efforts. The Visitor Studies Association was founded in 1988 in the United States, a professional organization that served as an informational forum for the emerging field of visitor studies and evaluation, offering an annual conference and a biannual journal. Through its Office of Policy and Analysis, the Smithsonian Institution began conducting visitor studies in 1989 (*Visitor Perspectives of Tropical Rainforests: A Report Based on the 1988 "Tropical Rainforests: A Disappearing Treasure"*) and continues actively today with all reports archived on its website (http://si.edu/OPANDA/studies_of_visitors). The American Association of Museums (AAM)[2] in Washington, DC, focuses on visitor studies through its standing professional Committee on Audience Research and Evaluation (CARE), publishing its own conference proceedings from the field since 2004 in *Current Trends in Audience Research and Evaluation*. In 1990, the AAM commissioned a report by museum consultants Randi Korn and Laurie Sowd titled *Visitor Surveys: A User's Manual*. The Association of Science-Technology Centers, also in Washington, DC, was founded in 1973 as a professional organization for science centers and museums and has published two important books: *Questioning Assumptions: An Introduction to Front-End Studies in Museums* by Lynn Dierking and Wendy Pollock (1998) and *Planning for People in Museum Exhibitions* by Kathleen McLean (1993). Most large museums have also conducted their own visitor studies for some time now, either through their education departments or by hiring outside consultants. For example, the Exploratorium in San Francisco has a Visitor Research and Evaluation department. Within the academy, most museum studies programs teach students about visitor studies, publishing papers and organizing conferences on the subject. For example, the University of Leicester offers a distance-learning course entitled *Learning and Visitor Studies*, and John F. Kennedy University offers graduate courses entitled *The Visitor Experience: Learning Theories* and *Understanding Audiences, Interpretive Methods and Applications*.

One concern with applying the constructivist approach to museums is its tendency toward reductionism and narrowcasting, resulting in a highly complex (and paradoxically simplified) categorization of visitors. While this now plethora of typologies[3] may be useful to museum staff and may serve to personify the masses, they disregard the multidimensionality of visitors' characteristics and actions, their multimodal networks of social relations, and the fundamental un-

predictability of human nature. Furthermore, in studies of online communities, categorization was found to produce in-group competition and discrimination among members.[4] The practice of narrowcasting has become a trend in the digital age not just with museums, but principally with corporations and the media in order to more efficiently target their customers, now enabled by technological developments in data mining, pattern mining, and Web mining, among others.

The incorporation of technology by museums raises new questions about how museums are considering the notion of their community and how they are serving that community (or communities). In his 2007 book *Recoding the Museum: Digital Heritage and the Technologies of Change*, British museologist Ross Parry notes the year 1967 as the momentous birth of computerization in the museum at the Smithsonian Institution in Washington, DC. Computers in those early days were mainly used for internal purposes of efficiency, record keeping, communication, and facilitating access to students and scholars. Museums today are incorporating the latest technologies in their continuing attempt to better serve their visitors. Their websites offer games, extensive image databases, social network connections, online shopping, videos, and a calendar of events that often overshadow the more scholarly (and behind-the-scene) aspects of museum activities. Interpretive tools within the physical galleries include digital kiosks, digital labels and iPads, and tours that are now mobile, multimedia, and digital. The digital age has spawned a participatory culture—particularly with the younger generation—that is accustomed to immediacy, visual enticement, less entry barriers, and an abundance of publicly available information. Museums have successfully managed a balance between upholding their traditional, scholarly standards of collection, research, conservation, and exhibition, while at the same time trying to meet the needs of a much wider and diverse public. The significance of a holistic vision of museology that incorporates the local and global, virtual and physical, fixed and mobile, becomes more manifest in the digital age where technology has contributed to a distributed museum experience. The institution of museums is once again (re)defining its social role, its authority, and its popularity as it responds and adapts to a changing society.

NOTES

1. Tony Bennett (1995) refers to British cultural reformers of the late nineteenth century, such as Sir Henry Cole and George Brown Goode, who looked to certain social institutions to civilize the masses (museums, libraries, parks, reading rooms, and theaters). Bennett quotes Cole as saying in 1884, "The Museum will certainly lead him to wisdom and gentleness, and to

Heaven" (p. 21). A particular concern was drunkenness of the working classes, as evidenced by the 1834 Committee on Drunkenness.

2. In August 2012, the American Association of Museums changed its name to the American Alliance of Museums. Throughout the book, it will be referred to as the American Association of Museums.

3. John Falk categorizes visitors based on their various needs (explorers, facilitators, experience-seekers, professional/hobbyists, rechargers); Bonnie Pitman and the Dallas Museum of Art based their 2010 categorization on preferred learning styles (observer, participant, independent, enthusiast); then there are the usual categories of museum constituents (students, families, members, teachers, artists, donors, etc.), as well as categorization by demographics (age, race, ethnicity, gender, level of education and income, and zip code).

4. A few of these studies include Dellarocas (October 2001), Building trust online: The design of reliable reputation reporting: Mechanisms for online trading communities, *MIT Sloan Working Paper No. 4180-01*; Rohde, Reinecke, Pape & Janneck (2003), Community-building with web-based systems—Investigating a hybrid community of students, *Computer Supported Cooperative Work, 13*, 471–499; and Yan & Xin Li (2009), Group identity and social preferences, *American Economic Review, 99*, 431–457.

Framing a Changing Museology in the Digital Age

Museology is experiencing a significant shift once again due to the institutional survival of museums in the digital age. But to understand this shift is not merely to study the new technologies used (by both museums and their visitors) or the new digital experiments conducted. The digital age has affected nearly every aspect of modern society, causing a cultural shift throughout the world. Therefore, it is necessary to frame a study of the shifting museology with four major constructs that are tightly interlinked in the digital age: place, community, culture, and technology. This chapter will describe these four notions as they have been described by other scholars, raising critical issues, debates, and questions about each that become more pronounced (and complicated) in the digital age, serving as the theoretical foundation upon which this book investigates situated technology praxis in the five case studies.

The American philosopher Edward S. Casey (1997) writes a remarkable philosophical history on the notion of *place* that references great theorists, historians, and philosophers throughout the ages starting with Aristotle and encompassing Newton, Kant, Heidegger, Lyotard, and Deleuze and Guattari. He traces how *place* was prominent in early Greek thought, but disappeared into the shadows of *space* throughout late Hellenistic times, medieval philosophy, and seventeenth-century physics, only to return again in modern culture. This book will not attempt to enter into the great debate over place and space—whether place is in space or space is in place, which came first or which is more relevant today—but acknowledges the presence and significance of both in the digital

age. Casey describes how the reappearance of place requires a distinctly different form: "To spread out in places is to leave (behind) the extensiveness of homogenous infinite space and to inhabit a new kind of space, one that is heterogeneous and open, genuinely spaced-out . . . it is open precisely *in places*" (1997, p. 341). One of these different forms is proposed by Eric Gordon and Adriana de Souza e Silva in their 2011 book *Net Locality*, who argue for the primacy of *locality* rather than physicality or place in the digital age (they call it the "networked world"). Locality, they suggest, is a new hybrid space "composed by a mix of digital information and physical localities." Spanish sociologist Manuel Castells (2001) prioritizes the "space of flows"—another form—over the "space of places" in his idea of the global network society. Henri Lefebvre (1974/1991) offers the idea of *rhythms* as one more form. Lefebvre believes that rhythms invest places but are not a thing, aggregation of things, or even a flow, and are derived from a relationship between space and time.

Today the central notions of place and space are integrally tied to the equally central notions of community and culture. Nevertheless, all of these isomorphic concepts (including the related terms public, public sphere, and society) have been points of discussion, debate, and writing since ancient times, with *culture* emerging later during the Industrial Revolution. What has changed in modern times, however, is the fluidity with which they are all correlated. Raymond Williams (1958/1983b) and the modern field of cultural studies declare that culture and society are separate in modernity, with the former being more a social idea that came to be associated with an elite part of society. Just as with place/space, this book will not enter into the debate over culture and society, but acknowledges the presence and significance of both in the digital age. One cannot discuss how culture is actively created and transformed without studying the social conditions within which that process takes place. When Glenn Lowry, the director of the Museum of Modern Art in New York, claims that "museums across America have become the defining public institutions of their communities" (as cited in Cuno, 2004, p. 131), he is referring to a modern (or post-postmodern) institution that somehow encompasses place, space, culture, community, public, public sphere, and society. The road toward greater inclusion has not been a smooth one—and for some museums more bumpy than others—but we can certainly acknowledge the great efforts of art museums in responding to diverse, and often competing, voices. And digital technology is one very crucial tool that museums are using to aid them in their continuing efforts. As public institutions where physical visits are still more social than individual, museums are

ever more concerned with inclusiveness and plurality regarding their visitors and local communities, yet they also strive to place themselves within a global framework. Museums have subdivided their members into groups that, aside from adding to their hierarchical, dominant nature, provide a stable foundation of interest-based constituents and financial support. The social capital that museums supply presents an opportunity for the public to interact socially (especially certain privileged members), but more importantly, for the different classes, races, and ethnicities to interact within a legitimate public space that still reflects normative, societal values.

An ethnographic study of art museums in the digital age looks at how museums and their visitors are using technology across all the contextual constructs in order to discover the broader implications. Because museums and museological practices today are ever more engaged in their respective places/spaces, communities, and cultures/societies, any contemporaneous study of them must be as well, including their use of digital technology that ultimately displaces our familiar understanding of all these terms. Each of the four concepts will now be discussed in further detail. Despite their division as separate subchapters, they are considered interrelated and so each will be woven throughout this theoretical discussion, as well as in the five case studies.

PLACE/SPACE/EXPERIENCE

This book claims, like Casey, that place has regained its prominence in the digital age. This is not such a simple statement, however, as the notion of place has changed radically from ancient times to the Enlightenment to the Industrial Revolution to the Digital Age. What do we mean by place today? Does place imply physicality? Not if you consider the validity of places in Second Life, or even when considering common Internet terminology such as "landing on a Web *site*." Does place imply locality? James Clifford (1997) gives the example of the great world's fairs starting in the nineteenth century (London, Paris, and Chicago) where the local was always global. And even more so today with synchronous digital communications technologies such as Skype, chat, Web conferencing, and the latest, telepresence videoconferencing where *place* becomes that indeterminate point of intersection within a global network of users; what Casey refers to as the "omnilocality" of place. Finally, we can ask if place implies permanence? For this answer, we turn both to theory and technology. Feminist theorists such as bell hooks (2000) write about the marginality of women in democratic society, philosophers such as Deleuze and Guattari (1987) write

about nomads inhabiting a "special kind of place," and cultural theorists such as Stuart Hall (1997a), Homi Bhabha (1994), Nestor García Canclini (2001), and Seyla Benhabib (2002) write about the causes and consequences of the migration of classes, races, and ethnicities from the periphery to the center, and the fluctuating nature of that new center. Similarly, developments in mobile and location-based technologies, including virtual and augmented reality, allow us to talk about the transference of place in the digital age. "We are where our devices are," claim Gordon and de Souza e Silva. To describe this portable nature of social connectedness due to online and mobile technologies, sociologist Mary Chayko uses the term *portable communities*, which are "groupings that use small, wireless, easily transportable technologies of communication (portable technologies) to facilitate interpersonal connectedness and to make and share a collective identity and culture" (2008, p. 8).

There are two main reasons why place has receded for the modern museum; one is due to technology and the other due to the primacy of experience. Both are related, however, as new digital technologies allow for new kinds of experiences, a rather continuous cycle of dependence. In her book on public art, philosophy professor Hilda Hein argues that the primacy of experiences in the mid-twentieth century served to displace the museum's collection, coining the term "experiential museum." As museums became about experiences—"process over stasis"—they became less connected to place; objects became "vehicles for the delivery of experience rather than as ends unto themselves" (2006, p. x). Nevertheless, Hein acknowledges that in our modern society saturated with opportunities for experience and entertainment, the museum is distinguished by the authenticity and materiality of its objects. Visitor experience can still be place-based as museums and other institutions offer experiences within their physical spaces, but ultimately experiences are defined by the *individual* that receives the experience in a unique manner, and less by institutional intentions. Experiences subjugate the place because they can be taken away by the visitor, stored in memory, and often recalled through various strategies (analog and digital) that may no longer relate to the original place-based experience.

Falk and Dierking concur with this idea that museum experiences detach visitors from the physical museum place.

> Since visitors do not make meaning from museums solely within the four walls of the institution, effective digital media experiences require situating the experience within the broader context of the lives, the community, and the society in which visitors live and interact. (2008, p. 27)

While museums certainly are not intentionally trying to drive visitors away from their physical buildings and collections, they have largely come to accept the constructivist notion of how learning and meaning are created by visitors within the context of their personal backgrounds, interests, and lives. Based upon this modern museology is a growing awareness that personal mobile technologies allow visitors to experience the museum wherever and whenever they choose. With mobile tours (such as Art on Call at the Walker Art Center), visitors can call a number to hear more about work they are standing in front of—inside museum galleries, outside in museum gardens or exteriors, or throughout the city—or visitors can call the number from their home at a later date and time, perhaps never intending a physical visit to the museum. Another feature called *bookmarking* creates a stronger connection between the physical museum experience and a pre- or post-museum experience at the visitor's home (or wherever they may have Internet access). For example, Getty Bookmarks at the J. Paul Getty Museum is a way for visitors to select their favorite works of art and then save them on the museum website in a personal gallery. There are many variations of bookmarks, with functions on audio and handheld tours where visitors are sent e-mails with links to their bookmarks; visitors can access their bookmarks or personal galleries at physical kiosks inside the museum, or through their own smartphones. A few more examples of such personal spaces on museum websites include My Collection at the Smithsonian American Art Museum, My Art Gallery at the Seattle Art Museum, My Scrapbooks at the Art Institute of Chicago, and Art Collector at the Walker Art Center and the Minneapolis Institute of Arts.

If *place* in the digital age no longer implies physicality, locality, or permanence, but rather a different form such as those suggested by the scholars mentioned above, then its reemergence in the digital age permits a symbiotic relationship with experience rather than a contradictory one. Furthermore, the proposal of *place/experience* allows for fluid movement through space and time as well as through society and community in general. In *Mobilities of Time and Space*, Marita Sturken refers to the term *nonplace* first discussed by Marc Augé in 1995. She writes,

> If modernity was characterized by a separation of space and place, in postmodernity, there is an emphasis on the proliferation of nonspaces—airports, freeways, bank machines. The postmodern concept of the nonplace thus bears a contiguous relationship to the modern sense of space as compressed, traveled through, removed from actual places. (2004b, p. 79)

This book does not negate or reduce place, as in the postmodern concepts of nonplace or nonspace, but proposes the additive concept of place/experience that acknowledges its new form. Casey (1996) similarly suggests, "A place is more an *event* than a *thing* to be assimilated to known categories," and James Clifford (1997) writes about location as "an itinerary rather than a bounded site—a series of encounters and translations."

Ethnographers and anthropologists have long been aware that places are socially and culturally constructed—*contact zones*—in turn influencing philosophers such as de Certeau, Lefebvre, and even Albert Camus, who stated in 1955, "Sense of place is not just something that people know and feel, it is something people do" (as cited in Basso, 1996, p. 88). This sociocultural process, however, does not serve to transform place into space, but rather remains an overriding and uninterrupted influence of space, place, and locality throughout their digital transmutations. Gordon and de Souza e Silva suggest that "now that our devices our [sic] location aware, we are much better positioned to be location aware ourselves" (2011, p. 54). As we pay more attention to place and location today, we must remain conscious of their sociocultural contextual framework. Referring to the idea of place-based education, David Gruenewald (2003) uses the term *place-conscious education* to demonstrate the need for the educational field to also pay more attention to places. Gruenewald believes that places are social constructions, calling this term "the new localism" that emerged in response to globalization. As the field of education extends outward toward places, it becomes more relevant to the lived experience of students and teachers that consequently become more accountable so that "places matter to educators, students, and citizens in tangible ways." A consciousness of place, Gruenewald argues, is accordingly a consciousness of ourselves as "place makers and participants in the sociopolitical process of place making" (p. 627). This call for active participation—for *place making*—is associated with recent calls for increased civic engagement (Putnam, 1995; Asen, 2004) and recognition of the participatory culture of the digital age.

When places are actively inhabited, created, and shared—like the *practiced place* of de Certeau or the *representational space* of Lefebvre—they become public spheres. Jürgen Habermas expounded on the bourgeois public sphere in his influential book from 1962. The public sphere of eighteenth-century Europe united strangers together, requiring only that one pay attention in order to become a member. The more active acts of deliberation, argumentation, and ultimately agreement were also necessary to form the ideal citizen that avoided

violence by engaging in reasoned discourse. Directly opposed to Habermas's bourgeois public sphere is the proletarian public sphere, first proposed by Oskar Negt and Alexander Kluge (1972/1993). The most important distinctions are that there is not merely one public sphere but multiple public spheres, and that the concept of community should be replaced with that of *counterpublics* (Fraser, 1990; Warner, 2005). Today's public sphere is more accessible and democratic than its predecessors, but discourse remains the defining factor. Museums can be considered public spheres as critical places for individual development because they reflect societal norms and values; they are places where public opinions are formed and presented, and where participation and discourse are encouraged both by peers and authority figures. Museums embrace the idea of the public sphere today; they offer free days to ensure accessibility, they have free WiFi that facilitates connectedness, they host lectures to encourage dialogue, they create social groups for members to interact onsite and online, and they solicit comments from visitors to share publicly.

While the public sphere is a useful concept to emphasize the need for individual discourse, participation, and engagement on a macro level, it is still possible to talk about place, or place/experience, as socioculturally generated without needing to transform it into other terms like public sphere, space, or public space. *Public space* is a more contemporary notion of the public sphere that is used in fields such as urban design, public policy, public art, and geography. Gordon and de Souza e Silva describe public space as "a collection of minor social contracts" and refer to the urbanist William Whyte's description of "good" public space as the Seagram Building in Manhattan that encourages casual conversation. Places have not disappeared (Castells, 2001; Lefebvre, 1974/1991), but they have certainly been transformed by their inhabitants through changing cultural practices, social relations, and developments in digital technology, along with the ways in which such technologies are culturally adapted.

COMMUNITY: TO BE, OR NOT TO BE
One of the most important changes in the modern populist museum is its increasing concern for community as reflective of sociocultural changes, particularly in the Western world. The museum's desire to deliberately incorporate its local community (or communities)[1] has witnessed a parallel interest in strengthening civic engagement on the part of governmental bodies, academia, and foundations that have all invested great sums of time, knowledge, and funding into the matter. It is generally assumed that a democratic society is

based upon the active participation of its members, resulting in, if not consensus, then at least dialogue and social interaction. In his influential work from 2000, *Bowling Alone: The Collapse and Revival of American Community*, political scientist Robert Putnam demonstrates how social capital has been steadily declining since the 1950s and is especially worrisome with the youth of today. He proposes that the acquisition of social capital through involvement in social organizations can lead to increased participation in all aspects of society, which can strengthen the democratic process.

Despite his calls for greater civic participation, social capital, and community engagement, Putnam acknowledges the complexities of the notion of community. He traces the individualistic strain in the United States back to the Pilgrims that first came to America escaping religious persecution in seventeenth-century England and to Alexis de Tocqueville's idea of *Democracy in America* in the early nineteenth century. Putnam writes, "Community has warred incessantly with individualism for preeminence in our political hagiology. Liberation from ossified community bonds is a recurrent and honored theme in our culture" (2000, p. 24). The debate between the individual and the community, and in particular, between the individual *in relation* to the community, is similar to the debate between culture and its place within society. It is a debate that started in an analog world hundreds of years ago and continues in a digital world where critics fear the socially isolating effects of technology. As with the other debates—place and space, culture and society—this book will not argue for one position or the other, but acknowledges the importance of both the individual and of the individual becoming situated within community. This book also recognizes the ability of technology to support individual identity while concomitantly supporting communities by creating new and improved means for communication on a one-to-one basis as well as a one-to-many basis. In describing his notion of *practiced place*, de Certeau asserts, "The approach to culture begins when the ordinary man *becomes* the narrator, when it is he who defies the (common) place of discourse and the (anonymous) space of its development" (1984, p. 5). Discourse is critical to place, to the public sphere, to public space, to integrating culture into society, and most decidedly, to building social capital and community as an active form of participation.

Before engaging in a conversation about museum communities, we must first ask, when and how did the masses or the public of the eighteenth century become the *community* of the twentieth century? Our modern-day notion of community encompasses the masses that Frankfurt school philosophers Max

Horkheimer and Theodor W. Adorno warned about, the somewhat restrictive public in Habermas's public sphere, as well as the more inclusive counterpublics of Fraser and Warner, and it even allows for the notion of culture in the very classification or constitution of communities. The notion of community empowers its members because it depends upon public participation and formation, as in online communities with chat forums and personal recommendations. However, communities can also be restrictive when imposing rules, social norms, and expectations (explicit or implicit). Museums are increasingly concerned about their community, but how do they define that community? If there are multiple communities, how are they classified? With practically every museum today having its own website, community takes on a global perspective through the ability to reach anyone, anywhere, and at any time with an Internet connection. How does this new global community of virtual visitors relate to the local community of physical visitors?

While at the same time expanding the notion of a museum community, digital technology has also allowed museums to more efficiently serve many of their different communities that they have already classified. Teachers can download lesson plans from websites, members can renew online, students and scholars can search online collection databases, mobile tours of exhibitions offer detailed information, and those more inclined to participate can comment on blogs and social media, upload photos, tag objects on the website, and play online games. This subchapter will briefly discuss how museums have considered their community, it will describe a number of ways in which to consider community today, and it will illustrate the impact of digital technology on community. I will now briefly note different types of communities (physical, virtual, and hybrid) as used by different theorists and fields for different purposes.

Interpretive Community

The British museologist Sheila Watson (2007) writes about museums that work with and for a number of communities rather than a single one in her edited book, *Museums and Their Communities*. She refers to Dr. Rhiannon Mason's (2005, cited in Watson, 2007) typology of museum communities as a useful way to extend Hooper-Greenhill's notion of *interpretive communities*: (1) shared historical or cultural experiences, (2) their specialist knowledge, (3) demographic/socioeconomic factors, (4) identities (national, regional, local, or relating to sexuality, disability, age, and gender), (5) their visiting practices, and (6) their exclusion from other communities. Watson notes that a target audience and a

public are entirely different from the notion of a community, although they are all related. Hooper-Greenhill acknowledges the problem with museums targeting their audiences, but supports her idea of interpretive communities.

> We have become accustomed in recent years to thinking about "target audiences," and know that each target group needs to be considered separately. We tend to talk about school-groups, families, tourists, people with disabilities and so on. The concept "target group" is a marketing term which enables the division of museum visitors on the basis of demographic variables such as age, disability or life-stage. "Interpretive communities" takes this a step further by focussing [sic] on those varying strategies of interpretation that differentiated visitors will use to make sense of the experience of the museum. (1999, p. 8)

The complexity of community can clearly be seen here. Just as Samuel Huntington (Harrison & Huntington, 2000) said about culture, if community includes everything, it explains nothing; hence the drive to deconstruct community into target groups, behavioral groups, and even interpretive groups which themselves morph into separate (micro)communities to once again become a target. How can a community be distinguished from a group, culture, counterpublic, or more? The term community is most often used—despite its relative uselessness—to describe the nature of any group, its individual members, and how they are related.

Community of Interest

In *The Age of Access*, Jeremy Rifkin describes how corporate management and marketing professionals discovered that establishing *communities of interest* is a productive way to engage new customers and keep them loyal to the product over the long term. The strong ties between customers and the product, as well as between individual customers, are based on a shared interest in a product that in turn strengthens the overall community. Most communities of interest are online because of the Internet's ability to connect like-minded people from around the world. Rifkin states, "Private communications networks are forging new communities of interest that have fewer and fewer ties to geography" (2000, p. 224). Museums have long created physically grounded membership groups based on shared interests, and are now digitally transforming them through their websites and social media use. Jerry Watkins and Angelina Russo argue that "increasing digital literacy within cultural institutions could be integral to the further development of a co-creative relationship between institutions and communities of interest" (2007, p. 219). The Internet is enabling museums to

forge stronger connections with their online visitors, but as of yet, the ability for individuals with similar interests to develop strong ties between themselves is still developing.

Community of Inquiry

Philosopher Matthew Lipman explains a *community of inquiry* within the context of learning and educational experiences as a means of "questioning, reasoning, connecting, deliberating, challenging, and developing problem-solving techniques" (as cited in Garrison, Anderson, & Archer, 2000, p. 91). Lipman writes,

> Inquiry is generally social or communal in nature because it rests on a foundation of language, of scientific operations, of symbolic systems, of measurements and so on, all of which are uncompromisingly social. But while all inquiry may be predicated upon community, it does not follow that all community is predicated upon inquiry. (2003, p. 83)

The ideal educational experience within this type of community is based on the overlapping factors of social presence, cognitive presence, and teaching presence that constitute the *community of inquiry model* (Garrison & Arbaugh, 2007). A community of inquiry is essentially an educational community based more on the *practice* of inquiry and learning than on a particular interest or affinity, and is most often adapted to online/distance learning as mediated by computers. An example of this type of community will be reviewed in the Museum of Modern Art's *Online Courses*.

Community of Practice/Knowledge Community

First proposed by Etienne Wenger and Jean Lave in 1991, *communities of practice* are knowledge-based, informally composed, self-organizing, and depend on deep individual commitment. Participation is not mandatory in these communities, but is encouraged by focusing on common interests, tasks, and goals. Wenger (2000) further explained these communities by stating that their effectiveness is a factor of how well they connect with other communities and constituencies, "not a matter of their internal development alone." Communities of practice are not principally educational communities, nor are they solely based on shared interests despite being compared to *affinity groups* (James Paul Gee), but are formed around common practices such as discourse

(also known as *discourse communities*) and knowledge transfer that prioritize social relations between members.

Communities of practice are also referred to as *knowledge communities,* based on the sharing of knowledge and specific topics of interest. Most knowledge communities are online (called *virtual communities of practice*) facilitated by digital communication technologies; a few examples are wikis, online forums, comments on blogs, and social media. Caroline Haythornthwaite (2011) distinguishes between *knowledge crowds* (crowdsourcing) and knowledge communities as two ends of the spectrum, the main difference being that the former comprises anonymous individuals with no defined commitment to contribute, and the latter has known participants that contribute often. Museums have experimented with crowdsourced exhibitions and now commonly use blogs and social media that solicit public comments, as well as occasional wikis for special projects. All of these participatory practices, however, do not imply that the overall structure of museums is to be considered a community of practice or a knowledge community, but that certain programs may benefit from the social, collaborative nature of these communities.

Collective

The concept of a collective is not a new one, or even one created by academics. It is simply, according to Douglas Thomas and John Seely Brown (2011), "a community of similarly minded people." The collective can be perceived as an alternative to the notion of community, and Thomas and Seely Brown clearly make the distinctions. Communities can be passive (although not all are), but collectives absolutely cannot be passive as they enable agency. In communities, people learn in order to belong, and in collectives, people belong in order to learn. Communities are strengthened by creating a sense of belonging to something greater than oneself such as an institution, but collectives are strengthened by participation where there is no sense of a center. They further define collectives as "an active engagement with the process of learning" and not by shared interests, actions, or goals. Thomas (2011) describes the importance of the collective as an outcome of the growth of the networked age and imagination (largely due to the Internet and social media): "the creation of new social formations that radically transform the relationship between structure and agency." Thomas and Seely Brown's concept of a collective is not related to the idea of *collective intelligence* that is based on collaboration (collective behavior) toward achieving a common goal, or even to *collective action*

theory (Olson, 1965), which is more applicable to social movements and also dependent on group action for the collective good. While Thomas and Seely Brown position communities and collectives at opposite ends of the spectrum, they also believe the two to be compatible.

Network

The concept of the network is another alternative means of perceiving community. John Barnes was the first to study social networks in the context of a Norwegian island parish in the early 1950s. Much like Putnam's emphasis on the value of social capital, *social network theory* views social relationships in terms of nodes and links between individuals which are ultimately more important than individual attributes or agency. Social networks are structured to increase individual connections, provide information, and set policies. Again favoring the communal over the individual, Mark Granovetter (1983) proposes his idea about "the strength of weak ties" where a large network of weak ties is more powerful than a small network of strong ties in relation to innovation. From a sociological perspective, Barry Wellman and Keith Hampton (1999) claim that "communities are clearly networks . . . people usually have more friends outside their neighborhood than within it." They observe a modern shift from living in "little-box societies" that deal with only a few groups such as home, neighborhood, work, or voluntary organizations—hierarchical structures—to living in "networked societies" with more permeable boundaries, more diverse members, and more opportunities for social connections. Providing an important perspective to social network theory is Manuel Castells's idea of *networked individualism* that highlights the increased individuation of the digital age. Castells states, "Networked individualism is a social pattern, not a collection of isolated individuals. Rather, individuals build their networks, on-line and off-line, on the basis of their interests, values, affinities, and projects" (2001, p. 131).

The emergence of the Internet generated a more comprehensive study of networks and patterns of relationships. *Computer-supported social networks,* or computer networks that bring together people and machines, emerged in the 1960s when ARPANET (The Advanced Research Projects Agency Network) was developed by the U.S. Department of Defense (Wellman et al., 2000; Wellman & Hampton, 1999). Peter Lyman (2004) proposes the idea of a *network-mediated community* as a new public space that originally referred to basic Web functions such as chat groups, electronic mail, and listservs, but eventually created a sense of intimacy and belonging for its users. However, Ross Parry detects a

problem with assigning the network concept to museums in the digital age. He believes that "the modularity of the distributed network was incompatible with the singularity that had for centuries defined the museum" (2007, p. 95). While museums have for years now used the Internet to reach out, Parry is concerned that the distributed, modular nature of the Web can fragment the centrality of the institution by deepening social divides and facilitating the broadcasting and publishing of content.

There has been a tremendous amount written about motivations to join and participate in communities, the effects of belonging to communities, and how communities can best sustain themselves. The *homophily theory* (McPherson, Smith-Lovin, & Cook, 2001; Kandel, 1978) suggests that people seek out others similar to themselves, which leads to a networking effect. For these individuals to find new information or different sources they have to look outside the group, which could lead to either a weakening of the group or an infusion of new members if they are successfully brought into the group. Related to the homogenizing of networks, the *contagion effect* states that different people become more similar if they are in the same network. In 2007, Ren, Kraut, and Kiesler proposed the *common identity* and *common bond theories* as ways to predict the causes and consequences of individual social attachments. *Common identity theory* focuses on individual attachments to the group where members feel a commitment to the community's mission caused by interdependence, inter-group comparisons, and social categorization, with effects such as high conformity to group norms, newcomers feeling welcome, and generalized reciprocity. *Common bond theory* focuses on individual attachments to other individual group members, where members feel a social or emotional attachment to other people in the group caused by social interaction, divulging personal information, and interpersonal similarity, with effects such as off-topic discussion, low conformity to group norms, direct reciprocity, and newcomers feeling ostracized. The *social identity theory* (Tajfel, 1978) claims that people are motivated to join certain groups in order to develop a positive self-image. Whether an individual identifies more with other group members (interpersonal attraction) or with the community (social identification) determines how much an individual self-categorizes, also known as *self-categorization theory* (Turner et al., 1987). Personal identity becomes more pronounced when individuals have greater interpersonal attraction (similar to the *identity-based attachment theory*). If individuals are not categorized by the community, then they will self-categorize, which could lead to self-

stereotyping and de-personalization, often based on perceived characteristics of the community. A person's identity, however, can be both personal and social, with one appearing more salient than the other at any given time. Relevant to the topic of online communities and computer-mediated communication is the *social identity model of deindividuation effects* (Reicher, Spears, & Postmes, 1995), which suggests that in virtual conditions of anonymity, a common group identity become more salient. In face-to-face, interpersonal interaction, those possessing a strong social identification with the community are more likely to develop interpersonal attractions with other members.

A review of these different concepts of community, as well as the many theories that explain motivations to join and participate, provides a basis for reconsidering the notion of museums and community that will frame the forthcoming case studies. In his book *Making Museums Matter*, Stephen Weil discusses how museums matter to community:

> The museum of the near future, as thus envisioned . . . will in essence be one of a range of organizations—instruments, really—available to the supporting community to be used in pursuit of its communal goals. As an intricate and potentially powerful instrument of communication, it will make available to the community, and for the community's purpose, its profound expertise at telling stories, eliciting emotion, triggering memories, stirring imagination, and prompting discovery—its expertise in stimulating all those object-based responses. (2002, p. 200)

Can museums be considered a community unto themselves and if so, what type of community, how do they motivate participation, and what are their rules of engagement? Is it more appropriate to talk about museums as a collective that have no hierarchy, center, or restrictions? Are museums a network of social relations or a network-mediated community? And if museums are themselves communities or networks, how do they relate to their external communities and networks on the local, national, and global levels? The answers to these questions depend largely on how each museum negotiates its changing relationship with the public.

CULTURE MATTERS TO MUSEUMS[2]

The notions of culture and the public sphere overlap because they both engage discourse, conflict, and convergence on a social level. As we briefly discussed the complexities of place in the digital age (space, nonplace, localism, mobility, virtual places, public sphere), so can we discuss the possibly even greater

complexities of culture (cultural production, cultural consumption, cultural imperialism, cultural hybridity, cultural plurality, cultural systems, cultural identity, etc.) and how the modern museum approaches the subject in relation to digital technology. Raymond Williams claims that partly due to its complicated historical development during the Industrial Revolution, culture "is one of the two or three most complicated words in the English language" (1976/2002, p. 36). The other reason is because it is a popular term that has been applied to a broad array of intellectual disciplines, fields, and ways of thinking. This is why Samuel Huntington (2000) argues that "if culture includes everything, it explains nothing," and therefore proposes to define culture in purely subjective terms. This leads to one of the great debates in the field of Cultural Studies; the *universalist* versus the *relativist* view of culture. Is identity based on shared experiences and histories (universalist), or is it self-constructed through everyday practices (relativist)? Can diverse identities be incorporated into a larger society by indoctrinating normative values through the education system or the global economy (universalist), or can society be reshaped instead through the multiple voices that refuse to be assimilated (relativist)? These are questions not only for scholars but also for museum professionals that have discovered how difficult—and contentious—can be the treatment of culture in a modern, social institution, and in particular one focused on art.

There are various meanings of culture due to its inherent ambiguity and ubiquity. Precisely because this book studies *art* museums, it will not consider the notion of culture as high (the fine arts generally considered to include painting, drawing, and later sculpture) or low (a factor of class, income, and education as expounded by Pierre Bourdieu). The modern art museum has aptly proven its ability to rise above this restrictive dichotomy by incorporating popular culture, folk culture, and outsider art into its hallowed exhibition halls, aided by the more recently formed departments of education, public programming, and interpretation that serve to coalesce high and low culture. Rather, this book will consider culture as it describes the shared characteristics of a group of individuals (ethnic, racial, religious, and social), a physical community, or an institution. The two meanings of culture are not dissimilar, however, as we observe in Horkheimer and Adorno's (1947) concept of the *culture industry* that describes the socioeconomic system in which symbols of high art are threatened by its very popularization.[3] Early art museums encouraged interaction between the working and upper classes for the purpose of urban socialization, but they also served as important spaces that were set

apart from the mundane world, encouraging contemplation, reverence, and reserved sentiment through their art objects and sacred environment.

This book will address both the local and diverse culture of the physical communities in which each museum is situated, as well as the broader culture of museums from their historical antecedents to their current place in the digital age. It must be noted, however, that the local does not imply provinciality; nor must it be treated as antithetical to the global. More pronouncedly in the digital age, local culture is unquestionably global due to increased migration, international commerce, and digital technology that facilitates both factors, including communication and the global distribution of entertainment. Similarly, locally based museums (*Boston* Museum of Fine Arts, Art Institute of *Chicago, Detroit* Institute of Art, etc.) can also be considered international institutions that owe their founding and still much funding to their local communities, but are increasingly global in reach and reputation. About 200 years ago, local community leaders aspired to acquire encyclopedic collections of the highest quality from around the world to draw attention to their burgeoning cities that would rise in stature together with these great museums.

The argument of cultural studies scholars that culture is formed through social relations and individual agency was a reaction to the great nineteenth-century German theorists Karl Marx and Friedrich Engels (1848), who instead believed that culture was purely a result of the economic system. Supporting Marx and Engels, Horkheimer and Adorno (1947/2002) wrote about the *culture industry* that they feared was impressing "the same stamp on everything." Modern capitalist societies produced culture as a commodity, and objects previously valued for their utility were now valued based on the extent to which they could be exchanged. These early debates within the field influenced later scholars that more deeply explored ideas of the hegemonic impact on culture and the extent to which culture is formed as a result of individual agency related to external forces. Raymond Williams (1980) offers an important contribution to the field with his belief that hegemony depends on a process of incorporating both residual and emergent forms, which explains how the dominant culture changes while remaining both dominant and relevant. Lawrence Grossberg suggests that people are often "complicit in their own subordination." Although people are repeatedly manipulated and lied to, Grossberg believes they are not passively controlled by the media or the capitalist system. Hegemony, he states, seeks to dominate "through consent rather than coercion, through representation rather than falsification, through legitimation rather than manipulation" (1997, p. 152).

The British cultural theorist Stuart Hall similarly discusses the *consensus theory of hegemony*. He claims, "Hegemony implied that the dominance of certain formations was secured, not by ideological compulsion, but by cultural leadership" (1982, p. 85). Hall distinguishes between the *humanities* definition of culture and the *structuralist* one which he espouses. He wants to rethink culture as a set of everyday practices that are part of what he describes as moments of encoding and decoding, and how they correspond to the potential positions of dominant, negotiated, and opposition. Writing about popular culture, Hall (2002) sees its relation to the dominant culture as "the dialectic of cultural struggle," with popular culture representing an alternative form but still subject to the forces of domination.

Raymond Williams is probably the most influential scholar to tackle the concept of culture. He views modernity as "constituted by the separation of culture and society," yet he refuses to accept such a separation. Hall also considers the separation of art from politics and everyday life to be a recent and uniquely Western historical phenomenon. Culture is a fundamental part of society and our idea of perfection must include the culture of the individual, the culture of the group, and the culture of the whole society as well. Another key area in which Williams influenced cultural studies is the discussion of culture (high and low) and the masses. In his influential book from 1958, *Culture and Society: 1780–1950*, Williams warned that "the masses . . . formed the perpetual threat to culture. Mass-thinking, mass-suggestion, mass-prejudice would threaten to swamp considered individual thinking and feeling" (p. 298). The culture he is referring to here is of the "high" nature because he describes the masses as having "lowness of taste and habit." In the new world of mass communication, Williams makes a distinction between a "physical massing of persons in industrial towns and factories" and a "social and political massing," the latter of which would lead to mass democracy and "the rule of lowness or mediocrity." Nevertheless, Williams believes there are actually no masses: "There are only ways of seeing people as masses. . . . What we see, neutrally, is other people, many others, people unknown to us. In practice, we mass them, and interpret them, according to some convenient formula" (p. 300). The masses are partly a result of a primitive desire for solidarity that Williams claims is necessary for society. He argues for a common culture and a common experience, but clearly writes that this does not mean an equal culture; in fact, he states that inequality is "inevitable and even welcome" in society.

Many of the issues that cultural studies has been struggling with are at the center of the discussion of museums as cultural institutions. If museums are cultural (and subsequently social) institutions, then how much must they reflect society's values and concerns? And which part of society, the popular masses or the power elite? Likewise, which culture must a museum represent, that of the nation or the community or certain subcultural groups (counterpublics) as defined by race, ethnicity, and religion? Are culture and society separate in modernity as Williams alleges, or if we consider ourselves beyond modernity today can we reconcile the two? Williams and most cultural studies scholars support a coming together of culture and society, but this places museums in the controversial—and hegemonic—position of representing very specific elements of both culture and society. Sheila Watson points out that "the relationship museums have with their communities must be based on the recognition that this is an unequal one, with the balance of power heavily tipped in favour of the institution" (2007, p. 9). While the relativist view of culture recognizes the diversity of people and societies around the world, refusing to make generalizations, the universalist view stresses the commonalities that bring disparate peoples together.

The early nineteenth-century European museum was not a cultural institution in the sense of high culture—despite its valuable collections of paintings, sculptures, and other treasure from around the world—but rather in its ability as an esteemed public institution to attract more educated crowds that would teach the masses proper manners, tastes, and dress. The culture of the masses was not recognized or even valued for its diversity in a pluralistic society, but instead was seen as needing to conform to a homogeneous ideal, that of civilized society. These museums were public only in that they received scholars and members of the bourgeois who were required to present their credentials upon entry. It took a while for museums to open up on Sundays and evenings to accommodate the working class, as there was still pervasive fear that the masses would disturb their precious collections and reverent atmosphere. By adopting functions of the state that catered more to the needs of the uneducated public than those of the educated bourgeoisie, the public museum soon became what Habermas called a "sphere of culture consumption," due to its promulgation of mass culture.

The modern museum inherited this difficult position that vacillates between representing interests of the state and the public(s). Today most U.S. museums exist as a hybrid public-private institution, receiving funding from both entities and responsible to both in varying degrees. The twentieth century saw a

proliferation in different genres of museums that responded to different groups: ethnic-specific museums, community museums, historic house museums, open-air museums, folk museums, maritime museums, children's museums, automobile museums, and railway museums, just to name a few. Nancy Fuller (1992) describes *ecomuseums* that started in France in the late 1960s and can now be found around the world, where the museum is seen as part of the larger landscape connected "to the whole of life." These museums are generally constituted from the bottom up, representing more the specialized interests of local constituents and public masses rather than the power elite. Nevertheless, there remain many museums today (mostly art museums) that would deny any association with mass or popular culture, despite placing great importance on populist activities such as community outreach, public programming, visitor studies, and the great equalizing force of the blockbuster exhibition. Most museums try to remain neutral, believing this to be their source of legitimacy and power, but even so, the modern museum addresses more social issues in its desire to be relevant to current issues, as well as in response to many artists who themselves address such issues in their work (e.g., agitprop art, activist art, political art, social art). British media scholar John Fiske raises the concept of *cultural distance* as a key marker of high and low culture. He believes that "the separation of the aesthetic from the social is a practice of the elite who can afford to ignore the constraints of material necessity, and who thus construct an aesthetic which not only refuses to assign any value at all to material conditions, but validates only those art forms which transcend them" (1992, p. 154).

The critical issue of how modern museums relate to society involves current social and political issues, but also the diverse people and cultures that comprise modern society, and in particular, the local, marginalized, and immigrants. In 1988, James Clifford wrote that the *predicament of culture* occurs when "marginal peoples come into a historical or ethnographic space that has been defined by the Western imagination." Whereas in the 1800s culture was viewed as a single, evolutionary process, Clifford argues that in the 1900s culture is viewed in the plural, a view shared by Michel de Certeau in his book *Culture in the Plural* from 1974. De Certeau explains that "the approach to culture begins when the ordinary man *becomes* the narrator, when it is he who defines the (common) place of discourse and the (anonymous) space of its development" (1984, p. 5). Since their inception, museums have acted in the service of the state and continue to do so to a lesser degree (yet not with the socially reformist intentions of the past), but museums have only recently begun to act in the service of their

public. In writing about the fundamental relationship between museums and community heritage in Ireland, Elizabeth Crooke declares:

> The links between museums, heritage and community are so complex that it is hard to distinguish which one leads the other—does heritage construct the community or does a community construct heritage? . . . Communities need the histories and identities preserved and interpreted in museums; and the museum sector needs the people, in the many communities, to recognise the value of museums and justify their presence. (2008, p. 1)

To rethink museums as cultural institutions in the digital age is to critically consider how they use technology to reflect and maintain their legitimacy and authority, the extent to which technologies support difference and dialogue, and how technology allows museums to reflect cultural norms and values in the pluralist sense.

TECHNOLOGY AND ITS IMPLICATIONS

Artists have always incorporated new innovations into their practice, starting with the invention of portable easels, canvas, and oil paint. Museums, on the other hand, have historically been more resistant to changing their practices. Museums benefited early on from technology in the 1920s such as the inventions of plate glass and electric spot lights to accommodate the working classes that visited in the evenings (Tallon, 2008), and they later embraced the development of computers and database systems for internal working purposes. Nonetheless, it was not until the emergence of the new museology in the late twentieth century that technology became utilized for visitor-centric practices that gave visitors agency in their own experiences and learning. The very large and dynamic field of digital art (also known as net art, computer art, electronic art, or new media art) visibly manifests the convergence of art and technology, and art museums are one of the main spaces for the conservation, display, dissemination, and interpretation of digital art. This book will not attempt to examine these artistic practices, however, as the sociocultural relevance of art museums in the digital age is best understood independent of their specific collections.

The new museology started museums thinking about how to best serve society and their community. Today in the digital age, museums are no longer working *for* their community but *with* their community; meaning that the participatory culture of the digital age, armed with the technology to facilitate instantaneous

communication from anywhere on the globe, inspires new museum experiences including user-generated content, crowd-curated exhibitions, personalized online collections, and social media–supported affinity and membership groups. In his introduction to *Museums and Communities*, Ivan Karp claims that "the best way to think about the changing relations between museums and communities is to think about how the *audience*, a passive entity, becomes the *community*, an active agent" (1992, p. 12). Karp distinguishes communities as demanding more active participation from their members, but by generalizing audiences as passive he denies the inherent value of a community that allows for a plurality of experiences, cultures, voices, histories, and even modalities of learning and participation that may prefer passivity. Although the new museology embraces such a plurality, it also actively seeks participation from its visitors; how to reconcile these two constitutes one of the great challenges facing museums in the digital age.

Some of the most prominent scholars working in the area of participation, learning, youth, and digital media include Henry Jenkins, S. Craig Watkins, Eszter Hargittai, Mizuko Ito, and Sonia Livingstone. A great amount of research has been supported by institutions such as the Pew Research Center (Internet and American Life Project), the John D. and Catherine T. MacArthur Foundation (Digital Media and Learning initiative), and the U.S. Institute for Museum and Library Services (Engaging America's Youth initiative). As described by Jenkins et al., "Participatory culture is emerging as the culture absorbs and responds to the explosion of new media technologies that make it possible for average consumers to archive, annotate, appropriate, and recirculate media content in powerful new ways" (2006, p. 8). A serious concern for these scholars and institutions is the *participation gap*, which is based on access to online spaces and experiences that enable participation, rather than the more well-known *digital divide* which concerns basic access to computers and the Internet. Jenkins et al. (2006) cite the goal of a participatory culture as to encourage families, schools, governmental policies, and media companies to persuade more youth to participate by teaching the necessary skills and cultural knowledge. John Palfrey and Urs Gasser call these youth *digital natives*. They focus on the importance of social identity for this group, where online creativity and digital creations are forms of self-expression inherently social and collaborative. According to Palfrey and Gasser, "Interaction and a sense of community are the key requests of those born digital when it comes to online learning" (2008, p. 248).

Jennifer Slack and J. Macgregor Wise (2005) propose a cultural studies view of technology with their notion of *technological culture*. Technology, they argue, is caused by culture rather than conversely being a cause for cultural change (*technological determinism*). "As culture changes," they claim, "it needs and develops new technologies to accomplish its goals." In this view, the adoption of technology in museums is a means of adapting to a changing culture that develops new technologies to serve its changing needs. Anne Balsamo (2011) proposes the term *technoculture* that addresses both technology and culture as unified rather than oppositional. Ross Parry summarizes this sociocultural constructivist view of technology:

> In every case we see a culture attempting to make sense of its material surroundings, its knowledge and its experience, by containing them within a closed, ordered and logical system. Museums belong to this history of structured knowledge. In a sense the museum project represents the endeavor of many societies, in their own time and cultural context, to extract and then give meaning to fragments of their past and present. (2007, p. 33)

While it is relatively easy to theorize about the cultural ground on which technology is used within society and about the symbiotic relationship between culture and technology, it becomes much more difficult to research and establish current technocultural practices in museums. As museums become more place-conscious due to new digital technologies, so must they remain culture-conscious in their integration of technology. Museums continue to struggle with what it means to be culturally conscious and inclusive in regards to their traditional roles and practices, but their speedy entry into the digital age is forcing them to resolve their position on the matter: what constitutes their particular *museum culture* and how that culture determines their usage of technology.

NOTES

1. The terms *community* and *communities* will be used interchangeably throughout the book, acknowledging that some museums consider community in its singularity and others in its plurality. One term is not judged to be better than the other; however, it must be noted that when museums consider their community in the singular, that entity is usually constituted by an intricate classification of subgroups that could be construed as separate communities.

2. L. E. Harrison, & S. P. Huntington (Eds.) (2000). *Culture matters: How values shape human progress*. New York: Basic Books.

3. Horkheimer and Adorno did not specifically mention the art museum in their writings, but other notable authors that have similarly approached the subject include Pierre Bourdieu and Alain Darbell in *The Love of Art: European Museums and their Public* (1969), Nestor García Canclini in *Hybrid Cultures* (1995), John Berger in *Ways of Seeing* (1972), and Bill Ivey in *Arts, Inc.* (2008).

Indianapolis Museum of Art

PLACE + LOCALIZED CULTURE

Indianapolis is known as the Crossroads of America for the number of Interstate highways that cross through it, connecting the city to the rest of the country. Today, Indianapolis advertises that it is within a one-day's drive of more than 50 percent of the nation's population. One-third of visitors to Indianapolis are in-state travelers that opt for "staycations," followed by the neighboring states of Ohio and Illinois, with eight out of ten visitors traveling by automobile. Indianapolis is on Eastern Standard Time for economic development reasons, despite the fact that the geographic dividing line for Central Standard Time is on Indiana's eastern border with Ohio. As the capital of the state of Indiana, it is the twelfth largest city in the United States and one of the top twenty-five most visited cities in the nation with eighteen million tourists a year (2009). Indianapolis is located in Marion County, but counts its metropolitan statistical area as including roughly 1.2 million people; what is commonly referred to by locals as the "doughnut counties" or the "nine-county region."

Indianapolis's national and international reputation is built upon sports. The names Indianapolis and Indiana are synonymous with the Indy 500, the largest single-day sporting event in the world, which draws 400,000 people; what the city tourism board's marketing director Chris Gahl refers to as "Our Disneyworld, our Mona Lisa, our Eiffel tower, our Golden Gate Bridge" (personal communication, August 2, 2011). The Indianapolis Motor Speedway was built in 1909 and the first Indy 500 race took place in 1911. The speedway's

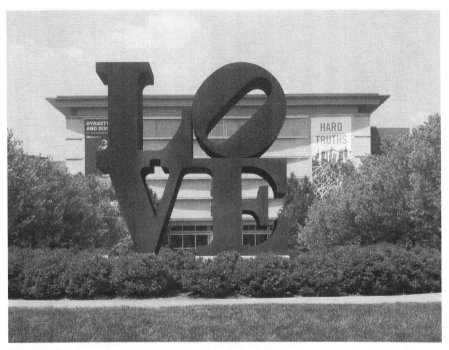

FIGURE 3.1
LOVE (1970) by Robert Indiana, in front of the Indianapolis Museum of Art, 2011.
Courtesy of the author.

museum houses most of the original winning cars along with original trophies, photos, and related memorabilia; it is the fourth most visited museum in the city with 250,000 visitors in 2010. In the 1970s when Indianapolis was called Naptown (either because of its name IndiaNAPolis or because of a lack of activities), a group of city leaders decided to become the amateur sports capital of the world. They began wooing national sports organizations to the city, and in 1987 Indianapolis hosted the Pan American games and the World Indoor Track and Field Championships. The city houses the country's first sports commission, Indiana Sports Corp, founded in 1979. The city is home to the Super Bowl–winning Indianapolis Colts, led by quarterback Payton Manning, who is tied for the highest paid NFL athlete and the fourth highest paid athlete in the world. Five amateur sports organizations are headquartered in the city (USA Football, USA Track and Football, USA Gymnastics, the National Collegiate Athletics Association [NCAA], and the National Federation of State High School Associations). Professional sports in Indianapolis include an NBA bas-

ketball team, the Indiana Pacers; a U.S. Hockey League team, the Indiana Ice; and a minor-league baseball team, the Indianapolis Indians, which was formed in 1902. Indianapolis also hosted the Super Bowl XLVI game in 2012.

Traditionally the city has relied on sports tourism to attract the majority of its visitors. Generating an estimated $336.8 million in economic impact just from the Indy 500 and its ancillary events, the city admits that it is hard to turn its back on sports. But it also recognizes the need to market itself as more than sports, since research shows that tourists are coming for other reasons; 52 percent come for business (conventions and corporate meetings) and 48 percent for leisure (visiting friends or relatives, and special events including sports). Overnight visitors report they are most interested in dining (30 percent), entertainment (21 percent), shopping (21 percent), sightseeing (13 percent), watching sports (10 percent), and visiting museums and art exhibits (9 percent).[1] In 2009 the Tourism Board changed its tag line to *Raising the Game*, which honors its sports heritage but allows it to profile arts and cultural institutions that are also raising their game. The city has been working at integrating arts into sports, what they call "infusion activities." Dave Lawrence, president and CEO of the Arts Council of Indianapolis, sat on the 2012 Super Bowl host committee, chairing the subcommittee responsible for these activities such as a mural initiative. Former Indianapolis Museum of Art (IMA) director Brett Waller comments on the change, "When I first came, those that were involved in the arts had a tendency to whine that 'it's all sports and nobody pays attention to us.' The city has matured so now sports and arts aren't thought of as antithetical but in fact both are pan [*sic*] of what it takes to make a community rewarding to live in" (Pacheco, 2006). The National Art Museum of Sport, founded in 1959, is located at Indiana University, and the former 1911 Stutz motor car factory was transformed into the Stutz Artists Association and Space that houses more than eighty-five visual artists.

In a city known primarily for its sports, Indianapolis has a surprisingly large number of cultural institutions and attractions. The city has the most war memorials in the United States, second only to Washington, DC, housing the national headquarters of the American Legion. The Children's Museum of Indianapolis (founded in 1925) is the largest in the world with over 470,000 square feet and also the most visited museum in the city with 1.3 million visitors a year. The Indianapolis Museum of Art comes in third place for visitors after the zoo, and is the tenth largest encyclopedic art museum in the nation. The Eiteljorg Museum of American Indians and Western Art is the most prominent collection of its kind

east of the Mississippi; the Indiana State Museum is one of the country's largest state museums, just behind Texas; and the Indiana Historical Society incorporates the latest technologies in its interactive exhibitions with touch screens, immersive technology, and computer kiosks. A recent addition to the city's cultural landscape is the Kurt Vonnegut Memorial Library which opened in early 2011 as a museum, library, and memorial to the Indianapolis-born author.

The state of Indiana appropriated $2,721,197 for the arts in 2011 (almost three times as much as the state of California), with the city of Indianapolis allocating an additional $1.3 million. The Arts Council of Indianapolis, a private nonprofit 501c3 organization, was formed in 1987 to reallocate city funds to arts organizations and artists through a grants process, to manage the city's public art, and to act as a resource connecting the public with the arts community. It has its own downtown gallery space to exhibit local artists. In 1999, the Sculpture in the Park program was created in the White River State Park to showcase artists from the Midwest, exhibiting large-scale sculptures outdoors for two-year periods. A public art program was initiated in 2005 as part of the planning for the new Indianapolis International Airport that opened in November 2008. There are currently thirty-six permanent pieces throughout the airport, a program of rotating temporary exhibitions, and a Guide to Airport Art from the airport website or available at the airport. The city has also created six cultural districts that offer jazz clubs, murals, museums, musical concerts, art galleries, public art, live theater, artist studios, restaurants, and cafes.

One of the reasons for such a wealth of arts and culture in Indianapolis is the support of affluent and civic-minded local citizens, primarily the Lilly family. Colonel Eli Lilly first moved to Indianapolis with his family as a young boy in the 1850s. After serving in the American Civil War, he founded a pharmaceutical company in 1876 which has become the tenth largest pharmaceutical company in the world today. Eli Lilly and Company has its own corporate foundation that focuses on improving global health. The separate Lilly Endowment Inc. was created in 1937 by the colonel's son, Josiah K. Lilly Sr., and two of his sons, J. K. Jr. and Eli, through gifts of stock in the company. The grandfather supported community projects such as paving streets, fixing sewers, and elevating railroad crossings, while the grandsons expanded this civic-mindedness to include arts and cultural organizations. Today the Lilly Endowment Inc. is one of the world's largest private philanthropic foundations, whose support of local organizations in Indianapolis and the state of Indiana encourages the support of other corporations and foundations through challenge grants. In particular, the

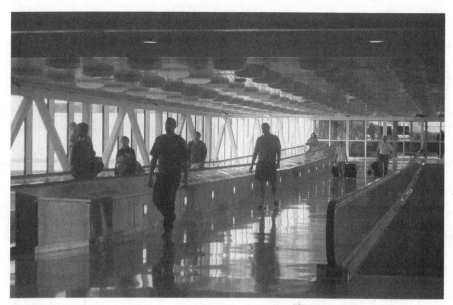

FIGURE 3.2
Connections (2008) by Electroland at the Indianapolis International Airport, 2011.
Courtesy of the author.

endowment focuses on long-term planned giving that strengthens endowments. The Children's Museum has a surprisingly large endowment of $252 million (2009), the Indianapolis Symphony's endowment is $30 million (2010), and the Indianapolis Museum of Art's endowment is an astounding $308 million (2010). Indianapolis has also witnessed a recent surge in giving from local corporations such as MS Communications, WellPoint, Rosche Diagnostics, Simon Malls (the country's top shopping mall developer), LDI Ltd., and Heartland Truly Moving Pictures.

At the beginning of the twentieth century, Indianapolis experienced great prosperity with ensuing economic, social, and cultural progress. In 1886, an enormous natural gas deposit was discovered in east-central Indiana, followed by the discovery of oil in an area that became known as Trenton Field. There was a boom in industries such as glass and automobile manufacturing, as the state offered a free supply of natural gas to factories that were built in the region. In the early 1900s, Indianapolis was known for its car manufacturers, including Marmon, National, Premier, Marion, Stutz, and Empire. The Indianapolis Motor Speedway was built to test these new cars, with a Marmon car winning the first race. Unfortunately, with the depletion of the natural gas deposits by 1920,

the Great Depression, and the significant decrease in oil production in the early 1930s, the golden age of Indianapolis soon came to an end.

Today, the Indianapolis area[2] has the highest poverty rate of all four regions discussed in this book at 20.1 percent (below the federal poverty threshold), rising well above the national average of 13.2 percent; the highest rate of uninsured at 18 percent, above the national average; the highest infant mortality rate of 9.28 per 1,000, above the national average; and a vacancy rate of total housing of 12.5 percent, the highest of all four areas studied. Compared to the other three cities (San Francisco, Minneapolis, New York), only Indianapolis rates *below* the national average for the following factors: human development index (4.22), life expectancy at birth (76.6 years), at least a bachelor's degree (23.8 percent), school enrollment ages three to twenty-four (82.1 percent), median personal earnings ($25,579), health index (4.43), education index (4.19), and income index (4.04). Indianapolis is a city that is predominantly young, with 25 percent of the population under the age of eighteen, and 20 percent is between thirty-five and forty-nine years of age. Only 10.5 percent of the population is over sixty-five years of age. Compared to the other three states (California, Minnesota, and New York), Indiana has the lowest rate of households with Internet access at 69.5 percent (2009), again below the national rate.

Indianapolis also ranks fairly low with regard to civic involvement as measured by service, giving, political action, social connectedness, and belonging to a group.[3] The city ranks lower than the national levels for most of these measures; however, compared to the other three cities studied, New York rates much worse for civic engagement (except for social connectedness). Measuring service, 28 percent of adults volunteer with an organization and 9 percent work with their neighbors. Measuring giving, 48 percent of adults give charitable contributions over $25. Measuring political action, 58 percent of adults are registered voters and 61 percent voted in the 2008 presidential election. Measuring social connectedness, 83 percent have dinner with household members frequently, 60 percent talk to family and friends on the Internet frequently, and 40 percent talk with neighbors frequently. Measuring belonging to a group, 41 percent of adults participate in any organization. Nevertheless, Dave Lawrence reports a huge sense of volunteerism in the city, mostly surrounding sporting events, and the Indianapolis Museum of Art reports having an impressive 510 volunteers.

A large part of the local culture is epitomized by the name *hoosier*; Indiana is known as "the hoosier state." Since the 1800s, the name has been used to refer

to those from the countryside, southerners, farmers, and workers. There are different theories on how the name originated, some citing the Native Americans and others the European settlers. Today the *Oxford Dictionaries Online* describes *hoosier* simply as "a native or inhabitant of the state of Indiana." Another more vernacular description is offered by the *Urban Dictionary*. One contributor, Woody Thomas (2008), summarizes most of the descriptions on this site:

> Usually overweight, trailor inhabiting, junk food eating, quasi-inbred folks whose idea of luxury is shopping at Wal-Mart and when in the mood for gourmet dining, go to Ponderosa. For the ultimate in entertainment, it's the Jerry Springer Show or pro wrestling. Of course, NASCAR is big also. But the mecca of the true hoosier is Six Flags Over Mid-America in Eureka, MO. A disproportinate [sic] number of hoosiers can be found at hospitals, as both patients and visitors, a result of a lifetime of artery clogging, blood pressure raising diet and smoking cigarettes.

On the same site, a more reasonable definition was contributed by Krock1dk (2007):

> The culture of Hoosiers is conservative, laid-back and may seem like hicks by persons from either coast, but not anymore backwards than anywhere else. They are an average folk in America's heartland who live in small towns, sizeable communities and their suburbs.

The demographic constitution of Indianapolis is overwhelmingly white (62 percent), with African Americans representing the largest minority group at 27.5 percent, then Hispanics/Latinos at 9.4 percent. Only 0.3 percent are Native Americans, despite the heritage of the names Indiana and Indianapolis which originate from what was designated Indian Territory in the early 1800s (U.S. Census, 2010). Indianapolis is situated in the middle of the state, but has historically aligned itself more with the south than the north, both culturally and politically; Kentucky is on its southern border. During the American Civil War period, the city was one of the major stops on the Underground Railroad that led escaped slaves to freedom in the north, contributing to a large African American population. Black history and culture have been an important part of Indianapolis, resulting in a rich jazz culture along Indiana Avenue with famous local musicians such as Cole Porter. Yet Indianapolis was also a center of racism and segregation. The famous Crispus Attucks High School became the first all-black high school in the United States to win an integrated state basketball

championship. The Ku Klux Klan was headquartered in Indianapolis in the 1920s and became the most powerful political and social organization in the city. The Klan controlled the Indiana Republican Party, the General Assembly, the City Council, and other public boards. The Klan eventually fell when its leader was convicted of a brutal crime, uncovered by the *Indianapolis Times*, which won a Pulitzer Prize in 1928 for revealing the scandal. Today, Indianapolis is home to the Indiana Black Expo, the largest black cultural event in the country, first organized in 1970.

THE MUSEUM AND ITS COMMUNITY

Mission Statement:

The Indianapolis Museum of Art *serves the creative interests of its communities* by fostering exploration of art, design, and the natural environment. The IMA promotes these interests through the collection, presentation, interpretation and conservation of its artistic, historic, and environmental assets. (emphasis mine)

A discussion of each museum must begin with analyzing the mission statement. While it is significant that this statement begins with the mission of the museum to "serve[s] the creative interests of its communities," it must be noted that the museum's previous mission statement began, "An education institution in the heart of the Midwest." This recent change profoundly reflects the new course of the museum under the leadership of Maxwell Anderson, who became the Melvin & Bren Simon Director and Chief Executive Officer in May 2006.[4] While the museum is undeniably located in the "heart of the Midwest," clearly it is also a global institution, reflecting the same complexities as Indianapolis.

The Indianapolis Museum of Art began as a grassroots community initiative. The Art Association of Indianapolis was formed in 1883 by May Wright Sewell, principal of the Girls' Classical School of Indianapolis and a well-known suffragette, along with her husband and a small group of citizens. Just a few months later, they organized their first exhibition of 453 works by 137 local artists at the downtown English Hotel, which attracted a large number of visitors and substantial public attention. The association continued organizing exhibitions and lectures around town until 1895, when they received a donation of $225,000 from the estate of Indianapolis real estate investor John Herron to build a permanent art gallery and school, becoming the John Herron Art Institute and later the Herron School of Art. In 1967, the school became part of Indiana University, and two years later the Art Association of Indianapolis formally changed

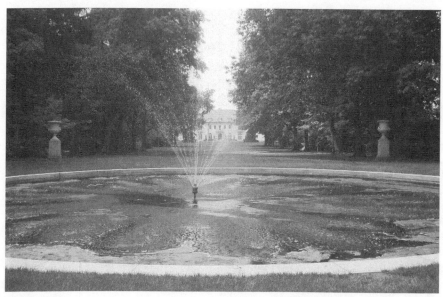

FIGURE 3.3
The Lilly House and Gardens, Indianapolis Museum of Art, 2011.
Courtesy of the author.

its name to the Indianapolis Museum of Art and moved into its own building. Over the years, the museum has developed a significant collection through gifts from prominent local citizens. Responding to the need for a larger, permanent site, Ruth and J. K. Lilly III offered the Oldfields estate with a twenty-two-room mansion, which the Lilly family had owned for more than thirty years. In 1970, the Indianapolis Museum of Art opened to the public at its new location.

A National Historic Landmark, the Oldfields estate was first built by Indianapolis businessman Hugh McKennan Landon and a partner, as part of a fifty-two-acre real estate development that came to be called the town of Woodstock. On his twenty-six acres, Landon began constructing his new residence in the early 1910s while he was an executive at the Indianapolis Water Company. The gardens and grounds were designed in the 1920s by Percival Gallagher of the famous landscape architecture firm Olmsted Brothers. J. K. Lilly Jr. and his wife Ruth Brinkmeyer Lilly purchased Oldfields from Landon in 1932 and remodeled the house. They expanded the estate significantly by building a house for their son, J. K. Lilly III, and his new wife in 1939, and then a recreation building called the Playhouse with indoor and outdoor swimming pools, a tennis court, and a four-seasons garden. The town of Woodstock ended in the early 1960s when

J. K. Lilly Jr. started buying out his neighbors and then tore down the houses to expand his estate to the original fifty-two acres.

Today, the museum campus consists of the twenty-six-acre Oldfields-Lilly House and Gardens, including the Lilly House that opened to the public in 2002, its surrounding gardens, a greenhouse, the Playhouse, and the Newfield residence. The campus also includes four pavilions from 1970 that house gallery and public spaces, which were renovated and expanded in 2005, and the 100-acre Virginia B. Fairbanks Art & Nature Park that opened in 2010. Many of these institutional changes occurred under the tenure of Maxwell Anderson, such as 100 Acres, but were begun under former director Bret Waller who instigated much of the strategic planning for the museum's current course. Waller served the IMA from 1990 to 2001, and is now director emeritus.

The museum reports that in 2010, 428,213 people came through its physical museum buildings. However, due to its free admission and parking, there are thousands more that explore the other 126 acres of gardens and park space, especially given the amount of public programming that occurs in this large outdoor space. The museum's iconic outdoor sculpture by local artist Robert Indiana (*LOVE*, 1970) was listed by *USA Today* in 2001 as one of the world's ten best places to propose. Meditation peace hikes take place around the museum grounds every week, facilitated by Global Peace Initiatives, and on weekends, visitors can take art and nature-focused tours of 100 Acres and free guided garden walks. The annual Penrod Arts Fair is one of the largest outdoor fairs that occur at the museum. First organized by the local, independent Penrod Society in 1967, the fair promotes Indianapolis-area artists, students, and arts organizations by providing space for displaying artwork and stages for live music, performing arts, and local cuisine. 100 Acres is accessed from the main campus by crossing an authentic red Pony Truss bridge across the canal. The park offers free admission to 100 acres of beautiful woods and wetlands, views of a thirty-five-acre lake, and a contemporary sculpture garden of internationally renowned artists: Marlon Blackwell, Ed Blake, Kendall Buster, Los Carpinteros, Jeppe Hein, Alfredo Jaar, Tea Mäkipää, Type A, Atelier Van Lieshout, and Andrea Zittel. The park opened with eight site-specific, temporary commissions, and the museum continues to add new commissions.

In March 2011, the IMA opened a 2,000-square-foot conservation science laboratory in partnership with Indiana University and BioCrossroads, a statewide initiative to promote the growing life sciences industry. The Lilly Endowment Inc. provided an initial $2.6 million grant, followed by an additional $3.5

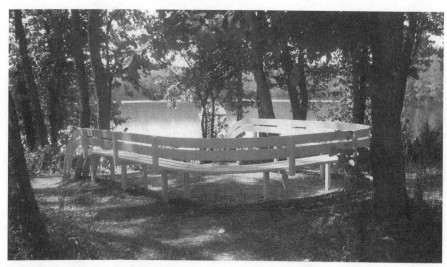

FIGURE 3.4
100 Acres, 2011, with *Bench Around the Lake* by Jeppe Hein in the foreground, and *Indianapolis Island* by Andrea Zittel in the lake.
Courtesy of the author.

million that was raised to endow the position of senior conservation scientist. To fill that position, the museum hired Dr. Greg Smith, who is quoted as saying that,

> The strong scientific community in Indiana is what's going to make this lab successful. With places like Dow AgroSciences and Eli Lilly, powerhouse academic institutions in Indianapolis and also nearby Indiana University and Purdue University—we're going to hopefully take advantage of the strong scientific community here in Indiana. ("Art and Science," 2010)

The museum admits that such a professional conservation lab is rare in the Midwest, with the Art Institute of Chicago being the exception. "We'll have one of the best outfitted labs in the country," states Smith, with the goal of putting the IMA and Indianapolis on par with Chicago in this respect.

Maxwell Anderson considers one of his greatest achievements to be the 2008 acquisition of the Miller House and Garden from the Irwin-Sweeney-Miller Foundation, together with a $5 million endowment gift. Described by *Travel + Leisure* magazine in 2011 as "America's Most Significant Modernist House" and a National Historic Landmark, the 1957 house showcases three of the leading

twentieth-century modernist architects and designers: Eero Saarinen, Alexander Girard, and Dan Kiley. Although located in Columbus, Indiana, fifty miles south of Indianapolis, the museum maintains a small exhibition space on the first floor across from its museum shop and restaurant with photographs, video, and design pieces from the house. The house is open to the public for scheduled tours through a partnership with the Columbus Area Visitors Center.

The IMA is situated outside the growing downtown area, which is heavily promoted by the city as being "compact, connected, and convenient." In 2011, *Forbes* magazine listed Indianapolis as having one of America's ten best downtowns. Downtown Indianapolis has over two hundred restaurants, twelve hotels, fifty museums, a convention center, the Circle Centre Mall and Artsgarden, and the new Lucas Oil Stadium, all connected by a three-block pathway of covered skywalks to protect pedestrians from extreme winter temperatures. While the museum is only eight miles away from downtown, a $1.50 bus ride, $10 cab fare, or a ten-minute car ride, the distance is symbolic. The fact that most of the city's museums (except for the Children's Museum) are in close proximity to downtown heightens the isolation of the IMA. The IMA recently partnered with a real estate development company (Buckingham Companies) that is building a new hotel in downtown Indianapolis called the Alexander. The museum is advising the hotel on selecting contemporary artists for site-specific commissioned works and acquiring more than forty works. Lisa Freiman, the museum's senior curator and chair of its department of contemporary art, is quoted in *Inside Indiana Business* (March 9, 2012) as saying, "This collaboration has allowed the IMA to participate in a dynamic and unique partnership that extends beyond the museum's campus and into the heart of downtown Indianapolis."

Katie Zarich, the museum's director of public affairs, reports that when targeting physical visitors to the museum, the museum spends its advertising dollars on Marion County and the doughnut counties surrounding Indianapolis, "thinking of everything from school groups to the stay at home moms to empty nesters to hipsters to college students to young professionals" (personal communication, August 3, 2011). Maxwell Anderson adds,

> I don't care how many people come. I do, but that's not what drives me. What drives me is that the attendance at the museum, to the degree possible, mirrors the makeup of people who might visit us. If my focus is on getting a lot of people in the door, I'd be doing what most museums do, which is looking at rich, white

people, middle-aged, female that go to museums. And they come serially, six times a year, so that's not a real number. (personal communication, September 10, 2009)

In 2009, the IMA was awarded the National Medal for Museum and Library Service by the federal IMLS for its community outreach, listing the museum's community partners as:

Indianapolis Public Schools, Metropolitan School District of Washington Township, Indiana Black Expo, Latino Youth Collective/Campecine Program, Indiana Department of Education, Ball State University, Butler University, Herron School of Art & Design, IUPUI, Marian University, Indiana University, Visual Thinking Strategies, Spirit & Place Festival, Indiana School for the Blind and Visually Impaired, Indiana School for the Deaf, Indianapolis Chamber Orchestra, Big Car and The 48 Hour Film Project, Indianapolis International Film Festival, LGBT Film Festival, Indianapolis-Marion County Public Library, American Institute of Architecture, Indianapolis Chapter, VSAI (formerly Very Special Arts), Indiana Humanities Council, Confucius Institute, Pecha Kucha Indy, Eiteljorg Museum, Indiana Historical Society.

After Anderson reinstituted free general admission in early 2009 (it was free before the museum's reconstruction in 2005), visitor attendance has increased. The museum reports that strong support from corporations and individuals enables them to not charge admission, although there are still admission fees for special exhibitions. In 2009, the museum's contributions and grants added up to approximately 42 percent of its total expenses, however, in 2010 its contributions and grants were reduced nearly in half, adding up to only 24 percent of the total expenses.[5] Perhaps this explains the museum's decision to begin charging for parking in 2011.[6]

The museum grounds are utilized for numerous community programs, and its free admission policy is a welcoming gesture for the community, but the museum's reach extends solidly outward as a key player in the international art world. Its encyclopedic collection of art spans Africa, Asia, the South Pacific, the Americas, and Europe, and includes an acclaimed collection from the Japanese Edo Period; it hosts international programs such as the annual Indianapolis International Film Festival and the 2009 International Design Symposium. In the museum's *Strategic Plan for 2011–2015*, the focus on collection and program vitality lists nine objectives, one of which is to utilize its exhibition program to strengthen the museum's national and international reputation.

In 2011, the IMA launched its Mellon Curators-at-Large program, funded with a $1.025 million grant by the Andrew W. Mellon Foundation. The pilot program allows the museum to hire leading scholars around the world to conduct research based on its collections in the following areas: art of India and South Asia, Chinese art, art of the Americas, African art, design arts, and Islamic art. The Curators-at-Large will regularly visit the museum, but will mainly work from their home base or another city, aided by the museum's acquisition of new high-definition teleconferencing technology that will facilitate ongoing visual communications with its collections and curatorial staff.

Another major international outreach was the U.S. State Department's selection of the IMA to host the U.S. Pavilion at the fifty-fourth Biennale di Venezia in Italy. The museum presented the work of the Puerto Rico–based collaborative Jennifer Allora and Guillermo Calzadilla with six new commissioned works, under the exhibition title *Gloria*. Senior Curator Lisa Freiman served as the pavilion commissioner; she states in a video on the museum's website that the choice of Allora and Calzadilla "problematizes the notion of nationality" and raises the "complexities of identity and representation." This was also the first time in the history of the U.S. Pavilion that performance art was on exhibition, involving gymnasts from the Indianapolis-based USA Gymnastics. Even the museum's teen program (Museum Apprentice Program) was given a global twist to coincide with the Biennale, transforming into the Teen Global Exchange Program. The IMA partnered with the Museo de Arte de Ponce in Puerto Rico and the Peggy Guggenheim Collection in Venice, Italy, to create an educational program for teenagers from the United States, Puerto Rico, and Italy. The students all met in Venice during the summer and documented their experiences on Facebook, Flickr, YouTube, and the blog *Our Voices/Le Nostre Voci/Nuestras Voces*, which was linked from the museum's website. The museum reports that over 73,000 people viewed the exhibition on the museum's website for the duration of the Biennale.

THE ROLE OF DIGITAL TECHNOLOGY

Maxwell Anderson summarizes the museum's philosophy toward technology as directly related to place:

> Technology—it starts with the fact that we're not Chicago we're Indianapolis. So the more remote you are from the centers of the art establishment, the noisier you have to be to be noticed. . . . Technology is a vehicle for making the museum

relevant to the world, which then makes the local audience pay attention. You can't get people locally to care about something if it hasn't been acknowledged elsewhere. They might have loyalty, but they won't have energy. (personal communication, September 10, 2009)

This same philosophy is confirmed by Robert Stein, the museum's deputy director for research, technology, and engagement.[7]

For us, technology is a way to extend audiences past a geographic border. I think that as you study the geographic communities and in particular, demographics about technology use and opinion in the Midwest, you'll find that they're very, very different than Manhattan, San Francisco, and even Minneapolis. My anecdotal experience is that most of Indianapolis has a more conservative use of technology for the sake of community. . . . The technology provides a reach for us that we wouldn't ordinarily have from tourism, and Indianapolis is not known as a destination for art, yet. So technology allows us to step outside the geographic definitions of where art is found and address that in a different way. (personal communication, August 3, 2011)

The museum utilizes digital technology to reach out to its global community more than to the local community, which is evident by the largely traditional museum experience in the physical galleries (to be discussed later). The museum's global community consists of the international art world, museums, and museum professionals, as well as that enormous group of anonymous online visitors. In 2011, Stein conducted a study of the IMA's website to count the number of online-only visitors to the museum. During 2010, the website received a total of 942,000 unique visits with 3.75 million hits. Stein removed those visitors who viewed any pages specifically connected with visiting the physical museum. The remaining online-only visitors comprised 480,000 unique visits or approximately 51 percent of the total online visits. Stein also tracked 498,000 (53 percent) online visitors that originated from outside the state of Indiana. These numbers are significant when compared to the museum's physical attendance in 2010 of 428,213. Stein reports that the museum is committed to "treating that online audience as a legitimate audience in the same way as those that come through the door." In the museum's *Strategic Plan for 2011–2015*, one objective for collection and program vitality is to "reach new online audiences by expanding content that highlights the IMA's permanent collections, exhibitions, and programs." The goals to achieve this objective include increasing online

engagement with local audiences and enhancing the museum's international reputation as one of the world's best encyclopedic art museums by increasing engagement with its online-only audience.

The museum website is the hub of its online activity, reaching out to its different communities, providing dynamic experiences for those nearly one million visitors from around the world. The Internet is the main medium by which the museum gets noticed at a global level and consequently at the national and local levels. There are two main sections (out of seven sections on the top navigation bar) on the museum website for an engaged online experience; the first is the Art section with the museum's digitized collection listed by theme (e.g., African art, design arts, oceanic art) and a tag cloud. There is a collections search function and a Collection Tags page. The museum integrates tags into its collections search based on lay words (tags) that online visitors use to describe the images. The page also has a tag cloud, where the more popular descriptive words (the more times the tag has been used to describe a work) are larger and bolder than the other words. Clicking on a tag takes the visitor to collections search, where a search can be performed for all works with that tag. When viewing works on the website, there is a heading on the right of each page called "Tell Us What You See," where visitors can log in to add their own tags to the work. At the bottom of the page, visitors can log in or register to post comments as well. "Collection Tags" provides a list of Tag Tours developed by the museum staff for visitors to discover new works of art grouped together in fun, different ways, such as: In the Nude, I'm in the Mood for Love, Indulge, Plugged In, Super Bowls, WTF?, Animals in Art, Happy Hour, The Blues, Indy Is a Sports Town, All Hallow's Eve, Mid Century Mod, LOL Catz, and Impress My Boss/Grandma/Hot Date. In 2006, the IMA was one of the first museums to become involved in the Steve Project, a collaboration of museum professionals, digital media specialists, and academics funded by the U.S. Institute of Museum and Library Services (IMLS). The IMA was one of the primary developers of the Steve Tagger software and has managed the technology aspects of the project since 2006. There are currently twenty-one institutional partners that conduct research on social tagging, create open source tagging tools, and disseminate findings through scholarly journals and conferences.

The other main section for engaging visitors on the museum's website is Interact. Interact includes the IMA Blog, Find us on . . . (list of social media and blog), IMA Magazine, IMA on ArtBabble, IMA on YouTube, Museum Dashboard, TAP, Tag Tours, The Davis LAB, First Impressions, and Join the IMA

FIGURE 3.5
Indianapolis Museum of Art website, Collection Tags (1/13/12 screen capture).

eNews List. While many of these elements are integrated into other sections of the website (Dashboard is in the About section, Tag Tours in the Art section, Join the IMA eNews List is on the bottom navigation bar, as is Share this Page that links to social media), Interact groups them all together for those visitors that want to "interact" with the museum in a variety of ways online. Interact also demonstrates the value that the museum places on providing their online visitors with an active, participatory experience. The landing page for Interact includes a short listing of recent comments (on artwork in the museum's online collection), recent videos with hyperlinked thumbnail images, excerpts and links from Facebook and Twitter, and the latest user tags.

First Impressions is a new social tagging experiment by the IMA that asks visitors to click on the first thing that catches their eye as they view a series of

artworks (such as Winter Solstice). All the clicks are collected, and at the end of the series the visitor can review where he or she clicked, and also where everyone else clicked as well (with the most popular clicks appearing in dark red contrasted to the visitor's click in green). Some of the more traditional pedagogical questions that are asked of the visitors on this last page are: "What can you notice? Did you select an area that others also tagged as their first impression, or did you see the work differently? Were there areas of the image that others noticed that you missed the first time through? Are there any areas of the image that everyone missed altogether?" The museum changes the series of artworks depending on what is happening at the museum or in the art world, and will announce new series on its blog. Each series lasts for about a week.

The social media that the IMA utilizes are Flickr, Twitter, Facebook, YouTube, Pinterest, Tumblr, iTunesU, and ArtBabble (an internal medium that will be discussed later). Katie Zarich comments on the museum's targeted use of social media:

> I think since 2005 when we expanded the building, it just happened to coincide with the popularity of social media. From day one we've used those channels to help us get to the general public, and we've done that in some targeted ways where we've reached out to mommy bloggers in Indianapolis that are very well read. And when we opened 100 Acres last year, we made a concerted effort to invite the mommy bloggers to our media tour and to do things where we could get in touch with them because that's a niche audience, stay-at-home moms. Our advertising budget has taken a hit, so we've done things to target specific groups that may have affinity or interest in certain programs. (personal communication, August 3, 2011)

Jennifer Anderson, senior communication officer, is responsible for tweeting on behalf of the museum, and explains how the museum is conscious of how it uses Twitter separately from Facebook (personal communication, August 3, 2011). Twitter is used for a more international audience, mostly the art world, where the museum tweets about news or art news of more international impact. Maxwell Anderson also has his own Twitter account @maxandersonusa with 916 tweets, 45 following, 2,220 followers, 148 lists followers (as of November 3, 2011). On the other hand, the museum uses Facebook to target a more local audience, Indianapolis- or Indiana-based, where it posts photos of artwork, the gardens, or events. For example, during the ten-month period of analysis, one IMA blog post (October 28, 2010) stands out as having received 222 Facebook "likes." The post by IMA associate conservator Richard McCoy described an

upcoming lecture and workshop at the museum, "Wikipedia & the Cultural Sector." The event was an extension of an Indiana-Purdue University course taught together with McCoy and Jennifer Geigel Mikulay, an assistant professor of visual culture at the university who started the project *Wikipedia Saves Public Art* to document public art in Indianapolis and beyond.

Of all five museum blogs studied, the IMA blog has the highest ratio of comments to post (3.2:1); with a total number of 498 comments and 158 posts (not the highest number of comments or posts, but the highest ratio).[8] Yet the IMA blog also has the lowest number of reported visits in 2010 (137,423),[9] which generates a ratio of one comment per 275 visits, the lowest of the four museums that provided data on blog visits. So while the IMA blog does not have the highest number of comments, posts, or visits, it is evident from this analysis of blog comments that its viewers are highly active and committed followers. The blog facilitates participation and peer-to-peer sharing by including at the bottom of each post Facebook like, Google publicly like, StumbleUpon submit, and Tweet. However, StumbleUpon has a hyperlink to submit, Facebook and Google don't link, and Twitter only links if there is a number attached for Tweets. Rachel Craft, director of publishing and media at the IMA, is responsible for the museum blog. She notes that there are a multitude of communities that the blog allows the museum to target (personal communication, August 3, 2011). For example, she cites the museum's horticulture department, whose blogs are the most commented on and have really generated a community around them. Most of the posts are from Irvin Etienne, horticulture display coordinator, who has an especially strong following with blog readers who know what and when to expect news from him, as he regularly posts every other Friday. This personalization is aided by the blog including a profile on the posting authors. A hyperlink on the name brings up all postings from that individual, as well as a profile that includes a photograph, job title, interests, favorite movies, music, food, pets, and "Something you should know about me." The museum blog also occasionally invites posts by outside individuals related to current museum events, adding up to fourteen posts in the ten-month period (excluding museum interns and temporary staff), or 8 percent of total posts.

Another way in which the museum "gets noticed" is by embracing collaboration in the international art and museum world that comprises a pivotal part of their community. The museum contributes 123 works from its permanent collection to the ARTstor Digital Library (as of March 5, 2012) that provides greater public access for research and educational purposes to more than a

million digital images from participating museums around the world. In 2011, the museum entered into ARTstor's Images for Academic Publishing (IAP) program[10] by providing TIFF image files of its works free for scholarly publications. Other main initiatives in which the IMA engages in professional, international collaboration are the IMA Lab, ArtBabble, and the Dashboard.

The IMA Lab is the media and technology consulting arm of the museum, supporting its efforts to create open source software for museums as an alternative to commercial software tools. The museum website states,

> In addition to serving the IMA's mission by leveraging these skills, the IMA Lab seeks to help other cultural organizations do the same by offering solutions and consulting services which contribute back to the community of museums and which help other organizations succeed.

The IMA dedicates substantial resources to technical expertise, having many software developers on staff that can create in-house projects for the museum. The IMA's *Strategic Plan for 2011–2015* includes a category for research leadership with five objectives. The first objective is to "establish the IMA as a research leader among its peers in the areas of art history, conservation science, information science, and visitor studies." The second objective is that "the IMA will become a leader among museums promoting the production and sharing of open-content and scholarship," with the goal of promoting the use of IMA assets by the community of scholars. Another objective is to "develop collaborative relationships with researchers and institutions that enhance IMA's research capacity internationally" with the goal of building relationships with regional academic leaders. Through a strong commitment to collaboration, digital research at the IMA serves equally the local and the global, scholarly community, as well as the global community of museums and arts institutions.

Rob Stein has been a strong promoter of open software since he arrived at the museum in 2006, believing that open source provides a unique opportunity for the nonprofit cultural sector to work together in ways that would not be possible for the for-profit sector. The IMA has taken a leadership role in promoting institutional collaboration for the purpose of software development based on its own collaboration with arts and cultural institutions around the world that seek advice from the museum on website design, collections management technology, and more. The lab is a way for the museum to offer a service to its professional community that could impact the entire community of museums—"a

way to pool resources for common needs" (Rob Stein, personal communication, August 3, 2011).

In 2008, the Getty Foundation, in conjunction with the J. Paul Getty Museum, launched the *Getty Online Scholarly Catalogue Initiative* (OSCI), a major grant initiative to address the challenges of transitioning from traditional print format to online delivery of exhibition catalogs. The Getty invited nine world-renowned art museums (the Art Institute of Chicago; the Arthur M. Sackler and Freer Gallery of Art; the Los Angeles County Museum of Art; the National Gallery of Art, Washington, DC; the San Francisco Museum of Modern Art; the Seattle Art Museum; Tate Gallery; the Walker Art Center; and the J. Paul Getty Museum) to work collaboratively on their own cataloging projects. The Getty contracted with the IMA Lab in 2011 to develop open source software tools that would facilitate the online publishing of catalogs for the participating museums, and eventually for the larger museum community. The Getty credited the IMA Lab's work with the Art Institute of Chicago as being the successful prototype for its collaborative, open source software project. The initiative aims to transform the way in which museums publish scholarly catalogs to enable broader access by digitally sharing their research and collections with the public.

Stein comments on the success of the lab in a blog post: "The absence of licensing fees and the ultimate flexibility for integration and enhancement mean that a museum's dollars of investment can more directly impact feature enhancements and underlying requirements" (2009, September 15). Most museums today are not only using open source software, but also adding to it and releasing their own versions. Stein states, "Museums are used to doing things together as a community through loan and exchange of objects, shared exhibitions, visitor studies, educational efforts and initiatives, those have already been shared. They're starting to say now we can do the same with software." The lab is not heavily promoted on the museum website, probably due to the fact that its clients originate more from the art/museum/digital technology community of which the museum is an active participant. A link to IMA Lab is placed on the bottom navigation bar next to more institutional functions such as Press/News, Contact Us, Image Rights & Reproductions, and Privacy Policy. Online collaboration for open source technology projects is a viable solution because most museums have neither the time, financial resources, nor technical experience to develop their own software tools, and because museums have strong, established peer-based networks of institutional relationships due to shared exhibitions, loans, and other collaborative projects among professionals.

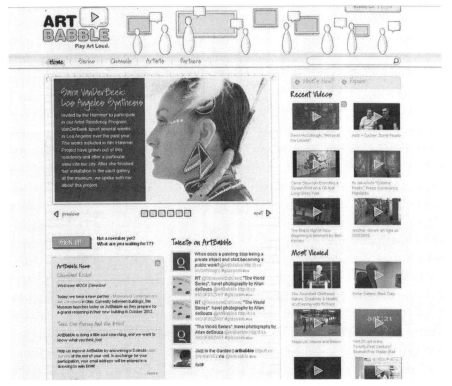

FIGURE 3.6
Indianapolis Museum of Art website, ArtBabble (5/2/12 screen capture).

ArtBabble is listed on the IMA's website in the section Interact as part of its listings of social media (Join us on) and under the heading "Find us on . . ." Art-Babble is described on the museum's website in the About section as:

Art-Bab-ble [ahrt-bab-uhl]
noun; verb (used without object) -bled, -bling (ArtBabble.org)

1. free flowing conversation, about art, for anyone.
2. a place where everyone is invited to join an open, ongoing discussion—no art degree required.

Although ArtBabble is essentially an art video–sharing website for the museum, it is much more, evidenced by the fact that the museum also has an active channel to share its 233 videos on YouTube with a notable 550,281 total video views and 1,204 subscribers (as of March 20, 2012). ArtBabble, on the other

hand, is about partnership and collaboration that is once again facilitated by the museum. This is first noticeable because the URL does not mention the museum (www.artbabble.org) and the contact information is not an IMA e-mail (contact@artbabble.org). The IMA's name and link are only apparent in ArtBabble in the About Us section and eNews Signup (both on the bottom navigation bar), but only after one has registered. However, a link from the IMA website lands on the museum's institutional partner page of ArtBabble. Since it launched in January 2009, ArtBabble now has 35 international partners that have contributed their videos for a total of 1,411 (as of December 19, 2011), including a public radio station (KQED the Gallery Crawl), the New York Public Library, a foundation (Chipstone), a nonprofit organization (Art 21), a multimedia Web book on art history (Smarthistory.org), and art museums from all over the United States as well as Madrid, Mexico City, Amsterdam, and Rotterdam. The IMA has contributed 278 of its videos to ArtBabble, which can be searched by artist name, channels (artistic genre with a tag cloud, series based on thematic groupings including "For Kids"), and by the partners linking to a separate subsection for each one. ArtBabble also has its own Flickr group (Play Art Loud), Twitter feed @artbabble, and Facebook page. By registering and creating an account, visitors can store favorite videos, leave comments, and receive e-newsletters. There are few public comments on the videos, but the YouTube channel also doesn't have many comments (about one a month as they are listed by date). ArtBabble won the Gold MUSE Award in the online presence category from the American Association of Museums in 2009.

The Dashboard is a recent initiative of Anderson that came online in 2010, due to his particular interest in transparency and open sharing of critical information among the museum community. The website states that the goal is to "seek to quantify and report out on areas of activity of general interest to museum observers and of particular interest to museum studies specialists, colleagues, and patrons." These areas are searchable by museum departments, topics, and by year (2007–2011). They include internal metrics on membership, endowment, attendance, energy consumption, number of Facebook fans, number of plants, average time spent on website, the number of works with gaps in WWII-era provenance, and an interactive map of museum admissions by zip code in real time. The museum regards the Dashboard as serving a variety of purposes; one aimed externally at visitors to better understand the complete picture of the museum, and also at funders to evaluate the success of their grants and the impact on the museum, and one aimed internally at museum staff to better gauge their

own performance against hard metrics that become publicly available. The museum is currently developing a second version of the Dashboard to be released at the end of 2011, which will integrate staff satisfaction and performance surveys and make it easier for the public to remove data from the website.

Upon receiving an award for Dashboard at the University of Southern California's National Summit on Arts Journalism in 2009, Anderson stated in a video,

> It's very easy, relatively speaking, with the ingenuity of Rob Stein and his team to produce these extraordinary experiences. It's much harder, to take one of the ten largest art museum buildings in the United States, and make the experience in there as lively and compelling and fluid as we can do electronically.

Museum consultant and administrator Nina Simon also noted the great discrepancy that she discovered upon entering the physical grounds of the IMA. She writes in her blog *Museum 2.0*,

> I showed up at the IMA expecting innovation. Instead, I found a standard art museum. Nice art. Impersonal guards. Lovely grounds. Obtuse labels. Interesting architecture. There was nothing that connected me to the visceral, exciting institution Max had sold in his talk, the institution that exists on the web. . . . Is this a problem? I think so. I felt like I had met someone online, someone sexy and open and intriguing, and then on our first date that mystery museum turned out to be just like all the others. (April 20, 2009)

It was only after Simon's blog post reappeared in the form of an article renamed "Bait and Switch" in the American Association of Museum's *Museum* magazine (2009, July/August) that Stein felt the urge to respond in the IMA blog (July 27, 2009). He stated firmly that the two experiences (online and onsite) are, and should be, "DISTINCTLY different." Because there are two distinct audiences, Stein sees no problem in "tailoring experiences differently based on where they are encountered." And the *where* is not merely a physical art museum versus online; it is the *where* of the physicality that matters here and in this book. Stein is referring specifically to his largely Indianapolis- and Indiana-based physical audience. Stein confirmed, "We have shied away from including a lot of technology in the gallery spaces, on purpose. As we understood our audiences, we were hearing that numerous people were coming to the IMA for that retreat-like experience, for serenity, to escape."

It is true that the physical spaces of the IMA are more traditional in character, but there are a few notable exceptions. Digital comment screens are placed at the end of special exhibitions in the museum. And there is TAP, the museum's mobile application platform that was designed for the iPod Touch in 2009. Both Stein and Anderson comment on how mobile technologies are a good solution for providing digital opportunities within a physical gallery environment that do not impose on more traditional-minded visitors. The museum has used TAP for four special exhibition mobile tours as well as for its 100 Acres, which is an enhanced mobile Web tour that plots the latitude and longitude of tour stops on OpenStreetMap. While visitors can access the 100 Acres tour on their own smartphones, the museum also owns sixty iPod Touches for visitors to rent at $5 a tour (or free for museum members). Because TAP was released as open source, other museums have adopted it to create their own tours, including the Balboa Park Online Collaborative, Gemeentemuseum Den Haag, the Museum of Fine Arts Boston, and Winona State University. The tours provide audio, video, text, still images, and polls.

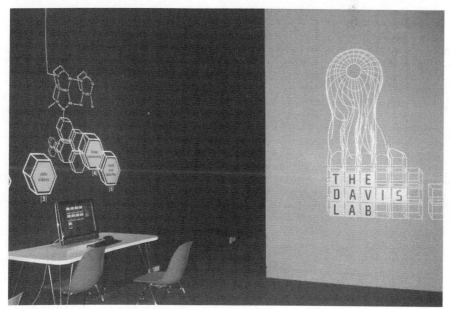

FIGURE 3.7
The Davis LAB, Indianapolis Museum of Art, 2011.
Courtesy of the author.

The Davis LAB opened together with ArtBabble in January 2009 as a separate space on the first floor of the museum. It connects to its online presence and introduces new media projects. The IMA does not consider the Davis LAB as an educational space or even a new media space, but rather a new gallery space mixed with cyberspace. The front of the LAB consists of tables with computers outfitted with kiosk software where visitors can access the museum's website, blog, ArtBabble, Flickr, and Facebook pages. Visitors can also leave comments and rate videos online. The back part of the LAB is a mini-theater with modern seating from the museum's Design Center and a large screen to showcase its high definition videos. The museum website describes the LAB as, "This space is meant to be fun, innovative and experimental. It is about risk-taking, brainstorming and interactivity."

LESSONS LEARNED

The IMA continues to be innovative in the field of digital media due to its substantial endowment, supported by experienced local funders (corporate, foundation, individuals) that understand the importance of long-term institutional stability. However, having this financial cushion to rely on is not enough; it was the foresight of its directors (primarily Bret Waller and Maxwell Anderson) that established a vision, took risks, and directed resources to hiring technologically proficient staff that are able to create programs and tools in-house, leading to greater flexibility, creativity, and efficiency. These innovative results have succeeded in reinforcing the museum's authority and legitimacy not only to its local community, but more importantly for the museum, to the global arts community where it has demonstrated strong leadership in creating ArtBabble as a collaborative art video–sharing website, in showing the importance of transparency with the creation of Dashboard, in offering open source software to other museums with the IMA Lab, and in its continued management of the Steve Project for tagging. While these initiatives may not be place-based, they are situated within the global arts world, an important community for the museum to belong to that includes arts institutions, museums, scholars, professionals, and policy leaders.

The IMA is conscious of its place at the crossroads of America, geographically isolated from the global arts world but filling an important cultural need for the local arts world. A place-conscious approach allows the museum to serve its local community with more traditional exhibitions, historic gardens, public programming, and the contemporary art and nature park of 100 Acres, while at the same time carefully and subtly infusing digital technology onsite

with the wired Davis LAB, mobile tours, and digital comment screens only at the end of exhibitions. The local and the global work together integrally at the IMA. Sometimes global attention will trigger local attention (Venice Biennale), and some local programs will incorporate global players (Curators at Large, 100 Acres), benefitting both audiences equally. Technology facilitates this symbiotic relationship through the Internet (the museum's website, blog, and social media), the physically situated IMA Lab with museum staff that create open source software for the global museum community, and with digital teleconferencing technology that connects people worldwide to the museum.

Technology is a means to extend audiences past a geographic border; it is particularly useful if one's immediate geography is not fully representative or supportive of one's identity and ambitions. The IMA uses technology and its human resources to not only better serve its previously identified communities (local and global), but to expand those communities into global cyberspace through new partnerships and initiatives. Anderson stated,

> If you look to be the best and the fastest and the brightest without sharing with everybody else, you end up being alone. And as an institution we don't want to be alone, we want to be in partnership with a lot of others. (personal communication, September 10, 2009)

Partnership means institutional initiatives, both local and global as described, but partnership also means opening up the museum to a *public* partnership for dialogue and participation. Dialogue occurs in the museum's blog, which has the highest ratio of comments to posts of all five museums studied, and through social media, with the museum astutely distinguishing between a local audience for Facebook and a global audience for Twitter (including Anderson's own Twitter feed). Dialogue is a form of participation, but other forms include the digital comment screens in the museum, as well as the social tagging and Tag Tours which occur on the museum's website for its online collection. At the IMA, however, a partnership with the public does not imply democratization or a collective-type relationship, as the museum clearly maintains authority and leadership within its community of peers and its local community.

NOTES

1. Indianapolis Convention & Visitors Association. (2010). *2009 visitor profile*. McLean, VA: D. K. Shifflet & Associates Ltd.

2. For these statistics, *Mapping the Measure of America 2010–2010* analyzes congressional districts only. The Indianapolis Museum of Art is located in Indiana Congressional District 7.

3. Data is taken from the 2010 federal report, *Civic Life in America: Key Findings on the Civic Health of the Nation*, collected through civic, volunteering, and voting supplements to the *Current Population Survey*, a monthly survey of about 60,000 households conducted by the U.S. Census Bureau for the Bureau of Labor Statistics. The data is distributed through a partnership between the Corporation for National and Community Service, an independent federal agency, and the National Conference on Citizenship, chartered by Congress in 1953.

4. At the time of writing this book, Maxwell Anderson announced that he will leave the Indianapolis Museum of Art on December 31, 2011, to become the Eugene McDermott Director of the Dallas Museum of Art in Texas. Anderson is quoted as saying that he is "going to a city that has put culture at the center of its identity" (as cited in Kightlinger, 2011, October 21).

5. Data taken from the museum's 2010 IRS 990 Form, as downloaded from the IMA website.

6. Museum members receive free parking privileges, and visitors who purchase more than $50 worth of merchandise in the Museum Store, Gallery Shop, or Greenhouse Shop will receive parking validation.

7. On March 3, 2012, the Dallas Museum of Art issued a press release stating that Robert Stein will become the museum's new deputy director, effective April 19, 2012.

8. Note that blog comments do not include Facebook likes, Tweets, Google Likes, or StumbleUpon submits.

9. Only the Brooklyn Museum did not provide any data on its blog visits.

10. The IAP program was initiated by the Metropolitan Museum of Art in 2007.

4

Walker Art Center

PLACE + LOCALIZED CULTURE

Minnesota is called the "Land of 10,000 Lakes"—it's on their license plates—and so the state capital Minneapolis is the "City of Lakes." The name comes from *Mni*, the native Dakota word for water. Minneapolis is situated on both banks of the Mississippi River and has over twenty lakes and wetlands regions. The Chain of Lakes district consists of five connecting lakes and 13.3 miles of biking/walking/jogging paths with rose gardens, a bird sanctuary, and a bandshell for live music. Minneapolis heavily promotes its natural physical beauty, as well as the diverse sports that take place seasonally such as fishing, boating, and skiing. Permanent sports attractions based in Minneapolis include a National Football League team, the Minnesota Vikings; a National Basketball Association team, the Minnesota Timberwolves; a National Hockey League team, the Minnesota Wild; and a Major League Baseball team, the Minnesota Twins.

Minneapolis was also called "the Mini Apple" during the 1970s because of its strong theater tradition; second only to New York ("the Big Apple") in the amount of theaters (production, attendance, and venues). Sir Tyrone Guthrie first started the idea of a nonprofit resident theater in 1959 as an artistic alternative to the large, commercial productions on Broadway. He choose Minneapolis for his experiment primarily because of its great enthusiasm for the idea of live theater, and also for what Guthrie noted was a central location in the Midwest, a vital cultural community, and the presence of a large state university and many small colleges. T. B. Walker (founder of the Walker Art Center) immediately

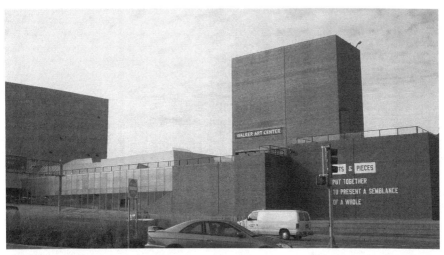

FIGURE 4.1
The Walker Art Center, front view along Hennepin Avenue (Barnes building on right,
Herzog & de Meuron building on left), 2011.
Courtesy of the author.

offered to donate land for the theater behind his museum, as well as $400,000
toward construction costs. Since 1963, the Guthrie Theater was physically and
often programmatically linked to the Walker Art Center (the Walker), but
in 2006, the Guthrie opened its own new building along the riverfront in the
historic (but now redeveloped and trendy) Mill district, designed by Pritzker
Prize–winning French architect Jean Nouvel and called a "21st-century dream
factory" by *Time* magazine.

While the state of Minnesota supports the arts with a substantial annual al-
location of $8.49 million (2011), the city of Minneapolis has no formal arts de-
partment, commission, or budgetary allocation, except for its public art program
that has an annual budget of $330,000. Nonetheless, city government supports
the arts through its different departments on a per-case basis when approached
by institutions, such as when the city funded the underground parking garage
ramp during the Walker's recent renovation. And the city recently hired a staff
person to act as liaison between city government and the local arts community.
Aside from the large number of independent theaters inspired by the success of
the Guthrie, Minneapolis is also home to dance companies, a symphony, and
other prominent museums including the Frederick R. Weisman Art Museum at
the University of Minnesota (designed by architect Frank Gehry), the Minneap-
olis Institute of Arts, and the Minnesota Historical Society, as well as community

arts centers and ethnic museums reflecting the state's immigrant history such as the Museum of Russian Art and the American Swedish Institute.

Minnesota is home to twenty Fortune 500 companies, the most per capita of any U.S. state except one. Most of these companies were started by families long ago and have now gone public, but they maintain family-owned foundations that are very philanthropic toward the local community. A few of the prominent family foundations located in Minneapolis are the Edward Dayton Family Fund (originally Dayton's Department Store that owned Target, Mervyn's, and Marshall Fields), the McKnight Foundation (William L. McKnight was an early leader of 3M), and the Curtis L. Carlson Family Foundation (Carlson Companies). Many of the corporations also heavily support the community through their own corporate foundations or marketing/outreach departments. Some of the most philanthropic corporations based in Minneapolis include Target, Best Buy, General Mills, 3M, and the Minneapolis *Star Tribune*. Following the Walker's recent expansion in 2005, the *New York Times* noted that the museum "has evolved in a city known for its outsize arts patronage."[1]

The city of Minneapolis has a population of 382,578 people (the smallest by far of the five museums studied). Demographics show that the city skews younger, with 20 percent of the population under eighteen years of age and only 8 percent older than sixty-five, with the majority age group (21 percent) ranging from twenty-five to thirty-four years of age (U.S. Census, 2010). The city is also predominantly white non-Latino (63.8 percent) due to the majority having descended from Scandinavian and German ancestors that settled the region in the late 1800s. The largest minority group is African Americans at 18.6 percent, followed by a growing population of Hispanic/Latinos at 10.5 percent, and 2 percent Native American Indian as the original inhabitants of the region (Dakota Sioux and Ojibwe tribes). There are eleven federally recognized Indian tribes in Minnesota today, each actively managing their own reservations and casinos.

Most impressive, however, is how highly Minneapolis ranks with regard to civic involvement.[2] Measuring service, 37 percent of adults volunteer with an organization and 12 percent work with their neighbors. Measuring giving, 62 percent of adults give charitable contributions over $25. Measuring political action, 69 percent of adults are registered voters, and 76 percent voted in the 2008 election (above the national average of 57 percent). Measuring social connectedness, 91 percent have dinner with household members frequently, 65 percent talk to family and friends on the Internet frequently, and 51 percent talk with neighbors frequently. Measuring belonging to a group, 49 percent of adults

participate in any organization. The region ranks only slightly above the national poverty rate at 16.5 percent, but it rises above the national rates for adults having at least a bachelor's degree (41 percent) and for school enrollment (92 percent). Median personal earnings are $31,442, and it ranks slightly higher than the national income index at 5.47.

The most recent visitor statistics (2008) profile the average Minneapolis metro region visitor as being from thirty to fifty-nine years of age, overwhelmingly white (90 percent), and coming in groups of two to three people without children. When traveling for personal reasons, the number-one reason to visit is shopping, below which falls dining, outdoor activities, and seeing city sites, with only 20 percent stating their reason is to visit museums. The Mall of America is the largest enclosed mall in the United States, located in nearby Bloomington, and there is no sales tax on clothes in the state of Minnesota.

In discussing the most recent expansion at the Walker, architect Jacques Herzog (of Herzog & de Meuron) describes how they considered the place-based context of the museum. Minneapolis, he states, "is a special kind of city. There's no public space apart from these skywalks. Since the beginning, the intention was that the museum should be an alternative public space . . . like a concentrated town" (as cited in Blauvelt, 2005). Minnesota is the northernmost state in the continental United States, and in response to the extreme winter temperatures, Minneapolis created its skyway system more than five miles long with elevated, covered walkways that connect buildings within the downtown area. Because the museum is located outside the downtown area, it does not connect to this system.

THE MUSEUM AND ITS COMMUNITY

Mission Statement:

The Walker Art Center is a catalyst for the creative expression of artists and the active engagement of audiences. Focusing on the visual, performing, and media arts of our time, the Walker takes a global, multidisciplinary, and diverse approach to the creation, presentation, interpretation, collection, and preservation of art. Walker programs examine the questions that shape and inspire us as *individuals, cultures, and communities.* (emphasis mine)

While there are many noteworthy museums and cultural attractions in the city, the Walker's *Spoonbridge and Cherry* in its sculpture garden remains one of the most popular icons when promoting the city, particularly with the

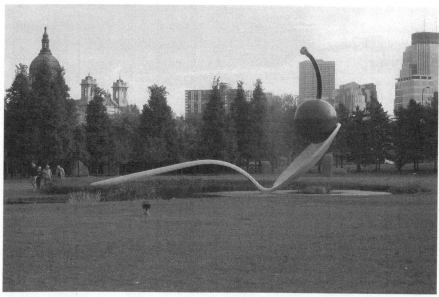

FIGURE 4.2
Spoonbridge and Cherry (1985–1988) by Claes Oldenburg & Coosje van Bruggen, Walker Sculpture Garden.
Courtesy of the author.

official visitor's guide and other marketing materials. A detail of the iconic sculpture also covers the front of the museum's own brochure. The sculpture garden played an important role in connecting the emerging museum to the Minneapolis community. The grounds had previously been used for military drills and exercises since the late nineteenth century, then as an armory to house volunteers from the Spanish War that later became the Armory Gardens, hosting a number of civic events, then baseball, softball, and football games on the grounds, an airstrip during the 1920s, and occasional temporary sculptural installations used by the adjacent Walker Art Center in the early 1970s. It was during Martin Friedman's long tenure as third director of the museum (1960–1991) that the Walker formally established a relationship with the Minneapolis Park and Recreation Board to develop a large-scale, permanent sculpture garden. The garden officially opened on September 10, 1988, with its glass-covered conservatory, an impressive collection of sculptures placed throughout the formal gardens, and the monumental *Spoonbridge and Cherry* sculpture commissioned by Frederick R. Weisman for the opening.

The sculpture garden has been used by the museum as an outdoor exhibition space to explore contemporary sculpture with new commissions, and for performances, readings, musical concerts, and educational workshops, but it has also been used by the local community as a place to gather, to contemplate, and to celebrate special occasions. Most significantly, the Irene Hixon Whitney pedestrian bridge, built in 1986 by the sculptor Siah Armajani, connects the garden with Loring Park and the northern and eastern parts of the city.

The Walker Art Center was borne out of a commitment to community and public education. In 1879, Minneapolis civic leader and lumber magnate Thomas Barlow (T. B.) Walker established a gallery in his downtown home consisting of his private collection of modern European paintings, Chinese jades, miniatures, porcelain, armory, and Indian portraits, which was touted as the first museum west of the Mississippi River. Walker, who also founded the Minneapolis Public Library, was dedicated to improving his local community and opened the gallery free of charge to the public. Walker later moved his private collection to a new building on the museum's current site in 1927, and changed the name to the Walker Art Galleries. In 1938, he transferred its administration to the newly established Minnesota Arts Council, that in turn decided to approach the federal Works Progress Administration (WPA) for support in creating a new public art center. The first director of the Walker Art Center was a WPA administrator, Daniel Defenbacher, who served from 1940 to 1951. Not only was Defenbacher in charge of the WPA program to create seventy such community art centers around the country, but he was also passionate about "creating a museum of the present for the people of today." In his visionary words from 1944,

> An Art Center is a "town meeting" in a field of human endeavor as old as man himself. By definition, it is a meeting place for all the arts. It provides space in which the public can both participate and be a spectator.[3]

In 1969, the original museum building was demolished in preparation for a new facility designed by the architect Edward Larrabee Barnes. During the two years of construction, the museum conducted its "Museum without Walls" exhibitions and activities off-site around the region, collaborating with local organizations and institutions. This period demonstrates the highly collaborative nature of the Walker still today with the local arts community. When the museum closed again for its most recent expansion from 2004 to 2005, it launched a citywide program called "Walker without Walls."

FIGURE 4.3
Walker Art Center flyer, 1940.
© Walker Art Center

The fourth director of the Walker, Kathy Halbreich, served for sixteen years (1991–2007) and was largely responsible for revitalizing Walker and Defenbacher's early ideas about a community art space. In 2004, Halbreich stated, "The metaphor for the museum is no longer a church or temple, but a lively forum or town square."[4] A number of the museum's visitor-centric initiatives that began in the late 1990s were based on the ideas of constructivist learning and personal meaning making. However, what made these ideas unique to the Walker was the museum's multidisciplinary approach to collecting, exhibiting, and programming the visual, performing, and media arts. Halbreich's *More Than a Museum* initiative began in 1999, based on her quest to determine the nature of a multidisciplinary art center in the twenty-first century. While the Walker functioned as an art museum from the beginning, and has long been accredited by the American Association of Museums, it is perhaps because the word *museum* was never formally attached to the Walker (art gallery, art center) that it felt more freedom from traditional institutional boundaries as well as the impetus to more clearly define its own particular institution. In seeking its identity, the Walker

was challenged to imagine "a town square that is a destination in itself, where distinct zones of quiet and conviviality introduce the visitor to a unique spectrum of programs and to the ideas animating them." *More Than a Museum* was also the name used for the 2000 capital campaign to raise funds for renovating the Barnes building, for the new Herzog & de Meuron building, and for increasing the operating endowment ($94 million was raised as of September 2005, exceeding the goal by $2 million). Today the Walker is dedicated to contemporary art and to embracing the multidisciplinary nature of contemporary art, as well as the multiple ways in which contemporary art can be experienced and understood by visitors, which leads it to offer multiple paths into both the museum and its art. This chapter will later discuss the technological tools which the Walker incorporates to facilitate individualized learning experiences for visitors, and for which it aptly calls itself "one of the first 'smart' cultural facilities."

In 2003, the Walker's Education and Community Programs department initiated *Art and Civic Engagement: Mapping the Connections.* This project was funded by the Minneapolis-based Bush Foundation (started in 1953 by 3M executive Archibald Bush and his wife). The questions that inspired this initiative were, How can a contemporary art center become a forum for civic engagement, and how can the contemporary issues that contemporary artists deal with become a part of public life? The museum defines civic engagement broadly as "the exercising of personal or collective agency in the public domain for the betterment of one's community."[5] Its goals for this program were to encourage genuine civic involvement from visitors, and for museum curators and staff to consider a more "socially conscious" approach to planning events, exhibitions, and hands-on learning experiences. The museum started with a belief in the social potential of art to address issues in the community or between groups of people. The program was based on the *4C Model* that the museum developed to recognize the roles of art and artists in the town square. These four roles are: Container, Connector, Convener, and Catalyst. The spectrum of civic engagement activities considered by the model includes Commentary, Dialogue, Action, and Leadership. Andrew Blauvelt, design director and curator at the museum, describes this new model in *Expanding the Center: Walker Art Center and Herzog & de Meuron* (2005) as "not so much a reshuffling of the hierarchy as it was an expansion of thinking around the network of relationships involved in the entire museum experience, whether objects and ideas, artists and audiences, or programs and places."

The Walker conducted an extensive visitor study in 2006 in order to further understand its visitors and the visitor experience, and in particular, "to further engage and inspire museum members and an ever broader audience." The study consisted of a visitor ethnography, engagement study, tracking study, and member focus groups implemented by the Institute for Learning Innovation and the General Mills Consumer Insights group. Research revealed that the majority of museum visitors are "enthusiasts" and not "experts," that visitors want a sense of familiarity, safety, and comfort (although 65 percent said that a major motivation for visiting the museum is a desire to learn something new), and that visitors who gained personal insights had the most meaningful interactions with the art and the museum. Based on this study, the Walker formulated a New Audience Engagement Plan to be implemented in 2011. The plan is to increase staff and visitor interactions, focus on gallery comfort to encourage extended viewing experiences, further refine public spaces to actively promote socialization, and to emphasize emotional and personal connections in all museum communications. The study specifically proposed three opportunities to building a stronger Walker community: being "in the know," directed learning, and special-interest learning.

The Walker's latest expansion was completed in 2005 by the Pritzker Prize–winning Swiss architects Herzog & de Meuron. The expansion consisted of renovating the existing Barnes building, creating a new building, and connecting both buildings. Two of the main goals included creating new kinds of "social and civic gathering spaces" and reorienting the museum to the city. Many of the new spaces contributed to the notion of museum as town square, such as large lounge areas between galleries and in the lobbies, an expanded grassy area outside the back of the museum, and shared spaces for experiencing audio and video works of art (media bays) as well as the Info Lounge for shared digital experiences around the *Dialog Table*. These media-based spaces and interactive lounges were distributed around the museum to support learning that the museum believes occurs "independent of a single time and place." The museum affirmed that no space was designed specifically for one audience (e.g., children, families, students), but for what they called "citizen visitors" of the museum to come together and interact, talk, learn, and enjoy.

When asked to describe a town square in the 2006 study, museum visitors used the words, "unstructured and flexible, commonly owned, safe for all opinions, family-friendly . . . a universally used public space where all worlds

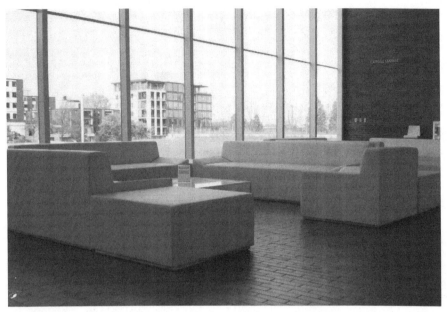

FIGURE 4.4
Cargill Lounge, Walker Art Center, with view to back of the museum, 2011.
Courtesy of the author.

of people collide." While the museum strove to become a town square in and of itself, it also needed to strengthen its connection to the larger community of Minneapolis and the Twin Cities, and in particular, to the downtown that it had long felt disconnected from. The architects responded by placing large windows facing the street and downtown, a new street-level entrance and entry plaza that incorporate the wide sidewalk along Hennepin Avenue, and a long glass curtain wall along Hennepin Avenue connecting visitors inside the museum to the outside street life with a video projection and LED display for digital signage.

In 2010, the Walker launched what it refers to as an "innovative community initiative" called Open Field during the summer months from June to September, which was repeated in 2011 and 2012. Talking about the program, Director of Education and Community Programs Sarah Schultz[6] said,

> It was a massive public experiment in what I had come to understand over several years, is that one of the resources an institution has is space, and offering up space or platforms to people to insert themselves into is very, very important, and I actually believe part of our civic responsibility as a public institution. Open Field showed me that there are so many different kinds of self-identifying and self-

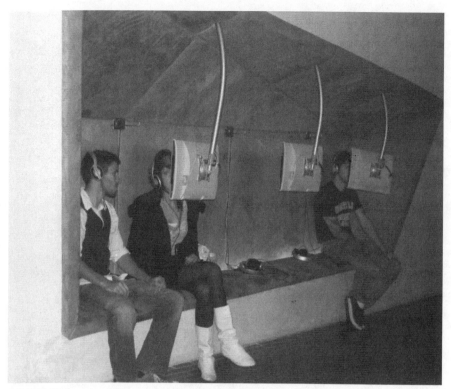

FIGURE 4.5
Best Buy Film/Video Bay, Walker Art Center, 2011.
Courtesy of the author.

> formed communities that can find a place and a home within the institution that
> the institution doesn't necessarily need to be the one to identify the community
> but needs to be a platform to find a way into the institution. . . . This idea of slow-
> ing down and being social together is a profound need that people have. (personal
> communication, October 19, 2010)

Open Field turned the Walker's outdoor grassy spaces (back of the museum
and the sculpture garden) into what it calls a "cultural commons," based on
the belief that certain cultural resources can and should be commonly owned,
such as images, languages, ideas, computer code, and other information. Open
Field depends on public participation; for individuals or groups to share their
talents and interests with others by scheduling activities, although spontane-
ity is also welcome. In addition to these publicly organized programs (such
as tai chi, tango, yoga, poetry reading, book club, badminton tournament),

the museum offers workshops, art-making activities, and an outdoor bar and grill in its newly created Open Lounge. The Open Field Tool Shed was built outside to store materials for visitors to check out, such as picnic blankets, books, games, sports equipment, and art materials. Open Field succeeds not only in creating the environment of museum as town square, but also in making the museum more of an integral part of its local community; a town square firmly placed within a town. With Open Field's reliance on participatory culture, the museum acknowledges and celebrates the incredible "cultural assets, creative spirit, and collective knowledge" within its local community.

While we see how the Walker is conscious of strengthening its own community and is committed to participating in and serving its greater community, the notion of community remains in the abstract. How does the museum categorize its own community and the larger community in which it participates? When asked this question, current museum director Olga Viso responded that the principal Walker communities are (1) local/regional, (2) global contemporary art world, and (3) online. She continued,

> These communities, of course, break down within each category. From the standpoint of emphases or priorities, I would say that we have been putting decided focus since my arrival on attracting the broader local/regional community as well as developing our online audiences. (personal communication, December 24, 2010)

Schultz emphasizes the museum's many communities of interest as a way of breaking down its own community. She explains, "We have various target audiences, but over the years I think, like many institutions, it's moved away from a demographic way of thinking about your audience to more of a psychographic way of thinking about your audience." Just as the museum is about multiple disciplines of art, so do they have multiple communities. For example, special membership groups at the Walker include a Design Council, Film Society, Collector's Council, and Producer's Council.

Two of the most significant and long-standing subcommunities of the Walker are artists and teens. In 1994, the Walker was one of the first art museums to develop teen programming that is still active today. Programming includes teen exhibitions, film showcases, poetry slams, hip-hop battles, internships, and workshops. The Teen Art Council (WACTAC) is central to this community: a group of twelve local teens that meet weekly to design, organize, and market events to other teens and young adults at the museum. WACTAC's website

(http://teens.walkerart.org) is remarkable for the sense of community that it generates for teens based on digital features such as a blog, links, calendar, and gallery of uploaded artwork. Even the teen alumni remain part of that community through the WACTAC Alumni Google Group and WACTAC Alumni Facebook group. The Walker's teen programming incorporates its diverse, local community of teens, and is significant because of the particular demographics of the museum: 22 percent of its visitors are teens and youth (recall that Minneapolis has a younger demographic); 20 percent of its visitors are low income; and 13 pecent of its visitors are people of color. The Walker is also highly cognizant of the key role that artists (local and international) play in the town square from its 4C model, evidenced by a number of museum programs that interact with the local community such as artist residencies, commissions, and the Art Lab (a multipurpose studio classroom for the last twenty years). Especially worth mentioning is mnartists.org, a virtual community in the form of a website and database of Minnesota artists and organizations from all disciplines with programming also at the physical museum. Mnartists.org is run by the museum and funded by the local McKnight Foundation. The Walker is also the only museum of the five studied that documents the number of works by local artists in its permanent collection (173 works or 11 percent of the collection by Minnesota artists as of October 2010).[7]

THE ROLE OF DIGITAL TECHNOLOGY

New Media Initiatives Mission Statement:

The department of New Media Initiatives explores the use of digital technologies to communicate contemporary artistic expression and the views of its interpreters to *diverse individuals, communities, and cultures.* Its mission is to make the rich resources of the Walker Art Center broadly accessible, and to investigate various technologies as a means to educate and inform. The department facilitates the communication of information *to the museum's public* through the innovative use of new media. The department maintains a highly visible presence in the field and *assumes a leadership role* in the investigation of the informational and educational possibilities that new digital technologies offer. (emphasis mine)

New Media Initiatives Blog Mission Statement:

The New Media Initiatives blog chronicles research and development of new media projects and technology at the Walker, *connects with a larger technical community, and shares information on relevant new media work from beyond our walls.* Authors are current and former NMI staff. (emphasis mine)

FIGURE 4.6
Dolphin Oracle II, 2005, Shelton, Richard, and Piotr Szyhalski, interactive, multimedia installation. Collection Walker Art Center, Minneapolis, Clinton and Della Walker Acquisition Fund and the Justin Smith Purchase, 2008.
Courtesy of the Walker Art Center.

The Walker Art Center has long been committed to digital technology. During the 1990s, technology was directed mostly to artist commissions and acquisitions with the establishment of a New Media Initiatives (NMI) department that built a significant collection (the Study Collection) of new media/digital/net art under the leadership of museum curator Steve Deitz. Two signature works were commissioned during this period: *Dolphin Oracle II* (by Minneapolis-based artist/designer Piotr Szyhalski) and *Dialog Table* (by Kinecity Llc). Both are still centrally placed inside the museum, but will soon be phased out due to outdated technology and the need to bring in new interactive works.

Gallery 9 was an online exhibition space for digital art that appeared on the museum website from 1997 to 2003 and is currently available for viewing in its archived form. As Deitz originally wrote about the gallery on the museum website:

> Gallery 9 is a site for project-driven exploration, through digitally-based media, of all things "cyber." This includes artist commissions, interface experiments, exhibitions, community discussion, a study collection, hyper-essays, filtered links,

lectures and other guerilla raids into real space, and collaborations with other entities (both internal and external).

Because of the post-9/11 economic downturn, the New Media department terminated both Deitz and the curatorial initiative in 2003, redirecting its focus to educational resources, as can be seen in the current NMI Mission Statement phrase, "to investigate various technologies as a means to educate and inform." In Halbreich's 2003 letter explaining this redirection, she discusses future plans: "We will be focusing on enhancing the Walker Web site's educational components and on realizing some of the interactive projects for our expansion."

Two of the most significant of these educational components that were subsequently developed are mnartists.org and ArtsConnectEd. Olga Viso believes in technology's potential for building and expanding community. She comments,

> I think technology plays a large role not only in creating and maintaining community, but also in expanding and potentially redefining it. There are entire communities of interest we can connect with and tap into online beyond those already engaged. . . . Our mnartists program and site is a great example of the successes in building an engaged artistic community online that is now actively translating into on-site programming and participation. ArtsConnectED, our joint site with the Minneapolis Institute of Arts, is an online educational resource for teachers that is also actively used by students. (personal communication, December 24, 2010)

Mnartists.org has already been discussed within the context of a community—a local artistic community—but this subchapter will highlight the role of digital technology in creating and maintaining this community for the museum. Mnartists.org grew out of a study of Minnesota artists funded by the McKnight Foundation, which revealed the need for artists to have greater access to resources, support, and other artists. Currently the website has 519 members (membership is free) and offers a blog, calendar, social media (Facebook with 8,659 fans and Twitter with 704 followers), forums, news and opportunities, videos, a separate e-mail listserve (11,514 subscribers), and a bimonthly electronic arts journal entitled *access+ENGAGE* (as of January 6, 2012). The website states, "It offers to Minnesota-based artists a central gathering place on the Web, and will grow to become a marketplace and community hub." Mnartists.org blurs the line between online and onsite with a very strong social network (several Facebook pages for separate events, several Twitter feeds, and subsites), online promotion of individual artists, and an active array of programming that take

place principally at the Walker and also around the state. This website and the programs and connections that it produces are critical to the mission of the Walker as being a "catalyst for the creative expression of artists."

ArtsConnectEd is a partnership between the Walker Arts Center and the Minneapolis Institute of Arts to create "tools for teaching the arts" for K–12 educators and their students, higher education scholars, and international audiences. In 1997, both museums received joint funding from the state of Minnesota to digitize and integrate their collections and educational resources. In 2006, a National Leadership Grant to both institutions from the Institute of Museum and Library Services was directed to redesign the ArtsConnectEd website by adding new online tools to empower teachers to create and manage the Web content themselves. Access to the website and all its content is free, and it invites new members to "take full advantage of all the site's features, become part of the ArtsConnectEd community by registering today." New online functions include Art Collector where members can save, customize, present, and share items (only the member's user name is displayed in sets), and Ask an Educator where members can submit questions electronically. Both the questions and answers appear on the website for public view categorized by latest, popular, and category tags (the person that asked the question is listed by first name and title). Images in the online database have a zoom function, comments, tags, and ratings. ArtsConnectEd is also on Facebook (259 fans) and Twitter (989 followers) with links from the home page, and RSS feeds (as of January 6, 2012).

The Walker Art Center Teen Art Council (WACTAC) was mentioned earlier regarding the teen community at the museum, but it is important to discuss the role of technology in strengthening bonds between these members and also in reaching out to other teenagers. WACTAC began in 1996, and is a closed group of twelve teenagers selected each year by the museum that meet weekly during the school year and receive a small stipend. The main objective of the council is to create events for other teenagers and young adults that will better connect them all to contemporary art. Therefore, the use of social media and the Internet is critical to these peer-to-peer marketing efforts. WACTAC has its own account on Facebook (Walker Teens, 116 fans), Twitter (243 followers), MySpace (45 friends), Flickr group pool (8 members and 687 items), and a RSS feed (as of January 6, 2012). Technology also helps bond the teenagers in the council within their own subcommunity. It is important to note, however, that these two objectives are separate, as the WACTAC website serves principally the teen art council, and social media serves principally the global, anonymous public of

supposedly teenagers. Social media is not promoted or linked from the WAC-TAC website, and online postings of the blog, artwork, and events are limited to council members, although the site is open for public viewing.

The Walker Channel is another technological innovation of the Walker Art Center. It started in 2003 as the Translocal Channel in conjunction with the exhibition *How Latitudes Become Forms: Art in a Global Age* (February 9–May 4, 2003) and provides live webcasts of museum programming, lectures, and readings with artists, scholars, and critics of contemporary art and culture. The Walker Channel also includes an archive of past webcasts, remarks by hundreds of artists, panel discussions, single-artist lectures, and musical and literary performances. Andrew Blauvelt (2005) describes its ability to transform information: "Regardless of format, the Walker Channel was our interpretation of ubiquitous computing, the integration of distributed digital content throughout the physical environment." The Walker Channel was renovated in 2010 with support from the Bush Foundation under a grant entitled "Expanding the Rules of Engagement with Artists and Audiences and Fostering Creative Capital in our Community." Improvements included the use of closed captions and transcripts (enabling search functions and greater accessibility), streaming video, the addition of public comments, and high-definition video capturing.

The Walker developed its cell phone tour called Art on Call in 2004 with an IMLS National Leadership Grant, launched in April 2005 to coincide with the opening of the newly expanded museum. A cell phone tour was necessary to provide visitors information on works in the sculpture garden, but Art on Call provides much more than the normal audio tour. The museum uses interactive voice response (IVR) technology integrated with its Web server and content management system that allows calendar content to be included through a text-to-speech engine that converts text to audio which is searchable, and for staff to easily update that content. Commentary on artwork (including visual descriptions and audio from curators, artists, and the tourguide) is available on three platforms: telephone (by dialing a phone number), Web browser (http://newmedia.walkerart.org/aoc/index.wac) with a digital image preview of the artwork, and a podcast for MP3 players (also available in the iTunes Store). Other features include breadcrumbing that automatically keeps track of the artworks that are accessed, expanding the playlist each time the phone is used to listen to a segment, and TalkBack that records personal audio comments on the phone, where the user enters a phone number in the search box to retrieve the playlist and comments. Art on Call also provides the option of transferring calls directly

to museum staff and services such as to the box office to purchase tickets, information on hours, directions, ticketing, museum shopping and dining, and for visitors to leave comments.

In 2010, the Walker was one of the first art museums to embark on an experiment in crowdsourced curating. Led by chief curator Darcie Alexander, *50/50: Audience and Experts Curate the Paper Collection* (December 16, 2010–July 17, 2011) consisted of works chosen by Alexander on one gallery wall, facing works chosen by the public on the opposite wall. Alexander selected 183 images from the Walker's permanent collection of works on paper, and for six weeks the public could vote on them from the museum's website and a kiosk inside one of the galleries. There was also a link from the MoMA website that brought many people to the exhibition subsite. The images were not identified by artist or caption; people voted based only on the image. Alexander stated, "People always have opinions. This exhibition gives those opinions a little bit of agency so that people feel they actually have a voice" (personal communication, January 6, 2011). This exhibition played an important role in how the museum is responding to an audience that has become more participatory in nature.

FIGURE 4.7
50/50: Audience and Experts Curate the Paper Collection.
Courtesy Walker Art Center. Photograph by Cameron Wittig. Reprinted with permission.

The Walker was invited by the Getty Foundation to participate in its Online Scholarly Cataloguing Initiative (OSCI) in 2008. The project which the museum selected was the online cataloging of works acquired since 2005, when the Walker published its seminal catalog *Bits & Pieces Put Together to Present a Semblance of a Whole* in conjunction with its reopening. The catalog is both an archival history of the Walker and a primer on modern and contemporary art, with contributions from museum staff and prominent independent writers. For the project, the Walker received $200,000 in planning support in 2009, and then $375,000 implementation support in 2011 from the foundation. Brooke Kellaway, the Walker's Getty fellow for the OSCI, summarizes the project in the museum's blog:

> [The OSCI] is a restaurant, not a grocery store; contributions to scholarship will supersede attempts at fullness, and likewise forego redundancies; the audience is firstly assumed as those studied in contemporary art; content will be commissioned from in and out of the institution; the move towards online publications is not foreseen as a total replacement for print catalogues. (February 17, 2010)

Nate Solas, senior new media developer at the museum, reveals that the exciting part of the OSCI project for him is "really opening up the Walker's data and connecting it to other online collections and resources" (as cited in Chan, 2011, December 3). The challenging part for the Walker, however, is archiving its multidisciplinary collection, including its fifty-year history of performance art commissions, contemporary art by living artists, and new media work.

Regarding the use of social media, the Walker promotes the four most common on its website (listed in the About section), including four separate groups on Flickr, seven Twitter accounts, thirteen domains on Facebook, and YouTube. Facebook is listed again under the heading "Social Networking." The museum also participates on Foursquare, LinkedIn, MySpace, SCVNGR, and iTunesU; however, these are not listed on its website. Walker director of marketing and public relations Ryan French explains,

> I don't think an institution's website has to connect out to all of the social networking platforms provided the platforms themselves tie to the Walker. I don't think a lot of people start at walkerart.org and seek social networking opportunities. Rather, it's the reverse. They stumble upon the Walker while they're engaging with a friend online and then bounce to the Walker's site. (personal communication, July 12, 2011)

French acknowledges the goal of social media to increase visitor engagement as a factor of a two-way community, which he calls "relational marketing" or "user-empowered promotion." Virtual visitors are also part of the museum community and the museum pays particular attention to its active followers on social media. Out of 47,771 fans on its main Facebook page, the museum notes 18,000 active users (as of July 2011).

Robin Dowden, director of New Media Initiatives, emphasizes the importance of the calendar of events that is integrated into their social media: "Taking advantage of the social networks is trying to connect people back to the Walker site in a meaningful way" (personal communication, December 3, 2010). Just as social media can be used to bring people to the central node of the Walker website, so can they be directed to visit the physical museum, a principal objective of every museum. Certainly this is more realistic with the local community, such as with the Walker's Open Field initiative. Sarah Shultz notes her surprise that despite creating a Flickr account and group pool for Open Field, the notion of an online community was not very successful, partly she believes, because visitors were not interested in coming to the event in order to document their experience and participate in the online community. Rather, Schultz states, "they wanted to be in the present, they actually talked repeatedly about the importance of just being together in the present" (personal communication, October 19, 2010). On the other hand, the museum has made a concerted effort to incorporate technology in its physical spaces with the aforementioned examples (*Dialog Table*, *Dolphin Oracle*, Media Bays, and computer kiosks). The Walker also recently installed digital signage in the Bazinet Lobby as a wayfinding device to navigate programming inside the old and new buildings, and will install signage in two additional locations inside the museum. The museum plans to use the screens for live-updating Twitter streams during parties and special events, to display severe weather and fire alerts, to show cinema trailers, and also to present decorative blasts of light and pattern. Digital signage is also placed inside the elevators and on the museum exterior.

Walker visitors are predominantly young, as are the Twin Cities region demographics, nevertheless the museum reports that its visitors have a low level of awareness or use of social media: Facebook has 38 percent, Twitter has 28 percent, and the Walker blog has 38 percent (R. French, personal communication, July 12, 2011). We can consider the Walker blog, Walker Channel, and the Art on Call tour as social media because they enable public discourse through comments; however, they don't really enable peer-to-peer communication or

networking. These media are located in the Resources section of the museum website (together with iTunesU), and while postings are subsequently placed in Facebook and Twitter, the blog itself does not connect to other social media. Furthermore, blog comments are not visible on the homepage until the reader clicks onto the extended text page. Despite reporting a significant number of user sessions in 2010 (341,031), the Walker blog had the least amount of public comments of all five museums surveyed and the lowest ratio (0.4:1) of comments to posts. Justin Heideman (2008), the museum's new media designer from 2006 to 2010, confirms, "Often the style of posting we engage in isn't the most comment inducing." The blog also had the lowest number of posts by outside bloggers (2 percent of the total posts).[8]

When I was in the midst of writing this chapter, the Walker introduced its newly redesigned website on December 1, 2011, described by director Olga Viso on the website as "an online hub for ideas about contemporary art and culture, both inside the Walker and beyond." The previous website was from 2005 and did not integrate social media as well or promote peer-to-peer computing with Share buttons. This new content-rich website demonstrates that the Walker continues to be a pioneer in the international field of museums, the arts, and digital technology. The website was immediately hailed by prominent museum writers. The anonymous blogger Museum Nerd states that it "represents the most forward-thinking best practices in the museum field today." He describes the website as a "game-changer" because it yields power:

> The secret weapon here is that this move to include content from unaffiliated sources on the Walker's website will actually give the Walker more—and more lasting—power, as the "Idea Hub" Olga Viso describes positions the Walker as the locus of the smartest discourse about the content areas that are central to its mission. (2011, December 2)

Nina Simon writes in her blog *Museum 2.0*, "What the Walker has done is commit to a unique online approach—not just for one program or microsite, but for their homepage. They took their vision of the institution as an idea hub, looked at comparable sites online that achieve that vision, and adopted and adapted the journalistic approach to their goals" (2011, December 7). In his blog *Fresh + New(er)*, Sebastian Chan interviews two members of the Walker editorial team (Nate Solas and Paul Schmelzer), calling the website "a potential paradigm shift for institutional websites" (2011, December 3). The new website is tightly

aligned with the mission and identity of the museum as a contemporary art center, dedicated to supporting artists, and grounded in the local culture while serving an international audience. Solas explains how the website was inspired by essentially three spaces the museum serves: local, onsite, and the world. Solas describes the idea, "We're a physical museum in the frozen north, but online we're floating content. We wanted to ground people who care (local love) but not require that you know where/who we are." Because of this global perspective that overshadows physical activities and events at the museum, Solas reveals that he expects an increase in nonlocal online users. The Walker's new Web editor, Paul Schmelzer, refers to details like the weather, the date that changes daily, updated events, as well as current top stories and Art News from Elsewhere that are all "subtle reminders we're a contemporary art center, that is, in the *now*." At the bottom of the website, visitors can find more traditional information under the three headings "About," "Programs," and "Network," the latter of which is more related to the museum's community and social media. Under "Network" is listed ArtsConnectEd, Minnesota Sculpture Garden, mnartists.org, Walker E-Mail Newsletter, and five hyperlinked icons (Facebook, Twitter, Flickr, YouTube, RSS feed). The voices of artists are featured in a new section, Artspeaks, mostly in videos, and another new section, Minnesota Art News, highlights mnartists.org. Viso reveals on the museum's website that

> the intent of the new site is to make visible our role as a generative producer and purveyor of content and broadcast our voice in the landscape of contemporary culture . . . understanding that we exist as part of a diverse media ecosystem.

Museum Nerd boldly proclaims that the Walker is "the first major museum to see the future."

LESSONS LEARNED

The Walker Art Center was able to be an early forerunner in the area of digital innovation because of two main factors that are still relevant today: strong local public and private support of the arts (state funding and private foundations, corporations, and individuals), and visionary, dedicated leadership with long tenures that support risk taking and innovative thinking. In reflecting on their early success, Robin Dowden points to the museum's strong commitment to design that involved developers and designers as part of internal teams working on digital projects. By not outsourcing as much work they gained flexibility,

control, and creativity with their digital projects. However, this independence requires a great amount of human resources; today the museum has an editorial team of four members, and five additional members in its New Media Initiatives group. The museum focuses its collections and programming on contemporary art, and in particular, new media art, which also necessitates greater staff resources with technological knowledge and abilities given the complex requirements for exhibiting and conserving new media art. By shifting its focus from collection to education, however, the New Media Initiatives now interacts with a wider portion of the museum staff, resulting in a greater understanding and appreciation of digital media throughout the museum.

Place matters greatly to the Walker. Commenting on the importance of technology, Darsie Alexander admitted, "We're in the Midwest, so a lot [of people] don't actually see our programs firsthand, they see our publications or they go to the website" (personal communication, January 6, 2011). While the museum has long been committed to its local community, it succeeds in serving that community largely because it focuses on core special interest groups: artists, educators, teens. The Walker promotes the acquisition of social capital by providing opportunities for these groups to interact both online and onsite, for local residents with Open Space, for Minnesota artists with the forums on mnartists.com, for teens with WACTAC, and for educators with ArtsConnectEd. Apart from the special interest groups, the museum also pays great attention to its regular physical visitors—what it calls "citizen visitors"—that have many opportunities to relax, observe others, and intermingle in the lounge areas inside the museum and outside in the "cultural commons" areas. Communities are created and maintained in museums not only when the public interacts with the museum staff, but when members of the public interact with each other, establishing strong bonds often based on shared interests, activities, and goals. The same is true whether interaction occurs online or onsite. Online interaction with the general public occurs on the museum's blogs, social media, Art on Call audio program, and the Walker Channel. In this sense, the museum also becomes a social experience through both analog and digital channels. Minnesota is a friendly place, with residents that demonstrate a high degree of civic involvement as data have shown, and the museum reflects those local cultural values in the pluralist and relativist sense that allows for difference and dialogue.

A combination of institutional commitment, external funding, and digital technology has transformed the museum's special interest groups into their own communities, but it has also served to expand the overall museum community

by inviting members from the larger, global communities of artists, educators, teens, and more. Ryan French explains that because the online visitor (the "end user") now has so much power, it is hard for the museum to understand the nature of its online community. Despite these difficulties, the Walker is aware that it is simultaneously both a local and a global institution, and that both factors are interrelated. Former director Kathy Halbreich (2003) stated,

> To be a more locally engaged institution, we need to become more sensitive to the increasingly interconnected world reflected in the demographics of our own community: a world in which social, political, economic, and cultural boundaries are recalculated daily by both ancient and new definitions of home, history, and hierarchy. One of our main challenges as an institution is to identify and pose the questions arising from such a shift in our community (and in our profession) in order to better understand the global issues that unite and divide cultures.

On the website homepage, "Art News from Elsewhere" offers images and links to online media sources from around the world that not only places the museum within the global arts world, but reaffirms its leadership within this community. The Walker's newly designed website is an important acknowledgment of its global community, grounded in its local place. The website offers virtual visitors a myriad of experiences, from the Walker Channel, Art on Call, its online collection, and its eight blogs. But the website also places "Today's Events" prominently on the homepage and displays the local weather just as prominently, firmly situating the website in Minneapolis. Paul Schmelzer speaks of the website as being "in the now," which echoes Sarah Schultz's comment of Open Space visitors as "being in the present." The Walker's notion of *museum as town square* is achieved holistically by providing both online and physical visitors with a sense of locality rather than physicality, a concept offered by Gordon and de Souza e Silva (2011). The Walker describes its concept of the town square: "Rather than being any specific physical place, [it] will be a philosophy of programming that incorporates the spirit of an imagined town square."[9] Both the museum and its website are hybrid spaces comprising the digital and the physical (local), creating a twenty-first-century town square that supports interaction, dialogue, social capital, and entertainment.

The crowd-curated exhibition *50/50* promoted audience participation in the selection process for the artworks, but the manner in which the museum exhibited the works reaffirmed its authority and legitimacy over the mass public. This was first accomplished by simply separating the two bodies (expert curator and

anonymous public) that ultimately confronted each other inside the museum gallery. The publicly selected works were displayed salon style from floor to ceiling, what the curator referred to as "scatter shot"—placed closely together on the entire wall organized from most to least votes, left to right—and the curator's selected works were sparsely displayed in the formal, traditional style that museum visitors are more familiar with. Previous to *50/50*, the museum had presented an exhibition entitled *Benches and Binoculars* (November 21, 2009–August 15, 2010) in the same gallery, with works from the permanent collection hung in a similar salon style. The difference was, however, that this exhibition was professionally curated by Alexander, who made public her intention to emulate the style in which museum founder T. B. Walker first installed his personal galleries in the 1920s. Alexander spoke of *50/50* as offering an experiment in curatorial authority being dispersed with only partial control over the process. This experiment serves to remind us that while the Walker does an exceptional job at creating a town square atmosphere for its visitors with its seventeen-acre campus and online spaces, there is still a well-entrenched hierarchy and authority within art museums that only temporarily become dislodged through digital projects and opportunities for discourse. Public participation strengthens personal connections to the museum and its exhibitions, which museum educators and administrators all strive for, but a town square requires sustained interaction *within* the public as well, which the museum can facilitate best through its long-established position of authority and legitimacy.

NOTES

1. The Walker Art Center. (2005, August). *Walker Art Center Capital Campaign*. Minneapolis, MN: Author.

2. For these statistics, *Mapping the Measure of America 2010–2010* analyzes congressional districts only. The Walker Art Center is located in Minnesota Congressional District 3.

3. The quotation is taken from the Walker Art Center website, as cited in former director Kathy Halbreich's statement about the 2005 museum expansion. Retrieved October 5, 2011, from http://expansion.walkerart.org/dir_statement.html.

4. *Art and Civic Engagement: Mapping the Connections* (Prim, Peters, Schultz, 2004), a PDF document posted on the museum's website, under the section Education and Community Programs. Retrieved October 20, 2011, from http://media.walkerart.org/pdf/walker_4c_map.pdf.

5. *Art and Civic Engagement: Mapping the Connections* (Prim, Peters, Schultz, 2004).

6. In February 2012, Sarah Schultz's title at the Walker was changed to director of education and curator of public practice.

7. As of May 2013, no reference to Minnesota artists could be found in the "Collections" area of the new website. Works are now searchable by date (decade), books, drawings and watercolors, media arts, mixed media, other/miscellaneous, paintings, photographs, prints, and sculpture.

8. I analyzed the Walker blog for ten months before the museum introduced its new website on December 1, 2011, where it categorizes its blogs into eight different blogs each with its own hyperlink that is not connected to the others internally. Previously there was one central blog and each posting was categorized by one of the same eight titles: "Performing Arts," "Visual Arts," "Film/Video," "Design," "New Media," "Education," "Off Center," and "MNARTISTS.org." The garden blog is now only accessible in the museum website's section for the Minneapolis Sculpture Garden. The new comprehensive blog can be viewed under the website heading "Media" by clicking on the title "Walker Blogs" (http://blogs.walkerart.org/).

9. *Art and Civic Engagement: Mapping the Connections* (Prim, Peters, Schultz, 2004).

San Francisco Museum of Modern Art

PLACE + LOCALIZED CULTURE

The San Francisco Museum of Modern Art (SFMOMA) is situated in the heart of the city; a city that is urban, affluent, artistic, cosmopolitan, and a tourist destination. San Francisco is not a large city (technically it's a consolidated city-county); it has 805,235 residents (2010 census) within an area of only 47 square miles that is bordered to the north and east by the San Francisco Bay and to the west by the Pacific Ocean with a total of 29.5 miles of shoreline. San Francisco is the second most densely populated city in the United States after New York City. It is part of the larger Bay Area that extends down the peninsula toward the South Bay Area or Silicon Valley; northward across the Golden Gate Bridge toward Napa Valley and the wine country; and eastward across the Bay Bridge toward Oakland and Berkeley. This particular geographic situation played an important part in the founding of the city, as the ports facilitated travel by ships that first brought Europeans in the eighteenth century and then Chinese immigrants in the nineteenth century. In 1776, Spain established a military post on the northern tip of the peninsula, now known as the Marina district next to the Golden Gate Bridge and a designated National Historical Landmark. Today, San Francisco has thirty-nine piers and eight bridges.

A significant increase in population started with the California Gold Rush in 1849, with an influx of people from the rest of the country as well as foreign immigrants, and continued through the 1850s including the 1859 Comstock Lode silver discovery. San Francisco soon became America's largest city west of

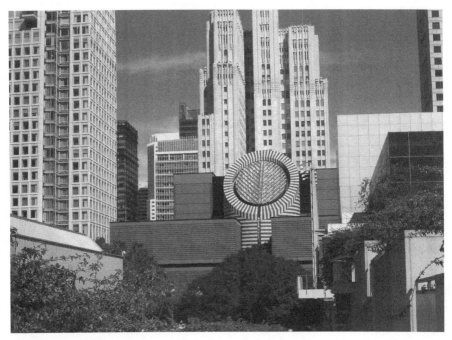

FIGURE 5.1
San Francisco Museum of Modern Art, in the foreground, 2010.
Courtesy of the author.

the Mississippi River, until Los Angeles took over that title in 1920. In an effort
to contain the rising flood of Chinese immigration and the growth of the city's
Chinatown district, both San Francisco and the federal government passed a
number of discriminatory immigration restrictions (the Chinese Exclusion Act)
that were not repealed until the 1940s. Nevertheless, San Francisco's Chinatown
became one of the largest in the country and remains so today. Many businesses
were founded to serve this growing population, including Levi Strauss & Co.
clothing (1873), Ghirardelli chocolate (1852), and Wells Fargo bank in New
York (1852) that offered "ocean to ocean" service. Early tycoons in railroad,
banking, and mining—Charles Crocker, Mark Hopkins, Collis P. Huntington,
William Chapman Ralston, Henry Brune, William Haas, and Leland Stanford—
settled in the city in its Nob Hill neighborhood. Some of their former mansions
have since been converted to expensive, landmark San Francisco hotels (Mark
Hopkins Hotel and the Huntington Hotel).

San Francisco experienced a devastating earthquake in 1906 that killed an
estimated 3,000 people, mostly in the city and throughout the Bay Area. Over

80 percent of the city was destroyed by the earthquake and the ensuing fire. At the time, San Francisco was the largest city on the West Coast and was the financial and cultural center, with the busiest port for trade to Asia and also a military stronghold. While the city was rebuilding, much of the trade, industry, and population moved south to Los Angeles, which soon eclipsed San Francisco as the largest and most important city on the West Coast. Perhaps because San Francisco was relieved of the burden of sustaining such a high level of global trade, military strength, and financial industry, the city was able to embrace other interests such as the arts (visual, literary, architecture, etc.). As early as 1872, the Bohemian Club was formed by local journalists with an affinity for the arts who wanted to socialize with artists and musicians. During the 1950s, San Francisco became the center of the Beat Generation when its writers moved from New York City to the Bay Area. In the 1960s, San Francisco became known for its hippie culture, mostly surrounding the Haight-Ashbury district during the Summer of Love in 1967. This sanctioning of alternative culture and lifestyles contributed to the city's reputation as being gay-friendly during the 1970s and 1980s, a reputation that the city has not only sustained in the Castro District but actively promotes in its tourism and marketing campaigns. The city's GLBT (Gay, Lesbian, Bisexual, Transgender) Museum is the first of its kind in the nation.

San Francisco is also known for its cutting-edge, alternative art spaces such as Capp Street Project that was the first visual arts residency in the United States to create and present installation art in 1983, later becoming part of the California College of the Arts Wattis Institute for Contemporary Arts in San Francisco. The avant-garde ArtSpace 4500 is a private, nonprofit space in the Castro district; Refusalon is a conceptual art gallery for local artists in a converted garage near SFMOMA; the Lab is an experimental, multidisciplinary art space in the Mission district; and the Gray Area Foundation for the Arts promotes creative technologies for social good through educational courses, art exhibitions, and research initiatives. Headlands Center for the Arts across the bridge in Sausalito is an innovative program of artistic residencies, lectures, and commissions on former military property that was handed over to the National Park Service in 1972. Even the city's renowned science museum, the Exploratorium, which opened in 1969, is innovative in blurring the boundaries between art and science.

San Francisco is currently the nation's largest municipal arts funder per capita, with $30.783 million allocated in 2008 to the San Francisco Arts Commission (SFAC). The SFAC gave out $4,320,587 in grants during the 2009–2010 fiscal

year and estimates that there are 450 arts groups in the city. The SFAC's total revenue for 2008 was $614,794,215, including earned revenue and contributions from individuals, corporations, foundations, and state and federal agencies. It has 2,635 full-time employees, 1,408 part-time employees, and 1,337 independent contractors.[1] The SFAC also has its own cable television program *Culture Wire*, a website (http://sfartscommission.org/), and accounts on Facebook, Twitter, Flickr, and YouTube. The SFAC Gallery (originally called the Capricorn Asunder Gallery) in the civic center area has been active since 1970. The most recent program of the SFAC is ArtCare, which supports the city's vast collection of 3,000 works of public art worth more than $90 million. Launched in 2010 in partnership with the San Francisco Art Dealers Association, the fund augments the $15,000 received from the city to maintain and repair public artwork. San Francisco was also the first city to have an arts and culture director, setting the trend for most major cities in the country today.

In 1961, San Francisco was the first city to levy a hotel tax to support arts grants, which has generated more than $300 million for local arts groups. Previously called the Hotel Tax Fund, the city's Grants for the Arts program is managed by the SFAC, providing an additional $8.8 million in 2010 to support major institutions (the opera, symphony, ballet, international film festival, and SFMOMA) as well as smaller, less traditional ones such as the San Francisco Lesbian/Gay Freedom Band, the Samoan Flag Day Celebration, and the Garage Space for the Arts. All grantees receive free publicity on the Grants for the Arts website and an iPhone app. Over time, the hotel tax has increased to 14 percent, and now more than half of it (almost $1 billion) goes into the city's general fund, with 5.3 percent allocated for Grants for the Arts. Kary Schulman has been director of Grants for the Arts for the last thirty years and describes the program: "This was never intended to be an arts entitlement fund—it's an investment in the arts to attract more tourism to the city" (as cited in May 2011).

Today, the city's arts district is located around Yerba Buena Gardens[2] in an area called SoMa or South of Market Street. Yerba Buena Gardens began as a nineteen-block Redevelopment Area in 1953 but did not fully develop until the early 1990s. It now comprises a 5.5-acre park with the Yerba Buena Center for the Arts; Zeum, a children's media and technology museum; an ice-skating rink and bowling alley; a restored 1905 carousel; the Martin Luther King Jr. Memorial and Waterfall; the Ohlone Indian Memorial; public art; restaurants; Metreon, a 350,000-square-foot Sony entertainment center with an IMAX theater; and the Moscone Convention Center. A number of museums and commercial art gal-

leries are also located in the vicinity of the Gardens, most prominently the San Francisco Museum of Modern Art (SFMOMA) that came to the area in 1995. That same year, Peter Plagens, the New York–based art critic for *Newsweek*, heralded Yerba Buena Gardens as "the most concentrated arts district west of the Hudson River."

Much of San Francisco's achievements as a center for arts and culture can be attributed to its proximity to Silicon Valley that has influenced the arts not only by providing substantial financial support during the dot-com boom of the 1990s, but more indirectly through the influence of technological innovation. Housed throughout Silicon Valley today are the following technology corporations: Google, Apple, Yahoo, Intel, HP, Oracle, Netflix, LinkedIn, Facebook, EBay, Electronic Arts, Cisco Systems, Adobe Systems, and Zynga. And headquartered in San Francisco itself are Linden Lab (Second Life), StumbleUpon, Dropbox, Yelp!, Twitter, Wikimedia Foundation, and the interactive studio Mediatrope. On top of these well-established companies, many more start-up companies are constantly emerging within the areas of the Internet, social media, and digital technology. With all of these companies it's hard to ignore the power of technology. Nevertheless, while technology companies support the arts often with in-kind services, there has not been a strong history of corporate philanthropy in the region; rather it has come from successful individuals in the industry, and only sporadically.

San Francisco is an expensive city to live in, with 47.2 percent of residents spending 30 percent or more of their income on housing (the national average is 36.9 percent of residents), the most of all five regions studied, and the median personal earnings is $42,815, well over the national average of $29,755.[3] The poverty rate, 11.5 percent, is lower than the national average; the number of uninsured, 11.3 percent, is lower than the national average; and the region ranks higher than the national average for the following factors: human development index (7.47, national average is 5.17), life expectancy at birth (82.6 years, national average is 78.6), at least a bachelor's degree (50 percent, national average is 27.7 percent), school enrollment ages three to twenty-four (104.3 percent, national average is 87.3 percent), health index (6.9, national average is 5.2), education index (7.89, national average is 5.15), and income index (7.61, national average is 5.09).

San Francisco's population is predominantly white, non-Latino (48.5 percent), but this group is much smaller than in Indianapolis, Minneapolis, or even Manhattan. Given its particular history, San Francisco has the highest concentra-

tion of Asians of all five regions studied (33.3 percent), followed by 15.1 percent Hispanic/Latino, and 6.1 percent African American (the lowest of all five regions) (U.S. Census, 2010). The demographics are quickly changing, however, as African American residents are being priced out of their traditionally black neighborhood of Bayview-Hunters Point and moving to more affordable cities in the East Bay. The decline in the black population was so remarkable that in 2007, Mayor Gavin Newsom launched the African American Out-Migration Task Force and Advisory Committee to investigate the exodus and reverse the trend. And the traditionally Latino Mission District is slowly becoming gentrified as white, middle-class professionals seek affordable housing in the city and are attracted to ethnically diverse neighborhoods, which are in danger of losing their ethnic culture with the proliferation of wine bars and sushi restaurants. San Francisco and Manhattan are tied for having a significant older population; 13.6 percent are sixty-five years and older, but San Francisco has the smallest percentage of residents under eighteen years at 13.4 percent (2010). The city is above the national average for all measures of civic engagement, but not at any exceptional level, except for Get News from Internet frequently which is a surprising 22.1 percent, below the national average of 32.5 percent. In 2010, the number of registered voters was 53.2 percent, below the national average, and 57 percent voted in the 2008 presidential election, the same as the national average.

San Francisco is a major tourist destination and reports 15.9 million visitors in 2010 that spent $8.3 billion during their stay, with leisure visits representing 75 percent of all trips. In 2010, 70 percent of San Francisco visitors were from the United States, with the top three areas being Los Angeles, San Francisco/ Oakland/San Jose, and Sacramento/Stockton/Modesto (Destination Analysts Inc., 2011, February 26). Visitors cite the top three reasons to visit San Francisco as (1) atmosphere and ambience, (2) restaurants, and (3) scenic beauty. The top five leading attractions visited are all tourist destinations, and only 12 percent of visitors mention the city's arts, culture, and museums as a destination. In citing the top tourist attractions in the United States for 2009, *Forbes.com* magazine (2010) lists the Golden Gate National Recreation Area as number six with 17 million visitors, and Fisherman's Wharf as number eight with 10 million visitors. The San Francisco Travel Association[4] promotes the city principally by neighborhoods, each with its distinct character and history. The residents of San Francisco are committed to community preservation and neighborhood advocacy, supported by a city that understands the importance it represents to

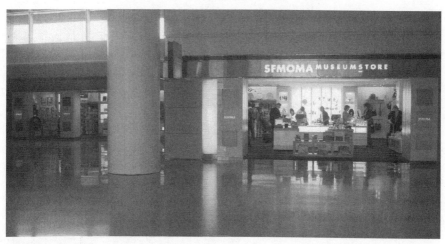

FIGURE 5.2
SFMOMA Store at the San Francisco International Airport, 2011.
Courtesy of the author.

its visitors: 11 historic districts, 250 buildings designated as historical landmarks, and notably no Target or Wal-Mart.

San Francisco has two major sports teams that its citizens support with fervent devotion. The San Francisco Giants, one of the oldest baseball teams in the nation, is a Major League Baseball team formerly known as the New York Giants. In 2010 the Giants won their first World Series title since moving to San Francisco in 1957 (they won five previously). The San Francisco 49ers is a National Football League (NFL) team, the oldest major professional sports team in California, established in 1946, and the first NFL team to win five Super Bowls.

Despite the majority of visitors to San Francisco coming from northern and southern California, most arrive by air (58 percent). In 1980, the San Francisco Airport Commission established the San Francisco Airport Museums Program to foster an environment that is "both entertaining and educational." It was the first such program in the country and remains the only accredited museum in an airport (accredited by the American Association of Museums in 1999). Today it has its own website (http://flysfo.com/web/page/sfo_museum), a Twitter account, and sends e-mails to registered individuals. The San Francisco Arts Commission curates the collection of permanent art displayed throughout the airport; seventy-three works by esteemed artists such as Wayne Thiebaud, Isamu Noguchi, Sam Francis, and Vito Acconci. When the new International Terminal

was built in 2000, it included a meditation center, the first airport-based Gucci boutique in the United States, and a SFMOMA Museum Store. A remodeled Terminal 2 opened in April 2011 with a children's play area incorporating interactive artworks by two San Francisco artists that work at the Exploratorium (Walter Kitundu and Charles Sowers). An audio tour is available for all art at Terminal 2 by dialing a local number (650-352-4331), and a podcast is on the Arts Commission's website. Director of cultural affairs for the San Francisco Arts Commission Luis R. Cancel describes the importance of the SFO Museum: "World-class art is a part of the fabric of everyday life in San Francisco, and what better way to set the stage for our visitors than with a museum-quality art collection at our gateway" (The San Francisco Arts Commission, 2011, February 10).

THE MUSEUM AND ITS COMMUNITY

Mission Statement:

The San Francisco Museum of Modern Art is a dynamic center for modern and contemporary art. The museum strives to engage and inspire a diverse range of audiences by pursuing an innovative program of exhibitions, education, publications, and collections activities. *International in scope, while reflecting the distinctive character of our region*, the museum explores compelling expressions of visual culture. (emphasis mine)

SFMOMA began operating in 1916 at the Palace of Fine Arts at the Marina (currently home of the Exploratorium) that was built for the Panama-Pacific International Exhibition the year before. The museum was founded by the San Francisco Art Association that organized temporary exhibitions and maintained a periodical library, and in its early days was called The Art Museum of the San Francisco Art Association. At the time, it was the only museum in the city dedicated exclusively to art, and the first on the West Coast. The museum was incorporated in 1921 and moved to a new site in 1935, the fourth floor of the War Memorial Veterans Building in the civic center. It had no permanent collection and hardly any money, but remained there on the fourth floor (and later also the third floor) until 1994.

In 1934, the first chairman of the board of the museum, William (W. W.) Crocker, was appointed by the directors of the San Francisco Art Association. Crocker was the grandson of Charles Crocker, one of the original "Big Four" that formed the Central Pacific Railroad along with Mark Hopkins, Collis Huntington, and Leland Stanford. W. W. Crocker continued growing the Crocker

National Bank, which his father, W. H. Crocker, had started. His mother, Ethel Willard Sperry, was one of San Francisco's first great art collectors. The Mary A. Crocker Trust (wife of Charles Crocker) was established in 1889 by her four children, making it the oldest family foundation west of the Mississippi, which currently distributes around $500,000 a year mostly to Bay Area programs.

Shortly after Crocker was appointed in 1934, Grace McCann Morley boldly called him up to inquire about working at the museum. Morley, originally from Berkeley, was an expert on modern art who had studied art history at the Sorbonne in Paris, where she received her PhD in 1926.[5] She became the museum's founding director and stayed for the next twenty-three years. Morley talks about the early days of the museum and the responsibility they felt toward the artistic community in San Francisco (as cited in Reiss, 1960, pp. 176–177):

> We thought that we had two functions in San Francisco. First, to inform the artists on what was going on in art of their time, for their benefit, and incidentally to help the public, by informing it, to understand what their own artists were doing, as well as about living artists in general. And second, to do our part in bringing to wider attention, locally, nationally, and internationally, the art of the area, because we were, in a sense, a regional museum—representing the region.

At that time, San Francisco was already a lively arts community. The California Guild of Arts and Crafts had been founded in 1907 in Berkeley to provide education for artists and designers, later becoming the California College of the Arts with both an Oakland and San Francisco campus. In 1874, the San Francisco Art Association founded the California School of Design, which was renamed the California School of Fine Arts in 1916 and later the San Francisco Art Institute in 1961. In 1930, Mexican muralist Diego Rivera arrived in San Francisco to paint a mural, *The Making of a Fresco Showing the Building of a City*, at the Art Institute's new campus. Yet despite the abundance of local private collectors, there were no art galleries and SFMOMA was the only art museum.

SFMOMA developed its permanent collection largely through the generosity of local collectors and benefactors. W. W. Crocker lent works from his mother's collection, and his sister Charlotte Mack was an important collector who also supported the museum. An early gift of thirty-six works from local collector Albert M. Bender, including Diego Rivera's *The Flower Carrier* (1935), established the core of the museum's permanent collection. Before his death in 1941, Bender donated more than 1,100 works to the museum and endowed its first purchase

fund. In 1936, Morley was approached by Robert Oppenheimer, the legendary "father of the atomic bomb," who was on faculty at the physics department of the University of California at Berkeley. His family collection of artwork was on loan at the Museum of Modern Art, and Oppenheimer wanted to offer it to SF-MOMA for long-term loan, as he believed these works were more needed in San Francisco than New York and that they might help the museum grow. The Oppenheimer collection (loaned anonymously) consisted of a blue period painting by Pablo Picasso, a pastel portrait by Edouard Vuillard, three works by Vincent van Gogh, and a bronze head by Charles Despiau, marking the first works of international stature at the museum. Later that year, the museum exhibited works by Henri Matisse primarily drawn from two local private collections, many of which were later donated to the museum.

One of the first exhibitions presented by the museum, in 1935, was the Carnegie International-European Section from Pittsburgh that traveled only to San Francisco. The museum furthered its international holdings after Morley began working with the U.S. State Department's Inter-American office as a consultant in Latin America during the early years of World War II (1941–1943). The State Department wanted to establish good relations with the region, and one way was to exhibit artwork in U.S. museums. The museum increased its Latin American collection at that time, adding works by Pedro Figari and Joaquin Torres-Garcia. Albert Bender and artist William Gerstle (then president of the San Francisco Arts Association that commissioned Rivera to paint his mural) also donated works by Mexican artists.

As the museum collected works by international artists, it did not disregard local artists but rather continued to focus on both simultaneously. Early on the museum felt accountable to its local community, confirmed by Morley who stated, "By 1936 it was clear that the museum must become a museum of contemporary and modern art, for that was the field that needed to be served in the Bay Area community" (as cited in Reiss, 1960, p. 48b). There were two principal programs in which the museum served the local artists. The first was the Rental Gallery (now called the Artists Gallery, located at Fort Mason in the Marina) founded by the museum's Women's Board. The Board was originally intended as a social organization that met monthly, but it was dedicated to supporting both the museum and local artists. Most of the museum's first purchases of works by local artists came from a fund established by the Board; it also supported other small projects such as purchasing the museum's first slide projector and movie projection equipment, paying subscriptions for art periodicals in the library, and pur-

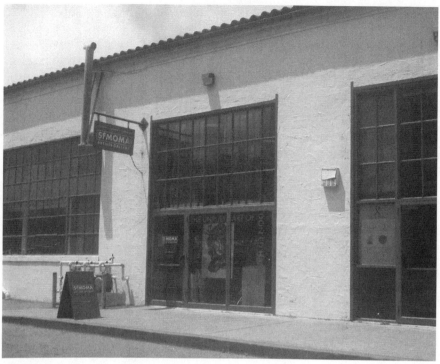

FIGURE 5.3
SFMOMA Artists Gallery at Fort Mason, 2011.
Courtesy of the author.

chasing books. The Rental Gallery was the first of its kind in the nation, with the aim of creating a new sales venue for local artists while expanding the collecting base in the Bay Area. The first president of the Women's Board was Mrs. Henry Potter Russell, sister of W. W. Crocker. Today, selections of artwork from the Artists Gallery are hung on the walls of the museum's restaurant, Caffe Museo.

In 1935, the museum established an Artists' Advisory Committee comprised of local artists that met regularly with Morley, specifically to help organize the Art Association Annual which was part of the museum's first big opening exhibition. The committee became more of an informal liaison with the director after that exhibition, but many of the same members served on selection and hanging juries for future annual exhibitions at the museum that were under the responsibility of the Arts Association. To ensure opportunities for all local artists to be recognized there were the Painting and Sculpture Annual, Watercolor Annual, and Drawing and Prints Annual exhibitions. Later on, prominent arts figures from outside

the region were invited to jury these exhibitions, such as the editor of *ArtNews* magazine, the director of the Whitney Museum of American Art in New York, and the director of the Carnegie Art Museum in Pittsburgh. This served to attract wider attention to the exhibitions and to local artists that might be included in their exhibitions. It was important to the museum and the Arts Commission that artists in the region be recognized on a national level. In 1961, the museum founded an auxiliary membership group, the Society for the Encouragement of Contemporary Art (SECA) to support contemporary Bay Area artists. This group continues to work closely with museum curators today in identifying the most promising artists in the region for the biennial SECA Art Award that provides winning artists with an exhibition at SFMOMA, a catalog, and a small cash prize.

Nevertheless, as the museum became increasingly more international in its collecting, exhibiting, and general outreach, local artists did not always see the benefits. John (Jack) Lane, who was director of SFMOMA from 1987 to 1997, oversaw the museum's second move to its present Mario Botta–designed building in the South of Market district. In a 2006 interview, Lane reflects on this often-conflicting relationship between the museum's local and global constituencies:

> In the community of people who were really dedicated Bay Area art enthusiasts, there was a lot of discontent with the direction that the museum took, because it was perceived as being disrespectful to the local community. I guess I took a more cosmopolitan view, that the biggest contribution that the SFMOMA could make to the Northern California art scene, including its artists, was to bring the best art in the world to be shown here. (as cited in Rubens, Cándida Smith, & Samis, 2008, p. 19)

Programmatically, the museum has consistently been responsive to its local community, collecting and exhibiting local Bay Area artists since the early days, including both emerging and more established artists such as Richard Diebenkorn, Richard Serra, Mark di Suvero, and Matthew Barney. Suzanne Stein, the museum's community producer, refers to the notion of "creative communities" that is used frequently by the museum to incorporate not just the visual arts, but also music, writing, and literature. More than just exhibiting local artists, the museum pays tribute to its local region with theme-based exhibitions such as *How Wine Became Modern: Design + Wine 1976 to Now* (November 20, 2010–April 17, 2011) that explored the history of wine and partnered with local wineries for its public programs. Also its landmark exhibition *The Steins Collect: Matisse, Picasso, and the Parisian Avant-Garde* (May

21–September 6, 2011) recognized the important contributions of local Bay Area collectors Gertrude Stein, her brothers Leo and Michael, and Michael's wife Sarah, that all supported emerging modern art in Paris in the early 1900s. The Steins not only contributed many significant modernist works to the museum's collection, but lent many for exhibitions at the museum (including Matisse's first solo museum exhibition on the West Coast in 1936), and influenced other local collectors and supporters of the museum.

Although originally from Salt Lake City, one of the greatest local supporters of the museum was Phyllis Wattis (1905–2002), who funded a significant portion of its current building, acquisitions of great masterpieces, and much more over fifty years' involvement. Previous museum director David Ross (1998 to 2001) describes her:

> She was just the great citizen of the Bay Area. If it wasn't for Phyllis, none of the things that have happened at SFMOMA would have happened, in my opinion . . . Phyllis was a San Francisco person. What she cared about was all of the institutions of this city. It was an amazing, amazing thing. (as cited in Rubens, Cándida Smith, & Sterrett, 2008, pp. 22–23)

The museum grew as the community grew, and the dot-com boom in the 1990s was a major growth period for the museum, with acquisitions of over $140 million worth of major modern artworks that established the museum as an important player in the international art scene.[6] Prominent local collectors that contributed to this growth include Mimi and Peter Haas, Donald and Doris Fisher, Helen and Chuck Schwab, Pat and Bill Wilson, Norah and Norman Stone, and Frances and John Bowes. Current museum director Neal Benezra comments on the importance of local collectors to SFMOMA:

> There are marvelous collections of contemporary art in this community. History will not judge us well if we do not make a real effort to build this collection. If we can win for this museum, our share of the great works in this community, this could truly become one of the great contemporary museums in the world. But we have got to make that happen. That's a job for the board and the staff to do together. We have an opportunity that most communities don't have, in that regard. (as cited in Cándida Smith & Rubens, 2009, p. 46)

The most recent acquisition of 1,100 modern and contemporary artworks from the Donald and Doris Fisher collection was first previewed at the museum in

2010 (*Calder to Warhol: Introducing the Fisher Collection*). The Fishers started collecting art after the San Francisco–based company they founded in 1969, Gap Inc., went public in 1976. The collection is on loan to the museum for one hundred years and renewable afterward for another twenty-five years, secured by SFMOMA trustee Bob Fisher, eldest son of the Fishers.

David Ross stated that "people should see their own histories reflected in this [museum's] history, as well." While Ross was specifically referring to the large Hispanic community of San Francisco and California, in 2011 only 4 percent of SFMOMA's visitors were Hispanic/Latino (a number which likely increased after the popular Frida Kahlo exhibition in 2008). A 2011 visitor survey conducted by the museum revealed that 78 percent of its visitors are Caucasian, 12 percent are Asian/Pacific Islander, and 3 percent African American. Forty-three percent of its visitors come from the Bay Area (identified by the museum as the five counties of San Francisco, Alameda, Santa Clara, San Mateo, and Marin), 12 percent from Northern California outside of the Bay Area, and only 5 percent from Southern California; 16 percent of visitors are international, and 80 percent have a college degree or higher. Even the museum's website visitors are similar in characteristics, with 74 percent from the United States, female, college-educated, no kids, and ranging from ages fifty-five to sixty-four (Alexa Web Statistics, September 2011). While the museum offers free admission on the first Tuesday of each month, half-price admission on Thursday evenings until 8:45 p.m., and Free Family Days, admission prices are still high ($18 for adults, $12 for seniors, and $11 for students); less than MoMA but still more than major art museums in Los Angeles. Former museum director Jack Lane revealed that "my wish was to keep the San Franciscans feeling like this was their museum. They were responsible for it; it was going to flourish only if they cared enough" (as cited in Rubens, Cándida Smith, & Samis, 2008, p. 40). The museum has long focused its attention on local artists, collectors, and philanthropists in order to grow and establish itself as an international art museum. The museum has benefited from the economic growth of the region and the growing international sophistication of its community leaders, but its visitors do not reflect the longtime ethnic, racial, and economic diversity of San Francisco. Nevertheless, the museum's community has always encompassed the larger Bay Area, a region much more diverse given the growing exodus of Latinos and African Americans from the city.

On the occasion of the museum's new building in 1995, art critic Peter Plagens (1995) stated,

San Francisco's mellow art scene almost gives provincialism a good name. An alternative to New York's grimy infighting and Los Angeles's sunny air-kissing, it's proud of its beatnik assemblages, psychedelic rock posters and the slather-it-on painting school of David Park and Wayne Thiebaud.

San Francisco possesses a unique culture that attracts millions of people to visit each year; however, it has always been extremely competitive with both New York and Los Angeles. SFMOMA has been similarly competitive first with MoMA and later with Los Angeles museums. Although SFMOMA collaborated closely with MoMA to share temporary exhibitions early in its history, there were small victories such as when it outbid MoMA on acquiring the seminal work by Rene Magritte, *Personal Values* (with the help of Phyllis Wattis), when it acquired the painting collections of Robert Rauschenberg and Ellsworth Kelly, and when its membership surpassed that of MoMA around 2001 (it does not anymore). In Los Angeles, the Museum of Contemporary Art and the Los Angeles County Museum of Art (established in 1961) were growing rapidly in the 1980s. Jack Lane reports feeling a sense of urgency in building SFMOMA because "Southern California was simply going to totally eclipse San Francisco if something really electrifying didn't occur here soon" (as cited in Rubens, Cándida Smith, & Samis, 2008, p. 4). When David Ross left his position as the director of the Whitney Museum in New York to lead SFMOMA in 1998, he felt the need to defend his decision to a surprised Glenn Lowry, director of MoMA. He said, "The twentieth century was very good to New York. It could be that the twenty-first century is going to be very good to San Francisco. So we'll see, in another hundred years, how these two museums compete" (as cited in Rubens, Cándida Smith, & Sterrett, 2008, p. 30). Competition encouraged the museum to focus more on international artists and programming, despite its history of supporting Bay Area artists that made the museum appear more regional; nevertheless, the museum has managed to maintain the challenging role of a regional museum with international stature.

SFMOMA is currently undergoing another structural transformation, this time an expansion of its current site designed by the Norwegian architectural firm Snøhetta. The museum's collection is quickly outgrowing its space, especially with the most recent acquisition of the Fisher collection. It began a capital campaign to build the new wing under the leadership of Board Chairman Charles Schwab (resident of San Francisco and chairman of the Charles Schwab Corporation, also based in the city). In November 2011, having raised nearly 80 percent of the capital campaign goal two years ahead of the ground-breaking date, the museum decided

to increase its goal by $75 million to a total of $555 million. A 14,400-square-foot rooftop sculpture garden was previously added behind the 52,000-square-foot Mario Botta–designed building in 2010. When completed in 2016, the expansion will give the museum a total of 137,500 square feet of gallery space and 40,000 square feet of free, public space (total museum space will be 373,000 square feet), surpassing MoMA's total gallery space of 125,000 square feet. The public space is a significant consideration for the museum in creating social spaces. Craig Dykers, one of Snøhetta's principal architects, comments on these areas:

> Is it a building filled with art with some people in it, or a building filled with people with some art in it? There needs to be enough social space to make people feel comfortable in what can be an austere environment, the white box. You shouldn't feel like you need to be quiet in the public spaces. (as cited in Pogrebin, 2011)

The museum's website states that the expansion "will not only create compelling new spaces, but also enhance the museum's contributions to the community." The new building will add three new entrances to better connect with its South of Market neighborhood; there will be a midblock outdoor promenade running from one street to another, a passage connecting the new Transbay Transit Center to Yerba Buena Gardens, and an all-glass gallery on street level, free to the public. In the words of Dykers, the new wing will "become the tissue that merges building and community, supports the museum's role as an educational and civic catalyst, and opens up the museum to the diverse audiences it serves" (SFMOMA website). Benezra (2010) affirms the connection between the new wing and the museum's local community: "The upcoming expansion offers the museum an unprecedented opportunity to reinforce our role as creative catalysts for San Francisco and a global force for contemporary art on the west coast." In an attempt to answer Dykers's question, Benezra announces that they have changed the psychology of the museum. "We want it to be an embracing, luminous space where you can get good coffee, a place where people come and meet their friends," he explains. "We really want the museum to be much more outward-looking, to open up the doors and bring the public in" (as cited in Pogrebin, 2011).

THE ROLE OF DIGITAL TECHNOLOGY

SFMOMA was an early adopter of technology for educational purposes, starting in 1937 when it was the first on the West Coast to use the Museum of Modern Art's motion picture rental services, which began just a year or two before. The museum

started showing experimental cinema and in 1946 initiated its Art in Cinema program, directed by independent filmmaker Frank Stauffacher. In 1951, SFMOMA created a biweekly television program about art that lasted four years, entitled *Art in Your Life* (a name borrowed from MoMA, later renamed *Discovery*). Founding director Morley commented on this initiative, stating, "We mean to try to make television serve for art and artists, for that seems the business of our kind of museum" (as cited in Reiss, 1960). Allon Schoener, producer of this program and assistant curator at the museum from 1951 to 1954, also started a series of short art films called *Man and Art*. In 2009, SFMOMA launched Pickpocket Almanack, a free educational program that is described on its website as an "experimental school without walls." Directed by local independent curator Joseph del Pesco, the program assembles a temporary faculty of artists, designers, writers, and filmmakers from the Bay Area that create their own curricula based on public events already taking place in the region, such as lectures, workshops, panels, and film screenings. Class discussions take place online, but participants meet with faculty at the end of each session. The website states that the program represents "an innovative addition to the cultural vitality that defines San Francisco."

The museum's curatorial program became integrally linked to education when, under Director Jack Lane (1987–1997), the director of education was elevated to a full curatorial role. John Weber was the museum's first education curator in 1993 (later named the Leanne and George Roberts Curator of Education and Public Programs in 1995), and Peter Samis worked as his curatorial assistant and program manager for interactive educational technologies.[7] The partnership of Weber and Samis contributed enormously to the museum's use of new technologies for educational purposes to enhance visitor understanding of modern and contemporary art. Samis explains "SFMOMA has been using interactive media to restore context to artworks that conditions of museum presentation strip away . . . through our program of video interviews with living artists, as well as research and media development focused on answering common visitor questions" (as cited in SFMOMA press release, 2007). Together, Weber and Samis created groundbreaking programs that earned the museum national attention and significant financial support. Samis is now associate curator in the education department's Interactive Educational Technologies (IET) team, along with two other curators of education. Samis describes the IET that was born in 1994 as

a very proactive way of reaching out and communicating the messages of modern and contemporary art to people in ways that the white cube galleries don't. So it's

trying to create a supplement or a complement to the experience, or the primary experience of the artwork in the galleries, so people can restore some of the context that the white cube galleries actually strip away. (as cited in Rigelhaupt, 2008, p. 11)

IET was initially funded by the James Irvine Foundation. It developed three major multimedia projects in 1995 in conjunction with the opening of the museum's new Botta building. Voices and Images of California Art was an interactive Web feature that highlighted eight California artists through audio and video, reproductions, photographs, and other documents. It was released in CD-ROM format in 1997, and a later kiosk version incorporated additional artists. The museum won a Gold MUSE Award for Education/Interpretive Art from the American Association of Museums (AAM) in 2006 for Voices and Images of California Art: Robert Bechtle, as well as first prize in the CD-ROM category of the AAM publications competition, and a Gold Apple Award from the National Educational Media Network. A second project, called Bay Area Artfinder, focused more on the local grassroots art community by creating a map-driven database of regional nonprofit arts spaces.

The third project was Making Sense of Modern Art, which began as an on-site kiosk-based program that presented an in-depth look at four works of art in the museum's permanent collection from different perspectives. David Ross refers to this project as "one of the great accomplishments of my time there." In 1999, the museum collaborated with Idea Integration and Perimetre-Flox Design to expand it into a Web-compatible version that could also be presented as a kiosk inside the galleries. This expanded version earned SFMOMA its second Gold MUSE Award in the category database/reference resource. The initial Web project was funded principally by The Getty Grant Program in Los Angeles and Compaq Computer Corporation in Silicon Valley. An interesting aspect of the project is the timeline, called Comparisons Across Time, which creates circles of related artwork around the ones chosen on the site from the museum's collection for the purposes of comparison, what Samis calls "subliminal conversations." Making Sense can be accessed on the museum's website and on interactive kiosks in Learning Lounges and in the Koret Visitor Education Center. Making Sense of Modern Art Mobile debuted in January 2010 as a free handheld multimedia tour to be checked out in the lobby or accessed by dialing a local number (415-294-3609) and entering the corresponding numbers next to artwork in the galleries. There are six total hours of the tour with sublevels that allow visitors to "Go Deeper," and it is available in English with selected

highlight stops in Spanish, French, and German. The museum intends to create an iPhone version of the tour.

Making Sense of Modern Art also provides the multimedia content—together with Voices and Images of California Art—for the museum's curriculum site ArtThink that was introduced in September 2006. ArtThink is primarily a standards-based resource for teachers to use in their classroom to teach about modern and contemporary art, from grade four through college. It provides hands-on and online activities that are grouped under the headings "Explore," "Create," and "Play," as well as interactive learning features such as artBasics and Detail Detective. ArtThink is available on the museum's website in its section Explore Modern Art, and then For Educators/Teacher Resources.

SFMOMA has been a leader in the collection, preservation, and exhibition of media art since the 1970s. David Ross was an early promoter and collector of video and net/online art. He co-curated the major exhibition *Bill Viola: A 25-Year Survey* in 1997 when he was director of the Whitney Museum of American Art, and brought the exhibition with him to SFMOMA in 1999. Ross's predecessor Jack Lane was also instrumental in recognizing the importance of digital art to both the region and the museum. Under Lane, the museum established its department of Media Arts in 1987, one of the first in the country, with Bob Riley as its founding curator. Today the museum's media arts collection includes time-based works and media installations, including video, film, slide, sound, computer-based, online projects, and performances. To build the collection, Lane worked closely with local media art collectors Pamela and Richard Kramlichs, whose collection is now part of a consortium (the New Art Trust) comprised of SFMOMA, MoMA, and the Tate Museum. At the time, the Bay Area had great collections of video art as well as numerous artists working in new media and industrial and graphic design. One of the largest digital projects that Ross was involved in at SFMOMA was the exhibition *010101. Art in Technological Times* (March 3–July 8, 2001) that took place in galleries and online. Although Ross clarified the exhibition as not being about technology but about "art in technological times," there was a substantial amount of digital artwork involved. For the exhibition, the museum commissioned five Web-based works and included installations, video works, sound pieces, and digital projects. The exhibition was sponsored principally by Silicon Valley–based Intel Corporation that presented the online component still available on the museum's website (http://sfmoma.org/010101) and

a separate website (http://artmuseum.net) that served as an online museum gallery, now defunct.

Another major exhibition at the museum that served as a platform and laboratory for digital technology was *Points of Departure: Connecting with Contemporary Art* (March 23–October 28, 2001), where technology was more focused on education and innovative ways to present the museum's permanent collection. The exhibition was a curatorial collaboration between the Painting & Sculpture and Education departments, and was what Samis (2001) describes as "an opportunity to prototype the museum of the future." The exhibition was supported by Ross, and new partners were brought in to design the interactive prototypes, including the MIT Media Lab, Idea Integration in San Francisco, and Compaq Computer Corporation in Silicon Valley. Together they created "an exciting environment for people to experience contemporary art, to really bring those meanings home," according to Samis. This was the first time the museum introduced touch tables with flat, interactive computer screens, called SmartTables, that included content on artworks in each exhibition gallery by other curators and artists and permitted visitors to test artistic strategies. This was also the museum's first use of handheld PDA (personal digital assistant) multimedia tours in a gallery that showed thumbnail images of several works with original video footage or archival videos of artists talking about their work on exhibit. Another experimental technology introduced was a curatorial game that allowed museum visitors to re-hang works in the exhibition in a virtual gallery. This game could be played on interactive Make Your Own Gallery kiosks at the end of the exhibitions. *Points of Departure* won a Gold MUSE Award in 2002 for best integration of new technologies into a gallery space.

David Ross left SFMOMA after a surprisingly short three years, and was replaced in 2002 by the more traditional Neal Benezra, who holds a PhD in art history from Stanford University. Benezra reflects on this transition:

> My predecessor, David Ross, was one of the smartest people I've met. He had created all sorts of exciting things. But at some point it became unsustainable. We had to scale some things back. There are positions that remain unfilled and frozen. (as cited in Guthrie, 2010)

Despite the financial scaling back and the shifting of priorities, SFMOMA has continued to innovate with digital technology. In 2005, the museum inaugurated SFMOMA Artcasts, a podcast art-zine that was co-produced with the Sausalito-based Antenna Audio Inc. (now Antenna International, based in Connecticut).

The first podcast (*The Art of Richard Tuttle*) was downloaded more than 250 times in its first weekend. There are now sixty-five Artcasts archived on the museum's website (in Explore Modern Art/Multimedia/Podcasts) and available on iTunes with new episodes every two months or so. What was innovative about them was the combination of music and poetry that complemented the audiovisual voices of artists, curators, and even visitors (through its features Vox Pop and Guest Takes). When accessed on the museum's website, Artcasts also offers interactive features based on relevant themes, including Making Sense of Modern Art programs. The episodes can be downloaded on computers and MP3 players with audio and images, or only audio. The *Times* of London named the Artcasts "Podcast of the Week" in January 2006, and they won a Best of the Web award in the innovative and experimental category at the 2007 Museums and the Web conference.

With the ubiquity of personal mobile devices and the popularity of museum mobile tours, the museum decided to start producing its own content after more than ten years of working with Antenna Audio. Erica Gangsei, manager of interpretive media in the museum's education department, reports that her department is interested in centralizing its infrastructure to publish content on a variety of digital platforms to facilitate updating and repurposing (personal communication, June 23, 2011). They currently outsource the audio editing with local sound production companies and also outsource for digital storytelling and applications development, but ideally would like to bring all video and audio production in-house. This would depend, admits Gangsei, on technology being prioritized a little more highly than it is today, as far as staffing. One innovative way in which the museum has repurposed its content is through a partnership with the San Francisco–based airlines Virgin America. For two years, Virgin's in-flight entertainment network coming in or leaving San Francisco include the SFMOMA channel that offers video programs on different topics with artists. During that time, Virgin America was the official airline of half-price Thursday evenings at SFMOMA. The museum also partnered with the video-sharing website ArtBabble (Indianapolis Museum of Art), for which it contributed five videos on its own channel. SFMOMA was invited by the Getty Foundation to participate in its Online Scholarly Catalogue Initiative, and in 2009 received a grant of $240,000 for planning support. The museum's project is an online catalog of its extensive collection of works by Robert Rauschenberg, including artist interviews, critical texts, exhibition histories, and conservation assessments, what the museum believes will represent "the most comprehensive and accessible repository of research" on Rauschenberg.

In 2003, SFMOMA began a partnership with the New Media Consortium (NMC) on the Pachyderm 2.0 project, funded by an IMLS National Leadership Grant. Based in Austin, Texas, the NMC is an international consortium of almost 200 colleges, universities, museums, and research centers dedicated to new media and new technologies. Pachyderm is the authoring and publishing tool developed by SFMOMA when it created Making Sense of Modern Art. Pachyderm 2.0 is a new, free, and open source version of the Web-based multimedia tool that is "interoperable, robust, easily distributable . . . and includes a wide range of pedagogically useful templates," according to its website (http://pachyderm .nmc.org/). The project brought together software development teams and digital library experts from six NMC universities and six major museums to design this new tool specifically intended for people with little or no multimedia authoring experience. Pachyderm 2.0 was released in November 2005, and a year later, SFMOMA was recognized with a Center of Excellence Award by the NMC for "its innovation and creativity in expanding the boundaries of informal learning and how we think about art."

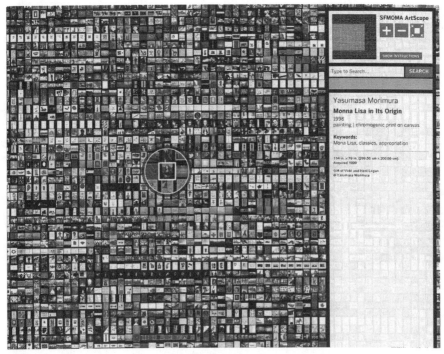

FIGURE 5.4
San Francisco Museum of Modern Art website, ArtScope (11/18/11 screen capture).

Another of SFMOMA's digital innovations is the visual browsing tool Art-Scope from 2008, accessed on its website in the Explore Modern Art section. It offers a fun, more exploratory alternative to the traditional search-based collections database. ArtScope currently features 6,050 objects (as of March 20, 2012) from the museum's permanent collection, arranged in a contiguous map-like grid based on the Modest Maps tile engine from the San Francisco–based company Stamen. By scrolling the cursor over thumbnail images there appears a text column on the right with information on the artwork and a list of keywords that when clicked, bring up related works much like a tag cloud but chosen instead by museum staff. The images can also be zoomed in on. The objects are searchable by artist, date, medium, and keyword, or instead, it facilitates a "chance discovery of artworks you might not have encountered before." ArtScope was funded by an IMLS Museums for America grant, and was a partnership between three museum teams: Web, Interactive Educational Technologies, and Collections Information and Access.

SFMOMA was one of the early art museums to create a website in 1995, with its latest website redesign in November 2008. The centerpiece of its website is the interactive section Explore Modern Art, for which it received an IMLS Museums for America grant to build. This online space combines the museum's multimedia interpretive programs (videos, podcasts, audio commentaries, interactive features), Our Collection, blog, and For Educators, including information for educators and teens with programs and events and a link to the Teen Program photostream on Flickr. The idea of bringing all these features together is to provide visitors with an online learning environment in which to learn about the contexts in which the artworks were created and to view high-resolution digital images of the artworks. In addition to ArtScope, Our Collection includes a more traditional online database of more than 9,000 objects from the museum's permanent collection, searchable by artist, title, nationality, date, and medium, that was launched in 2004 as Collections Access Online. The museum supports a direct path from onscreen to in-gallery experiences by providing updated information about museum programs and events that is connected to the pages where information on artists and artwork is viewed.

The museum's blog *Open Space* is another feature on the website's Explore Modern Art that debuted about six months earlier. In charge of *Open Space* is Suzanne Stein, the museum's community producer who was originally hired in 2008 for the exhibition *The Art of Participation 1950 to Now* and who has stayed with increased responsibilities to engage the museum's community. *Open Space*

is a blog unlike any other, in that it is more a community forum *for* the local arts community and *about* the local arts community that is merely moderated by the museum, free of editorial control. The blog takes its name (and spirit, says the website) from a small Bay Area poetry magazine in 1965 that included only local writers whose works were published without censorship, with the strict rule that no copies be circulated outside the region. SFMOMA selects a small group of bloggers (regular contributors and guest writers) from the Bay Area arts community, including writers, artists, critics, filmmakers, and staff from community arts organizations that create a loyal following of readers (30 percent of visits in 2010 were returning readers, half of which return once a week or more[8]). During the ten-month period of analysis, 77 percent of posts (201 out of a total 260, incidentally the same total number as MoMA) were by bloggers outside the museum (including staff interviews of outsiders). On the right column of the blog are lists linking to visual cultural websites: 135 local organizations and projects under the heading "Here," and 32 outside the local area under the heading "Elsewhere." As Stein describes the blog,

> Open Space is attended especially to the local community, which one of my colleagues used to say that it's totally ridiculous to use the web to attend to the local community. But that gave it a special niche, something that the community could attach to and belong to, could have a deeper sense of ownership and engagement in a way. Open Space does a really specific thing; it invites individuals who then bring their own communities with them. (personal communication, June 23, 2011)

Much like how the museum itself developed, *Open Space* is now starting to reach out further than the Bay Area to invite writers from across the country to contribute. For Stein, success is depth of engagement. So while she admits there is not a plethora of comments on the blog, the comments are really deep and engaged ones. The blog has a low ratio of comments to posts (1.2:1 or 350 total comments to 260 total posts), which when compared to the other four museums is not great, and only better than the Walker Art Center. Stein states that *Open Space* was intended as "an interesting place for people to talk and think about art, whether it's at SFMOMA, across the street, in another building, or across the world." Another program that Stein organized at the museum was the Talk and Conversation series that was meant to mirror *Open Space* in the physical museum. Stein's charge was to bring different people together to talk about art in public, online, and in real space. She admits, however, that it very quickly

became less about participation and more about collaboration. Stein is a strong believer in dialogue in all of its manifestations because it engages people on a much deeper level than just clicking something. Technology is a tool to support dialogue, but it is neither the priority nor even the subject matter for Stein and her contributors, manifest in the fact that only 0.4 percent of the blog postings are related to technology (1 out of a total 260).

Open Space provides a prominently placed link to SFMOMA's main website on the top right side of each page, which is more important to the museum than receiving traffic from the museum's website to the blog.[9] Social media is located on the right side of the bottom navigation bar, as well as in the Share box at the bottom of each post, but the museum's intention is not to drive traffic from *Open Space* to social media. Rather, by including links to posts on Facebook and Twitter, these social media initiate much of the blog's traffic. The museum also has accounts on YouTube and Flickr to post its videos and photos and those uploaded by visitors. Social media is handled by the museum's marketing and publications department that heads a cross-departmental Digital Outreach team. On the website, social media is placed in the Get Involved section that also includes the more institutional functions such as Membership, Support SFMOMA, My Account, and Participate ("Volunteer, be a docent, join art-interest groups, take SFMOMA-led trips, and comment on the blog").

While the social media used by the museum are the four basic ones (Facebook, Twitter, YouTube, Flickr), the museum's Twitter account was listed in the *San Francisco Weekly* as the best arts Twitter in the city (Swearingen, 2011). Ian Padgham was digital engagement associate at SFMOMA at the time from 2010 to 2011 (he held different positions at the museum since 2008), and was responsible for the museum's Twitter account that had amassed a strong following. Padgham began inviting social media followers to press previews, stating, "It's not just what *The Chronicle* says. We want [the local audience] to have a voice and spread the voice" (as cited in Fox, 2011). When the San Francisco Giants were in the Major League Baseball playoffs in 2010 (subsequently winning the World Series), Padgham changed the museum's Twitter avatar to incorporate the Giants' logo. Both the Giants and the MLB retweeted the museum. Padgham began using social media to take SFMOMA out into the community, and in the process made it appear more accessible. "There's a freedom to no longer be this very proper institution," claimed Padgham. Nevertheless, this freedom was easier to achieve with social media and the Internet, and much more difficult within the museum's physical building.

FIGURE 5.5
@SFMOMA (Twitter), 2010.
Courtesy of SFMOMA.

Like the Indianapolis Museum of Art, SFMOMA's galleries are more traditional in design and installation, regardless of the artwork exhibited. As an education curator, Peter Samis understands the curatorial concerns of technology interfering with the visitors' aesthetic experience. At the same time, however, he also understands how technology used for pedagogical purposes is most effective when placed nearby the artworks it provides information on. Samis states, "The white cube is still being defined as the circumscribed sacrosanct space that must not be breached by anything other than an art message to the point where in certain installations there might not even be a wall text" (personal communication, June 23, 2011). Although the use of cell phones is encouraged for accessing information on the Making Sense of Modern Art Mobile tours throughout the galleries, cell phones are not allowed for talking, as seen in a prominently placed sign on the stairway to the second-floor galleries and also inside the elevators, both in English and Spanish: "Please refrain from talking on your cell phone." The museum does offer free WiFi, as do all of the five museums studied, but promotes it mainly in its Koret Visitor Education Center.

One compromise to this quandary was the Learning Lounge, a small space between or within galleries (or in front of the Koret Visitor Education Center) that is frequently used for interactive interpretive materials, both analog and digital. Samis admits,

> The Learning Lounge is something that we really have to press for. It's not something that curators naturally leave space for. Only when there is an exhibition that is a little bit short in terms of the content and they have more square footage, they say, hey here's an opportunity for a Learning Lounge.

One lounge is situated between the second-floor Painting & Sculpture and Architecture & Design galleries in a small space with emergency exit doors that made

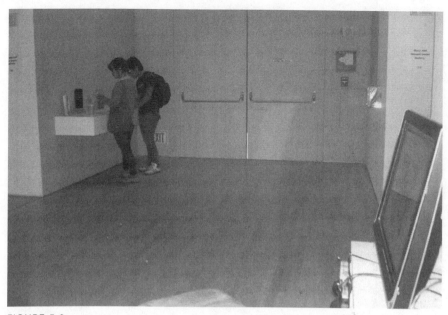

FIGURE 5.6
Second-Floor Learning Lounge, San Francisco Museum of Modern Art, 2011.
Courtesy of the author.

it unsuitable for hanging art. Attached to comfortable armchairs are iPads where visitors can relax and view the museum's video application Artists Working/Artists Talking that presents over seventy videos of more than forty artists. While the app is only available onsite, the videos can be accessed on the museum's online video archive in Explore Modern Art. The Learning Lounges are challenging for curators because they are hybrid spaces that breach the curatorial space with a personal and social space for education and engagement with the artwork. Permanent educational spaces, on the other hand, don't generate such difficulties because they are usually located apart from the galleries and are only indirectly related to specific exhibitions or works. For many years, SFMOMA's educational center was located in the museum's basement where there was no drop-in public access. Finally, in 2002, the museum not only brought it up to a prominent position on the second floor adjacent to galleries, but introduced its transformation as the 7,000-square-foot Koret Visitor Education Center. The center is a drop-in space for visitors that is staffed full-time, with a lounge area to read books and watch video screenings, a library of art books and exhibition catalogs, a separate area and library for children, and numerous stations with computer screens to access digital programs such as Making Sense of Modern Art and interactive features.

FIGURE 5.7
The Koret Visitor Education Center, San Francisco Museum of Modern Art, 2011.
Courtesy of the author.

LESSONS LEARNED

SFMOMA was able to build its collection of international modern and contemporary artwork, with a pioneering role in digital and new media art, due to the many private collections in the Bay Area, as well as the strong philanthropic support of local arts patrons. A sense of loyalty to San Francisco proved a great impetus to create a museum of international stature that would compete with New York and Los Angeles, and which concurrently kept the museum committed to local artists through a number of programs, both analog (Artist Talk and Conversation, Artists Gallery, Society for the Encouragement of Contemporary Art) and digital (Bay Area Artfinder, Voices and Images of California Art, Open Space). SFMOMA is an example of how to respond to the local community by becoming an internationally recognized museum that creates civic pride, yet it counts its local community as primarily the artistic sector and the more sophisticated arts patrons. For these two groups, the museum provides great social capital, which serves to bond them even more tightly together. San Francisco is also known for great ethnic and cultural diversity, evident in its eclectic neighborhoods that are strongly protected by residents, but this part of the city is not well reflected in the museum's programs, priorities, or objectives. The problem is not merely an inability to focus on certain segments of the community one serves, as the Walker Art Center has done effec-

tively with local artists, teens, and educators; the problem is that SFMOMA is so tightly identified with the city to outside visitors and tourists (SFMOMA Museum Store at SFO, SFMOMA Channel on Virgin American Airlines) that it has an even greater responsibility to reflect the true, local character of San Francisco.

SFMOMA is an example of Slack and Wise's notion of technology as being culturally determined. The museum's blog *Open Space* is a reflection of the San Francisco local culture that, while not entirely conventional, is not really interested in discussing technology, and the older, conservative nature of San Francisco is reflected in the museum's galleries that are still fairly traditionally installed. Yet there have been some groundbreaking experiments largely due to the unique synergy between the educational, curatorial, and technology departments, as well as occasional support from the technology industry in the Bay Area that provides strategic partnerships in universities and local companies to develop and evaluate innovative digital projects. Education curators understand curatorial concerns for the primacy of the artwork, and the museum as a whole has made clear its commitment to education. Almost all of the museum's technological developments have been for educational purposes, from its film program in the 1930s to its television program in the 1950s, to ArtThink, to its award-winning interpretive programs that accompany temporary exhibitions and support the permanent collection. The two major physical spaces for education at the museum—the Learning Lounges and the Koret Visitor Education Center—provide the visitor with a deeper understanding of the art by effectively bridging the physical and online spaces. The physical museum offers smart tables, interactive kiosks, computer screens, iPads, and mobile tours (using museum handhelds and personal cell phones), that connect to the museum's online programs such as Making Sense of Modern Art, Artcasts, Artists Working/Artists Talking, and ArtThink. Even with the traditional treasure hunt activity for kids at the museum, visitors are encouraged to upload photos to Flickr and tag them SFMOMA.

David Ross was extremely supportive of digital advances at the museum during his short tenure as director, as was Jack Lane before him; however, Neal Benezra's more conservative nature (fiscally and museologically) has slowed down some of the momentum, partially due to the museum's new capital campaign. When discussing the new wing, Benezra declares in broad terms that it will serve as a civic catalyst for the museum's continuing concern with visitor engagement; a visitor-centric museum. The problem is that many museum staff do not yet understand what this means in practical terms, as projects have been put on hold during this transitional period. The new wing will create 15,000 square feet of free-to-the-public space, supporting its increasing role in city life

and tripling the number of schoolchildren that it serves. Yet as the museum continues increasing its role also in the international art community, it will need to rely on digital technologies to further engage its online visitors that are both local and global. The museum's release of Pachyderm 2.0 as open source serves the global museum community, as does its participation in the Getty's Online Scholarly Catalog Initiative. But to serve more than special interest groups, or perhaps to widen its selection of special interest groups, the museum must rely more on its use of social media integrated into its website, which already offers many rich experiences for the online visitor. The future of the museum as embodied in its new expansion reflects the very nature of San Francisco: simultaneously local and global, innovative, and committed to artists and education.

NOTES

1. San Francisco Arts Commission. (2010). San Francisco Arts Commission district report. San Francisco: Author.

2. Yerba Buena is the original name of the city of San Francisco, named after the herb *mint* that was found in abundance in the area. The name was changed to San Francisco after the area was claimed by the United States in 1846 during the U.S.-Mexican War of 1846–1848.

3. For these statistics, *Mapping the Measure of America 2010–2010* analyzes congressional districts only. SFMOMA is located in California Congressional District 8.

4. The San Francisco Travel Association is an outgrowth of the San Francisco Convention and Tourist League that was founded in 1909, but now operates out of the mayor's office as a private, nonprofit organization with its own board of directors. The association has its own website dedicated to the arts (http://sfarts.org), an iPhone app, presence on Facebook, Twitter, and YouTube, and a monthly magazine that lists arts and cultural events in the city.

5. Morley was an incredibly accomplished woman who later chaired the Museum Division of UNESCO (that became the International Council of Museums), and served as founding editor of ICOM's professional journal, *Museum*. After leaving SFMOMA, Morley briefly headed the Guggenheim Museum, and then left to direct the National Museum in New Delhi, India, where she died at the age of eighty-four.

6. "Understand that it was such a growth period not because of an active tech leadership presence on the Board, but because of the tech investments in Board members' portfolios. The market skyrocketed and everybody was feeling plush" (P. Samis, personal communication, August 4, 2013).

7. Peter Samis's first interaction with SFMOMA was as a volunteer from 1982 to 1985 and a docent from 1982 to 1983, heading the Docent Education & Enrichment Committee from 1984 to 1985. He worked as curatorial assistant from 1988 to 1994 in various departments: Painting & Sculpture, Photography, Media Arts, and Architecture & Design.

8. S. Stein, personal communication, June 23, 2011.

9. Stein reports that only 10 percent of the blog's traffic is referred from SFMOMA's main website (personal communication, June 23, 2011).

6

The Museum of Modern Art

The Museum of Modern Art (MoMA) is located in New York City, the most populous city in the United States (8,175,133 in the 2010 U.S. Census), which is comprised of five boroughs: Manhattan, Queens, Brooklyn, Bronx, and Staten Island. Of the five, only Manhattan is *not* considered an "outer borough," acting essentially as the center of the city and the home of MoMA. Although Manhattan is not the most populous (1,585,873 in the 2010 U.S. Census) or the geographically largest borough at only twenty-three square miles, it is the financial, corporate, cultural, and tourist center of the city. Manhattan is also known as New York County, although it does not have a county government, only borough officials. New York City is the county seat of the five boroughs, each being their own county as well. These last two museums studied—MoMA and the Brooklyn Museum—are both located in New York City, but in different boroughs linked by three bridges (Williamsburg, Manhattan, and Brooklyn). First I will discuss some of the characteristics of New York City, as distinct from the other cities studied: Indianapolis, Minneapolis, and San Francisco. But because New York City is such a large and diverse city, it will be necessary to break down the municipality into boroughs and then discuss specific characteristics of the borough of Manhattan for MoMA, and the borough of Brooklyn for the Brooklyn Museum.

While New York City was officially formed in 1898 with the charter that unified the five boroughs, its history dates back to the sixteenth century preceding

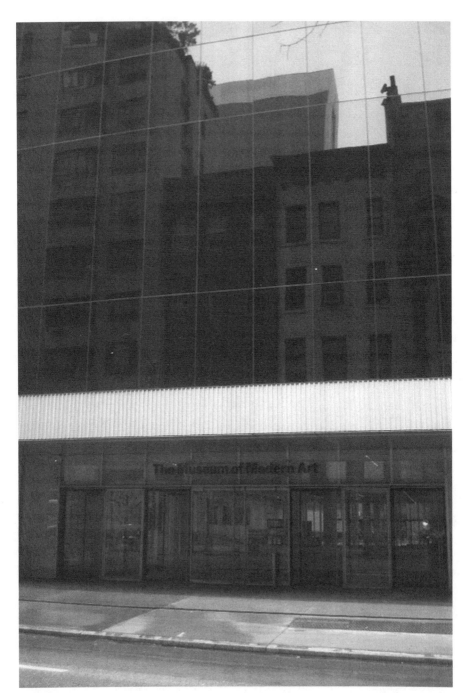

FIGURE 6.1
The Museum of Modern Art, 54th Street Entrance, 2011.
Courtesy of the author.

colonial times. The Italian navigator Giovanni da Verrazano was the first European to enter New York's harbor, in 1524 on a French ship, followed by the English explorer Henry Hudson in 1609, who was employed by the Dutch East India Company. Early Europeans encountered native Indians on Manna-hata Island (the Delaware/Lenape and the Mohican tribes) and began the lucrative business of trading fur and raw materials. The Indian tribes were driven westward with the growing European settlements, which is where most can be found today in the state of New York. New Amsterdam (what is now lower Manhattan) was established as a Dutch settlement by 1626, and was subsequently taken over by the British in 1664 and renamed for the Duke of York, brother of King Charles II. New York remained one of the original thirteen American colonies until the American Revolution in 1775–1783, becoming the eleventh state in 1788. New York City was the state capital until 1797, when it moved to Albany.

The particular geographic constitution of Manhattan as an island was a valuable asset to all who controlled it, providing great advantage for trade between Europe and America, and natural harbors to protect ships and troops. Manhattan began as a commercial center during the early colonial period. Wall Street in lower Manhattan was an actual wall that Dutch settlers built to protect themselves from Indians, pirates, and other dangers. The area on the southern tip of the island connected the banks of the East River and the Hudson River on the west, and became a busy commercial road together with a new city hall and church (Trinity Church). New York City was the country's first center of government when City Hall on Wall Street became the Federal Hall in 1789, although it lasted only one year. George Washington took the oath of office here to become the country's first president.

New York Harbor (also known as Upper New York Bay) is today governed by the Port Authority for the New York–Newark, New Jersey metropolitan area. The two cities of New York City and Newark are separated by the Hudson River. New York City has approximately 600 miles of waterfront, a combination of river estuaries and bays, and the harbor opens into the Atlantic Ocean to the southeast. The opening of Erie Canal in 1825 connected New York with the Great Lakes, making the port of New York even more valuable as it connected Europe with the interior of the country. New York was the world's busiest port from around 1900 until the 1950s, at which time it shifted to the New Jersey port due to New York's rising waterfront costs, outdated piers, and limited space. The U.S. Custom House from 1902 still stands at the southern tip of Manhattan, now housing the National Museum of the American Indian.

Not only commercial goods came through New York Harbor; it was also one of the most important and historical points of entry for immigrants to the new world. At the end of the seventeenth century, New Amsterdam was already very diverse ethnically and religiously. The Dutch West India Company was one of the largest slave traders with Africa in order to support its investments by building houses, roads, and clearing forests. In 1626, it brought its first shipment of slaves from Africa, and then expanded to the West Indies including the Dutch colony of Curaçao. These slaves defended the Dutch against Indian attacks, and often won their freedom after many years of hard work. At the time, free blacks had more rights than Jews; they were allowed to own property and intermarry with whites. Under British rule, the importation of black slaves increased from Africa as well as the British colonies of Jamaica and Barbados, but their few rights were taken away. In the late eighteenth century, antislavery sentiment began to grow in New York, both from liberal whites as well as established communities of freed blacks. Many churches of various dominations in Manhattan gave refuge to runaway slaves from the South and were known as important stops along the Underground Railroad. Slavery was abolished in New York in 1827, years before the Civil War began in 1861.

By the nineteenth century, the Irish and Germans held political and economic power and fought the multitude of new immigrants: Greeks, Russians, Hungarians, and Poles. In 1892, a new immigrant reception facility was built on Ellis Island in the harbor, serving 12,000 people per day. Between 1800 and 1900, 75 percent of all immigrants came to the United States through New York City (Donnelly, 2012). Most of these new immigrants settled in the Lower East Side of Manhattan, which became one of the most densely populated areas in the world by 1900. New York City in the twenty-first century is just as diverse. Almost 40 percent of resident New Yorkers were born abroad in over eighty countries, less than 49 percent of New Yorkers speak only English at home, and there are ninety-nine foreign language and ethnic newspapers in the city. The seven largest countries of origin are the Dominican Republic, China, Jamaica, Russia, Italy, Poland, and India (Donnelly, 2012), which are reflected in the city's modern-day ethnic communities such as Chinatown, Yorkville, Little Italy, and Spanish and Black Harlem. In 2009, 36 percent of residents were born outside of the United States, 29 percent entered in 2000 or later, and 42 percent entered before 1990. Today, 52 percent of new immigrants come from Latin America, 26 percent from Asia (the fastest growing group), and only 17 percent from Europe (U.S. Census, 2010). Manhattan is 57.4 percent white non-Latino, 25.4 percent

Latino/Hispanic, 15.6 percent African American, 11.3 percent Asian, and 0.6 percent Native American Indian (U.S. Census, 2010). The Jewish population in New York City is the largest in the world. The North American Jewish Data Bank reports that in 2002, a total of 972,000 Jewish people lived in the city, with 243,000 in Manhattan and 456,000 in Brooklyn. Jewish people comprised 8.3 percent of New York State in 2010.

Poor, struggling immigrants crowded the Lower East Side of Manhattan in deplorable tenement buildings, today reconstructed for public memory by the Lower East Side Tenement Museum. Immigrant masses also formed bohemian neighborhoods in Greenwich Village and populated Harlem just north of the city, but they were *not* in the financial districts, midtown, the Upper East Side, or along Fifth Avenue and Park Avenue by Central Park, which were reserved for the wealthy, influential, and industrial titans. The city is less segregated today than it was in the past. Formerly lower class, underprivileged areas such as the Lower East Side, East Village, and Greenwich Village are now filled with trendy restaurants and cafes, demanding exorbitant rents for the same cramped apartments. But reminders of the past still exist in the well-preserved architecture, with former mansions now housing museums, cultural centers, and luxury hotels.

Data from *Mapping the Measure of America*[1] reveal present-day demographics of Manhattan and New York City. MoMA's region is well above the national average for the human development index (8.79), the health index (6.98, San Francisco is 6.9), the education index (9.44), and the income index (9.96). Life expectancy at birth is 82.8 years (San Francisco is 82.6), above the national figure of 78.6 years; 65.7 percent have at least a bachelor's degree, above the national rate of 27.7 percent; and there is 100.5 percent school enrollment (San Francisco is 104.3 percent), above the national rate. The median personal earnings is $60,099, considerably above the national figure of $29,755, and 16 percent of all household incomes are over $200,000. Manhattan has a substantial population sixty-five years and older at 13.5 percent (same as San Francisco), with the largest age group (twenty-five to thirty-four) comprising 21.5 percent of the population. The New York–based Alliance for the Arts (2010) reports income sources for New York City cultural organizations by borough. While all five boroughs are relatively equal in the amount of earned income, Manhattan is disproportionately higher in the amount of private contributions (57 percent), and substantially lower in the amount of government funding (13 percent). This data can be explained by the higher degree of individual and corporate wealth in the borough, hence the decreased need for government funding.

Wealthy industrialists from the nineteenth century built a network of major cultural institutions such as Carnegie Hall (Andrew Carnegie), the Whitney Museum of American Art (Gertrude Vanderbilt Whitney), the Solomon R. Guggenheim Museum, and Rockefeller Center (John D. Rockefeller Jr.), that became internationally renowned and still enrich cultural life in the city. The Arts Students League of New York opened in 1875, helping to forge the careers of many important American artists, and the Metropolitan Museum of Art opened in 1897, both in Manhattan. In 1889, the Arts Students League joined with the Society of American Artists, the Society of Painters in Pastel, the New York Art Guild, and the Architectural League to form the American Fine Arts Society that contributed greatly to promoting the arts in New York. This individual wealth and philanthropy—as well as the rich ethnic and racial diversity of immigrants and residents and a preponderance of artists—contributed to New York City displacing Paris as the center of the arts by the 1950s.

Starting in the 1920s, the Harlem Renaissance represented the flourishing of African American writers, artists, and jazz musicians into the 1940s. Harlem was the destination not only for African Americans migrating from the South, but also for African and Caribbean immigrants. New York City became the center for theater with the advent of the Broadway musical that appeared in theaters on Broadway and along 42nd Street. Today there are thirty-nine Broadway theaters around what is popularly known as Times Square, as well as numerous smaller theaters referred to as "off Broadway," and the even more avant-garde "off-off Broadway" theaters. The New York Philharmonic was formed in 1842, but because Paris was still the center of the arts world at the time, it presented only European classical music. Later, American composers emerged to bring international fame to a new, American genre of music with the New York–born George Gershwin and Aaron Copland from Brooklyn. Today, the Lincoln Center for the Performing Arts is the largest arts institution in the world, housing twelve arts organizations in its 16.3-acre campus on Manhattan's Upper West Side. New York City embraced alternative arts expressions in the 1970s such as hip-hop that started in the Bronx, punk rock, and beat generation writers and poets that later moved to San Francisco. The city was also the center of modern dance, with internationally famous dancers and choreographers such as Martha Graham, Merce Cunningham, George Balanchine, Twyla Tharp, and the African American Alvin Ailey.

Ironically, it was the influence and influx of European artists in New York that helped to forge a truly American modernist art movement. The well-known

1913 Armory Show (*International Exhibition of Modern Art*) in New York City brought many avant-garde European artists to New York, including impressionists, fauvists, and cubists, who were exhibited next to American artists. New York collectors supported these new art forms, except for the most radical, French artist Marcel Duchamp's cubist masterpiece *Nude Descending a Staircase* (1912). The rise of fascism in 1930s Europe also brought many artists to New York, including surrealists such as Arshille Gorky and Wolfgang Paalen, who greatly influenced American artists. The second wave of European surrealists came in the 1940s during World War II, including André Breton, Yves Tanguy, and Max Ernst. The Museum of Non-Objective Painting in Manhattan—later changed to the Solomon R. Guggenheim Museum—played a vital role at that time, opening in 1939 with an important collection of the Russian abstract artist Wassily Kandinsky.

Early American artists included Charles Demuth, Marsden Hartley, and Alfred Stieglitz, the photographer and owner of the 291 Gallery in Manhattan. When MoMA opened in 1929, it promoted these early modernist artists as well as their European counterparts. The New York School of artists formed after World War II, based upon a new style of painting called Abstract Expressionism.[2] This was the first American avant-garde art style, influenced by radical European styles but distinctly American in its expressiveness, freedom, and monumentality. Notable artists in this group were Jackson Pollock, Willem de Kooning, and Mark Rothko who met regularly at the Cedar Tavern in Greenwich Village in Manhattan. The New York art scene in the 1950s and 1960s was notable for the birth of the American Pop Art movement, less focused on painting and including more sculpture and mixed media. Important pop artists included Jasper Johns, Andy Warhol, Larry Rivers, and Roy Lichtenstein. Many of these American artists were marked by their experiences in the federal Works Progress Administration program that paid artists to paint murals in government buildings between 1935 and 1943. In the late twentieth century, important alternative artists emerged in New York such as Keith Haring and Jean-Michel Basquiat, influenced by hip-hop, graffiti, and the counterculture that existed in many parts of the city.

The city and state of New York are today the greatest public supporters of the arts in the country. In 2011, the state of New York appropriated $39,988,000 for the arts and the New York City Council gave $35,348,790 to support cultural organizations. New York City's Department of Cultural Affairs had a total budget of $141 million in 2010. NYC & Company Inc., the official marketing and tour-

FIGURE 6.2
42nd Street Station, New York. *Times Square Mural* (1994) by Roy Lichtenstein, 2011.
Courtesy of the author.

ism organization for New York City, reports that in 2010, 46 percent of overseas visitors chose to visit art galleries and museums, following shopping, restaurants, historical places, and sightseeing.[3] For domestic visitors, 22 percent visited museums, again following shopping and restaurants. In its 2005 report *Creative New York*, the Center for an Urban Future writes, "Creative activity may be the closest thing to a natural resource in New York." *Forbes* magazine lists Times Square as the number one tourist attraction in the United States, with 37.6 million visitors in 2009 or 80 percent of all New York City visitors (Murray, 2010). Tourism is a major industry for the city, comprising $31.5 billion in total direct visitor spending in 2010 (international and domestic). New York City received 9.7 million international visitors and 39.1 domestic visitors in 2010, with almost 46 million people passing through New York's John F. Kennedy International Airport in 2009.

With so many different ethnicities, languages, races, religions, and cultures, with so many different neighborhoods, tourists, and transient residents (Manhattan is 70 percent renter occupied, 21 percent owner occupied), can there be any sense of community? New York City rates low in civic engagement

("Corporation for National and Community Service," 2010), lower than the other three cities. Measuring service, 17.2 percent volunteer with an organization and 5.3 percent work with neighbors, below the national average. Measuring political action, 52 percent are registered voters and 50.5 percent voted in the 2008 presidential election, below the national average. Measuring social connectedness, 54 percent talk to friends and family on the Internet frequently, 44.7 percent talk with neighbors frequently, and 86 percent have dinner with household members frequently, also below the national average (Indianapolis is even lower for the last two). Measuring belonging to a group, 28.7 percent participate in any organization, below the national average of 34.5 percent.[4] In October 2011, New York City embarked on a one-year experiment in participatory budgeting (the second city in the United States to try this, after Chicago), with four city council districts opening up their capital discretionary funds for community members to allocate: district 8 that includes Manhattan and the Bronx, district 32 in Queens, and districts 39 and 45 in Brooklyn.

Understanding a sense of the local community in Manhattan is very different from that of Minneapolis, Indianapolis, or San Francisco. Manhattan began as a center of international trade between the old world and the new, and then it became the financial center of the world, the artistic center, and also the political center of the world, with the United Nations headquartered by the East River since 1951. The local culture of Manhattan is one formed through constant exchanges with different individuals and cultures; it is a culture that offers opportunities and possibilities, and embraces new ideas, albeit an optimism that is now heavily guarded by reality. The September 11, 2001, terrorist bombing of the World Trade Center towers in lower Manhattan indelibly changed the culture of the region, a culture which locals say is now stronger and more unified than ever.

THE MUSEUM AND ITS COMMUNITY

Mission Statement:

The Museum of Modern Art is a place that fuels creativity, ignites minds, and provides inspiration. With extraordinary exhibitions and *the world's finest collection of modern and contemporary art*, MoMA is dedicated to the conversation between the past and the present, the established and the experimental. Our mission is helping you understand and enjoy the art of our time. (emphasis mine)

MoMA's mission statement includes not one reference to its local culture, place, or community; instead, it affirms that it possesses "the *world's* finest collection of

modern and contemporary art." This is telling indeed, as we begin to explore how the museum acknowledges its community and goals. MoMA is an international arts institution due to its world-class collection and its international reach for visitors, exhibitions, institutional partners, and financial supporters. It has stores in Japan, Korea, and four in New York City (two inside MoMA, one across the street, and one in SoHo). Yet MoMA's international focus is not at the expense of its local community. Rather, the local community of Manhattan and New York City is a global community of immigrants, residents, and tourists; one of the most international cities in the world. The museum affirms that approximately 60 percent of its ticket buyers are international visitors, which explains why its museum guides are in eight languages, its membership brochure is in six languages (including an individual category for national/international), and portions of its website are in seven languages (P. Reed, personal communication, April 11, 2011). MoMA focuses on the local community in very traditional (analog) ways, as will be described, while its robust, online presence addresses more its national and global audience, both integrated into the overall museum visitor experience.

MoMA was founded in 1929 principally by Abby Aldrich Rockefeller (wife of John D. Rockefeller), Lillie P. Bliss, and Mary Quinn Sullivan, known socially as "the daring ladies." MoMA's website describes the mission for this early museum as that of "encouraging and developing the study of Modern arts . . . and furnishing popular instruction." At the time, Europe was the center of modern art and these women wanted a place ("the *greatest* museum of modern art in the world") to exhibit this new art when it came to New York. MoMA was first housed on the twelfth floor of the Heckscher building in midtown Manhattan, then moved to a rented space on West 53rd Street also in midtown, the same location where the museum stands today. The inaugural exhibition consisted of the European post-Impressionist artists Vincent van Gogh, George Seurat, Paul Gauguin, and Paul Cézanne. It lasted one month (November 7–December 7, 1929), and attracted more than 47,000 visitors.

MoMA was an international museum from the very beginning. Nelson Rockefeller (one of six children of Abby and John D. Rockefeller) was arguably the museum's most influential supporter. He served as trustee from 1932 to 1979, and president from 1939 to 1941 and again from 1946 to 1953. While he preferred the style of European modern artists such as Henri Matisse and Pablo Picasso, he was also influenced by his mother's affinity toward Latin American art and her favorite artist, the Mexican muralist Diego Rivera. Abby Rockefeller donated the first works from Latin America to the museum with a gift of 36

paintings and 105 drawings, including important works by Rivera and José Clemente Orozco. Nelson was a strong supporter of the arts in general, and formed the New York State Council on the Arts in 1960 while he was governor of New York. His interest in Latin American art developed through his many political associations with the region. In 1940, President Roosevelt appointed him coordinator of inter-American affairs, responsible for helping Latin American nations, and in 1944 he was appointed assistant secretary of state for American republic affairs. In the 1950s he served President Truman as chairman of the International Development Advisory Board and special assistant to the president for foreign affairs.

Nelson eagerly drew upon these international connections for the benefit of both the museum and his country. He was instrumental in founding the museum's International Program in 1952 and its associated membership group, the International Council. The International Program was intended to organize exhibitions of American modern art that would be sent all over the world, working closely with (and funded largely by) the U.S. State Department and the Central Intelligence Agency. The program continues today with the tradition of organizing traveling exhibitions, but now includes publications, public programs, and workshops for mid-career museum professionals from specific regions around the world. In 2011, the International Council provided $716,000 in exhibition and programming support to the museum (MoMA, 2011). Nelson was also responsible for appointing the museum's second director, René d'Harnoncourt. After briefly living in Mexico and organizing exhibitions of Mexican modernist artists, d'Harnoncourt moved to the United States and worked for Nelson Rockefeller as acting director of the art division in the Office of Inter-American Affairs. At Nelson's instigation, d'Harnoncourt started working at MoMA in 1944 with the very bureaucratic title of vice president in charge of foreign activities, where he continued to work with Latin America and then Europe after the end of World War II. D'Harnoncourt was appointed director of the museum in 1949 and served for the next eighteen years.

MoMA first gained international recognition with its blockbuster exhibition of van Gogh in 1935, and even more so with its groundbreaking retrospective exhibition *Picasso: Forty Years of his Art* in 1939. At the time, MoMA favored modern European artists over the American abstract artists emerging in the city, which caused some consternation with the local artists. The museum's first director from 1929 to 1943, Alfred H. Barr Jr., was highly significant in bringing modern art to the American public's attention and placing it within a global

context, but his preference for European modern art was the main rationale for the museum being embarrassingly late to exhibit and collect American Abstract Expressionism. It was the Guggenheim Museum that presented the first exhibitions of American artists Jackson Pollock and Mark Rothko. In 1940, a group of New York artists, led by Ad Reinhardt, picketed the museum distributing leaflets that read, "How modern is the museum of modern art?" It was not until its highly influential exhibition in 1959, *The New American Painting*, that MoMA fully embraced the Abstract Expressionist movement in the United States, continuing up until today with the successful exhibition *Abstract Expressionist New York* (October 3, 2010–April 25, 2011).

Peter Reed, senior deputy director for curatorial affairs at MoMA as well as the head of its Digital Strategy Group, reveals that one of the museum's goals today is to engage the New York arts community. He states, "You need to rebuild community, and our trustees and our director have pushed us to engage artists as a priority" (personal communication, April 11, 2011). One of the ways in which the museum has physically engaged with its local community in recent years is by expanding into areas which are rapidly becoming new artistic centers, namely Queens just across the East River. MoMA QNS became the museum's temporary exhibition space while it closed its midtown building for a major expansion in 2002. MoMA had previously purchased the former Swingline stapler factory building to store its growing collection of artwork. Long Island City in Queens has a good number of museums and alternative art spaces (including the Noguchi Museum, Socrates Sculpture Park, Museum of the Moving Image, and Fisher Landau Center for Art), making it a burgeoning arts district just a quick subway ride from Times Square. At MoMA QNS, masterpieces from MoMA's permanent collection and a blockbuster *Matisse Picasso* exhibition drew up to 4,000 people a day into the historically industrial area that is now an ethnically diverse—and still affordable—residential neighborhood. The museum also provided buses to shuttle visitors from its Manhattan location. Nevertheless, Karen Davidson, deputy director for policy, planning and administration at the museum, admitted, "It is almost like moving from one country to another" (as cited in Bohlen, 2002). After the expanded MoMA reopened in 2004, it maintained MoMA QNS for workshops, permanent art storage, and a study center, but closed to the public.

Also in Long Island City, Queens is what is now called MoMA PS1. Originally founded by Alanna Heiss in 1971, the Institute for Art and Urban Resources Inc. was not a collecting institution, but was dedicated to organizing temporary

FIGURE 6.3
MoMA PS1, Long Island City, Queens, 2011.
Courtesy of the author.

exhibitions in abandoned spaces throughout New York City. It acquired its permanent home in a vacant public school (Public School 1) in 1976, which was later renovated in 1997 to serve as a studio, performance, and exhibition space. PS1 became an affiliate of MoMA in 2000 to "extend the reach of both institutions and combine MoMA PS1's contemporary mission with MoMA's strength as one of the greatest collecting museums of modern art," according to MoMA's website. The merger was completed just in 2010. Today, MoMA PS1 has the feel of an art school with its gritty, albeit spacious interiors; even the stairwells and basement are used for installations. MoMA calls its new Queens space an "artistic laboratory" that presents "diverse and innovative activities" in stark contrast to what it can achieve in Manhattan. To start with, MoMA PS1 engages with contemporary New York artists on a much deeper, and looser, level.

MoMA PS1 celebrated its opening in 2000 with the exhibition *Greater New York*, now a quinquennial event (in 2005 and 2010) still organized by both MoMA and MoMA PS1 that showcases artists and artist collectives living and working in the greater New York area. The exhibition includes performances, public programming, and artists commissioned to conduct experimental work in-residence in MoMA PS1's gallery space. The museum's website describes the exhibition: "Covering a full range of practices and media, the artists in *Greater*

New York are inspired by living in one of the most diverse and provocative centers of cultural activity in the world." The curatorial team reviewed 750 submissions in 2010, and in addition to the traditional open call for proposals and studio visits, they introduced a new online submission venue for artists called Studio Visit. Studio Visit remains publicly accessible on MoMA PS1's website, supporting artists from the greater New York area and providing them with an unprecedented means of visibility.

Just as MoMA QNS revitalized its neighborhood for a short stint, so has MoMA PS1 brought new artistic life and energy to Long Island City through its active schedule of cutting-edge public programming and free entrance for all Long Island City residents. Another MoMA PS1 program is called Free Space, where artists, nonprofit organizations, independent curators, collectives, and architects-in-residence occupy free physical gallery space and in turn conduct open spaces that engage the public with "uninhibited artistic exploration and fresh contemporary art programming." Established in 2000, the Young Architects Program is an annual international competition for emerging architects to build a site-specific, temporary project for the museum's outdoor recreational area during the summer, the site of its popular music concert series Warm Up. The 2011 competition was the first collaboration between MoMA PS1 and an outside institution, the National Museum of XXI Century Arts of Rome (MAXXI) in Rome, Italy, that created the international Young Architects Program network.

While MoMA values its new affiliated space in Queens that offers an opportunity to more fully embrace contemporary art, the local artistic scene, and a different segment of New York City, it continues to expand its original site on West 53rd Street in midtown Manhattan. The most recent expansion by Yoshio Taniguchi in 2004 increased the museum's square footage from 80,000 (from its previous 1984 expansion), to a total of 630,000 square feet. This amount of space in crowded Manhattan was acquired fortuitously when the adjacent nineteen-story Dorset Hotel came on the market in 1996. An important new addition at this time was the Lewis B. and Dorothy Cullman Education and Research Building, the museum's first building dedicated solely to these activities that increased space for classrooms, auditoriums, teacher-training workshops, and the museum's expanded library and archives. In early 2011, MoMA purchased another building (30,000 square feet) adjacent to it on West 53rd Street that housed the American Folk Art Museum. At this time, MoMA has only revealed that it plans to expand in that direction in the future. MoMA's midtown space

FIGURE 6.4
The Abby Aldrich Rockefeller Sculpture Garden, Museum of Modern Art, 2011.
Courtesy of the author.

is unlike the imposing architecture of early encyclopedic museums with their Greek columns and grand staircases, or even many contemporary art museums that build awe-inspiring architectural works of art themselves by "starchitects" (star architects). MoMA's buildings are modernist like its beginnings, forming a seamless part of the Manhattan skyline with street-level entrances, high-rise buildings, spacious interiors, and lots of windows. The museum's Abby Aldrich Rockefeller Sculpture Garden provides visitors with a bit of urban tranquility and an opportunity to look up and acknowledge the museum's urban surroundings, admiring artwork within its very dense, physical context.

Wendy Woon, MoMA's deputy director for education, describes community as "people coming together with some sort of affinity" (personal communication, April 11, 2011). Affinities change and develop as people grow through life, and the museum believes in being relevant at all stages of a visitors' life from infancy to retirement. Woon recognizes that the museum has both physical, local visitors, as well as online, global ones, but strives to reach people within their own communities, wherever those may be physically or virtually. The museum's

education department manages the Community Partnership Program that, since 2004, maintains a formal relationship with twenty-nine community-based organizations in New York, including Art in School in Prison, Housing Works, Passages Academy, Fortune Society, Project Reach Youth, F*E*G*S, YWCA Fresh Start, Project Luz, and Midtown Community Court's WISE Program. The museum's website allows organizations to custom design their program, their visit, or their partnership with MoMA by first choosing the type (i.e., group visit, art studio, MoMA outdoors), and then contacting museum staff by e-mail. The website describes the program as "Collaborate with MoMA: we tailor our programs to fit the needs, abilities, and interests of the people your organization serves." Calder Zwicky, the museum's community outreach coordinator, believes that the program helps to demystify the arts: "The arts in general are accessible to every resident of New York City . . . the arts really are there for everyone" (as cited in museum video, n.d.).

After a trustee retreat in 2005, the museum decided to focus on two priorities: contemporary art, and education specifically for young adults. Six years later, Peter Reed declares proudly that new initiatives on both fronts are succeeding. PopRally responds to both concerns, an initiative for young adults that was started in 2008 and organized by younger staff at the museum. PopRally creates innovative and social events at MoMA and MoMA PS1 with contemporary artists, musicians, and performers about once a month for youth between twenty-two and thirty-eight years that pay a minimal cost to attend. Marketing is conducted solely online because of a very low budget and the group's predilection for social media. The museum does not promote PopRally on its website other than listing its events in "Calendar" and its videos in "Multimedia," but a search for PopRally on the website brings up its subsite (http://moma.org/poprally/index) where visitors can register for e-mail invites (over 10,000 have signed up as of April 2011). Although social media is not listed on PopRally's subsite, the program has an active Flickr photostream, a Facebook page, and a not-so-active Twitter account @poprally.

Like most museums, MoMA has a strong Teen Program, centered on its work with New York City high schools and its own Youth Advisory Council (now called the Teen Voices Project). Art Underground consists of free teen nights at the museum every other Friday during the school year with movies, artist workshops, and pizza. In the Making is a free after-school program at the museum for high school students who participate in ten-week classes such as CLICK@ MoMA: Wearable Technology, What the #%!$@? Abstraction, Emotions, & Art,

and ¡Muralistas! Large Scale Painting from around the World. The Teen Program also has a substantial online component, including the now-archived Red Studio website from 2004 until July 2010, and the more recent website Pop Art from 2008 that is still active, both created and developed by teens in the Youth Advisory Council.

MoMA has won numerous awards for its Access Program that serves people with disabilities, including physical, learning, emotional, behavioral and developmental disabilities, and people who are partially sighted, blind, hard of hearing, or deaf. In 2000, the museum won the Access Innovation in the Arts Award, presented by VSA Arts and MetLife Foundation, in 2007 the Ruth Green Advocacy Award from the League for the Hard of Hearing, in 2010 the Innovations in Alzheimer's Disease Caregiving Legacy Award from the Family Caregiver Alliance and the Rosalinde and Arthur Gilbert Foundation, and the Community Leadership Award from the Alzheimer's Association New York City Chapter. Described on MoMA's website under "Visitors with Disabilities" in the Learn section: "Everyone is welcome at MoMA. We offer a variety of free programs and services to make MoMA accessible to you."

But the museum has perhaps made its greatest mark with Meet Me, the MoMA Alzheimer's Project: Making Art Accessible to People with Dementia. The program first started as Meet Me at MoMA, with specially trained museum educators that engaged participants in discussions by focusing on works in the museum's collections and in special exhibitions, and by providing a forum for dialogue and an expressive outlet. The program later expanded nationwide in order to develop resources that other museums could use, such as assisted-living facilities and community organizations serving people with dementia and their caregivers. The Meet Me subsite (http://moma.org/meetme/index) presents interviews with experts in the fields of art, aging, and Alzheimer's disease, guides for creating arts-related programs, multimedia content, and the results from a 2008 evaluative study of the program conducted by the New York University Center of Excellence for Brain Aging and Dementia. In 2010, the website received the Best of the Web award for Education from Museums and the Web, and first prize in the American Association of Museums' Museum Publication Design Competition for the Meet Me book, as well as its Excellence in Published Resources Award.

Peter Reed speaks of director Glenn Lowry's dream for the museum to represent a place for conversation, a think tank for modern and contemporary art and ideas. Today the museum presents an array of public adult programming (lectures,

conversations, performances) that promote dialogue under the umbrellas of the Photography Forum, Performance Art Forum, Film Forum, Independent Filmmakers Forum, and the Contemporary Art Forum. In talking about the notion of salons that has become popular with other curators at the museum, Reed gives credit to Senior Curator Paola Antonelli. The museum has become a convener, a conduit for conversations on a physical level with these public forums, as well as private forums on many of the same themes with leaders from around the world. Reed acknowledges that the physical interaction with visitors and members is extremely helpful in building trust, continuity, and community, but that those conversations need to be carried over into the digital realm. And one challenge that MoMA is struggling with now, according to Reed, is how to address different audiences, through different channels, in different ways.

THE ROLE OF DIGITAL TECHNOLOGY

The digital age has both complicated and expanded the possibilities for dialogue and convening, and MoMA has embraced new digital technologies that help to engage its visitors—physical and online—with the museum, and with modern and contemporary art. MoMA was an early enthusiast of mass media technology, beginning with radio broadcasts on modern art in the 1930s, and continuing into the 1940s and 1950s with television. At the time, New York City was one of the first major centers for television production with national networks and multiple stations (CBS, NBC, and local broadcasters). Museums saw the opportunities inherent in the medium to reach a mass audience, and the networks courted museums to provide them with novel content. MoMA hosted monthly meetings of the American Television Society during the 1940s, and the head of CBS, William S. Paley, was a MoMA trustee (CBS was already partnering with the Metropolitan Museum of Art). In 1939, MoMA presented a live broadcast from the NBC studios with director Alfred Barr and trustee Nelson Rockefeller discussing the museum's sculpture *Bird in Flight* by Constantin Brancusi. Media scholar Lynn Spigel notes that "MoMA saw television not simply as a venue for publicity or education, but as central to the maintenance of its own cultural power" (2008, p. 148). Part of this power was the ability to reach viewers in their own homes, especially the targeted housewives, more than could ever physically visit the museum. A three-year grant from the Rockefeller Brothers Fund helped MoMA start its Television Project that hired the avant-garde filmmaker Sidney Peterson to create in-house productions. A number of "tele art programs" that developed under this project together with NBC included *Point of View*, a series

of fifteen-minute programs, *Through the Enchanted Gate*, and the animated children's series *They Became Artists*. MoMA developed a television archive to complement its prestigious film archive, consisting more of art documentaries than commercial productions. The Television Project was short-lived, however, due to low ratings, difficulties in securing copyrights, and the fact that production houses began moving to Hollywood. Today, MoMA has similarly embraced the most recent medium of mass telecommunications, the Internet.

Peter Reed considers MoMA's website[5] as its third venue, following firstly its 53rd Street building and secondly PS1 in Queens. All three venues are equally valid and important to the museum, although Reed does acknowledge the need for many curators to recognize this. The Internet is critical for at least three of MoMA's priorities: young adults, education, and a global reach. Alexa statistics (September 2011) of MoMA's website reveal that the average online visitor is between twenty-five and thirty-four years of age (the same as for the Brooklyn Museum), which is much younger than SFMOMA, the Indianapolis Museum of Art, and the Walker Art Center. The museum's website is also tightly integrated with social media that is utilized by a younger demographic. It is noteworthy that the website has an Online Communities page under the Explore section—recognition that this "third venue" has constituted a community—in which the museum provides links to its social media (Flickr, YouTube, iTunes, Facebook, Twitter, and Foursquare). Also under Online Communities is listed MoMA's virtual gallery in the Google Art Project, its page in ArtBabble, and a link to online registration for MoMA.org. MoMA's online community is indeed a significant one at least in the quantitative sense. On Foursquare the museum has 80,219 followers, it has 928,291 Twitter followers @MuseumModernArt, on Facebook it has 1,002,320 fans, and almost 5.2 million video views on YouTube (as of March 19, 2012). The museum also has approximately 600,000 e-mail subscribers (2011), and in 2010 it had 18 million website visitors (A. Burnette, personal communication, April 11, 2011). Compare these to the number of physical visitors in 2010 (2,800,000) and we understand the magnitude of this third venue to the museum. Furthermore, 7.11 percent of website visitors go directly to the online store (http://momastore.org/) which received 5 million visitors in 2010 and substantial revenue for the museum (Alexa, December 2011). Even more remarkable is that all these online visitors (through social media or the website) are frequent repeat visitors, as opposed to the museum's physical visitors that may only visit once if they are tourists, or maybe a few times a year if they are locals.

Nevertheless, the distinction between local, physical visitors and global, online visitors is not a clear one. Certain social media are used by more of the local community, such as Foursquare that utilizes geolocation technology on GPS-enabled phones, offering tips from the museum when visitors are in the area or allowing visitors to leave tips themselves on what they recommend at the museum. On the other hand, the museum's website is only 40 percent international, compared to 60 percent international for its physical ticket buyers (P. Reed, personal communication, April 11, 2011). Despite the website being available in seven languages, the translated portions include only basic information aimed at visiting tourists such as restaurants, directions, store, annotated floor plan, audio guides, and membership. The deeper content is not yet translated, perhaps a reason for the low rate of international online visitors. Allegra Burnette, creative director for digital media at the museum, admits that the museum does more in its physical spaces to address different languages than online, partly due to the tremendous expense in translating thousands of pages of constantly changing content (personal communication, April 11, 2011). In the museum, the audio program is available in multiple languages, as is the printed museum guide, and volunteers and security guards wear buttons that show which languages they speak.

Regarding the museum's deeper online content, Reed admits that its ambition and reach is increasingly international. The museum is starting to look at new models of online publishing for sharing research,[6] such as with its recent *Talk to Me* exhibition (July 24–November 7, 2011) curated by Paola Antonelli. The museum's Department of Architecture and Design documented the organizing and installation process for the exhibition with an online journal (http://wp.moma.org/talk_to_me/) that allows for public comments and features additional content such as links, readings, projects to research and projects completed, and feedback from members of the international design community. The website also has a link to its Twitter feed (@talktome2011 with 1,229 followers as of March 20, 2012) and the museum's official exhibition subsite (http://moma.org/talktome).

MoMA's website offers multimedia information for all its visitors. For educators (K–12), the Learn section of the website presents videos of how MoMA educators teach with art objects, online registration for workshops and courses, and online resources. Hidden within these resources is its subsite Modern Teachers Online (now called MoMA Learning), where educators can download PDFs of educator guides, PowerPoints, and worksheets, browse images from the

collection, or search lessons by subject, theme, medium, or text. Both text and images can be printed, projected, or saved for a classroom presentation. Interactive games include Art Safari and Destination: Modern Art, An Intergalactic Journey to MoMA and P.S.1, for kids ages five to eight. Modern Teachers Online also links to the archived teen website, Red Studio. The Adobe Flash–based Red Studio is now obsolete because it was incompatible with mobile devices and has been replaced by the new teen site PopArt (not featured on the teacher's subsite). However, Red Studio's videos and audio podcasts can still be heard online, and the online activities still function, such as Remix: an interactive collage, Fauxtogram: objects exposed, and Chance Words (make a Dadaist poem). MoMA Channels (under "Multimedia" in the Explore section of its website) brings together all the museum's audio, video, and interactive features under those three headings. Under "Audio" one can find the museum's free audio guide (MoMA Audio) and MoMA Talks, the video feature has videos from PopRally and the ongoing short film series *30 Seconds* of museum members and staff, and the interactive feature has Red Studio, Art Safari, and Destination: Modern Art, Modern Teachers Online, as well as current and past exhibition subsites.

Since 2007, the museum has created interactive websites for its physical exhibitions, offering unique online experiences that seamlessly accompany the onsite ones. One example is the exhibition *Andy Warhol: Motion Pictures* (December 19, 2010–March 21, 2011) that offered visitors the opportunity to create their own screen test (actually a video portrait), both online and onsite. The online component was part of the exhibition's subsite (http://moma.org/interactives/exhibitions/2010/warhol/#5631286414), where visitors uploaded their videos (up to ninety seconds) to the museum's Flickr group momascreentests. At the museum, a screen test booth was set up to record minute-long videos, which MoMA then projected on the walls of its Marron Atrium and later uploaded to the exhibition subsite. Allegra Burnette explains that museum visitors became part of a community of screen tests through the event, both at the museum and online. Another integrated example is the exhibition *Marina Abramović: The Artist Is Present* (March 14–May 31, 2011), where the exhibition subsite offered a live streaming webcam of the exhibition (actually a live performance by Abramović for the duration of the exhibition) that would "transmit the presence of the artist," as the website declares. Visitors to the physical exhibition opted to sit silently across from the artist for as long as they chose, and the museum took photographs of each sitter that were subsequently uploaded to the website (http://moma.org/interactives/exhibitions/2010/marinaabramovic/). The museum also offered free,

FIGURE 6.5
MoMA Guide, Museum of Modern Art, 2011.
Courtesy of the author.

live-streaming gallery tours of the exhibition through either the museum's website or its Facebook page, where visitors could submit questions through Facebook and Twitter @ttmtour. Presence at the physical museum, therefore, was equated to a virtual presence as mediated by digital technology.

Also at the museum can be found MoMA Guide in the form of computer monitors placed in various locations such as next to the restrooms on the first floor, in a seating area outside galleries on the second floor, and in the lobby of Café 2. The monitors have headphones for listening to audio and video programs, visitors can register for e-news, send e-cards from the museum's permanent collection by e-mail, and can search the online collections; the same functions that are accessible by visitors outside the museum using its website.

MoMA Audio is listed under both "Mobile" and "Multimedia" in the Explore section of its website, and clearly states that the program can be enjoyed by visitors both at the museum and at home. At the museum, visitors can rent the free audio players at two locations (floors 1 and 6), and at home they can listen to tracks directly from the website or as podcasts downloaded from iTunesU. MoMA Audio includes guides for kids and teens, visual descriptions for the visually impaired, and guides for special exhibitions, and the permanent collection is available in eight languages. After listening to these programs, visitors

are encouraged to create their own audio program, either for their next visit to MoMA with their MP3 player or for e-mailing to the museum to upload to the Multimedia section of its website. In its detailed instructions, MoMA includes a recent podcast submission as an example: *291* (http://moma.org/explore/multi media/audios/85) by visitor Jason Sneed, who created his program inspired by the 2006 museum exhibition *Dada*.

Also included under "Mobile" in the Explore section of MoMA's website are its mobile applications (apps). There are free apps for the iPhone, Android, and the iPad (*Ab Ex NY* and *MoMA Books*), and one for purchase on iTunes (Vincent van Gogh, *The Starry Night*). The website's Mobile page also has a QR (quick response) code to scan for the Android app. At the museum, the apps are advertised with a sign directly above the paper floor plan and guide brochures: "Save paper, view website and download free apps at MoMA.org/ mobile." MoMA has a mobile website (as do all five museums studied), which is not advertised in the Mobile section. The museum's most recent app *MoMA Books* allows visitors to download e-books onto their personal iPads. Visitors can download free samples, and once the books are purchased and the PDFs downloaded onto the iPad, they can zoom in on high-resolution images with a bookmarking feature. Currently the museum has five e-books that are listed in the Publications section of the website. Curiously, MoMA Books is not featured in the Publications or even Shop sections of its website. The *Ab Ex NY* iPad app won a 2011 Gold MUSE Award from the American Association of Museums in the new category of applications and APIs, and MoMA Mobile (including the multiplatform app and the mobile website) won a Silver MUSE award in the category of mobile applications.

MoMA/MoMA PS1's blog *Inside/Out* is featured in the Explore section and on the museum website's homepage with a link to the most recent post. In June 2011, the museum changed the appearance of its blog to better integrate it into the museum's website and its activities, as well as other social media. Facebook and Twitter are placed most prominently in the blog's right column with links to sign up or login, below which is placed Follow Us/Links for more social media (Facebook, Twitter, Foursquare, YouTube, Flickr, iTunesU, and RSS feed), and below that an e-mail link for "Have ideas or feedback?" The bottom navigation bar promotes activities at the museum with hyperlinks, such as current exhibitions, membership, MoMAstore.org, and PopRally. While MoMA's blog has more comments (535), posts (260, same as SFMOMA), and visits (921,000 in 2010) than all five museum blogs studied in the ten-month period of analysis, it

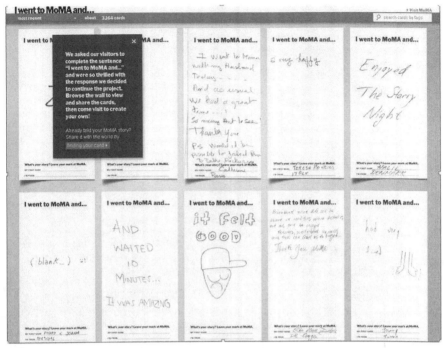

FIGURE 6.6
Museum of Modern Art website, I went to MoMA and . . . (12/5/11 screen capture).

is not exceptional for the ratio of comments to posts (2.1:1) or even comments to visits (1:1,721). The Indianapolis Museum of Art surpassed all five museums for those same ratios (3.2:1 and 1:275 respectively). MoMA places the authors prominently on top of each post with a link to their past posts, but with no biography. Only 3 percent of MoMA's posts during the ten-month period were by outsiders, which does not include artists and others participating in museum events and exhibitions, but does include postings in the Intern Chronicles by museum interns. This number, however, is not that unusual when compared to the Brooklyn Museum (4 percent), Walker Art Center (2 percent), and Indianapolis Museum of Art (8 percent).

Listed notably in the central column of *Inside/Out* under "Features" are the posts entitled "I went to MoMA and . . ." Starting out as a short-term marketing strategy targeting physical visitors, the museum placed cards and small pencils on top of tables in its second-floor restaurant (Café 2). The accompanying sign reads:

We'd like to share your story. Leave us a message, a drawing, a poem, an idea. We're interested in your day here—what you saw, felt, and thought. We may post it here: moma.org/iwent.

Due to its success, the program has been continued and is now highlighted on the museum's Web homepage with a link to its own subsite, offering a search function by tags, date of visit, or card identification number listed at the bottom of each card. So far the museum has digitized 18,137 cards (as of March 20, 2012), again providing a connection between the physical museum, its website, and blog.

MoMA PS1's artist website Studio Visit was mentioned briefly in the previous section, and is an important component of the museum's use of technology to better serve its visitors and community. Emerging artists from the greater New York area are invited to upload videos or still images of their studios and artwork, which are featured on the website for at least one month. The website supports New York–based artists by providing a highly reputable, global platform, and likewise helps the global arts community to gain a better understanding of the New York arts community. There are currently 1,768 artists on the site (as of March 20, 2012), searchable by last name, most recent entry, and location (with an interactive map of New York City). Each entry includes images of the artist's studio, exterior and interior, a Google satellite image of the studio location, images of the artwork, artist's statement, bio/resume, and e-mail address. The site also features Curators' Picks from both MoMA and invited curators that select artists of particular interest to highlight.

Studio Visit can be found under the Connect section of MoMA PS1's website along with its own social media (Facebook and Twitter). MoMA PS1 has 161,148 Facebook fans and 44,834 Twitter followers @MoMAPS1 (as of March 20, 2012). Visitors can register for the e-mail list in the Connect section where the hyperlink brings up MoMA's e-news page. Also in Connect is a link to the shared museum blog *Inside/Out*. While MoMA PS1 is clearly integrated into the overall MoMA structure, it still maintains its relative independence. MoMA links prominently to MoMA PS1 on the bottom left corner of its website homepage, but MoMA PS1's website is undoubtedly more minimalist, which promotes its distinct contemporary character. A link to the MoMA website is not found on the homepage or even under its eight headings.

Education is one of the priorities for MoMA and a priority which is well served by digital technology. The Internet gives a concrete visibility to the

more ephemeral experiences of education, says Wendy Woon. One of Woon's chief challenges is that "people don't value [educational experience] because they can't feel it or touch it or hold it like an exhibition or an object" (personal communication, April 11, 2011). In addition to MoMA Teachers Online and the abundance of online resources for teachers and children, the museum has recently embarked onto online teaching with online courses, which simultaneously serves the goals of both education and international reach. MoMA started with two pilot classes in fall 2010, and then increased them to three times a year in 2011. The ten-week courses are completely asynchronous, given the international composition of the classes, so that students can access all information at any time. Course information includes high-quality videos shot inside MoMA's galleries without the crowds, narrated PowerPoint presentations, text-based materials, and discussion forums where students and instructors post messages, comments, and questions. The two online courses currently offered are *Modern Art, 1880–1945* and *Materials and Techniques of Postwar Abstract Painting* (studio art class), each offered as either instructor-led or self-guided. The first class had twenty to thirty students and without advertising sold out, so the museum had to double the classes. Because not everyone chooses to participate actively, it was easy to increase the class size to forty-five with just one instructor. The class is essentially a digital version of the classes that MoMA has long offered in its physical spaces. Beth Harris, director of digital learning at the museum, admits that "what works face-to-face also tends to work online" (personal communication, May 23, 2011). Echoing Reed's analogy of the Internet being MoMA's third space, Woon refers to the museum's Online Courses as the New York dream,

> When you dream of finding another room in your apartment that you never had (that small space dream). In this case, the room has no floor, no crates, no insurance issues; it has this wide sense of possibility and it has to be an extension of what already exists and complement that in some way. (personal communication, April 11, 2011)

The educational experience, she continues, is "equal but different."

With online courses, the museum extends its reach globally (Spain, Australia, Canada, Venezuela, etc.), serving homebound visitors such as disabled persons or stay-at-home moms around the country, and connecting with all kinds of new communities. As diverse as is the local community of New York City, the museum could only achieve such a diverse, global classroom through the In-

ternet, and the multiplicity of voices is precisely what makes these courses so meaningful. One important advantage of online communities is the anonymity with which one participates (students post their profiles voluntarily), freed from the sociocultural constraints of MoMA's often-imposing physical environment. The students develop a deep social connection with one another because they share their different perspectives and knowledge, what Woon calls the "passion-ate affinity groups" that find each other through the museum. One of the biggest concerns for students was how to continue the relationships after the course ended, and so Harris created a Facebook page for MoMA Courses Alumni to extend the conversations between themselves and with museum staff, currently with 920 fans (as of March 20, 2012). What the museum learned through these courses, declares Woon, is that "there is a real passion for MoMA as a brand. They really want to be a part of this, they really believe in it and they really feel strongly about it. It's what they value about MoMA." Moreover, it is a great branding opportunity that furthers the museum's mission and generates rev-enue with student fees at $300 and $350 per course.

MoMA's most recent technological endeavor was with Google Art Project, released by Google on February 1, 2011, as "a unique collaboration with some of the world's most acclaimed art museums." Google initially selected seventeen international art museums to participate; four are in the United States, three of which are in New York City (MoMA, the Frick Collection, and the Metropoli-tan Museum of Art) and one in Washington, DC. Each museum selects its own artwork to be included: MoMA chose seventeen works by van Gogh, Cézanne, Seurat, Redon, and Rousseau, other museums chose up to sixty works. One work from each museum is shown in super-high resolution (seven billion pix-els). MoMA's gigapixel image is van Gogh's *The Starry Night*, accompanied by a museum-produced video that features visitors' perspectives on the painting. MoMA director Glenn Lowry praises the collaborative aspect of the project: "You can compare and contrast different museums at the same moment. That aspect of a community of museums, immediately accessible to a viewer anywhere in the world is fascinating" (as cited in Zirin, 2011). In addition to showcasing each museum's artworks, Google uses its Street View technology to show 360-degree views of the interior galleries. A panel on the right provides information on each artwork (Viewing Notes, Artwork History, and Artist Information), tags, a link to the museum's website, the museum floor plan, its location in Google Map, About the Museum, and YouTube videos. There is also a Share This Page link for e-mail and social media. With a Google account,

visitors can "Create an Artwork Collection" to build their personalized collections with comments on artwork that can be shared publicly.

Wendy Woon observes that early into his tenure as director of MoMA, Lowry was on record as being very interested in digital technology. "I think it took a while for the institution to catch up with him," she admits, "and I think it percolated at a very grassroots level." Lowry expresses many of his thoughts on digital technology in a video that is featured in Online Communities under the Explore section of the museum website. Lowry states,

> I think the digital revolution has been a very beneficial revolution for museums because it allows us to expand the ways in which we can reach and engage different audiences and at the end of the day it's driven by content and we're content-rich organizations. (as cited in Zirin, 2011)

Lowry comments further on what he believes to be the intimately linked relationship between the museum's "virtual and real space."

> You can't really disaggregate them at this point, and if anything they're collapsing. Virtual space, from a museum's perspective, can only exist as a result of real space. The growth in our audience online is largely the function of the growth of our audience onsite; the two are not unrelated. Clearly the online audience has a potential of growing faster and larger than anything we could do onsite. But we couldn't do what we're doing online if we didn't have our physical space in New York, where in fact the works of art do exist, and where we create the kinds of programs that are so engaging for our public. We can also create other programs online that are similar to, but can never be the same as those programs that exist in real space. So from my perspective, there's a kind of healthy, symbiotic relationship between our online presence and our presence in real space, and I suspect that over time we'll stop worrying about whether something is online and real space, and recognize that it's a continuum of experiences that are accessible and available to people at different points in their life. (as cited in Zirin, 2011)

Today, Reed, Woon, and Burnette all acknowledge that museum staff members are at various stages of comfort level and knowledge of technology. Much of the work at MoMA is increasingly accomplished collaboratively between departments, which requires not only reconfiguring physical spaces but also reassessing training and skill sets. The interlocking of onsite and online experiences and the repurposing of content and experiences across media and departments is a daunting task, even for an established, well-endowed institution such as MoMA.

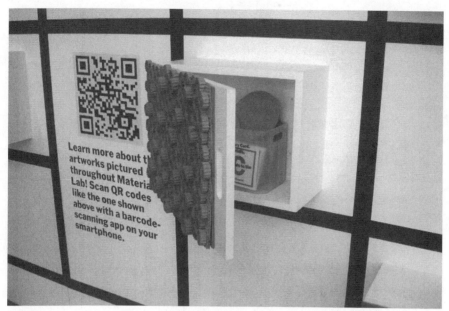

FIGURE 6.7
Material Lab, Museum of Modern Art, 2011.
Courtesy of the author.

Collaboration is a practical solution to achieving many of these lofty ambitions as MoMA continues adding to its online presence, but more importantly, collaboration contributes to greater cross-departmental understanding of how and why technology is central to museums today.

LESSONS LEARNED

Allegra Burnette explains how the museum's use of online content and technology serves to keep its current 135,000 members interested, engaged, and attached—particularly members *not* in the local area—and also to gain additional members. Because of the global nature of its local community, which is more New York City than just the borough of Manhattan, MoMA is able to focus concurrently on its local and global communities that are united symbiotically through its website, social media, and public programming. Furthermore, because of MoMA's international reputation as one of the world's leading museums of modern art, what happens at the physical museum is of interest to others around the world, further necessitating its integration of physical and virtual experiences. Wendy Woon describes these experiences as "equal but

different," just as are the museum's physical and virtual visitors and its three
venues: midtown, Queens, and the website. The physical space of the museum
is linked to the online space materially through MoMA Guides, MoMA Audio,
and the "I went to MoMA and . . ." cards. The online space is linked to the physi-
cal space through live streaming of events and tours, the Google Art Project,
online courses, and social media that offers photographs, videos, and comments
to the public on physical events. Although MoMA PS1's Studio Visit does not
reference the physical museum, it asks artists to upload photographs of their
studios' interiors and exteriors, and provides a Google satellite image of the
studio location. Most local, physical programs at the museum have online com-
ponents for marketing and knowledge dissemination, including PopArt by the
Teen Voices Project, PopRally, Modern Teachers Online, and Meet Me. MoMA
offers a distributed museum experience to all its visitors regardless of their local-
ity. Certainly, Glenn Lowry is correct to state that the success of the museum's
online and satellite presence is based upon and depends on the strength of its
midtown museum space, representing a central node within the growing net-
work of MoMA's distributed spaces and experiences.

Despite having 18 million online visitors a year, MoMA cannot ignore its local
audience that includes wealthy patrons, corporate sponsors, physical visitors, and
the 48.8 million tourists each year that are drawn to the city's physical attractions.
MoMA depends on earned income, particularly for general operating expenses.
The *2010 Alliance for the Arts* report shows that from 1999 to 2009, large orga-
nizations with budgets over $10 million in New York had a triple-digit income
in earnings and an increase in corporate funding, while foundation support and
government funding decreased. In 2010, admissions constituted 19.5 percent of
MoMA's total budget of $100.5 million, or $22.7 million (Stoilas & Burns, 2011).
MoMA's adult admission price increased from $12 to $20 in 2004, and then from
$20 to $25 most recently on September 1, 2011.[7] Smaller communities tend to have
free admission (Indianapolis), while those that attract more tourists can charge
high admission prices (New York and San Francisco). Higher admission prices
provide incentives for local visitors to purchase a museum membership, which in
turn solidifies a sense of community and loyalty, motivating museums to be more
innovative with members-only programming. For a museum that relies on earned
income and that has experienced a reduced endowment like most museums,
MoMA's website is a motivating factor to identify new means of revenue genera-
tion from the millions of online visitors that it attracts. This is a challenge that the

museum continues to successfully master through its new app MoMA Books, its online courses, and most markedly, MoMAStore.org.

The museum serves its local community admirably with its Access Programs and other public programming for teens, young adults, educators, artists, and special affinity groups such as film, contemporary art, and so on. It justifies the recent admission increase by the number of free days and times offered to the public and a reduced price for tickets ordered online. But the museum serves its online community just as admirably; in fact, MoMA.org has free admission for all visitors and is open twenty-four hours a day, seven days a week. The objects and experiences available online cannot be compared to MoMA's physical venues; they are "equal but different." Glenn Lowry reminds us that museums are content-rich organizations, a factor which has served as an asset for MoMA from its early days of collaborating with television studios to the present-day with the Internet (Google Art Project, MoMA Audio, online courses). MoMA's exhibitions and programs are indisputably of a high scholarly nature, contributing to its esteemed position as a leading authority on modern and contemporary art, which ironically explains its mass consumptive appeal on a physical and online level, as well as a local and global level. The museum is not largely interested in this mass audience to generate content, as with crowdsourced exhibitions, social tagging, or blog comments and posts that other museums employ; nonetheless, the museum looks to these masses to enlarge its community, to enrich it, and to fulfill its mission by "helping you understand and enjoy the art of our time."

NOTES

1. The project uses congressional districts as a geographic measurement, which does not exactly overlap borough borders. District 14 encompasses the central and eastern parts of the borough of Manhattan, where MoMA is located, as well as the western part of Queens (Astoria, Long Island City, and Sunnyside). Although the data suggest a prosperous, educated population, the district does not include other wealthy parts of Manhattan such as the Upper West Side and Wall Street.

2. Abstract Expressionism is also known as Action Painting, Color Field Painting, and Gestural Abstraction.

3. Santiago Grullón, senior director of research and analysis at NYC & Company, was extremely helpful in providing a number of reports breaking down tourism statistics for the city.

4. Certainly, these statistics vary within the different parts of New York City, which is why additional data for the boroughs and congressional districts paint a more detailed picture of the region.

5. The museum's website was last redesigned in March 2009, and in 2010, it won a Bronze MUSE Award from the American Association of Museums in the category of online presence.

6. It must be noted that MoMA decided *not* to participate in the Getty Online Scholarly Cataloging Initiative because it was busy pursuing its own related projects.

7. The Metropolitan Museum of Art has a suggested admission, but raised its fee to $25 as well during the summer of 2011.

The Brooklyn Museum

PLACE + LOCALIZED CULTURE

Brooklyn was first settled by the Dutch in the 1620s, representing the Dutch West India Company. Many believe that its name comes from the Dutch word *Breuckelen*, meaning broken land or marshland. The area had previously been home to the Nyack and Canarsie Native American Indian tribes that lived off the land by fishing and farming. From the 1630s until the early 1660s, what is now the borough of Brooklyn consisted of six towns: five settled by the Dutch (Breuckelen, Nieuw Amersfort, Midwout, Nieuw Utretcht, and Boswyck) and one by the British (Gravesend). Breukelen included today's Brooklyn Heights and DUMBO (Down Under the Manhattan Bridge Overpass) neighborhoods, Nieuw Amersfort is present-day Flatlands, Midwout is Flatbush, and Boswyck is Bushwick. Coney Island was originally called Conyne Eylandt, meaning Rabbit Island in Dutch, and Roode Hoek was the Dutch name for today's Red Hook neighborhood. The British seized power of the largely agricultural region from the Dutch in 1664, consolidating it with Manhattan to create the British colony of New York, and in 1683, Brooklyn's original six colonies were established as Kings County. The borough of Brooklyn is still considered Kings County today.

Brooklyn was the scene of many important battles during the American Revolution (1775–1783), including the first major confrontation led by George Washington, the Battle of Brooklyn (or the Battle of Long Island). Unfortunately, the Americans lost that first battle and the British occupied New York and Brooklyn for the remainder of the war. In the 1800s, Brooklyn emerged

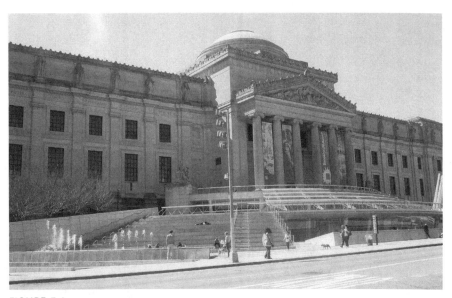

FIGURE 7.1
The Brooklyn Museum, 2011.
Courtesy of the author.

as an alternative residential area to Manhattan, offering abundant land and waterfront. The Brooklyn Navy Yard opened in 1801 on the East River, and Robert Fulton began steamship service between Brooklyn and Manhattan in 1814. Before that time, Brooklyn farmers crossed the river to sell their goods in Manhattan by horse-powered ferries, sailboats, and rowboats that would take an hour and a half to cross. Brooklyn incorporated itself as a city in 1834, and subsequently established its City Hall in 1846 (what is today's Brooklyn Borough Hall). By 1860, Brooklyn had become the third largest city in America (after New York City and Philadelphia) with a population of almost 267,000, an important international industrial center, and a port (U.S. Census, 1998). Merchants began buying land along the waterfront, and wealthy businessmen moved to suburban Brooklyn Heights for an easy commute into Manhattan. To facilitate rising transportation demands, the two cities decided to build a bridge, and the Brooklyn Bridge was completed in 1883. The new bridge not only brought more workers from Brooklyn into New York City (almost half of Brooklyn's working class), it also brought immigrants from New York City into Brooklyn looking for affordable housing. By 1860, 39 percent of Kings County residents were foreign born, compared to 47 percent of New York City (U.S. Census, 1999).

The city of Brooklyn continued to grow economically and culturally in the late nineteenth century. Brooklyn's largest industry at the time was sugar refining that produced most of the sugar consumed in the United States. Factories produced manufactured goods, and there were dockyards, gas refineries, ironworks, slaughterhouses, book publishers, and sweatshops that all employed thousands of workers. The renowned Brooklyn Academy of Music (BAM) opened in 1859 as the country's first performing arts center, the Brooklyn Historical Society opened in 1863 in Brooklyn Heights, and the 585-acre Prospect Park opened in 1867, designed by the famous landscape architects Frederick Law Olmsted and Calvert Vaux who designed Manhattan's Central Park just a few years earlier. Churches were built in the Gothic Revival and Romanesque Revival styles, banks and private clubs in the high Renaissance and Greek Revival styles, and brownstone mansions populated new residential areas like Park Slope and Crown Heights. Schools were created to serve the growing population of both workers and wealthy. The Polytechnic Institute was founded in 1854 as an engineering school, now part of New York University, the art school Pratt Institute was founded in 1887, and Saint Francis College was founded by a group of Franciscan Brothers in 1884. Transportation increased within Brooklyn itself, with the addition of street grids and electric trolleys in 1890. Yet there was still an ever-increasing need to connect with Manhattan, and so the Williamsburg Bridge was built in 1903, the first subway line was built under the East River in 1908, and the Manhattan Bridge was built in 1909. Nonetheless, in 1898 the city of Brooklyn agreed to become consolidated with New York City.

Today Brooklyn is the largest borough of New York City, with 71 square miles and 199 miles of waterfront. Kings County is the seventh largest county in the United States, the first largest being Los Angeles County. The 2010 census counted 2,504,700 residents in Kings County (New York City has a total of 8,175,133), surpassing the other three cities studied. All the same, New York City plans on challenging the census count because it marked a decline of 62,398 from 2009. It previously challenged the 2007 census count for Kings County, which resulted in the estimated population increasing by 11,156 residents. Brooklynites are proud of saying that if Brooklyn were still independent, it would be the fourth largest city in the United States.

Brooklyn has the largest population of African Americans of all five regions studied at 34.3 percent, which is its largest minority group. The rest of the population is 42.8 percent white non-Latino (the lowest of all five regions), 19.8 percent Hispanic/Latino, 10.5 percent Asian, and 0.5 percent Native American (U.S.

Census, 2010). The ethnic diversity of Brooklyn surpasses that of Manhattan: it has the nation's largest population of Caribbean Americans, Pakistanis, Turkish, Polish, Russians, as well as Orthodox, Hasidic, and Sephardic Jews, the second largest Greek population, and the third largest number of Chinese Americans. Bensonhurst was long known as Brooklyn's Little Italy, but has become home to a growing population of Chinese. Brooklyn also has one of the fastest growing populations of Latinos and Muslims in the nation. Today, 36.6 percent of the borough residents are foreign born, and 45.4 percent speak a language other than English at home (U.S. Census, 2010).

By 1930, more than 60 percent of blacks in Brooklyn were born outside the borough. That number increased when the A train was extended from Harlem to Brooklyn in 1936, bringing thousands of African Americans, along with Caribbean and West African immigrants, in search of affordable housing from an overpopulated Harlem. Blacks first came to Brooklyn just as they did to Manhattan, as slaves brought by European colonists to serve as workers, farmers, and domestic servants in the New World. Many slaves landed on Long Island (Brooklyn) so that their owners could avoid paying tariff duties to the authorities in New York harbor. Starting in the early 1800s, Brooklyn was a strong supporter of the abolitionist movement. Bedford was one of the nation's first free black communities, and the Plymouth Church of the Pilgrims in Brooklyn Heights was one the most important antislavery centers. In 1838, free black James Weeks purchased land from another free black in Crown Heights, creating the community of Weeksville as a safe haven for free blacks in the North and fugitive slaves from the South. Many Brooklyn churches (Baptist, Presbyterian, Quaker, Methodist, Episcopal) and private homes were stops along the Underground Railroad to protect fugitive slaves.

Several Brooklyn neighborhoods that were historically white, Jewish, and middle class became populated with blacks during the mid-twentieth century, creating major demographic shifts in the region that led to interracial tensions and clashes from the 1960s until the 1990s. The most prominent example is the Crown Heights Riot in 1991 that consisted of three days of rioting in August between Hasidic Jews and blacks, including African Americans, Jamaicans, Guyanese, and West Indians. The neighborhood of Bedford-Stuyvesant witnessed gang wars in the 1960s, race riots, and clashes with police, as did Brownsville, which today has the most public housing developments in New York City as well as some tenement housing and many abandoned buildings. During the famous New York City blackout of 1977, many of the poorer Brooklyn neighborhoods

such as Crown Heights and Bushwick experienced rioting, looting, arson, and clashes with police, followed by the crack epidemic of the 1980s. Today crime has decreased tremendously in most of these neighborhoods, leading to gentrification and increased housing prices. Brooklyn's poverty rate is 19.4 percent (families are 18.6 percent and individuals are 21.8 percent), higher than the national average of 13.2 percent but just under Indianapolis at 20.1 percent (U.S. Census, 2010). Brooklyn is also above the national average for all indexes (human development index, life expectancy at birth, at least bachelor's degree, school enrollment, median personal earnings, health index, education index, income index), but certainly not the highest of all five regions studied.[1]

A major factor contributing to the gentrification of Brooklyn is the recent influx of artists that are generating new, vibrant communities. While Manhattan served as the global destination for artists in the twentieth century (Greenwich Village and SoHo), Brooklyn has taken over in the twenty-first century. Ella Weiss, president of the Brooklyn Arts Council (BAC), declares that Brooklyn has become the "cultural capital" of New York City. Artists are drawn to its affordable housing and large studio spaces that are no longer an option in Manhattan, creating artistic communities all over Brooklyn such as Williamsburg, Red Hook, and DUMBO. These arts districts began in the 1990s and now include commercial galleries, alternative art spaces, expensive condos, trendy cafés, restaurants, and shops, connected to Manhattan by only a few subway stops. The BAC maintains an artist registry that maps the location of registered Brooklyn artists. A comparison of the registry maps from 2007 and 2011 reveals that artists are moving into new, outlying areas of the borough on the southern waterfront and other central neighborhoods. Artists themselves are being priced out of the now-gentrified artistic neighborhoods and are exploring previously blighted areas that have become much safer, albeit often located farther away from Manhattan. Brooklyn-based arts writer Carolina Miranda (2012) describes in *ArtNews* magazine the emerging arts scene in Bushwick, a working-class district next to Williamsburg with ample abandoned warehouses for studios and galleries.

In response to what the BAC refers to as "an extraordinary upsurge in locally-based artistic activity" at the turn of the millennium, it created a Directory of Brooklyn Arts Organizations in 2001, both in print and online, to serve the almost 800 arts organizations in the borough. The BAC's website (http://brooklyn artscouncil.org) offers an Artist Registry, Directory of Organizations, and BAC forum that it describes as "an online environment . . . to network, dialogue, share opportunities and work samples and discuss arts-related issues." The BAC

has operated since 1966, but only recently moved into its new space in an arts building in DUMBO. In 1980 it began to distribute grants on behalf of the New York State Council on the Arts and the New York City Department of Cultural Affairs, now called the Regrant program.

BRIC Arts | Media | Bklyn is a nonprofit organization that also supports Brooklyn artists since its inception in 1979. It has presented an online registry of contemporary artists from Brooklyn since 1983 on its website, and BRIC Community Media is the main source of television coverage about Brooklyn with its community-produced Brooklyn Free Speech TV and Brooklyn Independent Television. Also supporting the nonprofit community is the Brooklyn Community Foundation located in DUMBO. It began operating in 2009 and is funded largely by the Independence Community Bank that has been based in Brooklyn since 1850. Another important component of the Brooklyn arts scene is the Brooklyn Society of Artists, founded in 1917 to support artists living or working in Brooklyn. The society was later expanded to include artists living outside of Brooklyn, and in 1963 changed its name to the American Society of Contemporary Artists as the organization expanded nationally. Early on, the society held regular exhibitions at the Pratt Institute, the Brooklyn Academy of Music, and the Brooklyn Museum. The Heart of Brooklyn (HOB) is a key partnership that encompasses six major Brooklyn cultural institutions located in proximity: Brooklyn Botanic Garden, Brooklyn Children's Museum, Brooklyn Museum, Brooklyn Public Library, Prospect Park, and Prospect Park Zoo. Operating as an independent organization since 2001, HOB promotes cultural tourism to the central Brooklyn neighborhoods surrounding Prospect Park through collaboration with Brooklyn Tourism & Visitor's Center, NYC & Co. (the official tourism agency for New York City), and community groups. HOB encourages cross-programming between its six member organizations, and promotes these programs on its website.

The Brooklyn Chamber of Commerce supports the arts community with its successful project Brooklyn Designs, an annual juried show for local designers that attracts buyers around the world since 2008. The chamber also promotes Brooklyn as an emerging artisanal food center with its online promotional campaign Brooklyn Eats that started in 1997, and the related online campaign Buy Brooklyn. Brooklyn Borough President Marty Markowitz started the project Shop Brooklyn (http://ishopbrooklyn.com/) to promote local independent stores.[2] The borough's annual Brooklyn Book Festival has risen to international prominence, as have the Brooklyn International Film Festival and the Williams-

burg International Film Festival. The annual smART Brooklyn Gallery Hop is another initiative of the Office of the Brooklyn Borough President and Brooklyn Tourism that started in 2008. The Hop provides free buses to gallery districts around the borough, staffed with expert docents offering tips on collecting and buying art. Markowitz calls Brooklyn the "creative capital" of New York City and humbly describes his borough in a *2011 Strategic Policy Statement*:

> From music to food to film; from architecture to artisanal design; from immigration to innovation; from start-ups to sustainability to star power, the world is looking to Brooklyn—which has truly become the big stage. The days of calling Manhattan "the City" may be over. More and more we hear that visitors, tourists and young people looking to "make it" are not even setting foot in Manhattan! They're coming straight to Brooklyn. To them, Brooklyn is New York City!

Despite Markowitz's obvious bias toward Brooklyn, this is a sentiment increasingly shared by others. *Condé Nast Traveler* magazine lists Brooklyn as one of the fifteen best places anywhere in the world to see right now:

> Brooklyn's tide has been rising for the better part of a decade as hipsters, chefs, writers, and artists have fled Manhattan in search of more affordable . . . everything. As these stylish immigrants have filled the borough's old neighborhoods, they've transformed lowly bodegas into Michelin-starred restaurants, dive bars into wineries, abandoned warehouses into playhouses, and a gothic bank building into a massive flea market. (Payne, 2011)

GQ magazine named Brooklyn "the coolest city on the planet" and continues: "Don't take that as a knock on Manhattan, which is doing just fine. But for the first time since, well, ever, you can spend every New York minute of your trip on the far side of the East River and never feel like you're missing out" ("Brooklyn is the coolest city," 2011). The aging population of Brooklyn is decreasing and is being replaced by a younger generation more attracted to the hipness of the region. The 2010 Census reports that the largest group of Brooklyn residents (23.7 percent) is under eighteen years, and the second largest group (20 percent) is between the ages of thirty-five and forty-nine, while only 11.5 percent are sixty-five years and older.

In 2010, the Office of the Borough President reported that Brooklyn received fifteen million tourists from fifty-eight countries and forty-eight states. Brooklyn Tourism & Visitors Center[3] targets national and international tourists

that primarily come to New York City, marketing Brooklyn as a day trip from Manhattan, but acknowledges the sporadic international visitor that might have inside knowledge on the borough's cultural attractions. On the other hand, the tourism that HOB and local organizations target is mostly local. They admit that even Brooklynites have a hard time crossing neighborhoods to explore their own community, as many are accustomed to traveling into Manhattan for leisure activities. Brooklyn is a community that supports its own residents, cultural institutions, and history, but all the same, the lure of Manhattan remains strong as Brooklyn remains just one of the five boroughs of New York City.

THE MUSEUM AND ITS COMMUNITY

Mission Statement:

The mission of the Brooklyn Museum is to act as a bridge between the rich artistic heritage of world cultures, as embodied in its collections, and the unique experience of each visitor. *Dedicated to the primacy of the visitor experience*, committed to excellence in every aspect of its collections and programs, and drawing on both new and traditional tools of communication, interpretation, and presentation, *the Museum aims to serve its diverse public* as a dynamic, innovative, and welcoming center for learning through the visual arts. (emphasis mine)

The Brooklyn Museum was founded in 1823 as the Brooklyn Apprentices' Library in Brooklyn Heights. After the library moved into the Brooklyn Lyceum's building in 1841, the institutions merged two years later to form the Brooklyn Institute. The institute offered evening classes to accommodate workers, including various drawing classes (mechanical, architectural, landscape, and figure), exhibitions, and lectures. In 1890, civic leaders reorganized the institute as the Brooklyn Institute of Arts and Sciences that was intended to compete with the collections of New York's Metropolitan Museum of Art (the Met) and the American Museum of Natural History. The institute's Beaux Arts building opened to the public in 1897, built by the architectural firm McKim, Mead, and White. Its grand staircase, completed in 1905, was originally twice the height of the Met's famous steps. The initial design was intended to be four times as large as today's version, but was scaled back in a compromise with New York City government that owned the land. In 1899, the institute established the first children's museum in the world (the Brooklyn Children's Museum), and later expanded to include the Brooklyn Academy of Music, the Brooklyn Botanic Garden, and a separate Department of Education. The museum was one of the institute's many subdivisions and grew over the years to include its own department of fine arts,

natural sciences, and ethnology. In the 1930s, the museum decided to focus only on fine art and cultural history, and so its natural history items were disbursed to other institutions. All of the institute's subdivisions became independent in the 1970s, although the Brooklyn Museum today is legally called the Brooklyn Institute of Arts and Sciences, doing business as (DBA) Brooklyn Museum. The Brooklyn Museum belongs to the Cultural Institutions Group of New York City, one of thirty-three institutional members that are each located on city-owned property and receive significant financial and operating support from the city.

Augustus Graham (1776–1851) is considered the founder of the Brooklyn Museum. He and his "brother" (a euphemism for a probable homosexual relationship) John Bell started a brewery in upstate New York, among other businesses, which they later moved to Brooklyn in 1815. In 1822, Graham and Bell closed their brewery business and began a life of local philanthropy. Graham founded the Brooklyn Apprentices' Library to provide an alternative for young male workers drinking and gambling by offering books to read, lectures, and entertainment. In his will, Graham left the library $27,000 to establish a school of design and a gallery of fine arts. The design school that Graham envisioned first took the form of classes organized by the departments of fine arts and pedagogy at the Brooklyn Institute of Arts and Sciences, often in collaboration with local arts organizations such as the Brooklyn Art Association (founded in 1861). Later, classes were organized under the institute's Department of Education, which then became the Brooklyn Museum Art School. However, while the Brooklyn Museum's education division primarily served children, the art school served amateur artists. Notable artists that taught or studied at the art school include William Baziotes, Max Beckmann, Ben Shahn, and Donald Judd. In 1985, the art school was transferred to Pratt Institute's Continuing Education Division.

While the San Francisco Museum of Modern Art has been in competition with MoMA since its beginnings, despite being on opposite coasts of the country, the Brooklyn Museum has long been in competition with the Metropolitan Museum of Art; two encyclopedic art museums founded in the late 1880s, located in the same city just a few subway stops away. The founders of the Brooklyn Institute of Arts and Sciences wanted to build a collection—as well as an exterior stairwell—that would rival the Met's that opened fifteen years prior. Today, the Brooklyn Museum is the second largest art museum in New York City after the Met, with more than a million and a half objects. The Brooklyn Museum's African collection, moreover, is the largest of any American art museum today with over 5,000 objects, and in 1923 it organized one of the first exhibitions of African art in the

United States. Philippe de Montebello, former director of the Met, comments on the Brooklyn Museum:

> The problem with Brooklyn is that it's competing with the Guggenheim, the Whitney, the Met, MoMA, all the galleries, El Museo del Barrio—you name it. I don't know of any museum so marginalized by its locality and demographic change. The Detroit Institute of Arts and the Cleveland Museum of Art are struggling. But at least those institutions are the one thing in town, so you can still promote them as, "Come and see great works of art." (as cited in Pogrebin, 2010, August 5)

Yet despite the fact that the Brooklyn Museum and the Met are both located in New York City, they each have highly distinctive neighborhoods and institutional priorities. Manhattan has a proportionally higher number of tourist attractions and museums, and Brooklyn still has a reputation for crime and unrest. Like the Met, the Brooklyn Museum has a world-class collection of art (African, Egyptian, American) and international connections with regard to institutional partners and scholars, yet unlike the Met and other Manhattan art museums, the Brooklyn Museum considers the borough of Brooklyn to be its community, first and foremost. The volunteer Brooklyn Museum Community Committee has worked to raise awareness of the museum in the community through various programs since 1948.

Just as the early history of the Brooklyn Museum was well integrated into the community of Brooklyn, so is the modern history of the museum, largely due to the efforts of Dr. Arnold L. Lehman, the museum's current director since 1997 and a highly controversial figure that inspires either loyalty and praise or fierce criticism. Just one year into his tenure, Lehman inaugurated First Saturdays at the museum that initiated Target's corporate sponsorship of the now nationwide museum program. Target First Saturdays offer free general admission on the first Saturday of each month (from 5 p.m. to 11 p.m.), extended evening hours, free family events, gallery tours, live performances, films, a cash bar, and more activities. Visitors to Target First Saturdays comprise a quarter of the total museum visitors, and on July 3, 2010, there were a record 24,000 visitors. On these Saturdays, the Heart of Brooklyn operates HOB Connection, a free shuttle that runs circuitously between the Brooklyn Museum and places to eat, drink, and shop in the surrounding neighborhoods.

The museum also maintains a strong educational program with New York City schools, providing teachers with resources (online and print), teacher train-

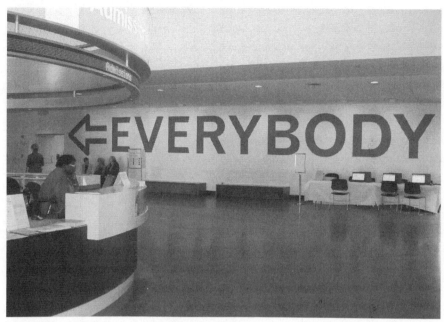

FIGURE 7.2
Lobby and Visitor Center, Brooklyn Museum, 2011.
Courtesy of the author.

ing workshops, monthly meetings at the museum, a five-day academic Teacher Institute, and an Education Gallery at the museum. In 2000, the museum started the Museum Apprentice Program, hiring teenagers in local high schools to give tours in the museum galleries during the summer, assist with weekend family programs, help plan teen events, and serve as a teen advisory board to the museum with a Teen Night Planning Committee. The museum is dedicated to serving teens, offering a Teen Guide to Art in the museum's collections, opportunities for internships and work-study programs, art classes, online activities (Ancient Egypt and Basquiat: Street to Studio), and links to social media on its website (MySpace, YouTube, Flickr, and Brooklyn Museum Teens on Facebook that has 725 fans as of February 28, 2012).

In 1999, Lehman was responsible for creating the current mission statement for the museum that places a priority on visitor experience and recognition of the museum's diverse public. To better serve this diverse public of Brooklyn, which demographics show is younger, multiethnic, and largely African American, Lehman embarked on an equally diverse exhibition program for the

museum that critics deride as overly populist. And he began with a bang. *Sensation: Young British Artists from the Saatchi Collection* (October 2, 1999–January 9, 2000) was first organized by the Royal Academy of London and traveled to the Hamburger Bahnhoff in Berlin, attracting hundreds of thousands of visitors before its only North American stop at the Brooklyn Museum, where the museum claims attendance increased 55 percent. Popular criticism of *Sensation* centered on the work *The Holy Virgin Mary* (1996), in which artist Chris Ofili covered the Virgin Mary with elephant dung, but it also extended to works by artist Damien Hirst, and even purportedly self-interested sponsors of the exhibition that included Christie's auction house and Charles Saatchi, owner of the collection. The controversies escalated into a court battle between New York City mayor Giuliani and Arnold Lehman. The mayor, backed by many senior city officials and religious organizations, threatened to cut off all funding to the museum (its monthly payments totaled $497,554), to replace its board of trustees, cancel its lease, and assume possession of the museum building, unless the museum cancelled the exhibition and removed *The Holy Virgin Mary* immediately, stating that taxpayer dollars should "not be used to support the desecration of important national or religious symbols, of any religion." In response, Lehman did not back down but rather defended the museum's first and fourteenth constitutional amendments that guarantee free speech and equal protection under the law. On September 28, 1999, the museum sued the city of New York and Rudolph W. Giuliani, both individually and in his official capacity as mayor, in the U.S. District Court, Eastern District of New York (99 CV 6071). Two days later, the city retaliated with a court order to evict the museum from its city-owned land and building. After this controversy quickly became an international scandal in the arts world and public media, the courts ruled against the mayor who agreed to settle with the Brooklyn Museum. Not only did the city of New York reinstate funding to the museum, but committed to provide $5.8 million in additional funding from executive budgets for physical improvements to the museum. Nevertheless, in spite of this great victory over public censorship of the arts, the ramifications lingered in the art world, as explained by James Cuno, former president and director of the Art Institute of Chicago and current president and CEO of the J. Paul Getty Trust, in his book *Whose Muse? Art Museums and the Public Trust*:

> Charges of blasphemy, pornography, and financial corruption were made against the Brooklyn Museum and for months stuck to the public image of museums as

such. Museums appeared elitist, both in the sense that they decided what was and what was not art, even at the expense of the feelings of the public, and because they partied and even perhaps partnered with the rich and famous. (2004, p. 14)

Following *Sensation*, the Brooklyn Museum presented two highly popular exhibitions, in terms of an increased audience and pop culture content, which also elicited criticism of the museum and its director as pandering to the masses instead of lifting them up to the level of the museum. The first was *Hip-Hop Nation: Roots, Rhymes, and Rage* (September 22, 2000–December 31, 2000), organized by the Rock and Roll Hall of Fame and Museum in Cleveland, Ohio. The exhibition included clothing, video, interactive D.J. stations, and artifacts of many Brooklyn-born hip-hop artists. The exhibition *Star Wars: The Magic of Myth* (April 5, 2002–July 7, 2002) was organized by the Smithsonian Institution Traveling Exhibition Service and debuted at the National Air and Space Museum in Washington, DC, where it attracted over one million visitors and was one of the most visited Smithsonian exhibitions of all time. Another popular exhibition was *Andy Warhol: The Last Decade* (June 18–September 12, 2010), organized by the Milwaukee Art Museum and critiqued as "flawed," "spread thin," and "imperfect" by critic Roberta Smith (2010) in the *New York Times*. The Brooklyn Museum organized *Who Shot Rock & Roll: A Photographic History, 1955 to the Present* (October 30, 2009–January 31, 2010), which did not receive negative reviews but rather charges of "dumbing down" the museum.

Also controversial was the museum's involvement with the 2010 Bravo reality show on cable television, *Work of Art: The Next Great Artist*. On the television show, contemporary artists from across the United States compete for a cash prize of $100,000 and an exhibition at the Brooklyn Museum. Judges included a New York magazine art critic, gallery owners, and an art collector; art auctioneer Simon de Pury was a mentor to contestants, and Brooklyn Museum's curator of contemporary art, Eugenie Tsai, advised in the final selection. The winner was Abdi Farah, whose exhibition at the museum was titled *Luminous Bodies* (August 14–October 17, 2010). The *New York Times* critic Karen Rosenberg (2010) denounced Bravo's marginalization of curators that were brought in at the last minute, and its elevation of an auction house. Criticizing the Brooklyn Museum, she writes, "The museum's affiliation with Bravo's 'Work of Art' is most worrying as a symptom of something bigger: a dampening of curatorial vision under the institution's director, Arnold Lehman." The *Village Voice* had a similar rebuke for Lehman, "You can't blame a 22-year-old for lunging at the

brass ring and, God bless him, snagging it. You've got to wonder, however, about the museum directors who allowed TV sharpies to foist this thoroughly mediocre exercise upon their venerable institution" (Baker, 2010). Dr. Lehman (2010) once again fought back against his critics in a letter to the *New York Times*:

> The Museum's current program is based upon both a very long and prominent history at the Museum of populist programming to engage every wave of immigration to Brooklyn from the beginning of the 20th century to the present—a truly amazing century-long commitment to new and underserved audiences. . . . The commitment to best engage our Brooklyn community—2.7 million strong—and the commitment to using our collection have worked together to create the most diverse and youngest audience of any general fine arts museum in the country. Our interest is in who is coming to the Brooklyn Museum—and embracing them—not in their numbers. We are looking ahead in this century, not backward to the early 20th. . . . The Brooklyn Museum seizes upon our location as a great asset in ensuring that we remain relevant in the 21st century, which is perhaps the greatest challenge to almost every cultural institution anywhere.

The Brooklyn Museum partnered with the program's second season that began on October 12, 2011, again hosting the winning artist Kymia Nawabi with a museum exhibition that proved its independent and strong-willed spirit.

Part of the problem that the museum faces with these popular exhibitions is a concurrent decrease in overall visitor attendance (23 percent in 2009). Lehman defends this fact by arguing that attendance fluctuates; rising with exhibitions that are more popular such as *Murakami* (April 5–July 13, 2008), then decreasing when the museum presents less popular and more scholarly exhibitions. For example, in 1998, the museum had 585,000 visitors, in 2006 it had 300,075 visitors, and in 2009 it had 340,000 visitors.[4] This issue was brought to public attention in an article in the *New York Times* by culture reporter Robin Pogrebin, entitled "Brooklyn Museum's Populism Hasn't Lured Crowds" (2010, June 14). There were seventy-two comments on the museum's website (and many more on Twitter) that revealed a great divide between fans and critics from both the general public and the arts community. The cultural journalist Lee Rosenbaum (2010) posted two separate interviews of Lehman on her blog *CultureGrrl*, one with a video calling Lehman "Brooklyn-tough" for facing such continuing public challenges. Museum blogger Museum Nerd (2010) also defended the museum by demonstrating that a reduction in staff in 2009 might be responsible for decreasing visitor attendance, and stating that the museum appears to be succeed-

ing in attracting the types of visitors that best reflect Brooklyn's demographics. Pogrebin even quotes New York City commissioner of cultural affairs Kate D. Levin as stating, "Arnold doesn't get enough credit for being a real pioneer in audience development." Pogrebin refers to a 2008 museum report that reveals the average age of the museum's visitors as thirty-five, compared to fifty-eight when Lehman first arrived in 1997, now more reflective of Brooklyn's current demographics. The report also shows that about half of the museum's visitors came for the first time, 40 percent are from Brooklyn, and over 40 percent identified themselves as "people of color."

In addition to new public programming and popular exhibitions, the museum has embraced its Brooklyn community by supporting the new generation of artists that contribute to its younger, more diverse population, and hip reputation. Sociology professor Vera Zolberg (1992) discusses the Brooklyn Museum as a case study for how museums work with artistic communities. As early as 1968, the museum had a Community Gallery for younger, emerging artists, organized not by museum curators but by a separate advisory committee from various Brooklyn neighborhoods. In 1985, the museum launched a new series of exhibitions with contemporary Brooklyn artists called Working in Brooklyn, in which the museum promoted the artists with public, social events. This program was revisited in 2004 for the museum's exhibition *Open House: Working in Brooklyn* (April 17–August 15, 2004) to celebrate the opening of its new entrance pavilion. The exhibition included works created since 2000 by 200 Brooklyn-based artists, including emerging, midcareer, and long-established artists such as Vito Acconci, Louise Bourgeois, Rico Gatson, Martha Rosler, and Danny Simmons. After the museum's Great Hall was redesigned in 2011 to accommodate more large-scale artworks, the Brooklyn-based Situ Studio inaugurated the space with its installation, *reOrder: An Architectural Environment by Situ Studio* (March 4, 2011–January 15, 2012). Most recently in September 2011, the museum initiated Raw/Cooked, a year-long series of five exhibitions by emerging Brooklyn artists for ten-week periods each, marking the first major museum exhibition for these artists. In 2011, the museum's annual Brooklyn Ball was renamed the Brooklyn *Artists* Ball in order to highlight the museum's partnership with local artists. The museum's website promoted the event: "Join us as we celebrate the art, creativity, and influence of Brooklyn artists and the Museum's role as a cultural gateway." At the ball, the museum honored well-known Brooklyn-based artists Fred Tomaselli, Lorna Simpson, and Fred Wilson; it featured an animated video environment in the Great Hall by Brooklyn-based video artist and designer

Sean Capone; and table decorations were designed by Brooklyn-based artists. Nonetheless, Ellen Salpeter, director of Heart of Brooklyn, acknowledges that Brooklyn artists remain dissatisfied with the museum. She explains that,

> The museum really is a great community partner, but Brooklyn artists always ask, Why isn't the Brooklyn Museum showing our work? It isn't a community gallery. Can you imagine people asking that of MoMA? But there's an expectation because they've done such a good job at being the community museum. Hey, I'm a Sunday painter and I should have my landscapes in your lobby. (personal communication, April 15, 2011)

In its continuing efforts to make the museum more accessible, the Brooklyn Museum made major improvements and renovations to existing buildings starting in 1991, designed by Arata Isozaki & Associates and James Stewart Polshek and Partners. The first addition was the 460-seat Iris and B. Gerald Cantor Auditorium, replacing the museum's original theater that was converted into the lobby more than fifty years earlier. The museum then renovated 3,000 square feet of gallery space spanning three floors in the museum's Morris A. and Meyer Schapiro Wing, although they temporarily closed the fourth floor in 2009 due to staff reductions. But the most visible changes did not occur until 2004, with the addition of a new 15,000-square-foot shingled-glass entrance pavilion facing the Eastern Parkway, echoing the original staircase that was removed for structural reasons in 1939. The 9,000-square-foot lobby was also renovated and now includes a full-service visitor center with digital signage. Along with these physical changes, the museum embarked on a strategic branding campaign with a new minimalist logo and a name change (from Brooklyn Museum of Art back to Brooklyn Museum), which Lehman says "better reflected the visitor-centered goals of the Museum." The new entrance pavilion, however, received a great amount of criticism, mostly surrounding the contemporary design set against the original Beaux Arts buildings, but surprisingly, the media was more favorable than the public. Herbert Muschamp (2004), architecture critic for the *New York Times*, wrote that the pavilion "has got a precise if not wildly imaginative grip on its place in urban history" and that the new interior "is potentially the best new public space New York has seen in years. In effect a winter garden, or orangerie, this is crystal palace architecture." The new pavilion provides transparency with its floor-to-ceiling glass panels, as well as flexible space for public programming and school groups. Ellen Salpeter describes how the Brooklyn Museum uses its new spaces to embrace the community.

The renovation was all about opening up the museum. No one ever hung out in front of the museum. Now there are benches, a dog run, free wifi, and in the summer you'll have 100 neighborhood people sitting in front of the museum. It's been about being a place for the community, without ceding scholarship or connoisseurship. (personal communication, April 15, 2011)

The street-level entrance was critical to welcoming the community in contrast to great museum staircases that imply transcendence and superiority. Even when the museum's original staircase was dismantled, it was replaced by dark, leaded doors that were uninviting. "It's not a museum on the hill," reiterated Salpeter, but more like what Lehman describes as "your favorite park."

Like the Met, the Brooklyn Museum has a suggested admission fee, but at a much lower amount. While the Met charges $25 for adults, $17 for seniors, and $12 for students (suggested donation), the Brooklyn Museum charges $12 for adults and $8 for seniors and students. The museum receives a substantial amount of contributions and grants ($35,657,735 in 2009), considerably higher than the Walker, IMA, and SFMOMA, and also in 2009 it made $3,483,794 in earned income (exhibition fees, admissions, space rentals, programs, parking

FIGURE 7.3
Entrance Pavilion of the Brooklyn Museum, Thursday Night program, 2011.
Courtesy of the author.

lot). The museum's endowment is the smallest of all five museums at $75,453,774 (2009), but Pogrebin reports that its endowment is back up to $85 million as the museum regains losses that it suffered in the stock market (2010, June 14). The museum is also supported by its 8,000 members, 250 1stfans (socially networked fans of Target First Saturdays), and only two collections support groups, the Asian and Feminist Art Councils. Although Lehman defends his low attendance numbers, he admits to being disappointed. "It's the one thing that frustrates me more than almost anything else," he says. "I've always felt, Where are all the people who should be here?" (as cited in Pogrebin, 2010, June 14). The Brooklyn Museum's diverse exhibition program, its public programming, and its renovated spaces must be understood by its visitor-centric mission and not compared to Manhattan-based museum models. The Brooklyn Museum's community is principally Brooklyn, but its vision certainly reaches outside of Brooklyn to attract visitors from the greater New York area, tourists, and to participate fully in the global art world. Digital technology provides the museum with innovative solutions that address its small advertising and marketing budget, and its unique visitor demographic.

THE ROLE OF DIGITAL TECHNOLOGY

In alignment with the museum's mission, technology has a visitor-oriented approach that targets both its physical and online visitors. The museum does not distinguish between these two; nevertheless, the differences are prominent as it acknowledges that most of its visitors do not carry smartphones, iPads, or MP3 players (iPods). The permanent collection galleries are more traditional like SFMOMA and IMA, with older, interactive screens inside the Egyptian galleries, electronic comment screens outside some galleries, and object labels for the cell phone tour. Part of the museum's Luce Center for American Art is a 5,000-square-foot Visible Storage and Study Center for public viewing that has a database inside the facility and also online, searchable by map (if you are onsite), theme, and advanced search. Shelley Bernstein, the museum's chief of technology, explains that technology should always be in the background at the museum. "When it becomes the focus," she continues, "we have failed" (personal communication, April 14, 2011).

The Brooklyn Museum introduced laptop computers into its galleries in 2008, first with *Click! A Crowd Curated Exhibition* (June 27–August 10, 2008) and then with *The Black List Project* (November 21, 2008–March 29, 2009), where they were used as an initiative by the education department for visitors to

FIGURE 7.4

Egyptian Galleries, signage for mobile tour, Brooklyn Museum, 2011.

Courtesy of the author.

create personal videos related to race and its impact on their lives, called *Community Voices*. As a photography exhibition, *The Black List Project* started out incorporating film with the HBO documentary *The Black List: Volume One* that premiered at the Sundance Film Festival in 2008, then aired nationally and was presented in its entirety throughout the exhibition. Inside the gallery, the museum set up two laptops that it had already used for *Click!*, it created a separate YouTube channel for the exhibition, and used a webcam for visitors to directly record videos that were sent live to the channel using YouTube's Quick Capture feature. Visitors recorded a total 482 videos, 236 of which stayed on the YouTube channel (after staff moderation), and 96 went to the Brooklyn Museum favorites playlist. There were 43,386 total video views, and one video (recorded by a museum security guard) was viewed over 23,000 times when it was featured on YouTube during Martin Luther King Jr. Day. The exhibition's channel was also given nonprofit status at YouTube that activated auto-play for the videos. Faced with the challenges of a minimal budget, minimal staff time for editing, time constraints, and the need for low technical barriers for visitors, the museum found a creative and simple solution. Bernstein (2008, November 4) sums it up with, "Presto, a working video kiosk with no overhead! I couldn't be more excited that we were able to find a Scrappy-Doo solution that got us over the technical and budgetary hurdles." In posting her analysis of the experiment in the museum's blog (2009, March 30), Bernstein reflects that given more preparation time she would have allowed gallery visitors to comment on and rate other videos, and she would have highlighted video favorites in the gallery next to the recording area so that visitors could get inspired by others, thereby "closing the loop and bringing the voices back into the gallery."

The Brooklyn Museum subsequently introduced iPads for the exhibition *Subjective Subversion: Women Pop Artists, 1958–1968* (October 15, 2010–January 9, 2011) at its Elizabeth A. Sackler Center for Feminist Art. The exhibition was another great example of bridging the physical and virtual divide. The iPads in the gallery displayed twenty-five Wikipedia articles in English on women pop artists that were created by the exhibition team through its extensive research on the subject. As Bernstein (2010, October 14) describes the project they called WikiPop, "First, how do we share the research and, second, how do we do it in a way that won't overwhelm the visitor experience? Wikipedia + iPads became the answer." The iPads allowed visitors to read the articles and also to browse through the entire English Wikipedia while standing in the gallery and sitting in lounge areas in the exhibition. Bernstein reports that there were over 32,000

visitors to the exhibition, and approximately 12,000 sessions on the iPads. For many visitors this was their first experience using an iPad. After noticing that most visitors did not pick up the devices from their stands, the museum added a sign; "Psst . . . It's okay to pick up the iPad." Bernstein comments on the success of the project:

> Overall, this project worked well on many levels. A high percentage of visitors utilized the devices for long periods of time going pretty deep into the wiki catalog, but also staying focused on exhibition content. Given most people come to museums with other people, the iPads turned out to be a social device which engaged people in a way that seemed natural to their visit. The information in the wiki articles on these 26 artists is now out in the world via Wikipedia and will contribute to information sharing beyond our exhibition. This leaves us likely to do it again at the next opportunity. (2011, January 28)

The museum contributing its research to Wikipedia made a much larger impact than just on its own website. WikiPop's twenty-five articles are available on the museum's website, each with a hyperlink to the articles on Wikipedia that still remain active.

The museum found that iPads in the gallery are more successful for groups of visitors than individual audio tours. One such example is the exhibition *Youth and Beauty: Art of the American Twenties* (October 28, 2011–January 29, 2012) that illustrates the museum's integrated approach to technology. In the physical exhibition, a popular culture timeline of the period was created along a wall, using words and photographs placed next to objects in acrylic cases atop a shelf. In between objects on the shelf were placed four iPads with an interactive program for visitors, the same program that is available on the museum's website. The program uses Google Images to present photographs from the American 1920s for visitors to select and compare with images in the exhibition. The exhibition subsite on the museum's website neatly arranges information by curatorial text on the left side, and on the right side images from the exhibition, hyperlinks to Twitter and Facebook, and then the categories of media (the interactive program), talk (visitor comments, blog posts), print (catalog, teacher packet), and events. Below these categories is a description of the exhibition's audio program with commentary by outside contributors.

There are two major exhibition projects which the Brooklyn Museum undertook to better engage its visitors. They are both fun, entertaining, and make a strong, direct connection between the online and physical spaces of the museum.

The first is *Click! A Crowd Curated Exhibition* (June 27–August 10, 2008). The *Click!* subsite is archived on the museum's website and displays Results, Blog, Podcast, and Blurb Book. *Click!* was organized by Bernstein (then manager of information systems at the museum) and inspired by James Surowiecki's 2004 book *The Wisdom of Crowds* that claims "a diverse crowd is often wiser at making decisions than expert individuals." In *Click!*, Bernstein applies Surowiecki's premise to making subjective decisions about evaluating works of art. First the museum put out an open call for artists to electronically submit a photograph on the theme "Changing Faces of Brooklyn" together with an artist statement. After the month-long open call ended, there was a six-week period of online audience evaluation of all 389 submissions that were presented on the museum's website without artist attribution. Part of the evaluation process included visitors categorizing their own knowledge of art and perceived expertise as a factor of their geographic location. The museum placed a number of constraints on the evaluation process in order to minimize the influence of others, since the wisdom of the crowds is most effective when each person works as an individual. A total of 3,344 online visitors[5] evaluated the photographs on the basis of aesthetics, photographic techniques, and how well they represent the exhibition theme, rating them on a sliding scale from most to least effective. *Click!* concluded with an exhibition at the Brooklyn Museum, where seventy-four works (the top 20 percent) were installed according to their ranking from the online evaluation process, with the more popular works enlarged. The museum placed laptops in the gallery, created a virtual tour of the museum for the exhibition subsite, and planned a *Click!* meetup for the Target First Saturday in July 2008 to "say hello in real space," according to Bernstein. The exhibition resulted in very similar rankings and an amazing amount of agreement among the evaluators, regardless of their knowledge level, demonstrating that knowledge was a less important factor in evaluating art. The museum's curator of contemporary art, Eugenie Tsai, supported the experiment from the beginning as a different type of exhibition, admitting that it successfully achieved its goals, but that collective intelligence will not replace curatorial expertise. The exhibition empowered the masses in the curatorial process by providing a space within the museum (online and physical) for their voices to be heard. As Bernstein stated, "Web 2.0 is about people and their interaction with technology, not about technology itself" (as cited in a museum video of a panel discussion on June 28, 2008).

A second, more recent, museum exhibition project utilizing public participation was entitled *Split Second: Indian Paintings* (July 13, 2011–January 1, 2012),

organized by Bernstein in consultation with Joan Cummins, the museum's curator of Asian art. This exhibition was also inspired by a book, *Blink: The Power of Thinking without Thinking* (2005) by Malcolm Gladwell. Bernstein describes her initial thinking for the project:

> The book explores the power and pitfalls of initial reactions. After reading it, I started to wonder how the same theories might apply to a visitor's reaction to a work of art. How does a person's split-second reaction to a work of art change with the addition of typical museum interpretive text? As visitors walk through our galleries, what kind of work are they drawn to? And if they stop, look, read, or respond, how does their opinion of that work change? (2011, February 3)

Similar to *Click!*, *Split Second* began with a ten-week online evaluation process, and three months later culminated in an exhibition at the museum. The project was centered on the museum's collection of Indian paintings dating from the fifteenth to the nineteenth centuries, which ranks among the top ten in the United States. Many of the works are very sensitive to light and consequently are not exhibited frequently, which makes them a good candidate for online evaluation. *Split Second* presented a total of 180 works and offered visitors three scenarios with which to evaluate the works, designed to demonstrate how different types of information, or lack of information, might affect one's reaction to works of art. The first scenario (the split-second task) presents visitors with a randomly generated pair of paintings for only four seconds and asks which they prefer. In the second (the engagement task), visitors were asked to write about a painting before rating it on a scale, thus showing the potential effect of participation. The third scenario (the info task) gives visitors unlimited time to view the works together with typical interpretive text. The exhibition presented seventy-eight of the works viewed online—those that generated the most controversial and dynamic responses during the evaluation process—along with computer screens to understand the online process and visualizations of the data collected (available under Stats in the archived exhibition subsite). Of the total 4,653 online participants, the majority was from New York City and spent more than twice the average time on the activity. Bernstein wrote, "I'll never forget seeing this map in Google Analytics, which so clearly visualizes what happened online—a local audience found us and they took this project very, very seriously" (2011, July 13). In reviewing the results, Cummins remarked that she was surprised people rated complex images higher than more brightly colored, straightforward images. She states,

People have asked me if the results of the *Split Second* experiment will change anything about the way I present works of art in the galleries and I have to say that the answer is probably no. Mostly that's because I'm not trying to sell anything in the galleries. I'm not in the business of giving people what they like. The one place where we want to give people art that they can instantly like (or at least find engaging) is in choosing the images we use for our advertising. Maybe the results of *Split Second* can give us some insight into the kinds of Indian paintings we choose for promotional materials in the future. Those images can get people into the galleries and then I'll take it from there. (2011, December 21)

What is remarkable about these two projects is how they are thoroughly archived on the museum's website, how much local participation these online projects generated, and also how the museum was able to transform a "digitally

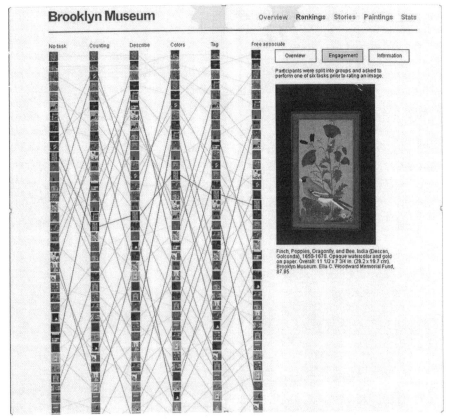

FIGURE 7.5
Brooklyn Museum website, *Split Second* Rankings (12/21/11 screen capture).

born" project to a pretty traditional exhibition within a physical gallery. Bernstein asserted, "I believe it is vital that digital projects inhabit the museum in real space, not just sit online" (2011, July 13). The field of visitor's studies has entered the twenty-first century at the Brooklyn Museum, and the results are open to the public.

Another example of online visitor participation that connects to the museum's collection was the museum's June 2011 campaign to increase Brooklyn's presence on Historypin, a crowdsourced social website that seeks, in its own words, "to build up a more complete understanding of the world." While the website initially had no historical images of Brooklyn, the Brooklyn Museum has 3,574 images in its collection from the late nineteenth century. As the museum began digitizing its photographic collection, it posted images on its Flickr Commons account hoping to enlist volunteers to geotag the images (tagging with precise geographical coordinates) so they could be displayed on Historypin using its Google Street View technology. Although the museum could identify many of the images, it also asked the public to provide any additional metadata such as who took the photographs, exact dates, and from where they were taken. The photos on Flickr were sorted into "mystery" images that lacked information on their location, and "solved" images. The project was again led by Bernstein, who rallied all Brooklynite fans with a call for "Let's represent!" While New York still has a disproportionately greater amount of photos than Brooklyn, Brooklyn is indeed represented on the site. The Brooklyn Museum is now an institutional partner of Historypin with its own profile on the website, where it continues its mystery-solving, collections-based project.

The museum's website was last redesigned in 2004, which some might call archaic in this rapidly changing digital age. Nevertheless, the website does a very good job at providing interactive experiences for the online visitor, at making connections with the physical museum and its exhibitions and events, and at linking with social media and the museum's blog. The Brooklyn Museum Labs is located under the "Collections" heading, described as "a new area of the website where we try out features and other cool, creative things." Three projects are currently listed in Labs: What Is Love? ("a comparison of the various ways Web visitors love our objects"), Where in the Wikiverse Is the Brooklyn Museum? ("an investigation of what happens to our images after we upload them to the Commons"), and Split Second: Indian Paintings.

What is most significant about the website, however, is the extent to which it aims to create a sense of community. On the top navigation bar, one of the ten

Brooklyn Museum

Community: #mapBK

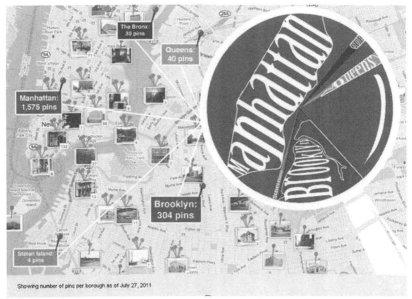

FIGURE 7.6
Brooklyn Museum website (12/21/11 screen capture).

headings (e.g., "Visit," "Support," "Exhibitions," "Shop," "Press") is "Community," which prominently states,

> The Brooklyn Museum believes in community and in the importance of the visitor experience. In this area you'll find a number of ways to connect with us: blogs, photo and video submissions, podcasts, and more. We look forward to hearing from you.

Under "Community" is included Posse (to be described later), Comment (sorted by exhibitions and archives), Blog, Network (social media), FourSquare, Photos (shows eight user-generated photos with a link to the Brooklyn Museum Group on Flickr), Videos (shows four user-generated videos and a request to e-mail the museum after uploading videos to YouTube), Tumblr, Podcast Archive (links to iTunesU and YouTube and archives from 2006), and RSS Feeds. The Community section was developed in early 2007 after the museum successfully experimented with social media and digital interactives starting in 2006. Nicole Caruth, formerly interpretive materials manager at the museum, and Bernstein in her former position as manager of information systems, discuss building an online community at a 2007 Museums and the Web conference:

> Having now developed a backbone of various Web 2.0 ventures, we gathered and combined them into one area on the Brooklyn Museum's Web site and called it "Community." The move allowed for more visible Web participation and permitted the unification of our two on-line audiences: the Web 2.0 communities and our general Brooklyn Museum Web site visitors. In addition to this special area, we are working to integrate community features more directly into all areas of the Web site. For example, when putting the Museum's collection of Brooklyn Bridge-related materials on-line, we also created a community area in which visitors can share their own photos and artworks of our community's iconic bridge. By providing e-mail addresses for feedback when we produce such Web projects, we are able to communicate with our visitors directly. Our commitment to community on the Web site will continue to evolve with each new exhibition and as we keep abreast of new developments in Web 2.0.

Despite the temptation to call the Community section a hub for the museum's engagement with social media and its online visitors, Bernstein resists, calling hubs more of a marketing tool. Bernstein explains, "I'd rather not create a hub and instead have a genuine presence in the networks we are on—posting when we have something to say and keeping communication from a personal voice instead of an institutional one, when possible" (2011, September 7). This strategy comes from understanding that visitors prefer to have the convenience of all-inclusive social networks, rather than having to leave those sites to find information on other places, such as the museum's website.

The museum's website has many other features that make it community friendly. It is available in fifty-two languages, far superseding MoMA's website that is in seven languages. And furthermore, while MoMA's translated pages

cover only the basic information pertaining to visits, the Brooklyn Museum has all its Web content translated through Google Translate, including exhibitions, collections, calendar, and more. Another unique feature of the museum's website is the About section, which lists eighteen curatorial staff and provides a photograph and biography for each (although no direct e-mail or telephone number). The museum also provides photos and biographies of its staff when they post blog entries. Museums are notoriously private, and while most museum websites list only their departments or the most important staff names, the Brooklyn Museum is participating proactively in its own community by sharing information about its own members.

The Brooklyn Museum's internal community consists of its staff, trustees, and members, including the approximately 8,000 general members, 235 1stfans, and 123 posse members (as of February 29, 2012). The museum launched its 1stfans in January 2009 as fans of Target First Saturdays, created by Bernstein and membership manager William Carey. The membership group is aimed at young visitors, given the low cost of $20 a year and its dependence on social media. Carey depicts 1stfans for *Fundraising Success Magazine* (2009):

> There are two primary demographics we're trying to reach with 1stfans. The first are our monthly Target First Saturday visitors, who repeatedly come to the museum for this free event but have not, historically, joined the museum as members. The second group is our Web followers, who live both near and far, and enjoy our online initiatives but also have not, historically, joined as members. We wanted to create a new structure for membership that makes membership more appealing for these two groups, while also providing benefits that appeal to them given their relationship with the museum at a low cost (both for us and for 1stfans). Our overall goal is to grow the museum's community of supporters through personal relationships with 1stfans both on-site and online.

As the first socially networked museum membership, 1stfans successfully bridges the physical and the virtual with online promotion and social interaction that directly relates to physical museum events. Social media includes the museum's accounts on Facebook, Flickr, and Twitter, as well as Meetup. com that serves as the group's central hub (http://meetup.com/1stfans/). By joining the 1stfans Meetup group, members receive announcements about museum events. Meetup also provides a list of 1stfan members by photo and personal comments, discussions, group reviews, photos, and tags that describe the Meetup and connect to Meetup Worldwide. A meet-up event is organized

for 1stfan members every Target First Saturday. Two of the more practical benefits are skipping the lines for movie tickets and coat check on those days, but the socializing that occurs both online and physically is also a great draw for members. From January 2008 to November 2010, 1stfan members also benefited from a Twitter Art feed, organized by Bernstein and the museum's curator Eugenie Tsai that together selected a featured artist each month, either by invitation or open call process. The featured artist would then tweet, using Twitter as a medium for art, and the museum described each project with a blog post. The Twitter Art feed is now archived on the 1stfans section of the museum's website, which curiously is not listed under the heading "Community," but under "Support" and then "Membership."

Another digitally enhanced membership group is the Posse, described on the museum's website in the Community section as: "pos•se: n. a large group, often with a common interest." There is no fee to join the Posse (which is presumably why it is not listed under "Membership"); rather, members register and create a profile with as much information as they like, including screen name, image, links to personal websites, and blog posts. The main objective of the Posse is to play collection-based tagging games with other Posse members on the museum's website, such as Tag! You're It! and Freeze Tag! These games are innovative ways in which the Brooklyn Museum encourages its online visitors to create and edit tags for its online collection, which in turn helps other visitors to find the objects. While Tag! You're It! is about creating tags, Freeze Tag! is about editing them. Posse members can flag certain tags for removal (currently the museum states that 2,796 tags in their collection have been challenged, marked with a red X), and then other members provide a second opinion about the tags' relevance. Tags, comments, and favorites are all displayed on Posse profiles, as well as any sets that members create to organize and share objects. Tags appear under the Collections section of the museum's website that currently contains 96,836 digitized items (as of March 21, 2012), with a link to play the two games and a list of the Collection Tags on the right side. On the bottom of the page are featured Recent Comments, Recently Favorited, and Recently Tagged Objects by Posse members. Posse members are very active on the museum's website, despite not yet being integrated with the museum's social media.

The Brooklyn Museum has the most active and diverse use of social media, compared to the five museums studied. In the Community section of its website is the heading "Network," where the museum lists its social media: Facebook, Flickr Commons, Tumblr, Yelp, iTunesU, Flickr, Twitter, Foursquare, and

YouTube. There is repetition on this page, presumably for the sake of emphasis and access, because "Photos" and "Videos" are prominent headings, under which are listed not only Flickr and YouTube respectively, but also sample photos and videos, and a podcast archive. "Foursquare" and "Tumblr" are separate headings under "Community." On the bottom navigation bar of the website are seven hyperlinked logos: Facebook, Google Plus, Twitter, Flickr, YouTube, Foursquare, and the museum blog (in WordPress). The museum also maintains accounts/pages on the photo-sharing website Instagram, Meetup (for its 1st-fans), Blip.tv for videos, Historypin, and until recently, MySpace. The museum is not equally active on all sites, however, with less activity on Blip.tv, Tumblr, and Foursquare. The Brooklyn Museum uses Foursquare very differently than MoMA, which uses it for museum staff to promote spaces and events at the museum (the Walker only recently joined Foursquare and does not yet have many tips, people, or check-ins). The Brooklyn Museum uses Foursquare to promote spaces and events *around* the museum's neighborhood with tips provided by both museum staff *and* the public.

The museum began to explore social media in early 2006, first with Blip.tv and then MySpace and Flickr. For the exhibition *William Wegman: Funney/ Strange* (March 10–May 28, 2006), the museum installed a video by Wegman called *Museum* in its lobby, which challenged Caruth and Bernstein to find a way to provide that same experience also to their online audience. With no way to integrate video into their website at the time, uploading to Blip.tv was a simple and fast solution that also let the museum track views and have public comments. Caruth and Bernstein (2007) explain their action: "It was the basic impulse of wanting to share—the impetus that drives most Web 2.0 sites." They comment on the results:

> Suddenly, we had two audiences: first, our regular visitors; and, second, a substantial new audience from Blip.tv, made up of people viewing our content on-line even though they might never have come to our homepage otherwise. Community happened instantly, and our visitors were giving us direct feedback on the video by posting comments.

The second exploration occurred concurrently with the exhibition *Graffiti* (June 30, 2006–September 3, 2006). Again, the challenge was to link the physical experience in the museum with a virtual one on the website. Alongside twenty large-scale graffiti paintings from influential artists were two blank walls designated

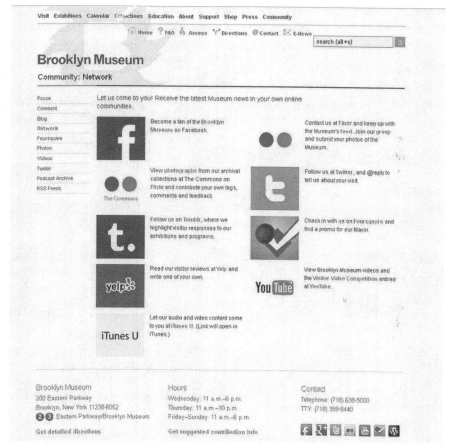

FIGURE 7.7
Brooklyn Museum website, Community: Network (2/29/12 screen capture).

for visitors to "tag" graffiti style for the duration of the exhibition. These walls became known as the *Museum Mural*. The museum took weekly photographs of the mural and uploaded 357 of them to its new Flickr account. The photographs are now archived on the museum's Flickr page as Brooklyn Museum Graffiti Wall (http://flickr.com/photos/brooklyn_museum/sets/72157594171809720/) with a link to the exhibition subsite. Online visitors to the museum's website were invited to create "virtual" graffiti using an online drawing tool that offered a virtual spray can, marker, pencil, or pen. They were then given the option to submit their work to the museum for public display on its website, listing only their name and location. A total of 1,388 of these virtual graffiti drawings were submitted and are archived on the exhibition's subsite.

The museum utilized Flickr to establish the first museum archive of lo-
cal street art during the *Graffiti* exhibition, entitled *Graffiti in Brooklyn*. The
public was asked to take photographs of existing street art from their local
Brooklyn neighborhoods and e-mail them to the museum, which the museum
then uploaded to its Flickr account during the exhibition; 913 photographs
were submitted to the archive. Caruth and Bernstein (2007) report what they
learned from *Graffiti*:

> The plan was a success in terms of sheer numbers, and an even bigger success in
> terms of mission. We had discovered that community on the Web didn't necessar-
> ily mean programming on our own site. On the contrary, seeking out our audience
> in their own Web communities (Flickr, MySpace, Blip.tv), was even more power-
> ful. After all, why should we expect them to come to us?

At the end of the exhibition, the *Museum Mural* was viewed 12,488 times
online, and *Graffiti in Brooklyn* was viewed 12,376 times. The museum's
MySpace page gained over 3,000 friends, largely aided by local street artist El-
lis G. who was interviewed for the museum's podcast series and had a popular
presence on MySpace.

In November 2007, the Brooklyn Museum launched ArtShare, an art-sharing
application on Facebook intended to create greater accessibility to the museum's
online collection by going to where its visitors are, mainstream social network-
ing. Bernstein describes the application:

> You can select works from the Brooklyn Museum collection to display on your
> profile. But then, because social networking is about connecting and seeing what
> others contribute to the social fabric, anyone can also use *ArtShare* to upload their
> own work and share it with others. You can use *ArtShare* to select a wide variety
> of work, then each time your profile is loaded a different work will be displayed at
> random from your selections. (2007, November 8)

ArtShare was also on Facebook pages for institutional homepages, as the Brook-
lyn Museum invited other art institutions to participate, including the Walker
Art Center, the Metropolitan Museum of Art, and the Powerhouse Museum
in Australia. In 2008, ArtShare won a silver award in the online presence cat-
egory of the American Association of Museum's MUSE awards, as well as its
Jim Blackaby Ingenuity Award. ArtShare was short-lived, unfortunately, due to
frequent changes in Facebook's API (application profiling interface) and profile

design layouts. The Facebook community began using fewer applications, perhaps for these reasons, and so the museum found that usage decreased over time.

In 2011, a provocative article appeared on the technology blog *ReadWrite-Web* by Richard MacManus, raising the question of how much social media is enough and citing the Brooklyn Museum as a case study. Here is a summary of the article:

> Some museums are trying to be more creative with social media, but step one is to make use of the main tools. Brooklyn Museum is certainly doing that. It has a main web site, a blog, a Facebook Page, a Twitter presence, a Flickr account, a Tumblr, a Foursquare, and more. Unfortunately, a closer inspection reveals that many of those social media accounts are infrequently updated. Perhaps Brooklyn Museum would be better off focusing on one or two of the tools and using those selected tools creatively. There may be lessons here for other organizations attempting to cover all social media bases.

MacManus is certainly correct regarding the infrequent updating of some social media by the Brooklyn Museum; however, the global museum technology community immediately defended the museum en masse. The article received 729 Tweets, 156 LinkedIn share, 63 Facebook recommend, 13 on Google Plus, and 20 online comments. One of those comments was by Bernstein, who also wrote her own museum blog post two days later to address MacManus's concerns. Bernstein describes the museum's experience with MySpace and how it intends to close that account due to increasingly lower usage and higher difficulty managing the platform. Even though many MySpace users had migrated to Facebook a while ago, the museum recognized that its visitor demographics (young, African American, multiethnic, poorer) was the same group drawn to MySpace, which was often characterized as a "ghetto" space compared to Facebook, which initially had a more white, middle-class, collegiate demographic.[6] Bernstein explains how the museum's social media strategy is consistent with its community-driven mission: "As our audience moves from one platform to another or as platforms modify beyond recognition, we'll change with them and that can mean making difficult and carefully studied decisions about when to stay and when to go" (2011, September 7). Bernstein also clarified the museum's social media strategy: stay personal, stay away from marketing, update when we have something specific to say, and keep the noise to a minimum. This is a very different strategy from most museums that tend to focus on the quantity over quality of information they release on social media. Today, four Brooklyn

Museum staff tweet from different departments (visitor services, exhibitions, collections, digital media), and Bernstein tells them to only tweet the essential. Nevertheless, Twitter is by far the museum's most popular social media site, currently with 349,637 followers, followed by Facebook with 53,913 fans, then Flickr with 2,483 contacts, and YouTube with 2,483 subscribers (as of March 21, 2012). The Brooklyn Museum closely examines how these media facilitate true visitor engagement, and Bernstein admits her disappointment with Facebook.

The museum's blog is a more effective way to engage deeply with visitors online, particularly for Bernstein and her technology department that is responsible for the blog. Of the five museums studied, the Brooklyn Museum's blog had the least amount of posts in the ten-month period of analysis (75), but a good ratio of comments to posts (2.9:1).[7] It also had the least amount of posts by outside bloggers (4 percent), and restricts posts by museum interns and temporary staff. The Brooklyn Museum's blog, however, was the highest rated for the number of technology-related posts (36 percent) by a diverse group of authors from the following museum departments: Technology, Sackler Center, 1stfans, Arts of Asia, Library & Archives, Publications, Conservation & Egyptian Art, and Photography. Bernstein is listed on the blog as its most active author, and her posts consistently receive a large number of comments as she reaches out to her colleagues in the field of museum technology and other interested readers by providing detailed information on technology projects, their successes and failures. She also responds to most comments and questions in her blog postings and is the only author on the blog that has an e-mail link in her biography.

It is important to mention Brooklyn Museum's mobile program, which also serves as a conduit between its online and physical offerings. In August 2009, the museum introduced a new mobile tour for smartphones called BklnMuse. This tour was designed for in-gallery use where visitors first connect to the museum's mobile website (http://m.brooklynmuseum.org) through its WiFi network, or simply call numbers placed next to the objects with their traditional mobile phone (cell phone audio stops). Bernstein describes BklnMuse as "a gallery guide that is designed to complement the more structured museum experience. In its most basic form, it's a community-powered recommendation system for the objects that are on display here" (2009, August 26). The Web-based tour offers images of the works as well as commentary from curators and the public, connects to the museum's YouTube videos, and is interactive by allowing visitors to customize their own tours, suggest works to friends, and tag works (Gallery Tag!)

that go directly into the online collection (more like a scavenger hunt through the galleries). Posse members can bookmark their favorite works by logging on through BklnMuse. Bernstein admits that the museum's mobile program was a failure mainly because it was such a solitary experience, because of its low usage, and because of the propensity for what she calls "screen glue" (personal communication, April 14, 2011). The museum has since discontinued BklnMuse, but today offers an audio gallery program by PocketMuseum that consists of four options: for visitors to use their personal cell phones to call a number at the museum for certain labeled works (the museum offers a printed map of all stops), to download podcasts (currently 36) for free at home using a personal MP3 player, to rent an MP3 player at the museum ($5 for nonmembers, free for members), and to listen to content on the museum website for specific exhibitions. The audio tours currently cover three permanent collection exhibitions—American Identities, Egypt Reborn, and *The Dinner Party* by Judy Chicago—in addition to any tours created for temporary exhibitions.

The museum released its collections database API as open source on the Creative Commons website on March 4, 2009, after its collection came online in October 2008, and since then has witnessed a number of individuals outside the museum using the API to create applications based on the museum's collection for iPads, iPhones, browsers, and mashups.[8] In April 2009, a developer from Brooklyn-based Iconoclash Media, Adam Shackelford, created the free Brooklyn Museum Mobile Collection application for iPhones. Later, in June 2010, the Brooklyn Museum created its own free application for the iPhone. These two apps were both offered in the iTunes Store, creating confusion for visitors. The museum changed its API terms to distinguish between apps originating from the museum and externally. Given this confusion, as well as the fact that Shackelford moved from Iconoclash Media to Caravan Interactive, also Brooklyn-based, the museum decided to temporarily remove the apps and reintroduce them later. In May 2011, another independent app was released on iTunes; this time by developer Wayne Bishop called the Art Collections iPad app, providing access to over 25,000 works. Nevertheless, Bernstein admits that visitors mainly use the apps for pre-visit basic information or for browsing elsewhere, and not so much inside the galleries.

In April 2011, Bernstein expressed a desire to terminate all applications and devices at the museum, but from her blog postings she appears satisfied with the current use of iPads for groups of visitors in the museum's *Youth and Beauty* exhibition. Bernstein explains her approach to mobile tours:

It is our responsibility, collectively, to try new approaches and provide as many entry points into content and the museum as possible. In terms of Brooklyn's people-focused mission, we believe a people-focused application is the way to go. The curated content is already on the walls in the form of object installation, labels and didactics, in-gallery multimedia and gallery design. The power of the device means we can provide something else, something more unique. We believe leveraging the power of our visitor's voices in combination with our own is a worthy goal. (2010, October 5)

Trying to provide entry points for all kinds of visitors is an expensive endeavor when only some visitors have the latest digital devices. On the other hand, most visitors have mobile phones, which explains the endurance of the museum's cell phone audio program. The museum also offers iPods for rent with audio tours, iPads for visitors to interact more deeply with exhibition content, paper brochures in Chinese, Russian, Spanish, and English, and both traditional comment books and digital comment screens. In October 2011, Bernstein began a year-long trial period for introducing QR codes into the museum. She reports that because of the very low usage in the building they may work best for special projects, especially when compared to the pre-QR code use of various applications, but "we probably need to stay away from it as a baseline visitor amenity if we are to be at all inclusive about how we serve content" (2012, January 4).

LESSONS LEARNED

The Brooklyn Museum was recognized by the federal Institute of Museum and Library Services (IMLS) with the 2011 National Medal for Museum and Library Service, described in an IMLS press release as "the nation's highest honor for museums and libraries for extraordinary civic, education, economic, environmental, and social contributions." In 2006, the museum won the Jim Blackaby Ingenuity Award from the American Association of Museums (for the teen website for its 2005 exhibition *Basquiat*), and in 2008 it won the Forrester Groundswell Award for Social Impact for three of its programs (ArtShare, *Click!* exhibition, and Posse). The museum has also received national awards for its scholarly work, including the 2006 AAM Curators Award for Excellence, for "Outstanding Catalogue Based on a Permanent Collection" (*American Paintings in the Brooklyn Museum: Artists Born by 1876*). Charity Navigator gave the Brooklyn Museum a score of 62.22, by far the highest of all five museums studied (the closest is the Indianapolis Museum of Art at 60.59, the Walker is 47.8, SFMOMA is 54.57, and MoMA is the lowest at 43.23). The independent

rating service evaluates nonprofit organizations by their financial health, organi-
zational efficiency, and organizational capacity. So then, how can an art museum
be simultaneously so highly recognized and criticized, serving a population that
is poor, multiethnic, and marginalized, and lying in the shadows of one of the
greatest art centers of the world (Manhattan)? What is its secret?

Perhaps the very location of the Brooklyn Museum is the answer to its
success. Perhaps the museum can afford to be risk-taking, controversial, and
independent-minded precisely because it lies in the shadows of Manhattan.
Despite the Brooklyn Museum's world-class collection and curatorial staff, it
cannot compete with the budgets, legacies, and fame of Manhattan art museums.
Brooklyn can also not compete with Manhattan as far as its residents (on the
basis of wealth and education) and its number of tourists, both of which con-
tribute to the wealth of its cultural institutions. When Philippe de Montebello
compared the Brooklyn Museum to the struggling Detroit Institute of Arts and
the Cleveland Museum of Art, he noted that those institutions "are the one thing
in town" as opposed to the Brooklyn Museum that must compete with Manhat-
tan museums. He called this competition a problem, and declared the museum
"marginalized by its locality." What de Montebello neglected to observe, how-
ever, were the opportunities afforded by this marginalization. Undoubtedly if
museums have large enough endowments—such as the Indianapolis Museum of
Art—they can afford to take risks and be innovative (even controversial), but the
Brooklyn Museum has an endowment of $75.5 million in 2010, up from $69.4
million in 2009 (the other four museums studied have endowments well over
$100 million). The popular phrase "necessity is the mother of invention" is par-
ticularly applicable to the Brooklyn Museum. One example is how the museum
uses third-party software (WordPress) for its blog to keep up with new software
developments despite not having programmers on staff.

De Montebello also notes another "problem" of the Brooklyn Museum: the
demographic change of its community. Again, de Montebello sees problems when
he should see opportunities. Brooklyn is a community that has continuously expe-
rienced change since the time of colonial explorers in the seventeenth century and
their introduction of African slaves. Thanks to Manhattan, Brooklyn welcomed
its poor immigrants at the same time that it welcomed its wealthy industrialists,
and today it welcomes artists as they escape the overcrowded, overpriced island
across the Hudson River. Brooklyn is a global community, but in a very different
way than Manhattan; it is a community of global immigrants and artists more than
global tourists and corporations. The Brooklyn Museum has a *local* community of

visitors that is *global* in nature. Responding to its local constituencies of African Americans, East Africans, West Africans, Asians, and Latinos, the museum creates innovative programming that connects to its permanent collection of works from Egypt, Africa, Islam, Asia, and the Americas. The demographic of Brooklyn is also younger, which offers an opportunity to produce socially focused programming online and onsite, creating social capital and bonding the already tight community of Brooklyn while still focusing on its contemporary art and photographic collections and incorporating local Brooklyn artists. The challenge with the more economically disadvantaged demographic of Brooklyn, however, is its general disconnect with technology and social media; I say general because while the younger population may not have their own digital devices, they are certainly familiar with them and will find ways to publicly access the Internet and social media, such as at the centrally located Brooklyn Public Library just down the street from the museum. The robust online experiences on the museum website demonstrate an understanding of locality over physicality. Whether or not the museum's physical visitors from Brooklyn and the greater New York area come and visit, the website provides them with an equally rich art experience that serves either as substitution or supplement to the physical visit.

The art world criticized the Brooklyn Museum for being too "populist" with its exhibitions and public programs, but the museum is successful because it confidently knows its community and dares to reach out to that community, responding to its needs and affinities that are sometimes scholarly and sometimes entertaining. The museum has had the freedom to experiment and pilot new programs, adapting to the changing needs of its community and the world around it, with the enthusiastic support of its equally courageous and controversial director Dr. Arnold Lehman. This agility and flexibility is important with digital technology that is constantly changing and introducing new platforms, devices, and opportunities for organizations that desire a greater interaction and communication with their public. Shelley Bernstein once told an audience that to use social media correctly, the museum must experience it the same way that the public does, 24/7. Another reason for the success of the Brooklyn Museum is the tenacity of Bernstein, her curiosity to experiment, her ingenuity to make things happen with limited staff and budget, and her commitment to sharing with her colleagues and the public. Bernstein has worked at the museum since 1999, initially as an assistant in the Egyptian department; she is a true Brooklynite who lives in Red Hook, although born in Houston. In 2010, she was listed in the "40 under Forty" list by Crain's New York Business. Many museums

hesitate to embark on digital projects because of the extra amount of staff time needed, which is true indeed, as Bernstein affirms. However, to Bernstein, her job is driven by a strong affinity toward digital technology and loyalty toward both the visitor-centric mission of the museum and its local community.

The Brooklyn Museum strives to be an egalitarian collective more than a network or even a community which both require a certain degree of hierarchy. The museum engages its visitors, local community, and local artists in order for them to actively participate in the museum, often facilitated by digital technology. Bernstein speaks of the museum's digital strategy that moves with its audience from platform to platform, that seeks out audiences in its own Web communities, and that leverages the power of visitors' voices in combination with those of the museum. The museum's use of technology is indeed culturally determined, reflecting firstly the culture of the museum as visitor-centric, and secondly reflecting the culture of those very visitors that it serves.

NOTES

1. Data taken from *Mapping the Measure of America 2010–2011*, which measures by congressional district. The Brooklyn Museum is located in Congressional District 11 that includes central Brooklyn areas surrounding Prospect Park (Park Slope, Prospect Park South, and Crown Heights) and Downtown Brooklyn.

2. In his *2011 Strategic Policy Statement* (Office of the Brooklyn Borough President), Markowitz states that 90 percent of Brooklyn businesses employ twenty people or less.

3. The Brooklyn Tourism & Visitors Center is located inside the Brooklyn Borough Hall and operates cooperatively with NYC & Co., but with its own website (http://visitbrooklyn.org/).

4. The Brooklyn Museum does not give out visitor statistics, unlike the other four museums studied, despite a request to the museum's Public Information Officer, so these numbers were taken from Judith Dobrzynski's article (2011, April 5) in the *Wall Street Journal.*

5. The exhibition's subsite reports that 46 percent of the online evaluators were from Brooklyn, 17.5 percent from New York City, and 5 percent from outside the United States.

6. In her blog post, Bernstein references danah boyd's 2007 article *Viewing American Class Divisions through Facebook and Myspace* that revealed many of these demographic characteristics of the social media.

7. I was unable to calculate the comparable ratio of comments to visits for the Brooklyn Museum because the museum did not disclose its annual number of blog visits, as did the other four museums.

8. All the applications are listed on the museum's website in its Application Gallery (http://brooklynmuseum.org/opencollection/api/docs/application_gallery).

Greater Than Five

SUPPORTING PLACE, COMMUNITY, AND CULTURE IN THE DIGITAL AGE

This chapter serves as a supplement to the five case studies just reviewed in great detail. While these five museums selected are the most technologically innovative art museums in the United States today, in the holistic way described, this book would be remiss if it did not acknowledge other notable examples of situated technology praxis in museums. But first, we must recognize a major factor contributing to "Greater Than Five": the external support provided to these institutions by governmental agencies and private foundations. Museums in the United States and around the world rely both on public funding and private donations (individuals, corporations, and foundations), but to a greatly varying degree. These external funding bodies not only provide capital, but often influence the direction of museums, arts organizations, and communities through their particular initiatives.

In the United States, the three main governmental bodies that fund museums and the arts are the National Endowment for the Arts (NEA), the National Endowment for the Humanities (NEH), and the Institute of Museum and Library Services (IMLS) that presents a National Medal Award to ten museums and libraries each year. In 2009, former IMLS director Dr. Anne-Imelda Radice described the medal winners as "institutions that demonstrate innovative approaches to public service, exceeding the expected levels of community outreach." Upon presenting the 2010 IMLS awards, First Lady Michelle Obama declared:

While some of your work may be national in scope, ultimately your most powerful impact is local. Each of you is an integral part of your community. Each of you strives every day to meet the needs of the people who walk through your doors.

The Brooklyn Museum won the award in 2011, and the Indianapolis Museum of Art won it in 2009. The Japanese American National Museum (JANM) in Los Angeles was a 2010 recipient of the award and is another particularly interesting case study. JANM has organized various exhibitions reflecting the ethnic and racial diversity of not only Japanese Americans, but also of its community of Los Angeles. One such exhibition was *The Power of Place: Boyle Heights* (September 8, 2002–February 23, 2003) that explored issues of immigrants, multiculturalism, and community building in one of the city's oldest neighborhoods. From the center of Jewish life in Los Angeles to a Chicano stronghold in East Los Angeles today, the neighborhood was never an important part of Japanese American culture in Los Angeles, but served to create strong connections between the museum and its local placement at the edge of Boyle Heights. On its website, JANM describes its rationale for the exhibition:

> The Japanese American National Museum has been working to become a new kind of museum—one that actively involves the people and communities it serves as equal partners. . . . The Boyle Heights Project is one facet of the National Museum's efforts and extends across disciplinary, generational, ethnic, and religious lines.

ArtPlace is a new grant from 2011 that results from public-private collaboration between the NEA, the Ford Foundation, ten other national foundations, and seven federal agencies. It encourages museums, municipalities, and arts organizations to jointly explore new ways in which to better engage their local places and communities, calling itself a "creative placemaking" effort that strives to revitalize cities and towns across the United States through innovative models that position the arts at the center of economic development. Its website states, "ArtPlace believes that art, culture and creativity expressed powerfully through place can create vibrant communities, thus increasing the desire and the economic opportunity for people to thrive in place. It is all about the local." For the initial round of grants, ArtPlace distributed $11.5 million to thirty-four projects and expects to distribute the same in its second grants cycle.

Another NEA program from 2011 is Our Town Grant that also mentions the goals of "creative placemaking" on its website. It initially distributed $6.6 million in grants to fifty-one communities in thirty-four states for public-private partnerships that will strengthen the arts while "shaping the social, physical, and economic character of their neighborhoods, towns, cities, and regions." The Our Town program seeks to create community identity and a sense of place, and to encourage transformative creative activity. The notion of *creative placemaking* originated from a 2010 white paper written by Ann Markusen and Anne Gadwa for the Mayors' Institute on City Design, an NEA initiative in partnership with the U.S. Conference of Mayors and the American Architectural Foundation.

The IMLS partnered with the John D. and Catherine T. MacArthur Foundation and its Digital Media and Learning Initiative to create twenty-first-century learning labs in libraries and museums around the United States. In November 2011 they announced the first twelve winners of the national competition for funding to plan and design the labs. The only art museum chosen was the Museum of Fine Arts, Houston, Texas, which will also participate—in person and online—in a "community of practice" that provides technical assistance, networking, and cross-project learning. The museum's lab is called hang@mfah: Houston.Art.New.Generation, and will operate in partnership with the Glassell Junior School of Art. The lab's primary audience is from the Houston Independent School District, the largest public school district in Texas, serving mostly economically disadvantaged and at-risk students. The museum envisions its lab as "a place where young people can learn about themselves, digital media, and art in an out-of-school museum setting, with a mentor and community of peers," a place to truly help bridge the digital divide not just by providing Internet access but by promoting creative uses of digital technology. IMLS director Susan Hildreth affirmed that "libraries and museums are part of re-envisioning learning in the 21st century; they are trusted community institutions where teens can follow their passions and imagine exciting futures" (2011, November 17).

Also in 2011, the Innovation Lab for Museums debuted as an alliance between EmcArts and the American Association of Museums' Center for the Future of Museums, supported by MetLife Foundation. The lab is intended to help museums incubate and test innovative strategies to address major challenges in all areas of their operations, providing funding, technical expertise, and networking opportunities to grantees. The program stated its preference for three areas: youth education, demographic transformation, and participatory experiences

(described as a *generational* demographic transformation). The 2011 Request for Proposals describes the latter two areas:

> Innovative projects related to *demographic transformation* may help develop a deeper and more nuanced relationship with the diverse communities surrounding the museum, nurture a cadre of diverse future museum practitioners, or help the museum serve unmet community needs that may be outside the scope of traditional museum operations. (p. 2)
>
> Innovative projects related to *participatory experiences* may explore how museums can become places to hang out, engage and contribute; blur the boundaries between "back of the house" and "front of the house;" and act as moderators and filters of contributed wisdom and diverse perspectives, in addition to being sources of scholarship and opinion. (pp. 2–3)

The MetLife Foundation also has its own granting program from 2008, called Museum and Community Connections, awarding $1 million a year for three years. This program is targeted at art museums that "reach out to large numbers of people of all ages and backgrounds through imaginative programs and/or exhibits that help us understand and appreciate each other and our world." One of the recipients was the Los Angeles County Museum of Art for *EAT LACMA*, an exhibition, education, and outreach program that focused on improving the quality of life through growing, preparing, and sharing food at the museum.

While only one of these programs specifically mentions digital technology, they all support projects that provide new and innovative solutions to revitalizing communities. Solutions are not always digital, but often comprise both analog and digital means, traditional and avant-garde ideas that respond to a multigenerational and diverse audience. What is important to note about these programs, however, is the recognition at a national, federal, and funder level of the importance for museums to connect with their local communities, particularly in partnership with public agencies and other cultural institutions.

GREATER THAN FIVE
The following examples include additional medium- to large-sized art museums across the United States and abroad, and a last brief case study of the Los Angeles County Museum of Art, a museum in my own community that has experienced a remarkable transformation in recent years under new leadership and a renewed commitment to marking its place. All these digital projects represent innovative ways in which the field of museums is incorporating new digital tech-

nologies, but only a selection stand out for the ways in which they do so while also strengthening their communities, engaging their visitors, and providing a link between online and physical spaces and experiences. An in-depth digital ethnographic analysis of any of the following museums would most likely reveal how many of their digital practices reflect their particular places, communities, and cultures, and how the museums are becoming increasingly conscious of and responsive to these three framing constructs.

The Smithsonian Institution in Washington, DC, is a federal initiative that includes nineteen museums and galleries, the National Zoological Park, nine research centers, and a traveling exhibition service (SITES). The Smithsonian is able to create many projects in-house because of its consolidated resources, as evident in its website (http://si.edu/). Under the "Connect" heading of the website, visitors can find not only the traditional social media links and museum blog, but also twelve mobile applications for iPhone, iPad, Android, and iPod Touch, seven different mobile websites, and seventeen podcasts on iTunes where the Smithsonian has a consolidated channel for its general application as well. Also under "Connect" is Virtual World that lists the institution's online exhibitions (340 total), three different online activities/games, and the Latino Virtual Museum in Second Life, described on the website as "a cross-platform immersive education initiative based on bilingual mixed-media experiences created to enhance visitor's knowledge, understanding and appreciation of Latino Cultural Heritage through innovative and engaging online experiences." Leading many of these projects is Nancy Proctor, head of mobile strategies and initiatives, who praises the multilateral nature of mobile technology as a social platform. Proctor is joined by Michael Edson, the director of Web and new-media strategy, and supported by the Smithsonian's secretary since 2008, G. Wayne Clough, who served as president of the Georgia Institute of Technology. Proctor was responsible for the Smithsonian's public Web and New Media Strategy Wiki (http://smithsonian-webstrategy.wikispaces.com/), which won the People's Choice Award at Museums and the Web 2011. The wiki states, "Anybody—inside or outside the Smithsonian—can join this wiki and help us. We figure it's your Smithsonian Institution too & you have a stake in its future." The Smithsonian is currently exploring AR (augmented reality) applications for Art & Industries, and the National Museum of Natural History's Bone Hall, and is incorporating the image recognition application Google Goggles into its projects.

A brief description of a few of the Smithsonian's digital projects provides insight into how it is utilizing technology today. Museums on Main Street (MoMS)

is a traveling project organized by SITES. Since 1994, MoMS has been exhibited in more than 690 communities in 42 states and Guam. On its website are the archived online exhibitions, links to social media, an interactive map of exhibitions and events, the *Road Reports Across America* blog, and Stories from Main Street where individuals share photographs, recordings, and videos from a mobile application (for all Apple devices) on their smartphones, as well as listen to other recordings "by people like you." In May 2011, the Smithsonian debuted its free iPhone and iPad application called Leafsnap, the first mobile app to identify plants simply by photographing a leaf. The app uses facial recognition technology so people can instantly search a library of leaf images created by scientists at the Smithsonian, providing a species name, high-resolution photographs, and information on the tree's flowers, fruit, seeds, and bark. For the first time, the public can directly access the collection of the U.S. National Herbarium at the Smithsonian's National Museum of Natural History that began in 1848 and is one of the world's ten largest plant collections. The Smithsonian is also interested in engaging citizen scientists with this app to augment the collection's data and provide information on specimens that could be added to the collection.

Another project that invited public participation was initiated by the Smithsonian American Art Museum (SAAM) in 2009, entitled Fill the Gap! At the SAAM, the Luce Foundation Center for American Art serves as the museum's visible storage facility with over 3,300 works of art displayed in 64 glass cases for public viewing. When artworks leave the storage facility for exhibition, loan, or conservation, there is a gap in the case that needs to be replaced. Using its Flickr photostream, the museum asks viewers to choose an image from a preselected group that best fits within the gap. The selected image is sent to the museum's chief curator for approval, inserted, and the person is credited on the object's label. The gap can also be filled by public vote, both at the Luce Foundation Center and online on Flickr. In 2006, SAAM launched the website Meet Me at Midnight, an interactive, online adventure for kids eight to ten years old that presents an art history mystery in cartoon style. The website won a number of awards, including Adobe Site of the Day (May 17, 2006); Interactive Media Awards: Outstanding Achievement: Museum (2006); International Academy of the Visual Arts: Davey Awards: Silver for Education and Children (2007); AAM MUSE Awards: Bronze (2007); and Web Marketing Association WebAwards: Arts Standard of Excellence (2006). In 2008, SAAM created the world's first museum-based alternate reality game (ARG) that ran for almost five months, titled *Ghosts of a Chance*. The scavenger hunt–like game took

place in the physical world (at SAAM, the Smithsonian Museum of Natural History, and the Congressional Cemetery) and also in the virtual world (on the museum's website, YouTube, Facebook, MySpace, and on a Flickr group created by a player). The game was a 2009 Official Webby Honoree in the environmental and experience marketing category.

The Denver Art Museum in Colorado created a new initiative in 2010 to cultivate young adults, funded by the IMLS. The Collective is an online community of 604 members (as of March 21, 2012) "who come together to create, converse, and connect," according to its website (http://collective.denverartmuseum.org). The Collective directly links to events at the museum and is based on the success of the untitled series of events on Final Friday nights at the museum, described by the museum as "this is your brain on art, your take on creative issues that are far from black and white." The Collective's website includes information on untitled events, Happenings around town ("One-of-a-kind happenings co-created by members of the Collective. Convene with creative movers and shakers"), a link to the museum's blog, and other educational initiatives including dDIY (digital Do It Yourself) at-home creative activities which can be uploaded to the website and shared publicly. Social media on the site includes Facebook and Twitter, with excerpts from the Blog and Twitter on the bottom. Aside from The Collective that targets young adults, the museum also has a website that targets kids eight to ten years old, called Wacky Kids Website. The website is interactive (Explore Cool Places) with art activities to do at home or school (Make Stuff), and links and book titles at the Denver Public Library. Inside its physical galleries, the museum has installed award-winning TouchTables and interactive kiosks with touch screens, spearheaded by the museum's former director of technology Bruce Wyman.

In 2008, the Dallas Museum of Art in Texas opened a Center for Creative Connections (C3) inside the museum, providing both analog and digital ways for visitors to explore the creative process by interacting with art, artists, and the community. The center brings visiting artists every six months, offers hands-on workshops for adults, and for children there is Arturo's Nest (ages zero to four) and the Young Learner's Gallery (ages five to eight). The center also houses the museum's Tech Lab, where visitors are encouraged to "experiment with and use technology in unique ways to respond to works of art in the Museum's collection and create original art work." At the Tech Lab there are Web-based interactive programs on computer stations, and drop-in classes and workshops for adults and families about social media, gaming, video, sound design, stop-motion

animation, 3-D design, and more. The museum also offers smARTphone tours of its permanent collection and temporary exhibitions. Visitors can use their own smartphones or borrow museum iPod Touches for free.

In 2003, former Dallas Museum director Bonnie Pitman began a seven-year study of museum visitors to better understand their preferences and behaviors. The study was conducted by the consulting firm Randi Korn & Associates Inc. and consisted of six separate studies,[1] culminating in a new museum strategy called *Framework for Engaging with Art*. The studies identified four distinct, yet related visitor types (clusters): tentative observers, curious participants, discerning independents, and committed enthusiasts. Findings from the research led the museum to seek an IMLS National Leadership Grant to redesign its website and create a new online content management and delivery system. The museum received a grant of $519,435 in December 2007 and introduced its new website in 2009. Front and center in the new website is the heading "Communities," listing the museum's social media (Facebook, Twitter, YouTube, Flickr, MySpace), as well as Gowalla, Foursquare, LinkedIn, the museum's Wikipedia page, e-news, calendar, and its blog *Uncrated* (by Wordpress). The museum also has a separate blog for families (*We Art Family!*) and for educators, and organizes Flickr meet-ups for visitors who upload their museum photos on the museum's Flickr photostream. Arts Network is the museum's new internal content management system that allows visitors to customize information across platforms, providing a mobile website and free WiFi at the museum. The museum describes it as "a television-style network system" that offers four different channels mirroring the four visitor clusters. Under the heading "View," the museum's website also has a section on Texas artists that highlights objects in the collection made by artists working in Texas, as well as an online database of Texan objects that it maintains jointly with local partner institutions.

Thomas Campbell became the new director of the Metropolitan Museum of Art (the Met) on January 1, 2009, replacing Philippe de Montebello who had served for thirty-one years as director. Campbell was curator of European sculpture and decorative arts at the Met for thirteen years, and at forty-seven, younger than his predecessor when he assumed the position. Campbell has made tremendous advances in his first two years, most amazing for a venerable institution like the Met; a museum in the classical tradition of marble columns, entrance steps that visitors climb to the top, and a world leader in art scholarship and conservation. Campbell's mark may not much change the external appearance of the museum; however, as he tries to bring the Met along the populist wave of the

modern museum there will be many great changes ahead. In order to assist him in this task, Campbell invited Pitman from the Dallas Museum of Art to talk to his staff about visitor engagement. Campbell explained, "We have to recognize that a great many of our visitors don't know their way around and they don't know much about art," adding that technology could be the best way to solve these challenges (as cited in Kennedy, 2011). Firstly, Campbell consolidated the museum's technology operations into a new department for digital media that reports directly to him, hiring Erin Coburn (formerly at the Getty Museum) in 2010 to head the department as its new officer of digital media. Another behind-the-scenes change still in process is the challenging task of wiring the museum's 1902 Beaux-Arts building for WiFi for visitors to utilize their digital devices for multimedia audio tours that the museum will start creating for its permanent collection. The Met has started introducing touch-screen computers in the galleries (so far in only the American period and decorative art rooms) and created its first iPhone application to accompany the popular exhibition *Guitar Heroes: Legendary Craftsmen from Italy to New York* (February 9–July 4, 2011). It currently rents iPod Touch devices to museum visitors at the price of $5–$7. In 2011, The Met also joined the Google Art Project as a partnering institution, choosing Pieter Breugel the Elder's *The Harvesters* as its iconic work to be featured in super-high definition. Campbell comments on this new collaboration in a museum blog post:

> The Google Art Project coincides with a variety of Met initiatives that demystify the Museum through digital means by sharing our collections and ongoing work with a broader online public around the world. Most important of all, these projects encourage people to visit museums and come face-to-face with great works of art. (2011, February 1)

A major change for the Met was a new redesign of its website in September 2011. Campbell describes the website, "Since becoming Director, I have stressed two priorities: scholarship and accessibility. Our new website, which launched today, certainly embodies both of these aims" (as cited in Kennedy, 2011). The website consolidated the museum's digital programs in the MetMedia section, available on its bottom navigation bar alongside MetKids and MetStore. Met-Media offers videos, podcasts and audio, interactive, Kids Zone and MetShare (Facebook, Twitter, Google Goggles, YouTube, Foursquare, iTunesU, and Delicious). MetShare is introduced by the following text on the website:

The Metropolitan Museum of Art is pleased to offer visitors several new ways to enhance their understanding of and appreciation for works of art in its collection, and to connect with and share their experiences with others. All of these endeavors simply represent additional ways for the Museum to further the mission that has guided it since 1870: ". . . encouraging and developing the study of the fine arts, and the application of arts to manufacture and practical life, of advancing the general knowledge of kindred subjects, and, to that end, of furnishing popular instruction."

A new feature of the website is the impressive audio-video program Connections, curiously located in the Exhibitions section. While Connections makes surprising connections between staff members and the permanent collection, its value lies more in shattering the cold, intimidating image of the Met by revealing a personal, softer image of its staff, democratically displayed all in black and white with provocative headings to their profiles (e.g., "Dark Energy," "Mutts," "Blood," "Magic," "Crocodiles," "Survival," "Date Night"). Museum staff are publicly presented for the first time with names, titles, photos (most smiling), and personal stories about their lives, jobs, and relationships to the museum and its collection.

Another notable new feature is Met Around the World that premiered on the Met's website in November 2011 in the form of an interactive map searchable by types of museum activities (traveling exhibitions, traveling works of art, conservation, excavations, fellowships, exchanges and other collaborations). The program is described on the website: "The work of the Metropolitan Museum reflects the global scope of its collections and extends across the world through a variety of initiatives and programs outlined here." It is telling of the Met's primary global focus that it first introduced an international map, and in 2012 it plans to introduce Met Around America. Probably the most important change to the Met's website is the new consolidated collections-management database system that allows for an easier search function and the ability to deliver information on multiple platforms. Digitization of the museum's entire collection is a primary concern for Campbell, who wants an online record for each of the nearly 2 million objects in the collection. He asks, "At a time when scholarship is rapidly advancing, are you best serving a collection by publishing a three-volume catalog of 800 pieces, where much of it becomes out of date within six months?" (as cited in Rosenbaum, 2010, February 2). Campbell's focus on the website is understandable, given that the museum's research has found that more than 40 percent of museum visitors first viewed the website before visiting

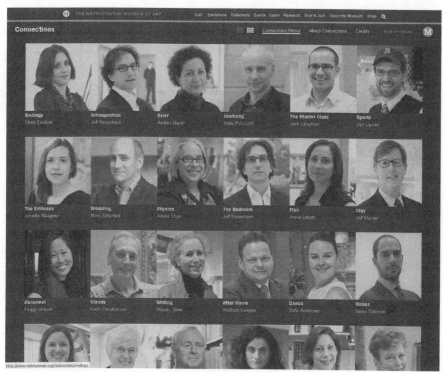

FIGURE 8.1
Metropolitan Museum of Art website, Connections (12/29/11 screen capture).

in person. In 2010, the physical museum had 5.6 million visitors (including the Cloister Museum & Gardens), and the website had 47 million visitors, a 19 percent increase from the previous year. The museum also generated $13 million in revenue online, also an 18 percent increase from the previous year.[2]

The Solomon R. Guggenheim Museum in New York is part of a global network of museums managed by the Solomon R. Guggenheim Foundation, also based in New York; it could be called the flagship museum as it all started there in 1939. Other museums include the Guggenheim Bilbao in Spain, the Peggy Guggenheim Collection in Venice, Italy (Solomon R. Guggenheim's niece), the Deutsche Guggenheim in Berlin, Germany,[3] and the upcoming Guggenheim Abu Dhabi in the United Arab Emirates. Despite the Guggenheim's decidedly global focus, it has not been known for using digital technology in the service of its global community other than a basic website and social media. Nevertheless, a few recent initiatives are bringing the Guggenheim quickly into the digital age, on both a local and global level. In 2010, the Guggenheim partnered with YouTube to develop

the first *YouTube Play: A Biennial of Creative Video*. In a video describing the project, Nancy Spector ("About YouTube Play," 2010), deputy director and chief curator at the museum, explains the impetus behind this project as wanting to "reach the broadest possible audience" and as a chance to explore digital media. "We have always been a museum of the new," she stated, where there is no hierarchy among mediums of art. YouTube's interest was in bringing "the world of access to the world of excellence and the established art world." The biennial was an open call for creative video entries made to the global YouTube community, resulting in more than 23,000 video submissions. A jury selected two hundred for the first round, and then made a final selection of twenty-five that were simultaneously presented at all Guggenheim museums around the world on October 20, 2010. The following night a live event took place at the Guggenheim Museum in New York. The public was not able to vote on the videos or to see the original entries, only the short list of two hundred and the final twenty-five. Still available on the YouTube Play channel is a video highlighting a selection of the final twenty-five videos, *YouTube Play: Live from the Guggenheim*. The biennial was also developed in partnership with HP and Intel that contributed to its online educational component (HP + Intel Make Tutorials) that offers videos of video-making techniques such as music and fashion film, digital flipbook, experimental film, time lapse, 2-D character animation, and stop-motion animation. Numbers show that clearly the Guggenheim has succeeded in reaching the broadest possible audience: 24,759,214 views on the YouTube Play channel, 9,902,512 upload views, 49,624 subscribers, and 45,255 channel comments (as of March 1, 2012).

Two other recent initiatives at the Guggenheim focus on the local place more than the global. Stillspotting nyc began in 2010 as a two-year multidisciplinary project centered on the museum's Architecture and Urban Studies Program in collaboration with the Spatial Information Design Lab (SIDL) at the Graduate School of Architecture, Planning and Preservation at Columbia University in New York. Projects are organized around the city's five boroughs, where every three to five months "stillspots" are identified, created, or transformed by architects, designers, composers, and philosophers into public events or installations. The website (http://stillspotting.guggenheim.org/) describes the project:

> Living in a big city can be fun. There's so much going on—lots of people, traffic, and things to do. But where can you go to get a break from all the activity? . . . *stillspotting nyc* has asked artists and architects to answer that question and to create "spots" for us to enjoy "stillness."

The museum commissioned SIDL to develop a mapping study on silence and noise in New York City, resulting in an interactive map that presents actual noise complaints to the city government from residents (over 270,000 in one year). The website offers a PDF activity for kids to find their own stillspots, designed by the museum's Sackler Center for Arts Education, and an interactive map to create personal stillspots and share them online. Another element was a partnership with students in the Master of Fine Arts Program in the Photography, Video and Related Media Department at the New York School of Visual Arts, to create short videos on "the visual, aural, and sociological ecology of the urban landscape." The project was funded by the Rockefeller Foundation NYC Opportunities Fund and a MetLife Foundation Museum and Community Connections grant.

In August 2011, the BMW Guggenheim Lab was launched as a long-term collaboration between the Guggenheim Foundation and the German auto company BMW. The lab works in three two-year cycles for a total of a six-year "journey around the world" to study issues and create innovative solutions for contemporary urban life. The lab is a mobile laboratory housed in a movable structure, located first in New York City (August 3–October 16, 2011), then in Berlin, Germany (May 24–July 29, 2012),[4] and finally in Mumbai, India, each cycle concluding with a museum exhibition. The Berlin cycle is presented in association with ANCB Metropolitan Laboratory, and the Mumbai cycle with the Dr. Bhau Daji Lad Museum. In addition, each cycle will have its own physical structure designed by a different architect, its own theme, and its own international team of emerging leaders in the fields of urbanism, architecture, art, design, science, technology, education, and sustainability. The New York theme was "Confronting Comfort" that explored "notions of individual and collective comfort and the urgent need for environmental and social responsibility." On its website, the Guggenheim Foundation describes its commitment to "international communication and cross-cultural exchange . . . that enable the Foundation to engage ever-broader audiences and promote broad cultural discourse." Richard Armstrong, director of the Guggenheim Museum and Foundation, describes the lab, "When people say we're taking it to the streets, we literally are. Hopefully this will be a petri dish of ideas for the decision makers of tomorrow. But it is no glamorous version of a Greek temple" (as cited in Vogel, 2011, August 1). Engaging public discourse is a central element to the lab, through free public programs organized at the physical lab, a website (http://bmwguggenheimlab .org/), blog (*LAB|log*), and social media (Facebook, Twitter, YouTube, Flickr, Foursquare). The website also offers an online game called Urbanology that asks,

"What would your future city look like?" Presented with a selection of real-world urban dilemmas, players make decisions that impact their cities negatively or positively, taking into account eight major categories (innovation, transportation, health, affordability, wealth, lifestyle, sustainability, and livability). The game calculates the closest real-world equivalent to the city created by the player.

The J. Paul Getty Museum in Los Angeles has very traditional art galleries, interrupted only in the passageways by its GettyGuide kiosk system for visitors to access multimedia information via headphones. The GettyGuide provides videos, audio recordings, and detailed information on over 300 works in the museum's collection in Spanish and English. In addition to the gallery kiosks, the GettyGuide can be accessed on an iPod Touch available for free at the museum, on visitors' smartphones using the new Google Goggles application, and in the Collection section of the museum's website that offers a bookmarking feature. Getty Bookmarks are free for visitors that register online with their e-mail address, and allows them to create a personalized online gallery based on favorite works of art first seen at the museum or in anticipation of a museum visit. Visitors can share their gallery and create customized museum tours. The Getty website also offers online activities for youth, including Getty Games and Whyville. Whyville is a virtual world for teens and preteens, accessed by a link to Getty Games from the museum's website under "Games," and also on the link for Connect with Us (that lists social media, blog, ArtBabble, calendar, and e-newsletter). As described on the museum's website,

> Visit the Getty Museum in Whyville where you can play games and learn about art from anywhere in the world! The Getty Museum in Whyville is a virtual companion to the renowned Getty Center in Los Angeles. Travel the Whyville virtual globe and explore the history of art with the Getty Treasure Hunt! The Getty in Whyville is where you can get together with friends to chat art, play art, and get inspired to make your own art!

Getty Games includes the interactive online games Match Madness, Switch, Jigsaw Puzzles, and Detail Detective, all based upon works in the Getty's permanent collection. Another interesting feature of the website is under the heading "Collection" that includes not only the traditional images and text, but seamlessly integrates multimedia information and social media with a section called Watch Videos that links to the museum's pages on YouTube and ArtBabble.

While this book focuses on art museums in the United States, primarily for the sake of brevity, it also acknowledges the innovative work in art museums

outside the United States, and particularly in Europe. I must note, however, that the new museology is presently more developed within the United States due to its longer history of populist museological practices, visitor studies, visitor services, and the field of museum education. This is another reason why these five case studies are important forecasters of situated technology practices in museums worldwide. I will very briefly list a few examples of museums outside the United States, which is certainly not complete, as museums around the world are rapidly embracing digital technologies. Yet while many of these museums are more technologically advanced than many U.S. museums, what they sometimes lack is an understanding of how technology can support and respond to a museum's community, physical place, and local culture.

The Powerhouse Museum in Australia is not a traditional art museum; it is a public museum that opened in 1988, but its collections date back to the 1880s covering history, science, technology, design, industry, decorative arts, music, transport, and space exploration. The museum incorporated QR codes in its exhibitions in 2008 and was an early adopter of the mobile website. It released its collection API as open source in 2010 and encourages outside applications, even going so far as to host developer hack days to build experimental applications. Inside the museum it uses iPads for audio-visual displays with touchscreen games. The museum's website is amazingly transparent, partly due to it being a public institution, and makes publicly available its strategic plan 2009–2012, annual report, organization chart, and facts and figures (number of visitors, staff, objects in collection, etc.). Under the heading "Open Access Information," the museum references the Government Information (Public Access) Act, in which government agencies are encouraged to proactively release government information. Most of the digital projects have been led by Sebastian Chan, formerly the museum's head of digital, social, and emerging technologies, and currently the director of digital and emerging media at the Smithsonian Institution's Cooper-Hewitt National Design Museum in New York. Chan's blog *Fresh + New(er)* is an excellent source of up-to-date information on museums and digital media.

In Barcelona, Spain, the Museu Picasso's website is notable for a number of reasons. It has an interactive timeline of Pablo Picasso, tags, and two virtual tours of the collection's highlights. Under the "Get Involved" heading is listed Subscribe to e-news, Play, and Online Community. The heading's text reads, "We invite you to become part of the Museu Picasso Community. With your participation, the museum will undoubtedly improve its performance. Thank

you, everybody, for your contributions." Play includes three interactive games: Picasso Memory, Game Chrono, and "The Embrace." Online Community includes the museum's social media (Facebook, Twitter, Flickr, YouTube, Delicious, and Slideshare), its free application for iPhone and iPad, *El Blog*, and RSS feeds. This website design was spearheaded by the museum's former project manager Conxa Rodá, now head of strategy and innovation at the Museu Nacional d'Art de Catalunya. Another important example in Barcelona comes from the Museu d'Art Contemporani de Barcelona (MACBA). RWM (Rádio Web MACBA) is described on the museum's website under the heading "Audio and Video" as an online radio project that "explores the possibilities of the internet and radio as space of synthesis and exhibition." The programs are organized by curatorial, research, special, and SON[I]A, are available on demand as podcasts on iTunes and by subscription, and are searchable by program, word, date, and tags. RWM also has a Twitter feed @Radio_Web_MACBA with 2,172 followers (as of March 21, 2012).

The Tate Museum in England (encompassing Tate Britain, Tate Modern, Tate Liverpool, and Tate St. Ives), has done a remarkable job with digital media, mostly on its website and mobile, two platforms in which it is easy to consolidate efforts much like the expansive Smithsonian Institution. Given the ethnic diversity of modern-day England, as well as the museum's global reach, its consolidated website (http://tate.org.uk/) is available in thirteen languages plus British Sign Language. Not only does the Tate have an e-bulletin, it also has a magazine, *Tate Etc.*, promoted by the museum as "Europe's largest art magazine," that is available in print as a paid subscription with selected content online. The Tate offers two online courses on art techniques and methods under the heading "Learn Online," an online art resource for visually impaired people since 2002 called i-map, and the Tate Channel that includes Tate Shots (weekly series of short videos), podcasts, its blog, and links to museum channels on YouTube, iTunes, and iTunesU. The Tate blog is well integrated with its social media and clearly promoted on the museum's homepage, and offers a segment called Tate Debate where museum staff post on special issues to debate with the public. In the galleries, Tate Modern has a multimedia guide with video, artist interviews, a children's tour and interactive games, and two new applications for the iPhone and iPad. One is called Tate Trumps, a card game for visitors to play with the collection, and the most recent is Race Against Time, which takes visitors back to 1890, visiting major art movements along the way. Also in the physical galleries is the museum's Interactive Zone with books, films, games, and interactive multimedia.

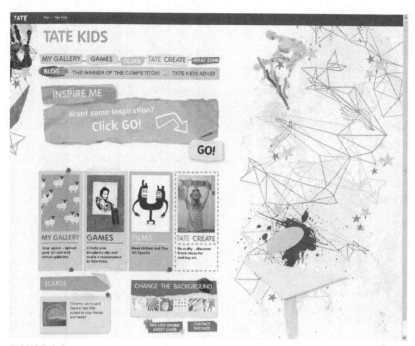

FIGURE 8.2
Tate Museum website, Tate Kids (12/3/12 screen capture).

The most notable digital projects of the Tate Museum, however, are its websites devoted to kids and youth. Tate Kids (http://kids.tate.org.uk/) is aimed at kids four to twelve years old, with additional downloadable information for teachers and parents and links to the websites Tate Families, and Tate Schools and Teachers. Tate Kids lets kids create their personalized gallery of works from the museum's collections on My Gallery which they can share publicly, submit their own artwork, leave comments, and rate other galleries that are highlighted by popularity. There are downloadable activities on Tate Create and E-Cards to send. Kids can select the website background from a preselected assortment of designs, play fourteen online games with three levels of skill, view five films created by other kids (Art Sparks), and read the *Tate Kids Blog* (with a link to Twitter). The website for youth ages thirteen to twenty-five is Young Tate, described on its own website (http://tate.org.uk/youngtate/) as "a youth art initiative run by and for young creatives giving everyone the opportunity to reach their own conclusions about art." Young Tate is different for each of the four Tate museums: Tate Modern has Raw Canvas for ages

fifteen to twenty-three, Tate St. Ives has the Collective (called SPEX) for ages sixteen to twenty-five, and Tate Liverpool and Tate Britain also participate in the Collective that offers an online community for youth. Similar to teen programs at U.S. museums, each Tate museum has a group of local members that organize events, workshops, and long-term projects. The Collective connects these local youth with a larger group of youth that register online to become members and create virtual public portfolios where they can upload works and participate in Community Groups. The Collective is on Twitter, Facebook, and Google Plus, and offers Student Resources with Exam Help, Artists Online (three virtual exhibitions), interactive games, and information on applying to art or design school with advice from working artists.

Also in England (London) is the Victoria and Albert Museum (V&A). For a museum that promotes itself as "the world's greatest museum of art and design" on its website, it should not come as a surprise that its website is remarkably rich in content and innovation. Back in 2007, the V&A was already using Web 2.0 technologies to build online interpretive communities with an interactive tile game, a blog by its artist-in-residence, and a ceramics wiki. Juliette Fritsch, the museum's former head of gallery interpretation, evaluation and resources, refers to constructivist models from the early 1990s and writes of the museum's approach to community and the Internet,

> The aim is also to enable visitors to be able to contact and exchange with others interested in the same areas of experience. That is to say, to build an environment of information population and exchange that links the idea and nature of the physical visit to the gallery beyond those physical boundaries. . . . By giving a forum for this community both on-line and in the galleries we hope to have a constantly evolving level of dynamic community experience and exchange as part of the permanent gallery interpretation. (2007a, p. 6)

Evaluating the V&A's website today reveals that it has minimal presence on social media (Facebook, Twitter, YouTube, Flickr), but it has its own V&A Channel for multimedia content. The website's Search the Collections feature won a Museums and the Web award in the category research in 2010. When a visitor clicks on a collections record, there appears not only the image and curatorial text, but also links to Related Content, Related Images from the museum's collections, Teachers' Resources, a Reading List, Links, Events at the museum, Shop Online, related videos, and a link that reads, "Browse More Images Like This." When accessing records, visitors are able to print, e-mail,

bookmark/share the record on screen, access a QR code with more informa-
tion, and "Help us improve our images." Once visitors are registered online,
they can contribute to the collections section. This crowdsourcing feature asks
online visitors to help the museum improve how it presents cropped images on
the website by suggesting the best view, with before and after examples. Gail
Durbin (2004), the museum's deputy director for learning and visitor services,
comments on the museum's incorporation of user-generated material: "The
Victoria and Albert Museum was founded in order to improve the quality of
British art and design, so it is entirely appropriate that our Web site should
include images and other creative work by visitors."

The Stedelijk Museum in Amsterdam was closed for renovations from 2003
to September 2012, but still wanted to make its collection accessible to the pub-
lic. Out of this challenge was born one of the first museum experiments with
augmented reality (AR). The project is called ARtours and was funded for the
first two years (2010–2011) by the Dutch Ministry of Culture. AR works with
smartphones that have the Layar AR application and GPS (global positioning
system) so that users can see images or text superimposed onto the real-world
environment in three-dimensionality (3D) when holding up their phone screens.
The ARtours consist of various projects, the first of which partnered with art
students to exhibit their work using AR, called Ik op het Museumplein or Me in
Museum Square. The second project, ARtotheque, places a unique QR code on
170 artworks in the museum's collection that are out on loan. Two upcoming
projects include an AR-based tour of Amsterdam including design objects from
the museum's collection, an indoor AR tour at the museum for a temporary
exhibition with two emerging Dutch artists, and a potential AR collaboration
between other museums and commercial partners in Amsterdam. Hein Wills,
the museum's project manager for ARtours, describes what he has learned:

> The moment that AR becomes linked to web and social media initiatives of a
> museum it will be a powerful tool, reaching out and engaging our audience. It's a
> great way of expanding the brand, giving the museum a more ubiquitous presence.
> But there will still be a need for real museums because looking at an augmented or
> virtual piece of art will never replace viewing the original, live and in person. (as
> cited in mobiThinking, n.d.)

The Musée du Louvre in Paris, France, is not only one of the most traditional
museums as far as gallery installation and as one of the first public museums
created in the eighteenth century in a Renaissance palace, but one of the world's

most international art museums regarding scholarship, professional relations, and visitors (66 percent of its visitors come from outside France). With a record 8.8 million visitors to the physical museum in 2011 (the world's most visited museum), the Louvre's new digital experiment targets those physical visitors. Starting in March 2012, the Louvre replaced its conventional audio guides with Nintendo handheld video game consoles, partly because of the low adoption rate of the audio guides (4 percent). The Louvre's head of multimedia, Agnes Alfandari, admits that the Louvre is the first museum in the world to make this bold move. The museum is starting out with 5,000 consoles for visitors with an interactive 3D museum map that will pinpoint their exact location, offer commentary in seven languages, and provide a variety of themed tours including some for children. At a museum press conference, the Louvre's director Henri Loyrette stated that, "Digital development has become a strategic issue for museums. People's habits have changed. But that offers us a huge opportunity to extend the museum's territory and build a lasting relationship with our visitors" (AFP, 2011). The Louvre has a definite reach outward through its satellite spaces in Lens, France, and soon in Abu Dhabi, United Arab Emirates, visually demonstrated with its interactive map (classified by exhibitions, excavations, partnerships, long-term loans, and satellite spaces) that are all listed under the section "The Global Louvre" on its website.

The concept of virtual museums supports this book's notion of reclaiming place today as a place/experience or a "soft space." Virtual museums exist only on the Internet, although their architecture mimics that of physical museums, their collections are genuine artworks (meaning both physical and digital) by physical artists, and they are administered by genuine professionals in physical offices. Nevertheless, virtual museums are more about experiences than places because they are freely accessible by anyone with a digital device and an Internet connection, regardless of where that visitor may be located. The most recent example, the Adobe Museum of Digital Media (AMDM), is perhaps more understandable as a virtual space because it is the first virtual art museum to focus on the medium of digital art. Launched in October 2010 by the Bay Area–based software company Adobe, the museum states on its website that "it is open 365 days a year, 24 hours a day, and accessible everywhere." The museum offers a tour of its building designed by the Italian architect Filippo Innocenti, which it claims would equal 57,680 square meters in the physical world. Space is used to house the museum's permanent collection, to archive past exhibitions, and to present temporary exhibitions. Museum membership is free, requiring visitors

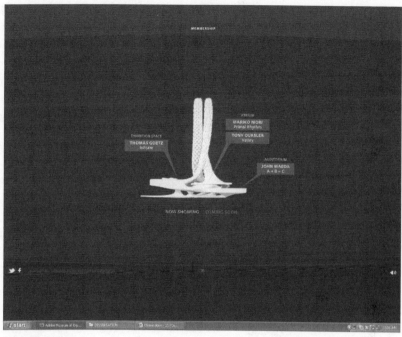

FIGURE 8.3
Adobe Museum of Digital Media website, Map (1/3/12 screen capture).

only to register their name and e-mail address to receive benefits such as special interviews with curators and artists, access to seminars and exclusive events, and advance viewing of exhibitions. As described on the website by the museum's creative director Keith Anderson,

> One of the things we kept stopping and asking ourselves as we were developing the museum is, how would this work in the real world? How would it be in a real brick and mortar building, because we wanted to take the museum experiences that were familiar to people and then transfer those over to the digital space?

While the buildings or collections may not be physical in a virtual museum, it is important to understand that there are indeed intangible connections to the physical realm, for both developers and visitors.

A second earlier example from 1997 is the Museo Virtual de Artes El País (MUVA), whose collection represents digital images of actual artwork from Uruguay. MUVA was first started by the Uruguayan art historian, critic, and curator Alicia Haber because of the lack of funds to build a contemporary art

museum in Uruguay. While the AMDM is not only virtual but also entirely separate from any local, physical place or culture, this is not the case for MUVA. Rather, the very existence of MUVA is a factor of its local place and culture, and as such it reflects both. Haber, the museum's director and curator, describes this factor on the website:

> The creation of MUVA . . . is related to the frustrations and limitations stemming from certain socio-economic realities and to the constraints of the Uruguayan society. . . . Funds for art, museums and art centres are insufficient. There is a gap between the high quality level and the strong production of art, the enormous quantity of artists in relation to the population and the very low investment in museum, collections, buying art, art in public spaces, etc.

MUVA was designed by the Uruguayan architect Ricardo Supparo and is situated virtually in Punta Carretas in Montevideo, the capital of Uruguay, described by the museum as one of the most beautiful and privileged neighborhoods in the city. The website shows the position of the museum within a residential area, next to a street with cars and pedestrians, with the ocean in the background and even the sound of birds and waves. MUVA presents the work of modern and contemporary Uruguayan artists, including a gallery of digital art. When viewing artwork, there is a zoom function, multimedia information, the background color can be changed, and the works can be saved in My Collection.

Presenting MUVA at a Museums and the Web conference in 1998, Haber discusses in great detail the demographics of Uruguay and Montevideo, its high adult literacy rate, life expectancy, and percentage of population living in the city. Culture is important to Uruguayans, she claims, but the art scene suffers. At the same time, Haber reports that Uruguay's consumption of the Internet is growing fast, with the largest per capita rate in Latin America. She confirms that, "Perhaps, to a certain extent and in certain circles, there is even more eagerness to use the medium in Uruguay because of an intense feeling of isolation of the Southern Cone from the centers of intellectual and cultural power." Haber believes that MUVA has the potential to give Uruguayan art "a new place in the world," a place that is no longer dependent on the traditional physical structure of museums or art institutions. She summarizes the museum on the website:

> The conception of museums has changed. They are not real buildings inside which heritage is preserved and exhibited anymore. The cyber-museums, an undeniable reality, play another role. They are an information site, a discussion forum, a useful

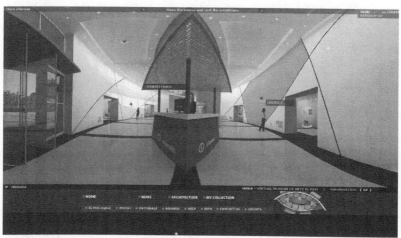

FIGURE 8.4
Museo Virtual de Artes El País website, Information (12/29/11 screen shot).

place for investigation and for the spreading of knowledge. They have the advantage of being an interactive system in which anyone at anytime can experience art, without the requirement of a physical place. The virtual thing is not opposed to reality. The virtual museum is much closer to the original idea of the museion: a lecture forum and, instead of objects, a collection of information, archives, investigation, knowledge and production.

Haber depicts MUVA much like how a museum blog serves a museum, as a virtual forum for discourse between professionals and the public, linking back to the museum website for more information and virtual interaction, and potentially to the physical museum at a later time. In MUVA's case, however, the website links back to Uruguay, a place which most visitors will not likely visit, but will learn more about through its art.

MARKING PLACE: THE LOS ANGELES COUNTY MUSEUM OF ART

At the time I began conducting research for this book in early 2010, the Los Angeles County Museum of Art (LACMA) was not one of the most technologically innovative art museums in the country. While its blog *Untitled* had won awards, there was nothing particularly notable about it in comparison with other museum blogs, except for the fact that the museum curiously produced a book on blog postings from the first few years, ostensibly for promotional purposes. A few of the museum's temporary exhibitions included interactive kiosks in the

gallery, it offered the standard audio tours with headphones and the wand for rent, and it offered free WiFi; again nothing noteworthy. It was a difficult decision not to include LACMA as a case study, as a Los Angeles–based researcher, a native of Los Angeles, and a long-time museum member. But everything has now changed. Michael Govan became the CEO and Wallis Annenberg director of LACMA in 2006, previously president and director of the Dia Art Foundation in New York City for eleven years and before that deputy director of the Guggenheim Museum for six years.

In reacting to the controversial high salary of Govan ($6 million for a five-year contract), museum trustee Bobby Kotick remarked in a 2009 *Los Angeles Times* article that "the reputation of LACMA was not a good one. There was definitely skepticism whether L.A. was committed to building a cultural institution that would be on par with the Met and MoMA." The competition that LACMA focuses on now is firstly on a local level and ultimately on a national level, as Kotick references New York City. LACMA compares itself with the Getty Museum, the top museum destination in Los Angeles and well recognized by residents and tourists alike. LACMA is not a major tourist destination, with its members and local repeat visitors comprising 85 percent of the museum's attendance. An Awareness and Visitation Study commissioned by the museum and conducted by Hall and Partners in 2008 reveals that two-thirds of Los Angeles County residents cannot correctly identify the museum's location in the Mid-Wilshire district.[5] The comparison is not a fair one, though, as the Getty Museum is part of a group of institutions including the Getty Research Institute, the Getty Conservation Institute, the Getty Foundation, and the Getty Villa, all funded by the J. Paul Getty Trust with an endowment of $9.58 billion (FY 2009–2010); the third largest foundation in the United States and the largest art institution in the world. LACMA notes that the Getty's progression in recent years makes it a "formidable competitor" in that people are more aware of the Getty Museum, but also of the campus as being a cultural and educational center. Furthermore, when the Getty Center opened in 1997, its very location was a source of great controversy. Perched atop a hilltop in the exclusive neighborhood of Brentwood, the museum appeared inaccessible to the people below, a symbol of the Getty's tremendous wealth and status, despite the Disneyland-like tram that it built to transport visitors from the underground parking lot. Nevertheless, in 2011, LACMA and the Getty jointly acquired the Robert Mapplethorpe archive, which will be housed at the Getty Research Institute. Acting Getty Museum president

David Bomford described it as "an unprecedented collaboration" between the two institutions (as cited in Finkel, 2011).

The second source of competition for LACMA today is the entertainment industry of Los Angeles, primarily Hollywood and the film industry, but also the ancillary and rapidly growing fields of gaming, digital media, animation, communication arts, product/industrial design, music, fashion, and architecture. The 2011 *Otis Report on the Creative Economy* notes that the creative economy (which includes all of these fields) of Los Angeles County generated an estimated $115 billion in revenues in 2010, representing the fourth largest industry in the region. LACMA understands well that it is located in the entertainment capital of the world, and that it must present itself to visitors as a leisure destination. The museum's *Strategic Plan* reflects this concern:

> In the crowded "entertainment" landscape of Los Angeles, the Museum competes for visitors amongst a diverse array of choices: from the well-financed marketing of films and popular culture, to the outdoor activities available year-round in Southern California, to major theme parks and beaches. Through expanded outreach to diverse audiences, from schoolchildren to the taste-making influencers of the entertainment industry, LACMA seeks to increase visitorship to rival and ultimately surpass that of the Getty, whose iconic architecture and location continue to make it the first choice among museum-going tourists. (2009, p. 25)

It is interesting to note a recent development in the museum's expansion that partners (rather than competes) with the entertainment industry: the announcement on October 4, 2011, of a memorandum of understanding signed between LACMA and the Academy of Motion Picture Arts and Sciences for the purpose of the latter creating a museum dedicated to movies and the movie industry in the museum's LACMA West building on its campus. Commenting on the news, Govan stated in a museum press release, "This represents a seismic shift in the cultural landscape of Los Angeles, and an extraordinary new resource for residents proud of their local history, and for fans of cinema worldwide" (2011, October 4). Co-chair of the LACMA Board of Trustees Terry Semel added, "The Academy Museum of Motion Pictures will provide a much needed destination for cultural tourists and Los Angelenos to learn more about cinema." LACMA will provide valuable space and visibility to the academy, and in return will reap the benefits of its tourists and visitors, as well as becoming an official part of the entertainment industry.

LACMA is substantially funded (more than 33 percent of its operating budget) by the county of Los Angeles and its board of supervisors, but is managed and operated by Museum Associates, a nonprofit public benefit corporation that is governed by a board of trustees. The museum was first established in 1910 as the Los Angeles Museum of History, Science and Art, located in Exposition Park close to downtown Los Angeles (later to become the Natural History Museum of Los Angeles County at the same location). In 1961, the Los Angeles County Museum of Art was created as a separate institution that focused on art, and four years later opened its new buildings on Wilshire Boulevard where it currently stands. The museum has continued to add new buildings to its extensive campus in the Mid-Wilshire district with the Anderson Building in 1986 (renamed the Art of the Americas building in 2007), the Pavilion for Japanese Art in 1988, the acquisition of the adjacent May Company department store in 1994 (now LACMA West), the Broad Contemporary Art Museum in 2008, and the Lynda and Stewart Resnick Exhibition Pavilion in 2010; the last two adding 105,000 square feet and designed by Pritzker Prize–winning architect Renzo Piano.

LACMA now talks comfortably about its campus much like the Getty Center's campus, and even provides a campus map on its website. Yet greater than a campus, LACMA refers to the notion of a "cultural town square" in its *Statement of Purpose*:

> The Board of Trustees of the Los Angeles County Museum of Art is committed to activating LACMA's collection, facilities, and programs in innovative ways that will set the institution apart from its peers. We strive to create a cultural town square in Los Angeles that expresses a twenty-first century worldview of excellence in art and provides a varied, enjoyable, and educational experience for the widest possible audience. (2009, p. 45)

While the museum has been adding new buildings since the 1980s, it initiated the Transformation Campaign in 2004 to expand, upgrade, and unify the twenty-acre campus. In addition to the new buildings for art, the museum also added a gourmet restaurant and outdoor bar, major large-scale artworks by Chris Burden, Barbara Kruger, Michael Heizer, and Robert Irwin's outdoor Palm Garden, with an increase in attendance from 600,000 in 2005 to nearly 1 million in 2011. LACMA's website describes this campaign: "LACMA is emboldening its status as an international destination and essential gathering-place for the diverse audiences of Los Angeles."

LACMA is also continuing its longstanding efforts to insert itself into the community of Los Angeles with educational programs in classrooms, libraries, and public exhibition spaces. Given the great expanse of Los Angeles County (the largest county in the United States with 4,058 square miles) and the miles of freeways that define it, the museum created two successful mobile programs: the Maya Mobile and the Ancient World Mobile. These mobiles are two forty-eight-foot trucks that travel to schools within the Los Angeles Unified School District (seventh and sixth grades respectively), serving as mobile studios and classrooms based on the museum's permanent collection. What is important here, though, is that the buses doesn't just take the museum experience to the schools, they also brings students and teachers to the museum by offering free transportation and docent tours, bridging its fixed and mobile spaces.

LACMA's participation in Watts is another extension into the community. In October 2010, LACMA announced a one-year agreement with the City of Los Angeles Department of Cultural Affairs to help preserve Watts Towers, a national historic landmark, providing staff time and expertise to identify repairs and partner with other local institutions as well as community members. Govan declared in a museum press release that,

> By expanding LACMA's mission to include the care, preservation, and interpretation of architectural and sculptural works of art within the community that are at risk of neglect and deterioration, we are changing the way LACMA functions as a museum, from what we collect to how we work within the community more directly. (2010, October 21)

Led by artist Edgar Arceneaux, the ongoing Watts House Project works with artists and architects to energize the underserved neighborhood across from Watts Towers and its adjacent arts center. LACMA sponsors the Garcia House, where architects Escher GuneWardena and Slanguage Studio (artists Mario Ybarra Jr. and Karla Diaz) work with the Garcia family to develop plans for their home. LACMA presented an exhibition of the Slanguage artists at the museum (July 2–September 25, 2011), connecting their public artwork completed at the Watts residency site to the museum.

While LACMA is working more closely than ever with its local community, it has not yet reflected that community in its physical visitors. The museum's Audience and Visitation study revealed that in 2008, museum visitors were 61 pecent Caucasian, 18 percent Hispanic, 4 percent African American, and 17

percent Asian American/Other (LACMA, 2009, p. 49). According to the 2010 U.S. Census, the Los Angeles County population is 28 percent white non-Hispanic, 48 percent Hispanic, 9 percent black, and 14 percent Asian. Yet institutional changes takes time; time to organize new exhibitions, to focus on specific collections for acquisition and exhibition, to hire new staff, and to create new partnerships and programs. In the museum's membership magazine for March/April 2012, Govan reveals that one of the achievements he's most proud of is the number of Latin American art exhibitions presented at the museum, resulting in partnerships with numerous Mexican institutions. LACMA is also organizing a traveling exhibition from its collection of ancient Indian art (*India's Universe*) that will travel to Mexico and Chile for the first time.

The museum's *Strategic Plan* notes a desire to redesign its website, to enhance its Web presence, and to prioritize the use of blogs, social media, search engine optimization, and e-mail/text/cell phone applications. A notable function of LACMA's website is its live Twitter feed prominently placed on the home page with three separate Twitter accounts, in English, Spanish, and a separate community account. LACMA also discloses its goal to become the first encyclopedic museum to adopt online publishing as the norm. The January 2010 launch of the online Reading Room takes the museum one step further to its goal. The Reading Room contains out-of-print or hard-to-find museum catalogs for free to read online or download as a PDF document. LACMA also recently created a new staff position, associate vice president of technology and digital media, held by Amy Heibel who was previously the museum's director of Web and digital media. Heibel will be leading many of the new digital innovations soon to come.

The museum's *Strategic Plan* identifies LACMA as a trendsetter and declares, "Culturally, the organization must become less cautious and more innovative." One of Govan's bolder moves was the acquisition of Michael Heizer's monumental earth work, *Levitated Mass*. Heizer conceived the work in 1968, but discovered the appropriate boulder decades later in Riverside, California. The monumental sculpture (open to the public June 24, 2012) consists of a 456-foot slot carved into the ground at the museum for visitors to walk through, over which is placed the 340-ton, 21-foot-tall monolithic granite boulder. The boulder was transported by the museum on a custom-made vehicle almost three freeway lanes wide, traveling an eighty-five-mile journey that lasted around twelve days. Govan admits that the cost is close to $10 million, most coming from private and corporate donations, but says, "It's a gift to the city of Los Angeles." Govan (2011) describes the significance of *Levitated Mass* to the museum in a video:

It is an ancient tradition of moving monoliths to mark a place. The idea is that LACMA's campus really is a center for Los Angeles, a cultural center, a multicultural center, and this rock will mark it very physically, in a very timeless and light manner as you walk under it. LACMA is busy marking its place in innovative and integrated ways, using a boulder, community partnerships, physical enhancements, and digital experiments.

The case of LACMA today characterizes the situation of most museums in the digital age. Museums are more than ever committed to recreating a sense of place; the place of their own museum, and the place of their museum *within* their local community. However, LACMA is at the same time more than ever aware of belonging to an international community facilitated by both the Internet and rapid developments in globalization across all facets of life such as travel, shopping, news, culture, and entertainment from around the world that seamlessly flow across borders. As Govan notes in the museum's membership magazine (2012), "LACMA is as active around the world as it is right here on campus." But LACMA's global focus is not inconsistent with its local focus; rather it is a

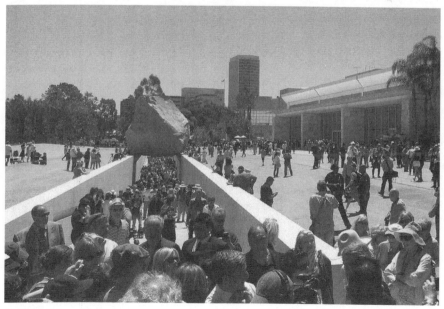

FIGURE 8.5
Levitated Mass (1969/2012) by Michael Heizer at the Los Angeles County Museum of Art, 2012.
Courtesy of the author.

reflection of it. In Los Angeles County, 35.4 percent of the population is foreign born and 56 percent speak a language other than English at home (U.S. Census, 2010). Furthermore, the museum's immediate neighborhood of Mid-Wilshire is the most diverse in the county, with a mixture of Mexicans, Koreans, and more living in close proximity. Therefore, the museum's global focus, particularly to Asia and Latin America, reflects a recognition of LACMA's diverse community, marking its place not only in Los Angeles but worldwide through its expanding network of people, experiences, and communications.

Museums today are symbiotic with their communities, cultures, and places. They have a reciprocal relationship where they grow and learn from their communities as much as they serve those very communities. The cultural heritage scholar Andrea Witcomb believes that museums should be understood today as "institutions which actually produce the very notion of community and culture" (as cited in Watson, 2007, p. 134). And with the opportunities afforded by digital technology, visitors continue to observe and learn from museums as much as they now create and participate in them. Museums are changing as their communities are changing, and communities are changing together with (not because of) technology and its infrastructures. Ross Parry calls this a change from "hard space to soft space." He asserts,

> With both the physical forms themselves (the architecture) and our conception of them (the discourse) transformed, we witness a movement from a museum's space that is prescribed, authored, physical, closed, linear and distant, to a space that instead tends to be something more dynamic, discursive, imagined, open, radical, and immersive. (2007, p. 72)

The museums that survive and succeed in the digital age are open to these new spaces that their visitors inhabit, embracing the new ways in which their visitors learn and experience art, and accepting the symbiosis of physical and virtual spaces and experiences. The physical places of the museum may not always reflect the changing nature of museology of museums in the digital age; to understand these changes is to understand the holistic museum as distributed throughout its physical and virtual spaces, its local and global communities, and through its offering of both immediate and timeless experiences.

NOTES

1. All of the studies are listed on the museum's website, http://dm-art.org/AboutUs/Frameworkforengagingwithart/index.htm.

2. The Metropolitan Museum of Art. (2011). *Annual report for the year 2010–2011*. New York: Author.

3. The Solomon R. Guggenheim Foundation and Deutsche Bank announced on February 6, 2012, that Deutsche Guggenheim in Berlin would close by the end of 2012, when the fifteen-year contract expires for the partnership.

4. The BMW Guggenheim released a statement on March 19, 2012, that it will withdraw from its proposed site in Kreuzberg, Berlin, scheduled to open on May 24, 2012, in response to threats by local activists who argued that the project would "accelerate the gentrification" of the neighborhood (Hickley, 2012).

5. LACMA's *Strategic Plan* from 2009, which is accessible not on the museum's website but on the Internet Archive with a Creative Commons license, presents the results from this study, as well as the benchmark study *Defining Success* conducted by McKinsey & Co. in Fall 2008, and a Collection Analysis of LACMA ranked by areas compared to "Top of Field" institutional partners, conducted by director Michael Govan.

9

A Balancing Act

The five case studies, as well as the preceding examples from around the world and cyberspace, all demonstrate the tremendous opportunities and value that arise from art museums employing situated technology praxis. New digital technologies have contributed to a displacement of place that no longer signifies physicality, locality, or permanence. Yet museums are not ignoring their local communities or physical collections and spaces, but rather they are constructing a synthesized vision of local and global, fixed and mobile, physical and virtual, hegemonic and populist, disregarding the limitations of traditional binary terms. Every local community has global connections with immigrant diaspora, the mass media, and the global reach of commerce, indicating parity reflected also in museum websites that are grounded in the local while connecting to the global. Even the smallest, locally based institutions have some Web presence, helping museums connect with their multiethnic communities, expanding the global reach of their audiences, and enriching programs with a more diverse selection of voices. Museums are focusing more on visitor interests and affinities that provide strong bonds to the museum and build social relations in a networked age.

The five case studies are exemplary not only because of their pioneering use of digital technology as related to locality, culture, and community, but above all, because they are highly cognizant of the changing museology in the digital age. Through extensive interviews with staff, reading staff writings in blogs, books, and articles, and even listening to them in videos, it is clear that these five

museums are already asking the right questions about how they must adapt to best serve their changing visitors in the digital age, and how *much* they must adapt, reconciling change with tradition and endurance. Even so, these five museums do not yet have answers to these questions that perhaps will be found only in retrospection. A changing museology offers opportunities for the museum institution to reinvent itself as it adapts and survives in the digital age, but it also offers threats that must be addressed. Situated technology praxis presents tremendous challenges to the museum institution, limiting or weakening certain distinctive characteristics, roles, and practices. As such, it is necessary to end this book with a balanced analysis by revealing many of the very questions and concerns that these museums have begun discussing internally.

Museums' attention to their visitors reached a peak in the late twentieth century with the new museology and the populist trend. The field of visitor studies continues strong, with museums still commissioning and conducting studies that provide detailed information on both physical and online visitor demographics, behavior patterns, and affinities. Aside from the more traditional surveys and focus groups, museums are adopting new practices for online analysis such as data mining and Web analytics, including geo-informational data mining that tracks location. Museums are also maintaining strong connections with their local communities through public programming, institutional partnerships, and school programs. Technology facilitates all of these activities, as we have seen great examples of in the preceding chapters, even serving to create new global communities and affinity groups through social media. Ironically, however, there are dangers associated with these ostensibly positive activities. One risk arises when museums stereotype visitors in order to better understand their broad community by breaking it down into more manageable types of personality, activities, and interests. This stereotyping leads to *narrowcasting*, a practice common in the advertising industry that directly targets select audiences, as opposed to the older form of broadcasting (television, radio, newspapers) that indiscriminately targets the masses.

An effort to personalize the masses is not dangerous by itself, nor is the museum's increased focus on visitor affinities such as film, photography, social events, and curatorial talks. The problem is that visitors are being defined by their demographic background and their past behavior, which museums and advertisers alike use to predict future behavior. Narrowcasting is indeed a more serious concern in the commercial sector, as customers receive specially targeted advertisements, coupons, and announcements that limit their selection and in-

fluence consumer activities, while museum visitors can still choose from a long list of categories of information to receive electronically (although self-selection bias is also a concern). Advertisers are often not as altruistic (and reputable) as the nonprofit sector in providing free information, educational services, and access to digital materials. Museums organize their websites into separate categories to facilitate online access of information largely by activities (e.g., visit, explore, learn, support, shop) or by identities (e.g., family, educators, members). As technology enables museums to better understand and serve their visitors, it is important to remember that those visitors are not merely static categories to be fed selected information. The societal value of art museums is to constantly surprise, educate, inspire, provoke, and invoke wonder based on unfamiliar activities and affinities. In the commercial world, it's called spontaneous purchasing, impulse buying, or browsing, and museums are no less familiar with the critical act of discovery, both online and onsite.

As museums continue responding to their changing visitors and communities, there is another danger of becoming too myopic. The digital age is responsible for a participatory culture, particularly among the youth who have come to expect a participatory museum experience that involves opportunities to contribute, usually through digital technologies. The term *participatory culture*, however, covers only a segment of society today that does not affect older, more traditional museum visitors that may be distracted by devices or upset by docents requesting their participation by asking too many questions. The condition of *museum myopia* is triggered by a desire to serve one group at the expense of another, one place at the expense of another, and by a desire to pursue trends at the expense of remaining dependable and familiar. Like advertisers, museums have target audiences, which at the moment are principally the younger visitors that will hopefully grow up to become loyal museum members and sponsors and then bring their families and friends to the museum. Yet our society is aging very rapidly as longevity increases and fertility decreases around the world. Older visitors have time for leisure activities such as museums, but they often have particular interests and behaviors that favor a more traditional museum experience. The threat to museums aspiring to reflect society too much is the impossibility of serving all segments equally, pandering to populism in curatorial and public programming, and losing sight of the enduring role of museums in society.

Another danger in following the latest trends is adopting technology purely for the sake of technology. It is generally agreed upon that digital technology can facilitate most traditional museum tasks, including internal ones for

administration and data management, as well as external ones for marketing, scholarship, and education. Being a technologically savvy museum with the latest digital devices can be the marker of a progressive, modern, even hip institution to trustees, foundations, and many visitors. Yet priorities must be chosen in a tight economic environment, and digital projects require great amounts of financial and human resources. The five cases have demonstrated ably that technology should always function in the service of the institution, never overshadowing the art or the visitors' experience. Even if some visitors come equipped with the most up-to-date phones and tablets, loaded with GPS and applications to read QR codes and access social media, museums must consider the totality of their community, visitors, and local culture—including their *internal* museum culture—when designing digital programs. Museums are not always quick to change, and even their adoption of new digital technologies may not signal institutional change. Entering the physical galleries of some of the most technologically advanced art museums today (SFMOMA, IMA, Brooklyn Museum), visitors may be surprised at the traditional nature of the spaces, with very little digital technology placed adjacent to the artwork. While these museums acknowledge their online and physical visitors as equally important, they also acknowledge that online experiences are different from physical ones and therefore should provide different environments.

Understanding the changing museology of the digital age allows museums to survive, which therefore reinforces their hegemony. The open culture in which visitors are now interacting, participating, and creating must be closely examined to determine to what extent these new activities truly allow for increased agency and signal enduring change in museums, or whether they are merely popular experiments meant to entice visitors, especially younger ones. Similarly, the occurrence of networked communities in museums must be examined for the extent to which museums are reinforcing the one-to-many transmission of information they have long relied upon, expanded to reach the global masses through telecommunications technology and the Internet, or whether museums are truly facilitating a more social, lateral relationship between their visitors, both physically and virtually, in order to foster social capital and expand social networks. I talk about networked *communities* for museums in the digital age rather than just *social* networks, because a community supports common interests, tasks, and goals that are the critical bases for social interaction among its members, both online and in physical spaces. Communities are hierarchical in nature, even communities of interest, and social pressure is placed on members to contribute and

participate at various levels. Participation requires individual identification by names, photos/avatars, biographical profiles, and personal contact information. A few examples of this level of community building are the Brooklyn Museum's 1stfans and Posse, the Metropolitan Museum of Art's Connections, MoMA PS1's Studio Visit, the Walker Art Center's mnartists.org, and the Tate Collectives, that all profile their individual members and provide for online social interaction, complemented by physically based activities and events.

As we recall the cultural struggle between *universalism* and *relativism*, museums must remain aware of the need to maintain a balance. Indeed, museums are universalist in that they represent socially normative values and promote universally shared experiences and sentiments through works of art that are expertly curated and exhibited to demonstrate such connections—predominantly so with encyclopedic museums. Yet despite their cultural authority and hegemonic position in society, museums are not interested in assimilating their visitors into the universal, but rather in using that influence to offer a forum for multiple voices to be heard in the relativist tradition. But celebrating diversity can also be challenging for museums that risk overlooking any one group. Furthermore, museums have always been voluntary places of respite, safety, and aspiration often likened to churches and temples. Much like modern churches today, museums try to somehow respond to commonplace needs and popular penchants (despite their struggle for neutrality), while retaining their lofty allure.

Since the populist museology began decades ago, museums have begun to experience a fundamental shift that has prepared them for this current shift in the digital age. We must recognize that, rather than fixed and static, communities are heterogeneous and transformative, that places are like circuits, flows, processes, and experiences, and that cultures are adaptable and migratory. Change is inevitable, but it nonetheless causes uncertainty and suspicion. Marita Sturken and Douglas Thomas comment on these repercussions in their introduction to *Technological Visions: The Hopes and Fears That Shape New Technologies*: "New communities are continually made possible by the innovations of new communication technologies, yet as these new communities form, fears surface that they will undermine existing networks of connectivity, the family and the neighborhood" (2004, p. 4). Nevertheless, there are significant, enduring elements of museums that will, and should, not change as they continue to influence society. Most museums have not changed dramatically in terms of their physical spaces, the installment of their galleries, and their basic composition (lobby, galleries, café, store, library, reading room, children's space). Once visitors become

familiar and comfortable with museums, they come to expect the same on repeat visits, especially with popular works in the permanent collections. In their book about online learning, William Crow and Herminia Din write, "The physical location of a museum can be one of its greatest assets but also one of its greatest challenges" (2009, p. 56). Even a commitment to maintaining traditional museum places can be difficult for museums that are exploring innovative online spaces and experiences.

Museums are essentially institutions of learning, of cultural and historic preservation, and scholarly pursuit. They are arbiters of cultural norms and values through their curatorial processes that merge high and popular culture within the sacred gallery space, mixing different periods and art forms, targeting current issues related to art for discussion and debate, and choosing certain artists above others to exhibit and collect. Museums are able to sustain this tremendous sociocultural power because they are trusted and revered organizations (AAM, 2001). Trust is a factor of authority, tradition, legitimacy, and expertise. That trust has grown during the populist museology because museums are now viewed as more conscious of and relevant to their visitors, evident in the popularity of New York City museums as places of refuge after the 2001 World Trade Center attacks. The challenge of how to adapt to a changing society by remaining relevant while still retaining familiar and traditional elements is one shared by large and small museums alike, much like the challenge of responding to local communities that may or may not reflect a museum's global connections, its interest in digital projects, or its robust website. There is much at stake for the future with digital technology, and these exemplary museums can help to guide the way.

Conclusion

To understand the changing nature of museology in the digital age is not merely to study the new technologies used by museums and their visitors, or the new digital experiments conducted, but rather to frame this shift with four major constructs: place, community, culture, and technology. The previous shift in museology that took place in the late twentieth century turned the museum into a populist institution more focused on the particular needs and interests of visitors, trying to study visitors and create personalized, meaningful experiences for them. In this current shift, the museum is no longer working *for* its visitors, but *with* its visitors, as participatory culture enables new shared experiences such as crowd-curated exhibitions, social tagging, and social media; shared between the museum and its visitors, but also shared between visitors and their personal networks. If museums are to remain relevant, vital, and meaningful, then they must adapt to a changing society, which means not only recognizing and incorporating new digital tools for communication, but more importantly, recognizing the changing needs and aspirations of society as reflected in their communities of physical and virtual visitors. While all these museums cited are large, financially stable, and well established, we cannot attribute their innovative uses of technology merely to having sufficient funding and staffing. For this reason, the implications of this research for the future of museums apply to cultural institutions of all sizes and types. By recognizing how the four major constructs have changed in the digital age, museums can better comprehend this sociocultural shift and consequently reflect it in their practices.

Place: In *Technological Visions*, Katie Hafner writes, "People still want a sense of place, a sense of belonging, in a physical way" (2004, p. 302). Hafner is referring more to an experience than a place, a physical sensation of comfort and familiarity that can occur with both physical and online spaces of any nature. Place remains a critical component of digital society in the same way that physical objects remain critical to art museums, despite the ubiquity of their digital images. This book proposes the reemergence of place for museums in the digital age, but a very different concept of place; rather a *place/experience* that allows for fluidity, process, and links through the interconnected network of space and time. Eileen Hooper-Greenhill notes, "Where the modernist museum was (and is) imagined as a building, the museum in the future may be imagined as a process or an experience" (as cited in Watson, 2007, p. 82). Place-based digital experiences can certainly be physically grounded in the museum and its environs, such as audio tours, kiosks, touch tables, iPads, or digital comment screens, but they can also reference the physical museum from virtual or physically remote spaces, such as the Global Louvre, Met Around the World, and the Guggenheim Museum's stillspotting project and BMW Lab. Museum websites are the main space in which museums draw online visitors to their physical collections, events, staff, and programs, especially for the valuable pre-visit information that comprises the majority of website visits (e.g., directions, hours, tickets, calendar). However, as museums become more like a distributed network of spaces and experiences rather than a single, brick-and-mortar place, these websites also take visitors farther away with hyperlinks to social media as well as to the websites of community organizations and programmatic partners. How museums conceive of their "place" in the digital age determines the extent to which they comfortably integrate online and onsite information, experiences, and objects, as well as local and global members into their holistic (and often nebulous) museum community.

Community: If we could classify present-day museums as communities of interest, websites would emerge as one of the vital tools for museums to support the development of specific interests while strengthening social bonds. Yet many museums are hesitant to call their website an online hub, as they recognize the decentralized nature of the museum experience today. Websites can be very effective tools for museums to better serve specific subcommunities or constituencies (artists, members, families, and teens), offering separate sections for each with downloadable information, hyperlinks, and rich multimedia content. Technology can best serve a museum's community when that community—or subcommunity—is well defined, even narrowly defined to the point of becom-

ing dangerously stagnant; such as local artists, international arts community, and educators. Yet websites are not self-sustaining online communities, just one more node within the distributed museum network. In *Museums and Community*, Elizabeth Crooke asserts, "the community unit will not bond without reason; instead, particular circumstances must give rise for the need to come together" (2008, p. 31). Social media play a critical role in this task, facilitating the coming together of individuals in virtual and physical spaces, perhaps even more effective because of their peer-based influence. In reflecting on today's relevance of his 2000 book *Bowling Alone*, Robert Putnam (2007) identifies the 9/11 generation that gives him more hope for participation and civic engagement based on the social cohesion that characterizes it, believing social capital and community to be "conceptual cousins." Communities are networked in the digital age as they organically connect with a myriad of other communities of individuals, interests, and institutions. By integrating social media within their websites, museums can access the networked communities that their visitors belong to, such as with MoMA's Facebook page for its Online Courses Alumni, SFMOMA's *Open Space* blog, or Brooklyn Museum's 1stfans on Meetup.com.

Culture: Art museums can be considered hegemonic in that they reflect the dominant culture in which they function and play a leadership role in shaping culture itself (Hall, 1982). The *consensus theory of hegemony* (Raymond Williams, Larry Grossberg, Stuart Hall) suggests that hegemony dominates through consent rather than coercion, and that it survives by changing and incorporating emergent forms that bolster its dominance and relevance to society. Today, private art museums in the United States operate as public/private nonprofit organizations that are largely influenced by powerful financial and corporate interests. They are indeed independent and are conscious of that being a factor of their cultural authority and legitimacy; nonetheless, art museums are not neutral organizations, and the decisions they make (curatorial, programmatic, administrative) are often interpreted as externally influenced or are critiqued for their partiality that in turn influences the field. For example, both the *Sensation* and *Murakami* exhibitions at the Brooklyn Museum were criticized for being influenced by private, corporate interests; MoMA's early focus on European modernist artists instead of emerging American abstract expressionist artists was due to its director Alfred Barr; and the Walker's decision to terminate its new media curatorial program incited and coalesced the global media arts community. Yet precisely because of the "social" nature of social media, there exist differences and hierarchies as in any society. Raymond Williams (1958/1983b) argues for a

common culture and a common experience like the universalists, but this does not mean an equal culture. He believes that inequality within society is "inevitable and even welcome." While peer-based social networks are more democratic, there are still opinion leaders and followers. The opinions, attitudes, and values of friends and family members play an important role in mediating (and reconstructing) messages, as Elihu Katz and Paul Lazarsfeld (1955) famously explain in *Personal Influence: The Part Played by People in the Flow of Mass Communications*. Museums are empowering their visitors with new digital experiments that allow common voices to be heard in the same space as curators—for online visitors to "curate" personalized online spaces and galleries, to judge works, and to be involved in other participatory practices—but the empowerment is bracketed within a deeply hierarchical space where the museum retains final authority over curation, installation, didactics, acquisition of works, and more.

Technology: The computer scientist Ben Schneiderman wrote *Leonardo's Laptop: Human Needs and the New Computing Technologies*, in which he describes technology today: "The old computing was about what computers could do; the new computing is about what users can do. . . . The time is right for the high-tech world to attend more closely to the needs of humanity" (2002, p. 2). Art museums are eager to embrace technologies that empower their visitors and provide social opportunities for networking which can ultimately benefit them. Yet more important than understanding and adopting the newest technological platforms is for museums to understand the context within which those technologies are used. Technology is a tool for museums to achieve certain goals, a tool to support experiential infrastructure, and only by first recognizing their goals and structure as locally and culturally constructed will museums have the most effective results. The differences between these five museums' uses of technology can be attributed to distinct museum strategies and objectives, often due to the very nature of the director, as well as distinct geographic and demographic communities. Considering the influence of digital technology on museums today, we can acknowledge both technological optimists and pessimists: Pierre Lévy and Clay Shirkey as the former, Jonathan Zittrain, Jaron Lanier, and Sherry Turkle as the latter. Then there are the technological determinists, most famously Marshall McLuhan (2003), who wrote, "The Medium is the Message." The political theorist Langdon Winner, however, is most appropriate to this discussion when he states in *Autonomous Technology*, "Pessimism, it is argued, leads to inaction, which merely reinforces the status quo. This is somehow different from optimism, which leads to activity within the existing arrange-

ment of things and reinforces the status quo" (1978, pp. 52–53). Technological optimism is ultimately as destructive as technological pessimism, according to Winner, in that both permit technology to overshadow its more critical socio-cultural implications.

MoMA director Glenn Lowry (Zirin, 2011) believes that the digital revolution is driven by content, and he reminds us that museums are content-rich orga-nizations. The ability to produce multimedia content, especially in-house, is a great asset for museums that can generate new partnerships (SFMOMA channel on Virgin America airlines), become leaders within the museum community (IMA's ArtBabble) and the global arts community (Walker's new website rede-sign), and allow for layered visitor experiences across various digital platforms such as mobile, online, video, and touch-screen displays. Museums have long been valued for the content they produce, exemplified by MoMA and SFMO-MA's radio and television programs from the 1930s to 1950s. Their ability to create multimedia content today keeps them relevant to visitors that are rapidly accessing data across new platforms as they develop. Nevertheless, the focus on content distracts us from discussing the socially relevant means with which mu-seum visitors are accessing, distributing, and personalizing such content. Walker curator Francesco Bonami describes this phenomenon: "Placing the art on the wall, or on the floor, and reproducing it in a catalogue is no longer sufficient. The institution should be a center for communication, not just exhibition" (as cited in Blauvelt, 2005, p. 229). Similarly, Sebastian Chan claims, "Once a visitor carries a fully searchable encyclopedia in their pocket . . . the whole idea of a 'mu-seum' and how it could and should be designed changes" (2011, September 15).

Understanding the changing nature of museology today helps explain how and why museums are creating new experiences not limited to physical or lo-cal places, how they are supporting an open, participatory culture while still maintaining authority and expertise, and how they are establishing networked communities even as they continue to embody a central node within the global, distributed space of museums in the digital age. The core implication of situated technology praxis, however, lies more in endurance rather than change, as mu-seums' ability to change is precisely the reason for their survival in the digital age and throughout the last 300 years. These five case studies are important to the field because they vividly demonstrate how to recognize the changing museol-ogy today as it relates to place, community, culture, and technology, and how to skillfully maneuver change by remaining faithful to the essential roles, practices, and constitution of museums in society.

Appendix A

Methodology

I selected the methodology of case studies in order to more deeply examine the changing nature of museology in the digital age. The five museums were chosen based on one criterion alone: their exceptional use of technology at the time this research began (spring 2010). While the museums were not chosen based on their geographic locations, it is important to note that two museums are located in the Midwest in urban metropolises (Walker Art Center and Indianapolis Museum of Art), two on the East Coast in a large, cosmopolitan city (MoMA and the Brooklyn Museum), and one on the West Coast in a mid-sized, cosmopolitan city (SFMOMA). The five museums are all art museums, but they were not chosen for their particular typology. While all are private museums, one focuses on contemporary art (Walker Art Center), two on modern art (MoMA and SFMOMA), and two are encyclopedic art museums (Brooklyn Museum and Indianapolis Museum of Art). In order to study society and culture as a context in which museums are integrating digital technology, we must look to the arts as one of the most potent expressions of that context. John Dewey confirms the social aspect of art that orders and unifies collective life in *Art as Experience*: "Art also renders men aware of their union with one another in origin and destiny" (1934, p. 271). Referring to artists as "the social conscience," Marshall McLuhan writes, "Art as a radar acts as an early alarm system, as it were, enabling us to discover social and psychic targets in lots of time to prepare to cope with them" (1964/2003, p. 16). Art (high and low, non-utilitarian and utilitarian) is representative of a culture because it is produced by members of a society that

reflect (and reflect upon) its shared cultural values, memories, meanings, and aspirations, and art museums are devoted to interpreting and exhibiting these sociocultural expressions for public benefit.

The theoretical basis for this book incorporates ideas from the various fields of cultural studies, museum studies, digital humanities, ethnography, sociology, communication, art history, education, and media studies. A similarly complex combination of methods was necessary to study a subject that is relatively nascent, often difficult to breach from the outside due to the traditional elite status of museums, and rapidly changing as it tries to keep up with a rapidly changing society and its changing modes of communication, socialization, creation, and learning. A quantitative approach to the research was needed because museums have traditionally measured success by counting the number of tickets sold, schoolchildren that come to the museum, total visitor attendance, seats filled in the auditorium, and even the number of clicks on a website, downloads of a video or podcast, or uploads of comments and photos. Numbers remain important to museum administrators, trustees, funders, and public officials, and are shared and even compared within the larger museum community (as with the Association of Art Museum Directors' annual *State of North America's Art Museums Survey*) or with the public (as in the Indianapolis Museum of Art's online Dashboard). Numbers are an essential starting point; however, a qualitative approach was also needed in order to reveal the full context in which technology is being used, and so I conducted a deeper ethnographic study of museums in the digital age.

Ethnographic research in museums experienced resurgence in the late twentieth century with the popularity of visitor studies that applied traditional ethnographic methods including observations, interviews, focus groups, and data gathering, resulting in the categorization of visitors by interests, motivations, prior knowledge, and background. Traditionally housed within the disciplines of anthropology and sociology, the use of ethnography for purposes of social research entered the field of communications in the 1960s. Well-known ethnographers targeted indigenous, isolated societies such as in Bali (Clifford Geertz), Brazil (Claude Levi-Strauss), New Guinea and Samoa (Margaret Mead), or the Native American Indians (Franz Boas). Ethnographic research is an immersed experience in a culture involving direct observation of its practices and people, and also participation within its community. Studying art museums in the digital age might not be considered a "primitive" culture, but modern museums still remain to a point isolated and inaccessible, despite their increased attentiveness

to being more socially relevant and responsive. Therefore, this research treats art museums as a cultural community unto themselves.

The practice of *digital ethnography* is a recent addition to the empirical fields of anthropology and ethnography that carry on well into the digital age. In the early 1980s, cyberspace was considered by scholars as a separate space from physical reality, and technology was merely a tool used to facilitate our everyday tasks, completely separate from and irrelevant to culture. Today, however, there can be found a wealth of scholarly digital ethnographic studies due to increased understanding that the online is integrally related to the physical, as is technology integral to culture and behavior (individual and collective), with the implications of identity, linguistics, communication, and new cultural practices. Some leading scholars in the field include Samuel M. Wilson and Leighton C. Peterson from the department of anthropology at the University of Texas at Austin; Michael Wesch, assistant professor of cultural anthropology and digital ethnography at Kansas State University; and danah boyd, a senior researcher at Microsoft Research who holds three academic positions at New York University, Harvard Law School, and the University of New South Wales. Boyd received her PhD from the University of California at Berkeley School of Information and conducted early digital ethnographies of Friendster, Blogger, MySpace, and Twitter, studying teens and youth in great detail and working with Mizuko Ito and her Digital Youth Project.

Ethnographers conduct fieldwork, where they physically live within the communities they are studying for an extended time period. For my digital ethnographic research, fieldwork took place within both the online and physical environments of each museum for a total period of one year (August 2010–August 2011).[1] The focus of ethnographic research is to observe and record social discourse, which when applied to the topic of art museums in the digital age means blogs and social media, the main digital platforms for contemporary social discourse between museums and their public (and also within that public). Certainly the digital age differs from primitive societies in that social discourse can now be archived on the Internet and disseminated to a global audience; nevertheless, institutional (and human) decisions remain the determining factor for the extent to which the public is able to access the archived information. While scholars are able to search and analyze past Tweets or Facebook posts, such as through the Library of Congress that added Twitter's public tweets to its national archive in 2010, for most users they still exist as a mere passing event.

The following describes specific components of the digital ethnography that I conducted on each of the five museums.

MUSEUM BLOGS

I read each museum's blog two to three times a week for a total period of ten months (October 2010–August 2011). Detailed notes were taken on how each blog was organized (aesthetically as well as functionally), from where the blog could be accessed on the museum's website, who were the individuals posting the blogs, from which departments, what information was provided on the authors, what was the content of the posts, what were the comments and where were they created (e.g., Twitter, Google like, StumbleUpon, and Facebook), and how many posts were related to technology (and from which museum departments did these come from). At the end of the observation period, quantitative data was collected on the total number of posts and comments for each blog. The total number of postings related to technology is a measurement of the importance of technology to the museum, and a diversity of departments demonstrates how a culture of technology is integrated throughout the museum. The total number of blog comments (including outside users and museum staff) and the total number of outside bloggers is a measurement of community engagement; and the total number of blog posts is a measurement of the museum's importance of the blog as a forum for discourse (as instigated by museum staff or invited guests).

SOCIAL MEDIA USE

Because social media (in particular Twitter) is a more frequent means of communication than a blog, the observation of museums' social media occurred over a two-week period, analyzing all of the social media utilized by each museum at the end of each day. Although all of the five museums use Twitter, Facebook, YouTube, and Flickr, there was a great variety as to the additional social media used, including iTunesU, Foursquare, Tumblr, MySpace, SCVNGR, LinkedIn, blip.TV, Instagram, Historypin, and Meetup. Detailed notes were taken on where the social media was positioned within the museums' websites and blogs, analyzing both their functional and aesthetic characteristics. Notes were also taken on how each social media account appears to the user, who were the individuals posting the information and from what museum departments, what was the content posted (including links, photos, videos), and what was the nature of the public comments. At the end of the observation period, quantitative data was

collected on the total number of tweets, followers, and listed (Twitter), check-ins, like this, and posts (Facebook), photos uploaded and members (Flickr), channel views, upload views, and videos (YouTube), and similar data for the other social media.

DATA COMPILATION

Data was compiled on each museum and on its geographic community. The information was compiled from the museums' latest annual reports or audited financial statements, their latest 990 forms reported to the federal Internal Revenue Service, from their websites, archived documents, press releases, and directly from staff whenever possible. For some categories, the data simply affirmed whether the museum offered a particular service, for others it reported recent statistics, and for others it was more descriptive in nature. Museums vary to a great degree in the amount of internal information that they publicly offer online. The Indianapolis Museum of Art is well known for its commitment to transparency with the Dashboard and is an exception to the generally private art museum. Some museums, such as the Brooklyn Museum, no longer produce annual reports and refuse to divulge internal information to the public.[2] Nonetheless, Brooklyn Museum's Shelley Bernstein is widely recognized for her prolific blog postings that publicly document in detail the planning, executing, and evaluation of her groundbreaking digital projects.

Data on the museums' geographic communities was compiled from the following public online reports: *Civic Life in America 2010*, *Mapping the Measure of America*'s 2010–2011 American Human Development Project (the Civic Engagement Supplements), *FBI Uniform Crime Report 2010*, and the U.S. Census 2010 (Current Population Study and the Computer and Internet Supplement from 2009 and American Community Survey 2005–2009). The local regions studied were municipalities, counties, boroughs, congressional districts (for the American Human Development Project), and states (for measures of state arts appropriation and households with Internet access). While the Museum of Modern Art and the Brooklyn Museum are both located in New York City, additional data was collected on their particular boroughs (Manhattan and Brooklyn) and congressional districts (14 and 11 respectively) because they are such distinct and populous parts of the city. Data was also obtained on the municipal arts funding for each museum. Finally, all the data from each museum and their geographic communities were compared in an Excel spreadsheet. Because of the diversity of each physical museum community and the range in each museum's number of visitors, revenue,

endowment, number of members, use of technology, and Web statistics, some interesting patterns emerged that revealed important correlations between the nature of the museums and their physical communities.

SITE VISITS

The physical fieldwork consisted of a research trip to each museum for approximately five or six days (except for the trip to New York City that covered two museums and lasted eight days). Each museum was visited at least twice at different days and times in order to gain a good understanding of the variety of museum visitors and programs, such as on a weekend, a free evening, or during a weekday. At the museum, research included observation of visitors, participation in tours (digital and analog) and special events, interaction with digital devices, visits to all public spaces including the gardens, cafes, restaurants, educational rooms, and also to any satellite spaces or programs within the community. In addition to the museum visits, fieldwork involved researching the cultural context within which each museum operates. This required visiting any partnering institutions of the museum, other noteworthy museums in the area, community and alternative arts spaces, commercial galleries, cultural/arts districts, as well as tourist offices and other tourist destinations such as shopping areas, natural parks or lakes, monuments, and sports attractions. Detailed observation notes and photographs were taken at all places visited.

FOCUSED INTERVIEWS

In researching the five case studies, I conducted thirty interviews with museum staff and other professionals in the museums' physical community, including marketing and tourism, municipal cultural affairs, foundations, and bloggers. It was also important to conduct interviews outside the museums to understand their integration within the local arts and cultural communities, and their relation to the greater geographic communities in which they are situated. The majority of the interviews were conducted in person, but because of time constraints a few were conducted by e-mail and telephone. The interviews lasted between forty-five minutes and an hour, and were all recorded with permission of the interviewee (except for Shelley Bernstein, who allowed only note taking). The interviewees were selected based on identifying the key individuals working directly with digital technology at the museums, and then from other departments such as administrative, curatorial, education, and public relations in order to gain an understanding of how technology is perceived and adopted

throughout the entire organization.[3] It was difficult to acquire interviews with the museum directors, despite repeated requests, and I secured only two: Maxwell Anderson (when he visited the University of Southern California for the National Summit on Arts Journalism) and Olga Viso. When it was not possible to secure interviews with museum directors, I found interviews with them from outside sources available on the Internet such as blogs and newspapers or magazines, often linked to the museums' own websites including videos.[4] It was important to combine museum staff interviews with observation, analysis, and data compilation in order to corroborate what is said in the interviews with concrete data and to provide balance and objectivity to my personal observations.

MUSEUM WEBSITES

At the beginning of this research, my intention was to conduct a content analysis of each museum website and its public content in order to measure how the websites contribute to a sense of online community by providing institutional information, services, and opportunities for public participation and sharing. The analysis would categorize variables of elements of the websites into a contextual framework providing for peer-to-peer connection, online interaction, and dialogue that allow for public contributions and promote shared activities, goals, and interests. Fortunately, this part of the research was left to the end. What was gleaned from all the preliminary research was a greater understanding of how museums regard their websites, particularly in relation to their use of blogs and social media. Web analytics demonstrate that the primary objective for viewing most museum websites is to find museum hours, directions, calendar of events, and the online store. There are certainly many specialized uses for the websites such as teachers downloading lesson plans, parents looking for activities for their children, or scholars researching certain works of art; however, these are not the most common. Furthermore, museums have found that most online users are not accessing their blogs and social media sites through the museum website but through other sources, many of which are a result of online peer connections. What is important is that their blogs and social media sites all link back to the museum website, which ultimately serves as the centralized, aggregated hub of information online. Therefore, I took a different approach to analyzing museum websites. Because museums redesign their websites frequently (every five years or so) in concurrence with changing digital technologies and institutional objectives, it was more important to consider the websites as a snapshot of this particular time and to understand better the strategies and elements that distinguish

each museum website. The five websites were analyzed by conducting digital fieldwork: repeatedly entering into each section and subsite, opening each link, online activity, and PDF document, noting the online services and activities offered to the user, the information presented about exhibitions, digital archives, the placement of social media links and the particular section in which they are listed, as well as the blog, and information about the museum history, staff, and policies, and the aesthetic and functional organization of all this information.

NOTES

1. This was the period of onsite fieldwork, but research began earlier around March 2010, and writing took place between September 2011 and May 2012. During the writing stage, I continued to receive e-newsletters from the five museums and to read their blogs on a less frequent basis, and I regularly reviewed their websites and social media. Any updated information was subsequently incorporated into the manuscript.

2. Telephone and e-mail correspondence between the author and Sally Williams, public information officer at the Brooklyn Museum.

3. I had secured more interviews for the Brooklyn Museum, including Kevin Stayton, chief curator; Cynthia Mayeda, deputy director; and Alisa Martin, manager of visitor services and marketing, but the museum decided to have me meet instead only with Dr. Arnold Lehman, the director. At the last minute that meeting was cancelled and I was able to meet with Shelley Bernstein, who was previously unavailable.

4. In celebration of its seventy-fifth anniversary in 2010, the San Francisco Museum of Modern Art partnered with the Regional Oral History Office at the Bancroft Library, University of California, Berkeley, to produce an Oral History Project with fifty-four video interviews and their transcripts from past and present museum directors, board members, collectors, dealers, artists, and museum staff. The interviews were a valuable source of information dating back to 1960 that are accessible on the Bancroft's website (http://bancroft.berkeley.edu/ROHO/projects/sfmoma/).

Appendix B

Interviews

INDIANAPOLIS MUSEUM OF ART (IMA)

Jennifer Anderson, senior communications coordinator, IMA, on August 3, 2011

Maxwell Anderson, the Melvin & Bren Simon Director and CEO, IMA, on September 10, 2009

Rachel Craft, director of media/publishing, IMA, on August 3, 2011

Chris Gahl, director of communications, Indianapolis Convention and Visitors Association, on August 2, 2011

Dave Lawrence, president and CEO, the Arts Council of Indianapolis, on August 2, 2011

Robert Stein, chief information officer/director of MIS, IMA, on August 3, 2011

Katie Zarich, deputy director for public affairs, IMA, on August 3, 2011

WALKER ART CENTER

Darsie Alexander, chief curator, Walker Art Center, on January 6, 2011

Robin Dowden, director of New Media Initiatives, Walker Art Center, on December 3, 2010

Siri Engberg, curator of visual arts, Walker Art Center, on October 20, 2010

Ryan French, director of marketing, Walker Art Center, on July 12, 2011

Kevin Hanstad, director of market research, Meet Minneapolis, on October 18, 2010

Sarah Schultz, director of education and community programs, Walker Art Center, on October 19, 2010

Olga Viso, director, Walker Art Center, on December 24, 2010

SAN FRANCISCO MUSEUM OF MODERN ART (SFMOMA)

Erica Gangsei, manager of interpretive media, education, SFMOMA, on June 23, 2011

Lisa Hasenbalg, director, arts and culture marketing, San Francisco Convention and Visitors Bureau, on June 25, 2011

Dana Mitroff Silvers, website manager, SFMOMA, January 20, 2012

Tere Romo, program officer for arts and culture, San Francisco Arts Foundation, on November 18, 2011

Peter Samis, associate curator of interpretation and education, SFMOMA, on June 23, 2011

Suzanne Stein, community producer, SFMOMA, on June 23, 2011

MUSEUM OF MODERN ART (MoMA)

Allegra Burnette, creative director of digital media, MoMA, on April 11, 2011

Santiago Grullón, senior director, research and analysis, NYC & Company, on November 28, 2011

Beth Harris, director of digital learning, MoMA, on May 23, 2011

Peter Reed, senior deputy director of curatorial affairs, MoMA, on April 11, 2011

Wendy Woon, deputy director for education, MoMA, on April 11, 2011

BROOKLYN MUSEUM

Shelley Bernstein, chief of technology, Brooklyn Museum, on April 14, 2011

Essie Lash, communications and new media manager, Heart of Brooklyn, on April 15, 2011

Carolina Miranda, Brooklyn-based art writer and blogger (C-Monster.net), on April 10, 2011

Ellen F. Salpeter, director, Heart of Brooklyn, on April 15, 2011

Ella J. Weiss, president, Brooklyn Arts Council, on April 15, 2011

References

About YouTube Play—with jurors [Video]. (2010, July 30). Retrieved January 16, 2012, from YouTube: http://www.youtube.com/play#p/a/u/1/fe4JPtbZGuU

Abram, R. J. (2005). History is as history does: The evolution of a mission-driven museum. In R. Janes & G. T. Conaty (Eds.), *Looking reality in the eye: Museums and social responsibility* (pp. 19–42). Alberta, Canada: University of Calgary Press.

Adobe Museum of Digital Media. http://www.adobemuseum.com/

AFP. (2011, December 15). *Louvre and Nintendo aim to make art child's play*. Retrieved December 18, 2011, from Google: http://www.google.com/hostednews/afp/article/ALeqM5gw2AbeSY2-6tyQSj3L3qpFCsaFUw

Agar, M. H. (1980). *The professional stranger: An informal introduction to ethnography* (2nd ed.). San Diego, CA: Academic Press.

Alexa The Web Information Company. http://www.alexa.com/

Alliance for the Arts. (2010). *Who pays for the arts? Income for the nonprofit cultural industry in New York City*. New York: Author.

Alliance for the Arts. (2010, May). *The recession and the arts II. The impact of the economic downturn on nonprofit cultural organizations in New York City*. New York: Author.

Alpert, L. I. (2009, September 2). Latest art tech-nique [Electronic version]. *New York Post*. Retrieved January 26, 2011, from http://www.nypost.com/p/news/regional/latest_art_tech_nique_tNcT4XerG6UOuKZg8Qi81L

American Association of Museums. http://www.aam-us.org/

American Association of Museums. (2001, February). *Trust and education. Americans' Perception of Museums: Key findings of the Lake Snell Perry & Associates 2001 survey.* Washington, DC: Author.

America's best downtowns [Electronic version]. (2011). *Forbes.* Retrieved October 10, 2011, from http://www.forbes.com/pictures/efel45eddf/indianapolis-ind/#gallerycontent

Anderson, B. (2006). *Imagined communities: Reflections on the origin and spread of nationalism* (Rev. ed.). New York: Verso.

Anderson, M. (2009, October 30). *Indianapolis Museum of Art Presented by Max Anderson: A national summit on arts journalism* [Video]. Retrieved November 23, 2009, from Annenberg School for Communication and Journalism, University of Southern California: http://najp.org/summit/watch/showcase/#showcase5

Andrews, G. (2011, October 20). Art museum CEO Anderson headed to Dallas. *Indianapolis Business Journal.com.* Retrieved October 21, 2011, from http://www.ibj.com/art-museum-ceo-anderson-headed-to-dallas/PARAMS/article/30267

Appadurai, A. (1986). *The social life of things: Commodities in cultural perspective.* England: Cambridge University Press.

Art and science to blend at new conservation lab [Electronic version]. (2010, February 25). *Inside Indiana Business.* Retrieved November 2, 2011, from http://www.insideindianabusiness.com/life-sciences.asp?ID=213&Detail=True

Art initiative planned for new hotel [Electronic version]. (2012, March 9). *Inside Indiana Business.* Retrieved March 20, 2012, from http://www.insideindianabusiness.com/newsitem.asp?ID=52612#middle

Asen, R. (2004). A discourse theory of citizenship. *Quarterly Journal of Speech, 90,* 189–211.

Asen, R., & Brouwer, D. C. (Eds.). (2001). *Counterpublics and the state.* Albany: State University of New York Press.

Association of Art Museum Directors. (2010). *State of North America's art museums survey.* New York: Author.

Baker, K. (2011, August 18). SFMOMA transitions to in-house multimedia tours. *SFGate (San Francisco Chronicle).* Retrieved November 7, 2011, from http://articles.sfgate.com/2011-08-18/entertainment/29899340_1_acoustiguide-tours-museums

Baker, R. C. (2010, September 8). *Work of Art* winner Abdi Farah limps into the Brooklyn Museum [Electronic version]. *Village Voice.* Retrieved December 18, 2011, from http://www.villagevoice.com/2010-09-08/art/work-of-art-winner-abdi-farah-limps-into-the-brooklyn-museum/

Bal, M. (1994). Telling objects: A narrative perspective on collecting. In J. Elsner & R. Cardinal (Eds.), *The cultures of collecting* (pp. 97–115). Cambridge, MA: Harvard University Press.

Balsamo, A. (2011). *Designing culture: The technological imagination at work.* Durham, NC: Duke University Press.

The Bancroft Library, University of California, Berkeley. Regional Oral History Office. SFMOMA 75th anniversary oral history project. http://bancroft.berkeley.edu/ROHO/projects/sfmoma/interviews.html

Bandura, A. (2002). Social cognitive theory of mass communication. In J. Bryant & D. Zillman (Eds.), *Media effects: Advances in theory and research* (2nd ed.) (pp. 61–90). Hillside, NJ: Erlbaum.

Barreneche, R. (2011, May). America's most significant modernist house [Electronic version]. *Travel + Leisure*. Retrieved October 20, 2011, from http://www.travelandleisure.com/articles/americas-most-significant-modernist-house

Bary, A. (2006). Creating a virtuous circle between a museum's on-line and physical spaces. In J. Trant & D. Bearman (Eds.), *Museums and the Web 2006: Proceedings*. Toronto, Canada: Archives & Museum Informatics. Retrieved June 6, 2011, from http://www.museumsandtheweb.com/mw2006/papers/barry/barry.html

Basso, K. H. (1996). Wisdom sits in places: Notes on a western Apache landscape. In S. Feld & K. H. Basso (Eds.). *Senses of place* (pp. 53–90). Santa Fe, NM: School of American Research Press.

Bates, E. (2010). Delivering gallery interactives using web technologies: Multimedia and web delivery at the Victoria and Albert Museum, London, in 2009. In J. Trant & D. Bearman (Eds.), *Museums and the Web 2010: Proceedings*. Toronto, Canada: Archives & Museum Informatics. Retrieved January 3, 2012, from http://www.archimuse.com/mw2010/papers/bates/bates.html

Baudrillard, J. (1985, Spring). The masses: The implosion of the social in the media. (M. Maclean, Trans.). *New Literary History, 16*. In S. Duncombe (Ed.), *Cultural resistance reader* (pp. 101–113). New York: Verso.

Baudrillard, J. (1994). The system of collecting. In J. Elsner & R. Cardinal (Eds.), *The cultures of collecting* (pp. 7–24). Cambridge, MA: Harvard University Press.

Bautista, S. (2009, May 28). *Digital media in community libraries, part 2: Teen websites* [Blog post]. Retrieved May 29, 2009, from Futures of Learning: http://futuresoflearning.org/index.php/Firda_08/comments/digital_media_in_community_libraries_part_2_teen_websites/

Bautista, S. (2009, July 3). *Museum collections: Digitization → Dissemination → Dialogue* [Blog post]. Retrieved July 4, 2009, from Futures of Learning: http://futuresoflearning.org/index.php/Firda_08/comments/museum_collections_digitization_dissemination_dialogue/

Bautista, S. (2009, July 10). *Online (art) museum experiences* [Blog post]. Retrieved July 11, 2009, from Futures of Learning: http://futuresoflearning.org/index.php/Firda_08/comments/online_art_museum_experiences/

Bautista, S., & Wallis, C. (2009, June 30). *Mobile experiences in art museums* [Blog post]. Retrieved July 1, 2009, from Futures of Learning: http://futuresoflearning.org/index.php/Firda_08/comments/mobile_experiences_in_art_museums/

Becker, H. S. (2008). *Art worlds*. Los Angeles: University of California Press. (Original work published 1982)

Bell, J. (2007, May 11). Arnold Lehman. *Artinfo*. Retrieved December 17, 2011, from http://www
.artinfo.com/news/story/24096/arnold-lehman/

Bell, L. (2008). Engaging the public in technology policy: A new role for science museums. *Science Communication*, *29*, 386–398.

Benezra, N. (Speaker). (2010, June 22). *Reimagining SFMOMA: Four architects* [video]. Retrieved November 10, 2011, from YouTube: http://www.youtube.com/watch?v=UGChDkvJ5VI

Benhabib, S. (Ed.). (1996). *Democracy and difference. Contesting the boundaries of the political*. Princeton, NJ: Princeton University Press.

Benhabib, S. (2002). *The claims of culture: Equality and diversity in the global era*. Princeton, NJ: Princeton University Press.

Bennett, T. (1995). *The birth of the museum: History, theory, politics*. New York: Routledge

Bennett, T. (1999). Useful culture. In D. Boswell & J. Evans (Eds.), *Representing the nation: A reader. Histories, heritage and museums* (pp. 380–393). New York: Routledge.

Bennett, W. L. (2008). Changing citizenship in the digital age. In W. L. Bennett (Ed.), *Civic life online: Learning how digital media can engage youth* (pp. 1–24). The John D. and Catherine T. MacArthur Foundation Series on Digital Media and Learning. Cambridge, MA: MIT Press.

Berger, J. (1990). *Ways of seeing*. New York: Penguin Group (USA) Inc. (Original work published 1972)

Bernstein, S. (2007, November 8). *ArtShare on Facebook!* [Blog post]. Retrieved December 21, 2011, from Brooklyn Museum: http://www.brooklynmuseum.org/community/blogosphere/2007/11/08/artshare-on-facebook

Bernstein, S. (2008, November 24). *Utilizing YouTube Quick Capture for community voices* [Blog post]. Retrieved December 21, 2011, from Brooklyn Museum: http://www.brooklynmuseum.org/community/blogosphere/2008/11/24/utilizing-youtube-quick-capture-for-community-voices/

Bernstein, S. (2009, March 4). *Brooklyn Museum collection API* [Blog post]. Retrieved December 26, 2011, from Brooklyn Museum: http://www.brooklynmuseum.org/community/blogosphere/2009/03/04/brooklyn-museum-collection-api/

Bernstein, S. (2009, March 30). *Wrapping up YouTube Quick Capture for community voices* [Blog post]. Retrieved December 26, 2011, from Brooklyn Museum: http://www.brooklynmuseum.org/community/blogosphere/2009/03/30/wrapping-up-youtube-quick-capture-for-community-voices/

Bernstein, S. (2009, August 26). *BklnMuse: Going mobile with a gallery guide powered by people* [Blog post]. Retrieved December 26, 2011, from Brooklyn Museum: http://www

.brooklynmuseum.org/community/blogosphere/2009/08/26/bklynmuse-going-mobile -with-a-gallery-guide-powered-by-people/

Bernstein, S. (2010, October 5). *A response to Rothstein's "From Picassos to Sarcophagi, Guided Along by Phone Apps"* [Blog post]. Retrieved December 27, 2011, from Brooklyn Museum: http://www.brooklynmuseum.org/community/blogosphere/2010/10/05/a-response-to -rothsteins-from-picassos-to-sarcophagi-guided-along-by-phone-apps/

Bernstein, S. (2010, October 14). *Welcome to WikiPop. 25 articles in English (on iPads in the gallery)* [Blog post]. Retrieved December 22, 2011, from Brooklyn Museum: http://www .brooklynmuseum.org/community/blogosphere/2010/10/14/welcome-to-wikipop-25 -articles-in-english-on-ipads-in-the-gallery/

Bernstein, S. (2011, January 28). *Wikipop iPads and visitor metrics* [Blog post]. Retrieved December 21, 2011, from Brooklyn Museum: http://www.brooklynmuseum.org/community/ blogosphere/2011/01/18/wikipop-ipads-and-visitor-metrics/

Bernstein, S. (2011, February 3). *What do you see in a split-second?* [Blog post]. Retrieved December 27, 2011, from Brooklyn Museum: http://www.brooklynmuseum.org/community/ blogosphere/2011/02/03/what-do-you-see-in-a-split-second/

Bernstein, S. (2011, May 5). *Brooklyn Museum API: Collections iPad app* [Blog post]. Retrieved December 26, 2011, from Brooklyn Museum: http://www.brooklynmuseum.org/community/ blogosphere/?p=4605

Bernstein, S. (2011, June 21). *Help us pin Brooklyn to the map!* [Blog post]. Retrieved December 21, 2011, from Brooklyn Museum: http://www.brooklynmuseum.org/community/ blogosphere/2011/06/21/help-us-pin-brooklyn-to-the-map/

Bernstein, S. (2011, July 13). *Come visit your data in Split Second* [Blog post]. Retrieved December 21, 2011, from Brooklyn Museum: http://www.brooklynmuseum.org/community/ blogosphere/2011/07/13/come-visit-your-data-in-split-second/

Bernstein, S. (2011, September 7). *Should I stay or should I go?* [Blog post]. Retrieved December 19, 2011, from Brooklyn Museum: http://www.brooklynmuseum.org/community/ blogosphere/2011/09/07/should-i-stay-or-should-i-go/

Bernstein, S. (2011, December 1). *Proving a point with Google Images* [Blog post]. Retrieved December 20, 2011, from Brooklyn Museum: http://www.brooklynmuseum.org/community/ blogosphere/2011/12/01/proving-a-point-with-google-images/

Bernstein, S. (2012, January 4). *QR in the new year?* [Blog post]. Retrieved March 20, 2012, from Brooklyn Museum: http://www.brooklynmuseum.org/community/blogosphere/2012/01/04/ qr-in-the-new-year/

Berry, S. (2008, September 15). *A town on the outskirts of town* [Blog post]. Retrieved October 25, 2011, from Indianapolis Museum of Art: http://www.imamuseum.org/blog/tag/hugh-mckennan -landon/

Bhabha, H. K. (Ed.). (1990). *Nation and narration.* New York: Routledge.

Bhabha, H. K. (1994). *The location of culture.* New York: Routledge.

Blauvelt, A. (Ed.). (2005). *Expanding the center: Walker art center and Herzog & de Meuron.* Minneapolis, MN: Walker Art Center.

Bly, L. (2001, February 9). Places to pop the question [Electronic version]. *USA Today.* Retrieved January 4, 2012, from http://www.usatoday.com/travel/destinations/10great/2003-09-29-proposals_x.htm

BMW Guggenheim Lab. http://www.bmwguggenheimlab.org/

Bohlen, C. (2002, April 1). The Modern on the move, out to Queens: Museum hopes art lovers find its temporary home [Electronic version]. *New York Times.* Retrieved November 29, 2011, from http://www.nytimes.com/2002/04/01/arts/modern-move-queens-museum-hopes-art -lovers-find-its-temporary-home.html?pagewanted=all&src=pm

Boroff, P. (2011, May 10). Museum of Modern Art to buy embattled folk art museum building [Electronic version]. *Bloomberg.* Retrieved June 6, 2011, from http://mobile.bloomberg.com/ news/2011-05-11/museum-of-modern-art-will-buy-headquarters-of-struggling-folk-art-museum

Boswell, D., & Evans, J. (Eds.). (1999). *Representing the nation: A reader. Histories, heritage and museums.* New York: Routledge.

Bourdieu, P. (1984). *Distinction: A social critique of the judgement of taste* (R. Nice, Trans.). Cambridge, MA: Harvard University Press. (Original work published 1979)

boyd, d. (2007, June 24). Viewing American class divisions through Facebook and MySpace. *Apophenia Blog Essay.* Retrieved December 6, 2011, from http://www.danah.org/papers/essays/ ClassDivisions.html

Brooklyn is the coolest city on the planet: An eater's guide. (2011, November). *GQ.com.* Retrieved on December 14, 2011, from http://www.gq.com/food-travel/travel-features/201111/brooklyn -new-york-guide-food-dining

Brooklyn is the coolest city on the planet: A nightlife guide. (2011, November). *GQ.com.* Retrieved on December 14, 2011, from http://www.gq.com/food-travel/travel-features/201111/ brooklyn-new-york-guide-nightlife-bars-drinks

Brooklyn is the coolest city on the planet: A shopper's guide. (2011, November). *GQ.com.* Retrieved on December 14, 2011, from http://www.gq.com/food-travel/travel-features/201111/ brooklyn-new-york-guide-shopping-stores#slide=1

The Brooklyn Museum. http://www.brooklynmuseum.org/

The Brooklyn Museum. (n.d.). *Guide to the records of the Brooklyn Museum art school 1941–1985.* New York: Author.

The Brooklyn Museum. (2004, March). *Brooklyn Museum to open new front entrance and plaza designed by Polshek Partnership Architects, Saturday, April 17, and Sunday, April 18, 2004* [Press release]. New York: Author.

The Brooklyn Museum. (2004, March 12). *Brooklyn Museum makes strategic changes to its name, logo, and graphic identity* [Press release]. New York: Author.

The Brooklyn Museum. (2008, June 28). *Panel discussion: Click! A Crowd-Curated Exhibition* [Video]. Retrieved on December 18, 2011, from Brooklyn Museum: http://www.brooklyn museum.org/community/podcasts/

Butler, N. (2010, January 25). *Introducing the Reading Room* [Blog post]. Retrieved February 27, 2010, from Unframed, Los Angeles County Museum of Art: http://lacma.wordpress.com/2010/01/25/introducing-the-reading-room/

Cándida Smith, R., & Rubens, L. (2009). *Neal Benezra*. Berkeley: University of California, Berkeley, The Bancroft Library.

Carey, J. W. (1989). *Communication as culture: Essays on media and society*. Winchester, MA: Unwin Hyman.

Carey, W. (2008, December 5). *Introducing 1stfans: A socially networked museum membership* [Blog post]. Retrieved December 23, 2011, from Brooklyn Museum: http://www.brooklynmuseum.org/community/blogosphere/2008/12/05/introducing-1stfans-a-socially-networked-museum-membership/

Caruth, N. (2009, May 14). *What goes down must come up: Talking with Arnold Lehman of the Brooklyn Museum* [Blog post]. Retrieved September 15, 2011, from Art21: http://blog.art21.org/2009/05/14/what-goes-down-must-come-up-talking-with-arnold-lehman-of-the-brooklyn-museum/

Caruth, N., & Bernstein, S. (2007). Building an on-line community at the Brooklyn Museum: A timeline. In J. Trant & D. Bearman (Eds.), *Museums and the Web 2007: Proceedings*. Toronto: Archives & Museum Informatics. Retrieved December 22, 2011, from http://www.archimuse.com/mw2007/papers/caruth/caruth.html

Casey, E. S. (1996). How to get from space to place in a fairly short stretch of time: Phenomenological prolegomena. In S. Feld & K. H. Basso (Eds.), *Senses of place* (pp. 13–52). Santa Fe, NM: School of American Research Press.

Casey, E. S. (1997). *The fate of place: A philosophical history*. Los Angeles: University of California Press.

Castells, M. (2001). *The Internet galaxy: Reflections on the Internet, business, and society*. New York: Oxford University Press.

Center for an Urban Future. (2005, December). *Creative New York*. New York: Author.

Chan, S. (2011, September 15). *More on mobile tech impacts in museums (extended Mashable remix)* [Blog post]. Retrieved September 15, 2011, from fresh + new(er): http://www .powerhousemuseum.com/dmsblog/index.php/2011/09/15/more-on-mobile-tech -impacts-in-museums-extended-mashable-remix/

Chan, S. (2011, December 3). *The museum website as a newspaper—an interview with Walker Art Center* [Blog post]. Retrieved December 6, 2011, from fresh + new(er): http://www. freshandnew.org/2011/12/museum-website-newspaper-interview-walker-art-center/

Charity Navigator. http://www.charitynavigator.org/

Chayko, M. (2008). *Portable communities: The social dynamics of online and mobile connectedness.* Albany: State University of New York Press.

Clewley, R. (2010, March 1). 010101's man behind the numbers. *Wired online.* Retrieved November 9, 2011, from http://www.wired.com/culture/lifestyle/news/2001/03/41973

Clifford, J. (1988). *The predicament of culture: Twentieth-century ethnography, literature, and art.* Cambridge, MA: Harvard University Press.

Clifford, J. (1997). *Routes: Travel and translation in the late twentieth century.* Cambridge, MA: Harvard University Press.

The Corporation for National and Community Service. (2010, September). *Civic life in America: Key findings on the civic health of the nation* [Issue brief]. Washington, DC: Author.

Craig, R. T., & Muller, H. L. (Eds.). (2007). *Theorizing communication: Readings across traditions.* Los Angeles: SAGE Publications.

Crooke, E. (2008). *Museums and community: Ideas, issues and challenges.* (2nd ed.). New York: Routledge.

Crow, W., & Din, H. (2009). *Unbound by place or time: Museums and online learning.* Washington, DC: AAM Press.

Cummins, J. (2011, December 21). *Split Second: A curator's reaction to the results* [Blog post]. Retrieved on December 21, 2011, from Brooklyn Museum: http://www.brooklynmuseum .org/opencollection/labs/splitsecond/stories.php?slug=split-second-a-curator%E2%80%99s -reaction-to-the-results

Cuno, J. (Ed.). (2004). *Whose muse? Art museums and the public trust.* Princeton, NJ: Princeton University Press.

The Dallas Museum of Art. http://www.dm-art.org/

The Dallas Museum of Art. (2009, July 7). *Dallas Museum of Art launches enhanced web site and online experience* [Press Release]. Dallas, TX: Author.

The Dallas Museum of Art. (2012, March 9). *Dallas Museum of Art appoints Robert Stein as deputy director* [Press Release]. Dallas, TX: Author.

de Certeau, M. (1984). *The practice of everyday life* (S. Rendall, Trans.). Los Angeles: University of California Press.

de Certeau, M. (1997). *Culture in the plural* (T. Conley, Trans.). Minneapolis: University of Minnesota Press. (Original work published 1974)

Deitz, S. (2003, June 26). *Steve Dietz's response to the net art community's concerns regarding the future of new media at the Walker Art Center.* Retrieved June 2, 2011 from MTEE: http://www.mteww.com/walker_letter/dietz_response.html

Deleuze, G., & Guattari, F. (1987). *Capitalism and schizophrenia: A thousand plateaus* (B. Massumi, Trans.). Minneapolis: University of Minnesota Press. (Original work published 1980)

The Denver Museum of Art. http://www.denverartmuseum.org/home

Destination Analysts, Inc. (2011, February 26). *Findings: San Francisco visitor profile research.* San Francisco: San Francisco Travel Association.

Dewey, J. (2005). *Art as experience.* New York: Penguin Group (USA) Inc. (Original work published 1934)

DiMaggio, P., & Mukhtar, T. (2004, April). Arts participation as cultural capital in the United States, 1982–2002: Signs of decline? *Poetics, 32,* 169–194.

Din, H., & Hecht, P. (2007). *The digital museum: A think guide.* Washington, DC: American Association of Museums.

D. K. Shifflet & Associates, Ltd. (2010). *2009 Indianapolis visitor profile report.* Indianapolis, IN: Indianapolis Convention and Visitors Association.

Dobrzynski, J. H. (2011, April 5). The unapologetic director [Electronic version]. *Wall Street Journal.* Retrieved September 15, 2011, from http://online.wsj.com/article/SB100014240527487 04471904576228801235511170.html

Donnelly, F. (2012, February 17). *New York City data guide* [Data entry]. Retrieved December 5, 2011, from the Newman Library at Baruch College, City College of New York: http://guides.newman.baruch.cuny.edu/nyc_data

Dreyfus, H. L., & Spinosa, C. (2003). Heidegger and Borgmann on how to affirm technology. In R. C. Scharff & V. Dusek (Eds.), *Philosophy of technology: The technological condition: An anthology* (pp. 315–326). Malden, MA: Blackwell Publishing.

Duncan, C. (1995). *Civilizing rituals. Inside public art museums.* New York: Routledge.

Duncombe, S. (Ed.). (2002). *Cultural resistance reader.* New York: Verso.

Durbin, G. (2004). Learning from Amazon and eBay: User-generated material for museum web sites. In J. Trant & D. Bearman (Eds.), *Museums and the Web 2010: Proceedings.* Toronto: Archives & Museum Informatics. Retrieved January 3, 2012, from http://www.museums andtheweb.com/mw2004/papers/durbin/durbin.html

Durham Peters, J. (2003). The subtlety of Horkheimer and Adorno: Reading "The Culture Industry." In E. Katz, J. D. Peters, T. Liebes, & A. Orloff (Eds.), *Canonic texts in media research: Are there any? Should there be? How about these?* (pp. 58–73). Malden, MA: Blackwell.

Durham Peters, J., & Simonson, P. (Eds.). (2004). *Mass communication and American social thought. Key texts, 1919–1968.* New York: Rowman & Littlefield.

Durrer, V., & Miles, S. (2009). New perspectives on the role of cultural intermediaries in social inclusion in the UK. *Consumption Markets & Culture, 12*, 225–241.

Echeverría, J., Alonso, A., & Oiarzabal, P. J. (Eds.). (2011). *Knowledge communities* (Conference paper series no. 6). Reno: Center for Basque Studies, University of Nevada, Reno.

EmcArts & The American Association of Museums' Center for the Future of Museums. (2011). *The innovation lab for museums: Request for proposals.* New York: Authors.

Falk, J. H. (2004). The director's cut: Toward an improved understanding of learning from museums (Issue Supplement 1). *Science Education, 88*, 83–96.

Falk, J. H., & Dierking, L. D. (2000). *Learning from museums: Visitor experiences and the making of meaning.* Walnut Creek, CA: AltaMira.

Falk, J. H., & Dierking, L. D. (2008). Enhancing visitor interaction and learning with mobile technologies. In L. Tallon & K. Walker (Eds.), *Digital technologies and the museum experience: Handheld guides and other media.* Lanham, MD: AltaMira.

Faubion, J. D. (Ed). (2000). Michel Foucault. Power (Vol. 3) (R. Hurley, Trans.). In P. Rabinow (Ed.), *Essential works of Foucault. 1954–1984.* New York: The New Press.

Feenberg, A. (2003). Critical evaluation of Heidegger and Borgmann. In R. C. Scharff & V. Dusek (Eds.), *Philosophy of technology: The technological condition: An anthology* (pp. 327–337). Malden, MA: Blackwell.

Federal Bureau of Investigation. (2010). *Crime in the United States* [Report]. Retrieved July 2, 2011, from http://www.fbi.gov/about-us/cjis/ucr/crime-in-the-u.s/2010/crime-in-the-u.s.-2010

Feld, S., & Basso, K. H. (Eds.). (1996). *Senses of place.* Santa Fe, NM: School of American Research Press.

Filippini-Fantoni, S., & Bowen, J. (2007). Bookmarking in museums: Extending the museum experience beyond the visit? In J. Trant & D. Bearman (Eds.), *Museums and the Web 2007: Proceedings.* Toronto: Archives & Museum Informatics. Retrieved October 7, 2011, from http://www.archimuse.com/mw2007/papers/filippini-fantoni/filippini-fantoni.html

Finkel, J. (2011, February 8). LACMA, Getty to share Robert Mapplethorpe artwork [Electronic version]. *Los Angeles Times.* Retrieved February 10, 2011, from http://articles.latimes.com/2011/feb/08/entertainment/la-et-lacma-mapplethorpe-20110208

Finnis, J., Chan, S., & Clements, R. (2011). *Let's get real: How to evaluate online success* (Action Research Project). Brighton, UK: Culture24.

Fiske, J. (1992). Cultural studies and the culture of everyday life. In L. Grossberg, C. Nelson, & P. A. Treichler (Eds.), *Cultural studies* (pp. 154–173). New York: Routledge.

Fox, Z. (2011, August 11). Five ways museums are reaching digital audiences. *Mashable*. Retrieved September 13, 2011, from http://mashable.com/2011/08/11/museums-digital/

Fraser, N. (1990). Rethinking the public sphere: A contribution to the critique of actually existing democracy. *Social Text, 25/26*, 56–80.

Fritsch, J. (2007, March 30a). *The museum as a social laboratory: Enhancing the object to facilitate social engagement and inclusion in museums and galleries.* Unpublished manuscript, Kings College London, England.

Fritsch, J. (2007, March 30b). *Thinking about bringing web communities into galleries and how it might transform perceptions of learning in museums.* Unpublished manuscript, Kings College London, England.

Fuller, N. J. (1992). The museum as a vehicle for community empowerment: The Ak-Chin Indian community ecomuseum project. In I. Karp, C. M. Kreamer, & S. D. Lavine (Eds.), *Museums and communities: The politics of public culture* (pp. 327–367). Washington, DC: Smithsonian Institution Press.

García Canclini, N. (2001). *Consumers and citizens: Globalization and multicultural conflicts.* (G. Yúdice, Trans.). Minneapolis: University of Minnesota Press. (Original work published 1995)

García Canclini, N. (2005). *Hybrid cultures: Strategies for entering and leaving modernity* (C. L. Chiappari & S. L. López, Trans.). Minneapolis: University of Minnesota Press. (Original work published 2001)

García Canclini, N. (2009). How digital convergence is changing cultural theory (M. Schwartz, Trans.). *Popular Communication, 7*, 140–146.

Garrison, D. R., Anderson, T., & Archer, W. (2000). Critical inquiry in a text-based environment: Computer conferencing in higher education. *The Internet and Higher Education, 2*, 87–105.

Garrison, D. R., & Arbaugh, J. B. (2007). Researching the community of inquiry framework: Review, issues, and future directions. *Internet and Higher Education, 10*, 157–172.

Geertz, C. (1973). *The interpretation of cultures: Selected essays.* New York: Basic Books.

Geography and the net: Putting it in its place [Electronic version]. (2001, August 9). *Economist*. Retrieved January 6, 2012, from http://www.economist.com/node/729808

The Getty Foundation. http://www.getty.edu/foundation/

Giddens, A. (1991). *Modernity and self-identity. Self and society in the late modern age.* Palo Alto, CA: Stanford University Press.

Goffman, E. (1959). *The presentation of self in everyday life.* Garden City, NY: Doubleday.

Goldfarb, B. (2002). *Visual pedagogy: Media cultures in and beyond the classroom*. Durham, NC: Duke University Press.

Goldstein, A. M. (2010, June 15). Is it time for Brooklyn museum director Arnold Lehman to step down? *ArtInfo*. Retrieved December 19, 2011, from http://www.artinfo.com/news/story/34910/is-it-time-for-brooklyn-museum-director-arnold-lehman-to-step-down/?page=1

Google. (2011, February 1). *Google and museums around the world unveil Art Project* [Press Release]. Retrieved December 3, 2011, from https://sites.google.com/a/pressatgoogle.com/art-project/press-release-and-or-googlegram

Gordon, E., & de Souza e Silva, A. (2011). *Net locality: Why location matters in a networked world*. Malden, MA: Wiley-Blackwell.

Gordon, R. (2011, July 25). S. F. blacks' political clout imperiled. *SFGate.com (San Francisco Chronicle)*. Retrieved November 18, 2011, from http://articles.sfgate.com/2011-07-25/news/29811593_1_black-district-black-representation-political-clout

Gosden, C., & Larson, F. (2007). *Knowing things: Exploring the collections at the Pitt Rivers Museum 1884–1945*. Oxford: Oxford University Press.

Gould, C. C. (1996). Diversity and democracy: Representing differences. In S. Benhabib (Ed.), *Democracy and difference. Contesting the boundaries of the political* (pp. 171–186). Princeton, NJ: Princeton University Press.

Govan, M. (Speaker). (2011, April 27). *Levitated mass* [Video]. Retrieved January 13, 2012, from YouTube: http://www.youtube.com/watch?v=PLMZUpUBrOM&list=UUBrtMtJE5tqHLpCCqoPw-lg&index=19&feature=plcp

Granovetter, M. (1983). The strength of weak ties: A network theory revisited. *Sociological Theory, 1*, 201–233.

Greenberg, R., Ferguson, B. W., & Nairne, S. (Eds.). (1996). *Thinking about exhibitions*. New York: Routledge.

Gregg, G. (2011, November 1). The persistence of memories [Electronic version]. *ArtNews*. Retrieved November 3, 2011, from http://www.artnews.com/2011/11/01/the-persistence-of-memories/

Griffiths, J., King, D. W., & Aerni, S. E. (2007). The use, usefulness and value of museums in the U.S. In J. Trant & D. Bearman (Eds.), *Museums and the Web 2007: Proceedings*. Toronto: Archives & Museum Informatics. Retrieved November 5, 2011, from http://www.archimuse.com/mw2007/papers/griffiths/griffiths.html

Grossberg, L. (1997). *Bringing it all back home: Essays on cultural studies*. Durham, NC: Duke University Press.

Grossberg, L., Nelson, C., & Treichler, P. A. (Eds.). (1992). *Cultural studies*. New York: Routledge.

Gruenewald, D. A. (2003, Fall). Foundations of place: A multidisciplinary framework for place-conscious education. *American Educational Research Journal, 40*, 619–654.

Guthrie, J. (2010, January 10). Director canvasses endless potential for SFMOMA. *SFGate.com (San Francisco Chronicle)*. Retrieved November 8, 2011, from http://articles.sfgate.com/2010-01-10/news/17823417_1_sfmoma-neal-benezra-modern-art

Gutierrez, H., & Heimberg, J. (2007). Dallas Museum of Art presents the Arts Network. In J. Trant & D. Bearman (Eds.), *Museums and the Web 2007: Proceedings*. Toronto: Archives & Museum Informatics. Retrieved July 2, 2008, from http://www.archimuse.com/mw2007/papers/gutierrea/gutierrez.html

Haber, A. (1998). The importance of a virtual museum in a third world country: The experience of MUVA, Virtual Museum of Arts, *El País*. In J. Trant & D. Bearman (Eds.), *Museums and the Web 1998: Proceedings*. Toronto: Archives & Museum Informatics. Retrieved January 3, 2012, from http://www.museumsandtheweb.com/mw98/papers/haber/haber_paper.html

Habermas, J. (1991). *Structural transformation of the public sphere: An inquiry into a category of bourgeois society* (T. Burger, Trans. with the assistance of F. Lawrence). Cambridge, MA: MIT Press. (Original work published 1962)

Hafner, K. (2004). When the virtual isn't enough. In M. Sturken, D. Thomas, & S. J. Ball-Rokeach (Eds.), *Technological visions: The hopes and fears that shape new technologies* (pp. 293–304). Philadelphia: Temple University Press.

Halbreich, K. (2003, June 6). *Kathy Halbreich's response to the net art community's concerns regarding the future of new media at the Walker Art Center*. Retrieved June 2, 2011, from MTEE: http://www.mteww.com/walker_letter/halbreich_letter.html

Hall, S. (1982). The rediscovery of "ideology": Return on the repressed in media studies. In M. Gurevitch, T. Bunnett, J. Curran, & S. Wollacott (Eds.), *Culture, Society and the Media* (pp. 56–90). London: Methuen.

Hall, S. (1992a). Encoding/decoding. In S. Hall, D. Hobson, A. Lowe, & P. Willis (Eds.), *Culture, media, language: Working papers in cultural studies, 1972–1979* (pp. 128–137). New York: Routledge. (Original work published 1980)

Hall, S. (1992b). Cultural studies and the centre: some problematics and problems. In S. Hall, D. Hobson, A. Lowe, & P. Willis (Eds.), *Culture, media, language: Working papers in cultural studies, 1972–1979* (pp. 128–137). New York: Routledge. (Original work published 1980)

Hall, S. (1992c). Cultural studies and its theoretical legacies. In S. Hall, D. Morley, & K. Chen (Eds.), *Stuart Hall: Critical dialogues in cultural studies* (pp. 262–275). New York: Routledge.

Hall, S. (1997a). The local and the global: Globalization and ethnicity. In A. D. King (Ed.), *Culture, globalization and the world-system: Contemporary conditions for the representation of identity* (pp. 19–40). Minneapolis: University of Minnesota Press. (Original work published 1991)

Hall, S. (1997b). Old and new identities, Old and new ethnicities. In A. D. King (Ed.), *Culture, globalization and the world-system: Contemporary conditions for the representation of identity* (pp. 41–68). Minneapolis: University of Minnesota Press. (Original work published 1991)

Hall, S. (2002). Notes on deconstructing "the popular." In S. Duncombe (Ed.), *Cultural resistance reader* (pp. 185–192). New York: Verso. (Original work published 1981)

Hall, S., Hobson, D., Lowe, A., & Willis, P. (Eds.). (1992). *Culture, media, language: Working papers in cultural studies, 1972–1979.* New York: Routledge. (Original work published 1980)

Harris, B. (2011, March 9). *The real and the virtual art museum* [Blog post]. Retrieved December 3, 2011, from Museum of Modern Art: http://www.moma.org/explore/inside_out/2011/03/09/the-real-and-the-virtual-art-museum

Harrison, L. E., & Huntington, S. P. (Eds.). (2000). *Culture matters: How values shape human progress.* New York: Basic Books.

Hart, D. (2010, March 15). *Live-streaming Marina Abramovíc: Crazy or brave?* [Blog post]. Retrieved December 3, 2011, from Museum of Modern Art: http://www.moma.org/explore/inside_out/2010/03/15/live-streaming-marina-abramovic-crazy-or-brave

Hart, H. (2010, December). Citizen curators: Walker visitors vote for half the works to view in new show. *ARTnews*, 58.

Haythornthwaite, C. (2011). Online knowledge crowds and communities. In E. L. Lesser, M. A. Fontaine, & J. A. Slusher (Eds.), *Knowledge and communities* (pp. 193–209). Boston, MA: Butterworth Heinemann.

Heidegger, M. (1977). *The question concerning technology and other essays* (W. Lovitt, Trans.). New York: Harper Perennial.

Heideman, J. (2008, November 19). *Walker blogs survey results* [Blog post]. Retrieved April 29, 2009, from the Walker Art Center: http://blogs.walkerart.org/newmedia/2008/11/19/walker-blogs-survey-results/

Heideman, J. (2010, March 10). *Announcing the new Walker Channel–HD video, improved design, search, accessibility* [Blog post]. Retrieved October 18, 2011, from the Walker Art Center: http://blogs.walkerart.org/newmedia/2010/03/10/new-walker-channel/

Hein, G. E. (1995). The constructivist museum. *Journal for Education in Museums, 16,* 21–23. Retrieved October 10, 2011, from http://www.gem.org.uk/pubs/news/hein1995.html

Hein, G. E. (1998). *Learning in the museum.* New York: Routledge.

Hein, H. (2006). *Public art: Thinking museums differently.* Lanham, MD: AltaMira.

Hickley, C. (2012, March 20). BMW, Guggenheim cancel Berlin lab project on violence threats [Electronic version]. *Bloomberg.* Retrieved March 21, 2012, from http://www.bloomberg.com/news/2012-03-20/bmw-guggenheim-cancel-berlin-lab-project-on-violence-threats.html

Holmquist, J. D. (1981). *They chose Minnesota: A survey of the state's ethnic groups.* St. Paul: Minnesota Historical Society Press.

Holo, S., & Álvarez, M. (2009). *Beyond the turnstile: Making the case for museums and sustainable values.* Lanham, MD: AltaMira.

Honeysett, N. (2011). The transition to online scholarly catalogues. In J. Trant & D. Bearman (Eds.), *Museums and the Web 2011: Proceedings.* Toronto: Archives & Museum Informatics. Retrieved December 12, 2011, from http://conference.archimuse.com/mw2011/papers/transition_to_online_scholarly_catalogues

hooks, b. (2000). *Feminist theory: From margin to center* (2nd ed.). London: Pluto Press.

hooks, b. (2009). *Belonging: A culture of place.* New York: Routledge.

Hooper-Greenhill, E. (1992). *Museums and the shaping of knowledge.* New York: Routledge.

Hooper-Greenhill, E. (1999, April 20). *Museums and interpretive communities.* Paper presented at the Musing on Learning Seminar, Australian Museum, Australia.

Hooper-Greenhill, E. (2007). Interpretive communities, strategies and repertoires. In S. Watson (Ed.), *Museums and their communities* (pp. 76–94). New York: Routledge.

Horkheimer, M. (2004). Art and mass culture. In J. D. Peters & P. Simonson (Eds.), *Mass communication and American social thought. Key texts, 1919–1968* (pp. 290–304). New York: Rowman & Littlefield. (Original work published 1941)

Horkheimer, M., & Adorno, T. W. (2002). Dialectic of enlightenment: Philosophical fragments (Jephcott, E., Trans.). In G. Schmid Noerr (Ed.), *Cultural memory in the present.* Palo Alto, California: Stanford University Press. (Original work published 1947)

Horn, L. (2011, December 16). Tour the Louvre with a Nintendo 3DS. *PCMag.com.* Retrieved January 3, 2012, from http://www.pcmag.com/article2/0,2817,2397744,00.asp

How museums can bring their collections to life: an interview with Stedelijk Museum Amsterdam ARtour's Hein Wils [Blog post]. (n.d.). Retrieved January 3, 2012, from MobiThinking: http://mobithinking.com/how-museums-use-augmented-reality

Hudson, K. (1999). Attempts to define "museum." In D. Boswell & J. Evans (Eds.), *Representing the nation: A reader. Histories, heritage and museums* (pp. 371–379). New York: Routledge.

Huyssen, A. (2000). Present pasts: Media, politics, amnesia. *Public Culture, 12,* 21–38.

Ihde, D. (2003). Heidegger's philosophy of technology. In R. C. Scharff & V. Dusek (Eds.), *Philosophy of technology: The technological condition: An anthology* (pp. 277–292). Malden, MA: Blackwell.

Indianapolis Convention & Visitors Association. (2010). *2009 visitor profile.* McLean, VA: D. K. Shifflet & Associates, Ltd.

The Indianapolis Museum of Art. http://www.imamuseum.org/

The Indianapolis Museum of Art. (2011, May 5). *Indianapolis Museum of Art launches groundbreaking Mellon Curators-at-Large program piloting new model for museum scholarly appointments* [Press Release]. Indianapolis, IN: Author.

The Indianapolis Museum of Art. (2011, November 2). *IMA strategic plan 2011–2015*. Indianapolis, IN: Author.

The Innovation Lab for Museums. (2011). *Request for proposals*. New York and Washington, DC: American Association of Museums, Center for the Future of Museums, EmcArts, and MetLife Foundation.

The Institute of Museum and Library Services. http://www.imls.gov/

The Institute of Museum and Library Services. (2009). *2009 National Medal for Museum and Library Service*. Washington, DC: Office of Policy, Planning, Research and Communications.

The Institute of Museum and Library Services. (2010). *2010 National Medal for Museum and Library Service*. Washington, DC: Office of Policy, Planning, Research and Communications.

The Institute of Museum and Library Services. (2011). *2011 National Medal for Museum and Library Service*. Washington, DC: Office of Policy, Planning, Research and Communications.

The Institute of Museum and Library Services. (2011, November 17). *National competition selects 12 libraries and museums to build innovative learning labs for teens* [Press Release]. Washington, DC: Author.

The International Council of Museums. http://icom.museum/

Ito, M., Horst, H., Bittanti, M., boyd, d., Herr-Stephenson, B., Lange, P. G., Pascoe, C. J., & Robinson, L. (2008, November). *Living and learning with new media: Summary of findings from the Digital Youth Project*. Chicago: MacArthur Foundation.

Ivey, B. (2008). *Arts, Inc.: How greed and neglect have destroyed our cultural rights*. Los Angeles: University of California Press.

Jameson, F., & Miyoshi, M. (Eds.). (1998). *The cultures of globalization*. Durham, NC: Duke University Press.

Janes, R. R., & Conaty, G. T. (Eds.). (2005). *Looking reality in the eye: Museums and social responsibility*. Calgary, Alberta: University of Calgary Press.

Jenkins, H. (2006). *Convergence culture: Where old and new media collide*. New York: New York University Press.

Jenkins, H., Puroshotma, R., Clinton, K., Weigel, M., & Robison, A. J. (2006). *Confronting the challenges of participatory culture: Media education for the 21st century*. Chicago: MacArthur Foundation.

The John D. and Catherine T. MacArthur Foundation. (2009, November). *Exploring digital media and learning*. Retrieved April 11, 2010, from http://www.macfound.org/atf/cf/%7Bb0386ce3 -8b29-4162-8098-e466fb856794%7D/DML_BUFF.PDF

The John S. and James L. Knight Foundation. (2010). *Knight soul of the community 2010. Why people love where they live and why it matters: A national perspective.* Miami: Authors.

Johnson, L., Witchey, H., Smith, R., Levine, A., & Haywood, K. (2010). *The 2010 Horizon Report: Museum edition.* Austin: New Media Consortium.

The J. Paul Getty Museum. http://www.getty.edu/museum/

Kandel, D. (1978). Similarity in real-life adolescent friendship pairs. *Journal of Personality and Social Psychology, 36*, 306–312.

Karp, I., Kreamer, C. M., & Lavine, S. D. (Eds.). (1992). *Museums and communities: The politics of public culture.* Washington, DC: Smithsonian Institution Press

Karp, I., & Lavine, S. D. (Eds.). (1991). *Exhibiting cultures: The poetics and politics of museum display.* Washington, DC: Smithsonian Institution Press.

Katz, E., & Lazarsfeld, P. (1955). *Personal influence: The part played by people in the flow of mass communications* (2nd ed.). New Brunswick, NJ: Transaction Publishers.

Kellaway, B. (2009, December 15). *Walker + Getty, part II: Amped up after a couple of days in LA* [Blog post]. Retrieved December 12, 2011, from Walker Art Center: http://blogs.walkerart.org/visualarts/2009/12/15/walker-getty-part-ii-amped-up-after-a-couple-of-days-in-la/

Kellaway, B. (2010, February 17). *Walker+Getty+Helio Oiticica, Katharina Fritsch, Tino Sehgal . . .* [Blog post]. Retrieved December 12, 2011, from Walker Art Center: http://blogs.walkerart.org/visualarts/2010/02/17/walkergettyhelio-oiticica-katharina-fritsch-tino-sehgal/

Kennedy, R. (2011, February 11). The Met's plans for virtual expansion [Electronic version]. *New York Times.* Retrieved February 15, 2011, from http://www.nytimes.com/2011/02/12/arts/design/12campbell.html?pagewanted=all

Kightlinger, C. (2011, October 21). IMA CEO Maxwell Anderson's resignation stuns many. *IndyStar.com.* Retrieved October 23, 2011, from http://www.indystar.com/article/20111021/LOCAL18/110210333/Maxwell-Anderson-ima-Indianapolis-museum-of-art

King, A. D. (Ed.). (1997). *Culture, globalization and the world-system: Contemporary conditions for the representation of identity.* Minneapolis: University of Minnesota Press.

Knight Foundation & Gallup Inc. (2010). *Knight soul of the community 2010. Why people love where they live and why it matters: A national perspective.* Miami: John S. and James L. Knight Foundation.

Koster, E. (2006, May–June). The relevant museum: A reflection on sustainability [Electronic version]. *Museum News.* Retrieved April 10, 2010, from http://www.aam-us.org/pubs/mn/MN_MJ06_RelevantMuseum.cfm

Koster, E. H., & Baumann, S. H. (2005). Liberty Science Center in the United States: A mission focused on external relevance. In R. Janes & G. T. Conaty (Eds.), *Looking reality in the eye: Museums and social responsibility* (pp. 85–112). Alberta: University of Calgary Press.

Kramer, H. (2004, May 17). The Brooklyn Museum gives open house on dumbing down [Electronic version]. *New York Observer*. Retrieved December 19, 2011, from http://www .observer.com/2004/05/the-brooklyn-museum-gives-open-house-on-dumbing-down/

Krock1dk. (2007, December 2). Hoosier [Blog post]. *Urban Dictionary*. Retrieved November 2, 2012, from http://www.urbandictionary.com/define.php?term=hoosier%20&page=2

Kuan, C. (2012, January 10). *ARTstor collections summary 2011* [Blog post]. Retrieved January 14, 2012, from ARTstor: http://artstor.wordpress.com/2012/01/10/artstor-collections-summary-2011/

LaGanga, M. L., & Weikel, D. (2011, July 3). When it comes to amenities, San Francisco airport soars above the competition [Electronic version]. *Los Angeles Times*. Retrieved September 29, 2011, from http://articles.latimes.com/2011/jul/03/local/la-me-sfo-glitz-20110702

Lang, K., & Lang, G. E. (2009). Mass society, mass culture, and mass communication: The meaning of mass. *International Journal of Communication, 3*, 998–1024.

Latour, B. (2009, Spring/Summer). Spheres and networks: Two ways to reinterpret globalization. *Harvard Design Magazine, 30*, 138–144.

Latour, B. (2011). Networks, societies, spheres: Reflections of an actor-network theorist. *International Journal of Communication, 5*, 796–810.

LaWare, M. R. (1998). Encountering visions of Aztlan: Arguments for ethnic pride, community activism and cultural revitalization in Chicano murals. *Argumentation & Advocacy, 34*, 140–154.

Lefebvre, H. (1991). *The production of space* (D. Nicholson-Smith, Trans.). Malden, MA: Editions Anthropos. (Original work published 1974)

Lehman, A. (2010, August 7). Letters: Response from the director of the Brooklyn Museum [Electronic version]. *New York Times*. Retrieved December 17, 2011, from http://www.nytimes .com/2010/08/08/arts/design/08alsmail-BROOKLYNMUSEUM-LETTERS.html

Lesser, E. L., Fontaine, M. A., & Slusher, J. A. (Eds.). (2000). *Knowledge and communities*. Boston, MA: Butterworth Heinemann.

Lessig, L. (2003). *Free culture: The nature and future of creativity*. New York: Penguin.

Lessig, L. (2008). *Remix: Making art and commerce thrive in the hybrid economy*. New York: Penguin.

Levine, C. (2007). *Provoking democracy: Why we need the arts*. Malden, MA: Blackwell.

Lévy, P. (1997a). *Collective intelligence. Mankind's emerging world in cyberspace*. (R. Bononno, Trans.). New York: Basic Books.

Lévy, P. (1997b). Cyberculture (R. Bononno, Trans.). In K. Hayles, M. Poster, & S. Weber (Eds.), *Electronic mediations* (Vol. 4). Minneapolis: University of Minnesota Press.

Lewnes, A. (2010, October 6). *Adobe unveils new digital museum* [Blog post]. Retrieved January 3, 2012, from Adobe Featured Blogs: http://blogs.adobe.com/conversations/2010/10/adobe-unveils-new-digital-museum.html

Lipman, M. (2003). *Thinking in education* (2nd ed.). New York: Cambridge University Press.

Lloyd, M. (2007). *Media, creativity and the public good* (a report of the Aspen Institute Roundtable on Leadership and the Media). Washington, DC: Aspen Institute.

The Los Angeles County Museum of Art. http://www.lacma.org/

The Los Angeles County Museum of Art. (2009, October). *Strategic plan*. Los Angeles: Author.

The Los Angeles County Museum of Art. (2010, October 21). *LACMA announces partnership to preserve historic Watts Towers* [Press Release]. Los Angeles: Author.

The Los Angeles County Museum of Art. (2011, October 4). *Historic alliance opens door to academy museum at LACMA* [Press release]. Los Angeles: Author.

The Los Angeles County Museum of Art. (2012, March/April). *Connect* [Membership magazine]. Los Angeles: Author.

The Los Angeles Times. Mapping L.A. Neighborhoods. http://projects.latimes.com/mapping-la/neighborhoods/

Lyman, P. (2004). Information superhighways, virtual communities, and digital libraries: Information society metaphors as political rhetoric. In M. Sturken, D. Thomas, & S. Ball-Rokeach (Eds.), *Technological visions: The hopes and fears that shape new technologies* (pp. 201–221). Philadelphia: Temple University Press.

MacArthur, M. (2007). Can museums allow online users to become participants? In H. Din & P. Hecht (Eds.), *The digital museum: A think guide* (pp. 57–66). Washington, DC: American Association of Museums.

Macdonald, K. (2011, July 22). Using new tools, mapping old Brooklyn [Electronic version]. *New York Times*. Retrieved December 21, 2011, from http://lens.blogs.nytimes.com/2011/07/22/using-new-tools-mapping-old-brooklyn/

Macdonald, S., & Basu, P. (Eds.). (2007). *Exhibition experiments*. Malden, MA: Blackwell.

MacManus, R. (2011, September 5). Social media case study: Brooklyn Museum. *ReadWriteWeb*. Retrieved December 20, 2011, from http://www.readwriteweb.com/archives/social_media_case_study_brooklyn_museum.php

Manovich, L. (2001). *The language of new media*. Cambridge, MA: MIT Press.

Markusen, A., & Gadwa, A. (2010). *Creative placemaking*. Washington, DC: National Endowment for the Arts.

Marx, K., & Engels, F. (2007). *The German ideology.* In R. T. Craig & H. L. Muller (Eds.), *Theorizing communication: Readings across traditions* (pp. 433–436). Thousand Oaks, CA: Sage. (Original work published 1845–1846)

Marx, L. (1987, January). Does improved technology mean progress? *Technology Review,* 33–41.

May, M. (2011, November 6). Grants for the arts keep S.F. culture afloat. *SFGate (San Francisco Chronicle).* Retrieved November 9, 2011, from http://www.sfgate.com/cgi-bin/article.cgi?f=/c/a/2011/11/03/PKJR1LHFB3.DTL

McCarthy, K. F., Ondaatje, E. H., Zakaras, L., & Brooks, A. (2004). *Gifts of the muse: Reframing the debate about the benefit of the arts.* Santa Monica, CA: RAND Corporation.

McHoul, A., & Grace, W. (Eds.). (1993). *A Foucault primer: Discourse, power and the subject.* New York: New York University Press.

McLuhan, M. (2003). *Understanding media: The extensions of man* (W. T. Gordon, Ed.). Corte Madera, CA: Gingko Press. (Original work published 1964)

McPherson, M., Smith-Lovin, L., & Cook J. M. (2001). Birds of a feather: Homophily in social networks. *Annual Review of Sociology, 27,* 415–444.

Mediated Cultures: Digital Ethnography with Professor Wesch. http://mediatedcultures.net/

Meet Minneapolis. (2009, January). *The economic impact of expenditures by travelers on Minnesota's metro region and the profile of travelers.* Minneapolis, MN: Author.

Membership 2.0: A socially networked museum membership [Electronic version]. (2009, February 18). *Fundraising Success Magazine.* Retrieved December 15, 2011, from http://www.fundraisingsuccessmag.com/article/membership-20-a-socially-networked-museum-membership-403238/1

Mercer, K. (1992). 1968: Periodizing postmodern politics and identity. In L. Grossberg, C. Nelson, & P. A. Treichler (Eds.), *Cultural studies* (pp. 424–449). New York: Routledge.

The MetLife Foundation. http://www.metlife.com/about/corporate-profile/citizenship/metlife-foundation/index.html

The Metropolitan Museum of Art. http://www.metmuseum.org/

The Metropolitan Museum of Art. (2011). *Annual report for the year 2010–2011.* New York: Author.

Met museum taking part in Google Art Project [Blog post]. (2011, February 1). Retrieved January 15, 2012, from the Metropolitan Museum of Art: http://www.metmuseum.org/about-the-museum/now-at-the-met/News/2011/Met-Museum-Taking-Part-in-Google-Art-Project

Miller, M. H. (2010, April 4). Scholars use Wikipedia to save public art from the dustbin of history [Electronic version]. *The Chronicle of Higher Education.* Retrieved October 15, 2011, from http://chronicle.com/article/Scholars-Use-Wikipedia-to-Save/64929

Mills, C. W. (2004). The mass society. In J. D. Peters & P. Simonson (Eds.), *Mass communication and American social thought. Key texts, 1919–1968* (pp. 387–400). New York: Rowman & Littlefield. (Original work published 1956)

Miranda, C. A. (2012, February). A scene grows in Brooklyn. *ArtNews*, 68–75.

Mirapaul, M. (1998, November 5). Head of San Francisco museum embraces digital art [Electronic version]. *New York Times*. Retrieved October 20, 2011, from http://theater.nytimes.com/library/tech/98/11/cyber/artsatlarge/05artsatlarge.html

Mitchell, W. J., Inouye, A. S., & Blumenthal, M. S. (Eds.). (2003). *Beyond productivity: Information technology, innovation, and creativity*. Washington, DC: National Academies Press.

MoMA PS1. http://momaps1.org/

Morey Group. (2011, April). *SFMOMA visitor survey report.* (2011, April). San Francisco, CA: San Francisco Museum of Modern Art.

Murray, V. (2010, May 20). America's Top Tourist Attractions [Electronic version]. *Forbes*. Retrieved November 22, 2011, from http://www.forbes.com/2010/05/20/top-tourist-attractions -lifestyle-travel-magic-kingdom-disneyland-times-square.html?partner=forbeslife_newsletter

Muschamp, H. (2004, April 16). Architecture review: Brooklyn's radiant new art palace [Electronic version]. *New York Times*. Retrieved December 17, 2011, from http://www.nytimes .com/2004/04/16/arts/architecture-review-brooklyn-s-radiant-new-art-palace.html?src=pm

Musée du Louvre. http://www.louvre.fr/en

Museo d'Art Contemporani de Barcelona. http://www.macba.cat/es/inicio

Museo Virtual de Artes El País. http://muva.elpais.com.uy/

MuseumMobile Wiki. http://wiki.museummobile.info/

Museum Nerd. (2010, June 15). *Brooklyn Museum visitorship on the rise where it counts: Some New York Times readers are missing the point* [Blog post]. Retrieved September 19, 2011, from Museum Nerd (>140): http://museumnerd.wordpress.com/2010/06/15/brooklyn-museum -visitorship-on-the-rise-where-it-counts-some-new-york-times-readers-are-missing-the-point/

Museum Nerd. (2011, December 2). *The Walker's new website is an earthshaking game changer* [Blog post]. Retrieved December 12, 2011, from Museum Nerd (>140): http://museumnerd .wordpress.com/2011/12/02/the-walkers-new-website-is-an-earthshaking-game-changer/

The Museum of Modern Art. http://www.moma.org/

The Museum of Modern Art. (n.d.). *Community partnership programs* [Video]. Retrieved November 29, 2011, from Museum of Modern Art: http://www.moma.org/learn/community/ showcase

The Museum of Modern Art. (2009). *MoMA Consolidated Financial Statements, June 30, 2009 and 2008*. New York: Author.

The Museum of Modern Art. (2010). *MoMA Consolidated Financial Statements, June 30, 2010 and 2009.* New York: Author.

The Museum of Modern Art. (2011). *MoMA Consolidated Financial Statements, June 30, 2011 and 2010.* New York: Author.

Museu Picasso de Barcelona. http://www.museupicasso.bcn.es/

National Endowment of the Arts. (2010). *Audience 2.0: How technology influences arts participation.* Washington, DC: Author.

Negt, O., & Kluge, A. (1993). *Public sphere & experience: Toward an analysis of the bourgeois and proletarian public sphere* (P. Labanyi, J. O. Daniel, & A. Oksiloff, Trans.) (Vol. 85). Minneapolis: University of Minnesota Press.

The NMC Horizon Report: 2011 Museum Edition Wiki. http://museum.wiki.nmc.org/

NYC & Company. (2010). *Overseas visitors. Travel to New York City in 2009.* New York: Author.

NYC & Company. (2011a). *2010 annual summary.* New York: Author.

NYC & Company. (2011b). *Business travel to New York City in 2010.* New York: Author.

NYC & Company. (2011c). *Cultural visitors. New York City in 2010.* New York: Author.

NYC & Company. (2011d). *Domestic visitors. Travel to New York City in 2010.* New York: Author.

NYC & Company. (2011e). *Family travel to New York City in 2010.* New York: Author.

NYC & Company. (2011f). *Hotel guests in New York City in 2010.* New York: Author.

NYC & Company. (2011g). *Leisure travel to New York City in 2010.* New York: Author.

NYC & Company. (2011h). *Meeting and convention delegates. Travel to New York City.* New York: Author.

NYC & Company. (2011i). *Overseas visitors. Travel to New York City in 2010.* New York: Author.

NYC & Company. (2011j). *Shopping visitors to New York City in 2010.* New York: Author.

Office of the Brooklyn Borough President. (2011). *2011 Strategic policy statement.* New York: Author.

O'Grady, J. (2004, February 14). Neighborhood report: Western Queens; maybe it should be called museum warehouse mile [Electronic version]. *New York Times.* Retrieved November 29, 2011, from http://www.nytimes.com/2004/02/15/nyregion/neighborhood-report-western -queens-maybe-it-should-be-called-museum-warehouse.html

Olson, E. (2011, March 16). Smithsonian uses social media to expand its mission [Electronic version]. *New York Times.* Retrieved December 28, 2011, from http://www.nytimes.com/ 2011/03/17/arts/design/smithsonian-expands-its-reach-through-social-media-and-the-public .html?_r=1

Olson, M. (1965). *The logic of collective action.* Cambridge, MA: Harvard University Press.

Open letter to Kathy Halbreich, director, Walker Art Center. (2003, May 16). Retrieved June 2, 2011 from MTEE: http://www.mteww.com/walker_letter/index.shtm

Otis College of Art and Design. (2011, November). *2011 Otis report on the creative economy of the Los Angeles region: Investing in our creative capital.* Los Angeles: Los Angeles County Economic Development Corporation.

Oxford Dictionaries Online. http://oxforddictionaries.com/?region=us

Pacheco, D. (2006, January 9). Where are they now? Brett Waller, former IMA director still teaching others about art. *All Business.com.* Retrieved September 26, 2011, from http://www.allbusiness.com/management/strategic-planning/10580221-1.html

Palfrey, J., & Gasser, U. (2008). *Born digital: Understanding the first generation of digital natives.* New York: Basic Books.

Parry, R. (2007). *Recoding the museum: Digital heritage and the technologies of change.* New York: Routledge.

Patterson, O. (2000). Taking culture seriously: A framework and an Afro-American illustration. In L. E. Harrison & S. P. Huntington (Eds.), *Culture matters: How values shape human progress* (pp. 202–218). New York: Basic Books.

Payne, B. (2011, April). The informer: The 15 best places to see right now [Electronic version]. *Condé Nast Traveler.* Retrieved December 15, 2011, from http://www.cntraveler.com/features/2011/04/The-Informer-The-15-Best-Places-to-See-Right-Now

Pearce, S. M. (1992). *Museums, objects, and collections.* Washington, DC: Smithsonian Institution Press.

Pearce, W. B. (1989). *Communication and the human condition.* Edwardsville: Southern Illinois University Press.

Pettingill, L. (2007, September). Engagement 2.0? How the new digital media can invigorate civic engagement. In H. Gardner (Ed.), *GoodWork° Project Report, 50.* Cambridge, MA: Harvard University Press.

Pierson, J., Cavanaugh, Hagan, Pierson, & Mintz, Inc. (2010, November 1). *Arts and livability: The road to better metrics* (A Report from the June 7, 2010 NEA Research Forum). Washington, DC: National Endowment of the Arts.

Pitnam, B. & Hirzy, E. (2010). *Ignite the power of art: Advancing visitor engagement in museums.* New Haven, CT: Yale University Press.

Plagens, P. (1995, January 30). New museum by the bay [Electronic version]. *Newsweek.* Retrieved November 14, 2011, from http://www.thedailybeast.com/newsweek/1995/01/29/new-museum-by-the-bay.html

Pogrebin, R. (2010, June 14). Brooklyn Museum's populism hasn't lured crowds [Electronic version]. *New York Times.* Retrieved September 19, 2011, from http://www.nytimes.com/2010/06/15/arts/design/15museum.html?pagewanted=all

Pogrebin, R. (2010, August 5). Sketching a future for Brooklyn Museum [Electronic version]. *New York Times.* Retrieved December 17, 2011, from http://www.nytimes.com/2010/08/08/arts/design/08museum.html

Pogrebin, R. (2011, November 30). An imposing museum turns warm and fuzzy [Electronic version]. *New York Times.* Retrieved December 9, 2011, from http://www.nytimes.com/2011/12/01/arts/design/san-francisco-museum-of-modern-art-expansion-aims-for-friendly.html

The Port Authority of New York–New Jersey. (2009). *2009 annual airport traffic report.* Jersey City, NJ: Author.

The Powerhouse Museum. http://www.powerhousemuseum.com/

Pratty, J. (2006). The inside out web museum. In J. Trant & D. Bearman (Eds.), *Museums and the Web 2006: Proceedings.* Toronto: Archives & Museum Informatics. Retrieved June 6, 2011, from http://www.museumsandtheweb.com/mw2006/papers/pratty/pratty.html

Price, E. (2011, November 18). *Digital wayfinding in the Walker, Pt. 1* [Blog post]. Retrieved November 28, 2011, from Walker Art Center: http://blogs.walkerart.org/newmedia/2011/11/18/digital-wayfinding-1/

Prim, R., Peters, S., & Schultz, S. (2004). *Art and civic engagement: Mapping the connections.* Minneapolis, MN: Walker Art Center.

Prim, R., Peters, S., & Schultz, S. (2005). *Art and civic engagement: Mapping the connections. The workbook.* Minneapolis, MN: Walker Art Center.

Putnam, R. D. (1995). Bowling alone: America's declining social capital. *Journal of Democracy, 6,* 65–78.

Putnam, R. D. (2000). *Bowling alone: The collapse and revival of American community.* New York: Simon & Schuster.

Putnam, R. D. (2007). E pluribus unum: Diversity and community in the twenty-first century. The 2006 Johan Skytte Prize lecture. *Scandinavian Political Studies, 30,* 137–174.

Reicher, S., Spears, R., & Postmes, T. (1995). A social identity model of deindividuation phenomena. *European review of social psychology, 6,* 161–198.

Reiss, S. B. (1960). *Grace L. McCann Morely. Art, artists, museums, and the San Francisco Museum of Modern Art.* Berkeley: University of California, Berkeley, Bancroft Library.

Rifkin, J. (2000). *The age of access: The new culture of hypercapitalism, where all of life is a paid-for experience.* New York: Jeremy P. Tarcher/Putnam.

Rigelhaupt, J. (2008). *Peter Samis*. Berkeley: University of California, Berkeley, Bancroft Library.

Robbins, B. (Ed.). (1993). *The phantom public sphere*. Minneapolis: University of Minnesota Press.

Rosenbaum, L. (2010, February 2). The Met's marathon man [Electronic version]. *The Wall Street Journal*. Retrieved December 29, 2011, from http://online.wsj.com/article/SB1000142405274870 3699204575017351893052866.html

Rosenbaum, L. (2010, June 18). *MeTube: "Populist" Arnold Lehman strikes back* [Blog post]. Retrieved December 19, 2011, from CultureGrrl: http://www.artsjournal.com/culturegrrl/2010/06/metube_arnold_lehman_strikes_b.html

Rosenbaum, L. (2010, August 10). *"Mr. Populism": My Q&A with Brooklyn's Arnold Lehman–Part I* [Blog post]. Retrieved September 15, 2011, from CultureGrrl: http://www.artsjournal.com/culturegrrl/2010/08/mr_populism_my_qa_with_brookly.html

Rosenbaum, L. (2010, August 16). *"Mr. Populism": My Q&A with Brooklyn's Arnold Lehman–Part II* [Blog post]. Retrieved September 15, 2011, from CultureGrrl: http://www.artsjournal.com/culturegrrl/2010/08/mr_populism_my_qa_with_brookly_1.html

Rosenberg, K. (2010, August 18). A museum show as a TV contest prize [Electronic version]. *New York Times*. Retrieved December 19, 2011, from http://www.nytimes.com/2010/08/19/arts/design/19abdi.html?pagewanted=all

Rosentiel, T., Mitchell, A., Purcell, K., & Ranie, L. (2011, September 26). *How people learn about their local community* (2006–2011 Project for Excellence in Journalism). Washington, DC: Pew Research Center.

Rothstein, E. (2010, October 1). From Picassos to sarcophagi, guided by phone apps [Electronic version]. *New York Times*. Retrieved January 26, 2011, from http://www.nytimes.com/2010/10/02/arts/design/02apps.html

Rubens, L., Cándida Smith, R., & Samis, P. (2008). *Jack Lane*. Berkeley: University of California, Berkeley Bancroft Library.

Rubens, L., Cándida Smith, R., & Sterrett, J. (2008). *David Ross*. Berkeley: University of California, Berkeley Bancroft Library.

Samis, P. (2001). "Points of Departure": Curators and educators collaborate to prototype a museum of the future. In *International Cultural Heritage Informatics Meeting Conference Proceedings: Vol. 1. Cultural Heritage and Technologies in the Third Millenium* (pp. 623–637). Retrieved November 18, 2011, from http://testing.archimuse.com/publishing/ichim01_vol1/samis.pdf

Samis, P. (2007a). Gaining traction in the vaseline: Visitor response to a multi-track interpretation design for *"Matthew Barney: DRAWING RESTRAINT."* In J. Trant & D. Bearman (Eds.), *Museums and the Web 2007: Proceedings*. Toronto: Archives & Museum Informatics. Retrieved June 14, 2011, from http://www.archimuse.com/mw2007/papers/samis/samis.html

Samis, P. (2007b). New technologies as part of a comprehensive interpretive plan. In H. Din &
P. Hecht (Eds.), *The digital museum: A think guide* (pp. 19–34). Washington, DC: American
Association of Museums.

Samis, P., & Pau, S. (2006). Artcasting at SFMOMA: First-year lessons, future challenges for
museum podcasters broad audience of use. In J. Trant & D. Bearman (Eds.), *Museums and
the Web 2006: Proceedings*. Toronto: Archives & Museum Informatics. Retrieved June 6, 2011,
from http://www.museumsandtheweb.com/mw2006/papers/samis/samis.html

Sander, T. H., & Putnam, R. D. (2010, January). Still bowling alone? The post-9/11 split. *Journal
of Democracy, 21*, 9–16.

The San Francisco Arts Commission. (2010). *San Francisco Arts Commission district report*. San
Francisco: Author.

The San Francisco Arts Commission. (2011, February 10). *Five new public artworks debut at San
Francisco Airport's new Terminal 2* [Press Release]. San Francisco: Author.

The San Francisco Convention and Visitors Bureau (2009). *San Francisco fact sheet*. San
Francisco: Author.

The San Francisco Museum of Modern Art. http://www.sfmoma.org/

The San Francisco Museum of Modern Art. (2000, October 5). *SFMOMA to unveil redesigned,
web-compatible Making Sense of Modern Art Multimedia Program groundbreaking program
launches in galleries and on web* [Press Release]. San Francisco: Author.

The San Francisco Museum of Modern Art. (2001, March 29). *New technologies help connect
visitors and contemporary art in SFMOMA's Points of Departure Exhibition* [Press Release].
San Francisco: Author.

The San Francisco Museum of Modern Art. (2007, September 1). *SFMOMA wins prestigious
media and technology awards* [Press Release]. San Francisco: Author.

The San Francisco Museum of Modern Art. (2009, August 5). *SFMOMA celebrates 75 years of
looking forward* [Press Release]. San Francisco: Author.

Schneiderman, B. (2002). *Leonardo's laptop: Human needs and the new computing technologies*.
Cambridge, MA: MIT Press.

Schultz, S. (2010, June 22). *Pioneering Participation* [Blog post]. Retrieved October 10, 2011, from
the Walker Art Center: http://blogs.walkerart.org/ecp/author/sarah/

Schwartz, B. (1982). The social context of commemoration: A study in collective memory. *Social
Forces, 61*, 374–402.

Seely Brown, J., & Adler, R. P. (2009, January/February). Minds on fire: Open education, the long
tail, and learning 2.0. *Educause Review*, 16–32.

Segal, H. P. (2006). Technology and utopia. In P. O. Long & R. C. Post (Eds.), *Historical perspectives on technology, society, and culture.* Charlotesville, VA: Society for the History of Technology and the American Historical Association.

Sherman, A. (2011, September 14). How tech is changing the museum experience. *Mashable Tech.* Retrieved September 21, 2011, from http://mashable.com/2011/09/14/high-tech-museums/

Sheskin, I., Dashefsky, A., & DellaPergola, S. (Eds.). (2010). *Jewish population in the United States, 2010.* Storrs, CT: Mandell L. Berman Institute North American Jewish Data Bank, University of Connecticut.

Simon, N. (2007, November 14). *Interview with Brooklyn Museum's Shelley Bernstein* [Blog post]. Retrieved December 26, 2011, from Museum 2.0: http://museumtwo.blogspot.com/2007/11/interview-with-brooklyn-museum-shelley.html

Simon, N. (2009, April 20). *Avoiding the participatory ghetto: Are museums evolving with their innovative web strategies?* [Blog post]. Retrieved October 6, 2011, from Museum 2.0: http://museumtwo.blogspot.com/2009/04/avoiding-participatory-ghetto-are.html

Simon, N. (2010). *The participatory museum.* Santa Cruz, CA: Museum 2.0.

Simon, N. (2011, December 7). *Digital museums reconsidered: Exploring the Walker Art Center website redesign* [Blog post]. Retrieved December 12, 2011, from Museum 2.0: http://museumtwo.blogspot.com/2011/12/digital-museums-reconsidered-exploring.html?utm_source=feedburner&utm_medium=email&utm_campaign=Feed%3A+museumtwo+%28Museum+2.0%29

Slack, J. D., & Wise, J. M. (2005). *Culture and technology: A primer.* New York: Peter Lang.

Smith, A. (2011). *Why Americans use social media* (Pew Internet & American Life Project). Washington, DC: Pew Research Center.

Smith, R. (2010, June 17). Andy Warhol, outside his comfort zones [Electronic version]. *New York Times.* Retrieved January 6, 2012, from http://www.nytimes.com/2010/06/18/arts/design/18warhol.html?pagewanted=all

The Smithsonian Institution. http://www.si.edu/

The Solomon R. Guggenheim Foundation. http://www.guggenheim.org/guggenheim-foundation

The Solomon R. Guggenheim Museum. http://www.guggenheim.org/

Special report: Geography and the net, putting it in its place [Electronic version]. (2001). *Economist,* 18–20. Retrieved on September 20, 2011, from http://www.economist.com/node/729808

Spigel, L. (2004). Portable TV: Studies in domestic space travels. In M. Sturken, D. Thomas, and S. Ball-Rokeach (Eds.), *Technological visions: The hopes and fears that shape new technologies* (pp. 110–144). Philadelphia: Temple University Press.

Spigel, L. (2008). *TV by design: Modern art and the rise of network television*. Chicago: University of Chicago Press.

The Stedelijk Museum. http://www.stedelijk.nl/en

Stein, R. (2009, July 27). *In response to Nina Simon: Bait and switch* [Blog post]. Retrieved October 20, 2011, from Indianapolis Museum of Art: http://www.imamuseum.org/blog/2009/07/27/nina-simon-response/

Stein, R. (2009, September 15). *A 100 word elevator pitch for museum software* [Blog post]. Retrieved October 20, 2011, from Indianapolis Museum of Art: http://www.imamuseum.org/blog/2009/09/15/museum-software-elevator-pitch/

Stein, R. (2010, April 5). *Five reasons why TAP should be your museum's next mobile platform* [Blog post]. Retrieved October 14, 2011, from Indianapolis Museum of Art: http://www.imamuseum.org/blog/2010/04/05/5-reasons-why-tap-should-be-yourmuseums-next-mobile-platform/

stillspotting nyc. http://stillspotting.guggenheim.org/

Stoilas, H., & Burns, C. (2011, September 26). To charge or what to charge [Electronic version]? *Art Newspaper*. Retrieved October 18, 2011, from http://www.theartnewspaper.com/articles/To+charge+or+what+to+charge%3F/24451

Sturken, M. (2004a). The aesthetics of absence: Rebuilding ground zero. *American Ethnologist, 31*, 311–325.

Sturken, M. (2004b). Mobilities of time and space: Technologies of the modern and postmodern. In M. Sturken, D. Thomas, & S. Ball-Rokeach (Eds.), *Technological visions: The hopes and fears that shape new technologies* (pp. 71–91). Philadelphia: Temple University Press.

Sturken, M., Thomas, D., & Ball-Rokeach, S. (Eds.). (2004). *Technological visions: The hopes and fears that shape new technologies*. Philadelphia: Temple University Press.

Subcommittee on Healthy Families and Communities, Committee on Education and Labor, U.S. House of Representatives. (2008, September 11). *Examining the role of museums and libraries in strengthening communities* (Serial No. 110–109). Washington, DC: U.S. Government Printing Office.

Swearingen, J. (2011, September 2). *SF Weekly* web awards 2011: We have some winners! *SFWeekly*. Retrieved October 4, 2011, from http://blogs.sfweekly.com/exhibitionist/2011/09/sf_weekly_web_awards_2011_we_h.php

Szántó, A. (2010, December 2). Time to Lose Control (Art Basel Miami Beach daily edition). *Art Newspaper*. Retrieved January 19, 2011, from http://www.theartnewspaper.com/articles/Time+to+lose+control/22092

Tajfel, H. (Ed.) (1978). *Differentiation between social groups: Studies in the social psychology of intergroup relations*. London: Academic Press.

Tallon, L. (2008). Introduction: Mobile, digital, and personal. In L. Tallon & K. Walker (Eds.), *Digital technologies and the museum experience: Handheld guides and other media* (pp. xiii–xxv). Lanham, MD: AltaMira.

Tallon, L., & Walker, K. (Eds.). (2008). *Digital technologies and the museum experience: Handheld guides and other media*. Lanham, MD: AltaMira.

Tan, E., Chisalita, C., Raimjakers, B., & Oinonen, K. (2008). Learning and entertainment in museums: A case study. *Changing Media, Changing Europe, 5,* 91–110.

The Tate Museum. http://www.tate.org.uk/

Taylor, K. (2010, October 25). U.S. to send visual artists as cultural ambassadors [Electronic version]. *New York Times.* Retrieved September 15, 2011, from http://www.nytimes.com/2010/10/26/arts/design/26friends.html

Taylor, K. (2011, May 10). MoMA to buy building used by museum of folk art [Electronic version]. *New York Times.* Retrieved May 12, 2011, from http://www.nytimes.com/2011/05/11/nyregion/moma-to-buy-american-folk-art-museum-building.html

Thomas, D. (2011, February 2). From community to collective: Institution and agency in the age of social networks (working paper series). *Social Science Research Network.* Retrieved September 10, 2011, from http://ssrn.com/abstract=1754214

Thomas, D., & Seely Brown, J. (2011). *A new culture of learning: Cultivating the imagination for a world of constant change.* Lexington, KY: Authors.

Thomas, W. (2008, July 4). Hoosier [Blog post]. *Urban Dictionary.* Retrieved November 4, 2012, from http://www.urbandictionary.com/define.php?term=hoosier%20&page=2

Turkle, S. (1995). *Life on the screen: Identity in the age of the internet.* New York: Simon & Schuster.

Turkle, S. (1996, Winter). Virtuality and its discontents: Searching for community in cyberspace. *The American Prospect, 24,* 50–57.

Turkle, S. (Ed.). (2007). *Evocative objects: Things we think with.* Cambridge, MA: MIT Press.

Turner, J., Hogg, M., Oakes, P., Reicher, S., & Wetherell, M. (1987). *Rediscovering the social group: A self-categorization theory.* New York: Blackwell.

UNESCO. (2005). *Towards knowledge communities* (UNESCO World Report). Paris: UNESCO Publishing.

Urban Dictionary. http://www.urbandictionary.com/

U.S. Bureau of the Census. (1998, June 15). *Population of the 100 largest urban places: 1860* (Table 9). Washington, DC: Author.

U.S. Bureau of the Census. (1999, March 9). *Nativity of the population for the 25 largest urban places and for selected counties: 1860* (Table 20). Washington, DC: Author.

U.S. Bureau of the Census. (2010). *American community survey 2005–2009* (Table S 0201). Washington, DC: Author.

U.S. House of Representatives, Committee on Education and Labor, Subcommittee on Healthy Families and Communities. (2008, September 11). *Examining the role of museums and libraries in strengthening communities* [Hearing report]. Washington, DC: U.S. Government Printing Office.

Vankin, D. (2011, September 22). LACMA set to roll away the stone [Electronic version]. *Los Angeles Times.* Retrieved September 30, 2011, from http://articles.latimes.com/2011/sep/22/entertainment/la-et-heizer-rock-20110922

Van Mastrigt, E. (2011, October 31). *Interview with Hein Wils: Stedelijk Museum and ARtours* [Blog post]. Retrieved January 3, 2012, from Masters of Media blog, University of Amsterdam: http://mastersofmedia.hum.uva.nl/2011/10/31/interview-with-hein-wils-stedelijk-museum-and-artours/

The Victoria and Albert Museum. http://www.vam.ac.uk/

The Virtual Museum of the City of San Francisco. http://www.sfmuseum.org/

Vogel, C. (2008, December 15). Brooklyn Museum's costume treasures going to the Met [Electronic version]. *New York Times.* Retrieved December 19, 2011, from http://www.nytimes.com/2008/12/16/arts/design/16muse.html?pagewanted=all

Vogel, C. (2011, March 16). Four to follow [Electronic version]. *New York Times.* Retrieved February 15, 2012, from http://www.nytimes.com/2011/03/17/arts/design/four-innovating-for-museums-online.html

Vogel, C. (2011, August 1). Guggenheim outpost as a pop-up urban lab [Electronic version]. *New York Times.* Retrieved August 12, 2011, from http://www.nytimes.com/2011/08/03/arts/design/bmw-guggenheim-lab-to-open-as-pop-up-in-east-village.html

The Walker Art Center. http://www.walkerart.org/

The Walker Art Center. (1998). *Minneapolis sculpture garden: A collaboration between the Walker Art Center and the Minneapolis Park and Recreation Board.* Minneapolis, MN: Author.

The Walker Art Center. (2005, August). *Walker Art Center Capital Campaign.* Minneapolis, MN: Author.

The Walker Art Center. (2010, May 7). *Walker Art Center launches innovative community initiative: Open Field* [Press Release]. Minneapolis, MN: Author.

The Wallace Foundation. (1998, November). *Opening the door to the entire community. How museums are using permanent collections to engage audiences.* New York: Author.

Warner, M. (2005). *Publics and counterpublics.* Brooklyn, NY: Zone Books.

Watkins, J., & Russo, A. (2007). Cultural institutions, co-creativity and communities of interest. In D. Schuler (Ed.), Human-Computer Interaction International, Beijing, China. *Online communities and social computing* (pp. 212–221). Germany: Springer-Verlag Berlin Heidelberg.

Watson, S. (Ed.). (2007). *Museums and their communities*. New York: Routledge.

Weil, S. E. (2002). *Making museums matter*. Washington, DC: Smithsonian Institution Press.

Weil, S. E. (2003, November/December). Beyond big & awesome: outcome-based evaluation. *Museum News*, 40–45, 52–53.

Wellman, B., & Hampton, K. (1999, November). Living networked on and offline. *Contemporary Sociology, 28*, 648–654.

Wellman, B., Salaff, J., Dimitrova, D., Garton, L., Gulia, M., & Haythornthwaite, C. (2000). Computer networks as social networks: Collaborative work, telework, and virtual community. In E. L. Lesser, M. A. Fontaine, & J. A. Slusher (Eds.), *Knowledge and communities* (pp. 179–208). Boston: Butterworth Heinemann.

Wenger, E. (2000). Communities of practice: The key to knowledge. In E. L. Lesser, M. A. Fontaine, & J. A. Slusher (Eds.), *Knowledge and communities* (pp. 3–20). Boston: Butterworth Heinemann.

West, C. (1992). The postmodern crisis of the black intellectual. In L. Grossberg, C. Nelson, & P. A. Treichler (Eds.), *Cultural studies* (pp. 689–705). New York: Routledge.

Wilkening, S., & Chung, J. (2009). *Life stages of the museum visitor: Building engagement over a lifetime*. Washington, DC: American Association of Museums.

Williams, R. (1980). *Problems in materialism and culture: Selected essays*. London: Verso.

Williams, R. (1983a). *The year 2000*. New York: Pantheon Books.

Williams, R. (1983b). *Culture and society: 1780–1950*. New York: Columbia University Press. (Original work published 1958)

Williams, R. (1990). *Notes on the underground: An essay on technology, society, and the imagination*. Cambridge, MA: MIT Press.

Williams, R. (2002). *Keywords: A vocabulary of culture and society* (Rev. ed.). In S. Duncombe (Ed.), *Cultural resistance reader* (pp. 35–41). New York: Verso. (Original work published 1976)

Wilson, S. M., & Peterson, L. C. (2002). The anthropology of online communities. *Annual Review Anthropology, 31*, 449–467.

Winner, L. (1978). *Autonomous technology: Technics-out-of-control as a theme in political thought*. Cambridge, MA: MIT Press.

Winner, L. (2003). Social constructivism: Opening the black box and finding it empty. In R. C. Scharff & V. Dusek (Eds.), *Philosophy of technology: The technological condition: An anthology* (pp. 233–243). Malden, MA: Blackwell Publishing.

Witcomb, A. (2007). "A place for all of us?" Museums and communities. In S. Watson (Ed.), *Museums and their communities* (pp. 133–156). New York: Routledge.

Zarembo, A., & Boehm, M. (2009, August 18). Behind Michael Govan's almost $1 million LACMA salary [Electronic Version]. *Los Angeles Times*. Retrieved August 20, 2009, from http://www.latimes.com/entertainment/news/arts/la-et-lacma18-2009aug18,0,7489611.story

Zirin, J. D. (Speaker). (2011, March 25). *Digital museum: Will the minnow swallow the whale?–Glenn Lowry* [Video]. Retrieved November 21, 2011, from YouTube: http://www.youtube.com/watch?v=TzGLTtr574c

Zolberg, V. L. (1992). Art museums and living artists: Contentious communities. In I. Karp, C. M. Kreamer, & S. D. Lavine (Eds.), *Museums and communities: The politics of public culture* (pp. 105–137). Washington, DC: Smithsonian Institution Press.

Index

About the Author

Susana Smith Bautista is a multidisciplinary scholar on museums, digital technology, and the arts.